UTAMARO

Text: after Edmond de Goncourt

Translated from the French by Michael & Lenita Locey

© 2008, Parkstone Press International, New York, USA
© 2008, Confidential Concepts, worldwide, USA

Layout:
Baseline Co Ltd.
33 Ter - 33 Bis Mac Dinh Chi St.,
Star Building; 6th floor
District 1, Ho Chi Minh City
Vietnam

ISBN: 978-1-85995-682-3

Printed in Korea

After Edmond de Goncourt

UTAMARO

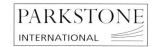
PARKSTONE
INTERNATIONAL

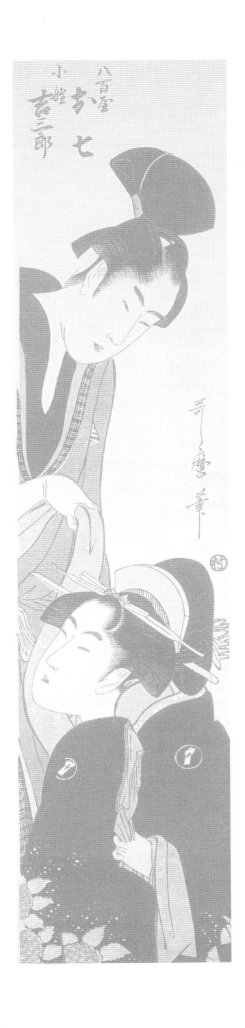

Contents

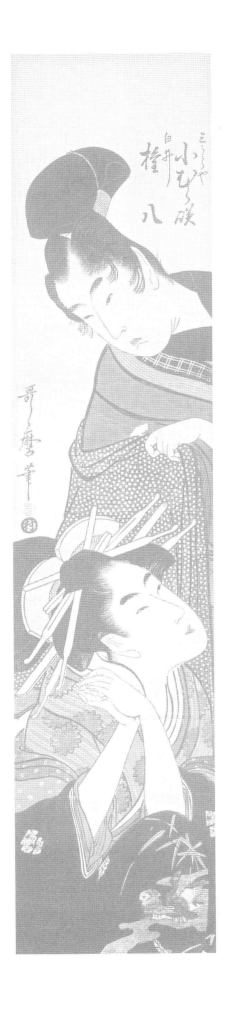

FOREWORD

In his *Life of Utamaro*, Edmond de Goncourt, in exquisite language and with analytical skill, interpreted the meaning of the form of Japanese art which found its chief expression in the use of the wooden block for colour printing. To glance appreciatively at the work of both artist and author is the motive of this present sketch. The *Ukiyo-e** print, despised by the haughty Japanese aristocracy, became the vehicle of art for the common people of Japan, and the names of the artists who aided in its development are familiarly quoted in every studio, whilst the classic painters of Tosa and Kanō are comparatively rarely mentioned. The consensus of opinion in Japan during the lifetime of Utamaro agrees with the verdict of de Goncourt: no artist was more popular than Utamaro. His atelier was besieged by editors giving orders, and in the country his works were eagerly sought after, while those of his famous contemporary, Toyokuni, were but little known. In the *Barque of Utamaro*, a famous *surimono**, the title of which forms a pretty play upon words, *maro* being the Japanese for "vessel," the seal of supremacy is set upon the artist. He was essentially the painter of women, and though de Goncourt sets forth his astonishing versatility, he yet entitles his work *Utamaro, le Peintre des Maisons vertes*.

– Dora Amsden

Hanaōgi of the Ōgiya [kamuro:] Yoshino, Tatsuta (Ōgiya uchi Hanaōgi),
1793-1794.
Ōban, nishiki-e, 36.4 x 24.7 cm.
Musée national des Arts asiatiques – Guimet, Paris.

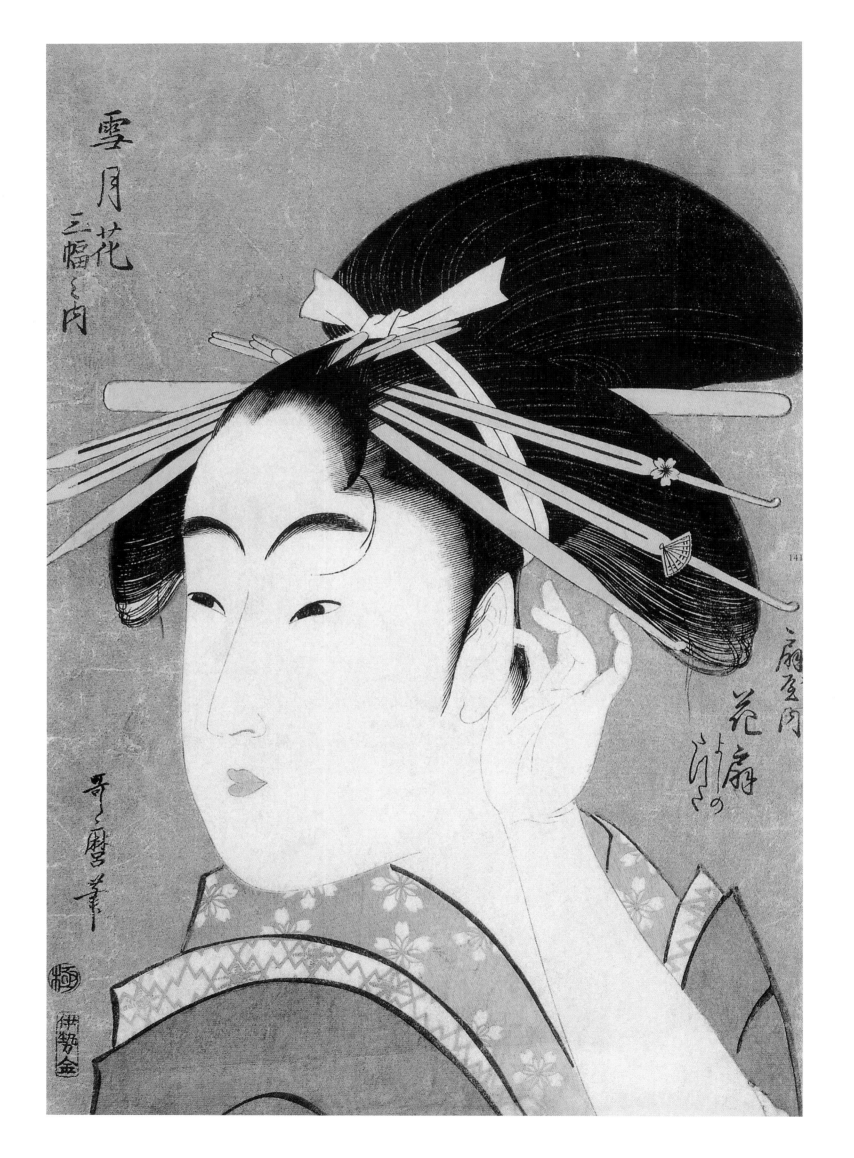

I. THE ART OF UTAMARO

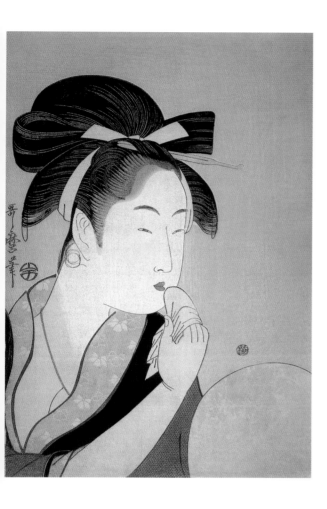

To leaf through albums of Japanese prints is truly to experience a new awakening, during which one is struck in particular by the splendour of Utamaro. His sumptuous plates seize the imagination through his love of women, whom he wraps so voluptuously in grand Japanese fabrics, in folds, contours, cascades and colours so finely chosen that the heart grows faint looking at them, imagining what exquisite thrills they represented for the artist. For women's clothing reveals a nation's concept of love, and this love itself is but a form of lofty thought crystallised around a source of joy. Utamaro, the painter of Japanese love, would moreover die from this love; for one must not forget that love for the Japanese is above all erotic. The *shungas** of this great artist illustrate how interested he was in this subject. His delectable images of women fill hundreds of books and albums and are reminders, if any were needed, of the countless affinities between art and eroticism. Thus Utamaro's teacher, the painter Toriyama Sekien, could say of the magnificent *Picture Book: Selected Insects* (pp. 234, 236, 237): "Here are the first works done from the heart." The heart of Utamaro shines forth in the quest for the beauty of animals through this effusion with which he depicts the women of the *Yoshiwara**: the love of beauty in an artist is not real unless he has the sensuality for it. Love and sex are at the foundation of aesthetic feelings and become the best way to exteriorise art which, in truth, never renders life better than by schematisation, by stylisation.

Among the artists of the Japanese movement of the "floating world" (*Ukiyo*), Utamaro is one of the best known in Europe; he has remained the painter of the "green houses", as he was called by Edmond de Goncourt. We associate him at once with the colour prints (*nishiki-e**) of his great willowy black-haired courtesans dressed in precious fabrics, a virtuoso performance by the printmaker.

In addition to romantic scenes set in nature, he dealt with themes such as famous lovers together, portraits of courtesans or erotic visions of the *Yoshiwara**. But it is Utamaro's portrayals of women which are the most striking by their sensual beauty, at once lively

Snow, Moon and Flowers from the Ōgiya Tea House (Setsugekka Hanaōgi),
Kansei period (1789-1801).
Ōban, nishiki-e, 36.2 x 24.9 cm.
Musée national des Arts asiatiques – Guimet, Paris.

Woman Making up her Lips (Kuchibiru), c. 1795-1796.
Ōban, nishiki-e, 36.9 x 25.4 cm.
Private Collection, Japan.

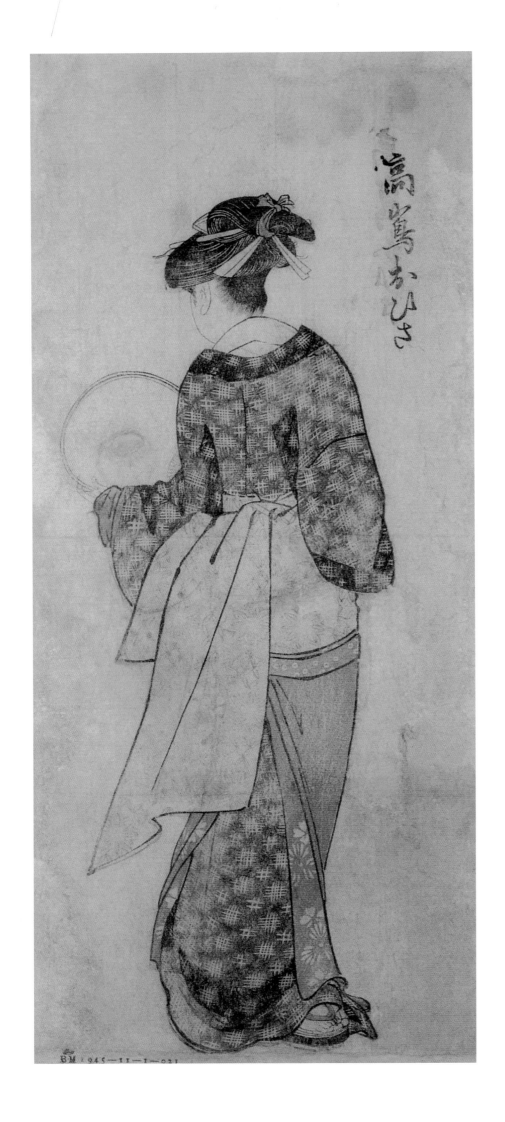

and charming, so far removed from realism, and imbued with a highly-refined psychological sense. He offered a new ideal of femininity; thin, aloof, and with reserved manners. He has been criticised for having popularised the fashion of the long silhouette in women and giving these figures unrealistic proportions. He was, to be sure, one of the prominent representatives of this style, but his portraits of women, with their distorted proportions, remain works of an art which is marvellous and eminently Japanese. In truth, the Japanese value nobility in great beauty more highly than observation and cleverness. Subtly, the evocative approach brings beauty to full flower, offers its thousand facets to the eye, astonishes by a complexity of attitudes which are more apparent than real and takes absurd liberties with the truth, liberties which are nonetheless full of meaning.

Little is known of the life of Utamaro. Ichitarō Kitagawa, his original name, is said to have been born in Edo around the middle of the eighteenth century, probably in 1753, certainly in Kawagoe in the province of Musashi. It is a time-honoured tradition of

"Naniwaya Okita", 1792-1793.
Hosoban, nishiki-e (double-sided (back view shown)),
33.2 x 15.2 cm.
Unknown Collection.

Japanese artists to abandon their family name and take artistic pseudonyms. The painter first took the familiar name of Yūsuke, then as a studio apprentice the name Murasaki, and finally, as a painter promoted out of the atelier and working in his own right, the name of Utamaro.

Utamaro came to Edo at a young age. After a few years of wandering, he went to live at the home of Tsutaya Jūzaburō, a famous publisher of illustrated books of the time, whose mark representing an ivy leaf surmounted by the peak of Fujiyama, is visible on the most perfect of Utamaro's printings. He lived a stone's throw from the great gates leading to the *Yoshiwara**. When Tsutaya Jūzaburō moved and set up shop in the centre of the city, Utamaro followed and stayed with him until the publisher's death in 1797. Thereafter Utamaro lived successively on Kyūemon-chō St, Bakuro-chō St, then established himself, in the years "preceding" his death, near the Benkei Bridge.

He first studied painting at the school of Kanō. Then, while still quite young, he became the pupil of Toriyama Sekien. Sekien taught him

"Naniwaya Okita", 1792-1793.
Hosoban, nishiki-e (double-sided (front view shown)),
33.2 x 15.2 cm.
Unknown Collection.

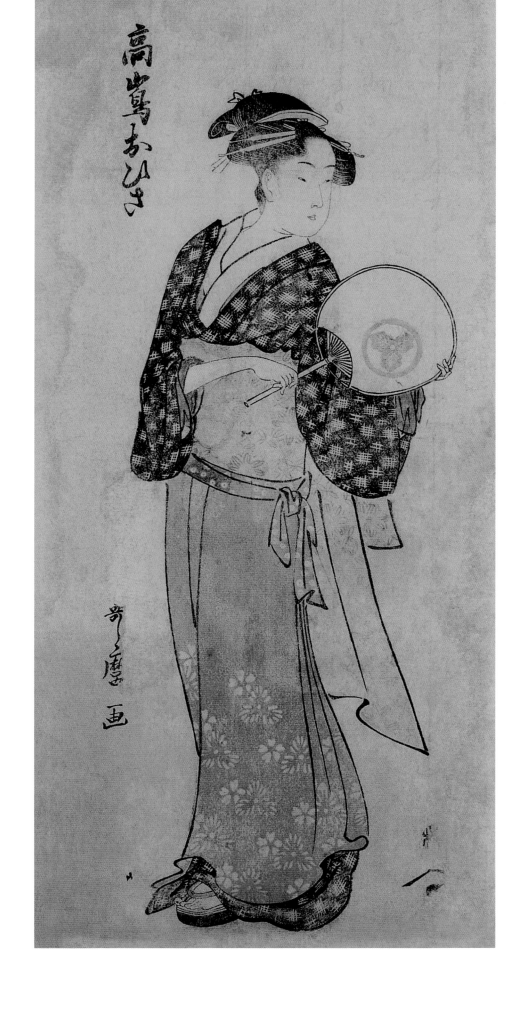

the art of printing and of *Ukiyo-e** painting. In his early years, Utamaro published prints under the name of Utagawa Toyoaki. It was his prints of beautiful women (*bijin-e*) and of erotic subjects which would make him famous. The masters Sekien and Shunshō passed on to Utamaro the secrets learned from the great Kiyonaga and from the amiable and ingenious Harunobu (1752-1770). He became a sort of aristocrat of painting, not deigning to paint people of the theatre or even men. At the time, painters' popularity depended on the popularity of their subject. And, in a country where all strata of the population adored theatre players, it was common for a painter to take advantage of their fame by integrating them into his work. Utamaro refused to draw actors, saying proudly: "I don't want to be beholding to actors for my fame, I wish to found a school which owes nothing except to the talent of the painter." When the actor Ichikawa Yaozō had an enormous success in the play of *Ohan and Choyemon* and his portrait, done by Utagawa Toyokuni (1769-1825), became famous, Utamaro, did indeed show the play, but represented it by elegant women, playing in imaginary scenes. It was his

way of demonstrating that the artists of the popular school, who had replicated the subject in the manner of Toyokuni, were a troop swarming out of their studios, a troop which he compared to "ants coming out of rotten wood". Women were his only interest, filling his art, and soon he became the wonderful artist we know. Amongst those who played an influential role for Utamaro at the time, Tsutaya Jūzaburō (1750-1797) published his first illustrated albums. Jūzaburō was surrounded by writers, painters and intellectuals, who gathered to practise *kyōka** poetry, which had more liberal themes and more flexible rules than traditional poetry, and which was meant to be humorous. These collections of *kyōka** were lavishly illustrated by Utamaro. His collaboration with Tsutaya Jūzaburō, whose principal artist he soon became, marked the beginning of Utamaro's fame. Around 1791, he left book illustration to concentrate entirely on women's portraits. He chose his models in the pleasure districts of Edo, where he is reputed to have had many adventures with his muses. By day, he devoted himself to his art and by night, he succumbed to the fatal charm of this brilliant

"underworld", until the time when, seduced by the "tiny steps and hand gestures", his art undermined by excess, he "lost his life, his name and his reputation".

But, make no mistake, the *Yoshiwara** has nothing in common with western houses of prostitution. It was, in the eighteenth century especially, a garden of delights. In it one paid an elaborate court to prostitutes of great charm, versed in letters and in the rituals of the most exquisite etiquette. Eros assuming the figure of love. Utamaro had no trouble gathering all the elements of his work in "the green houses", of which he was the recognised painter. For many connoisseurs of Japanese prints, Utamaro is the undisputed master of the representation of women, whom he idealises and whom he depicts as tall and slim, with a long necks and delicate shoulders, a far cry from the real appearance of the women of the time.

In terms of style it was around 1790 that Utamaro took his place as the leader of *Ukiyo-e**. This style captivated the Japanese public from the very beginning. Its spread was the product

of the time of Edo, that is to say, a great
renaissance of middle-class inspiration, which
flourished in the midst of a civilisation
brilliantly developed by the aristocracy, the
military, and the clergy. However, in the early
years of the nineteenth century, Utamaro's
talent and his incessant production began to
lose originality. The artist grew old along with
the man. He who had been so opposed to the
representation of theatrical themes, goaded by
the success of Toyokuni, who was beginning to
become his rival, began to deal with subjects
taken from plays, and he produced several
*mitiyuki**. In these compositions, as well as in
others, the elongated women, those slender
creatures of his early period, put on weight
and become rounder and thicker. The feminine
silhouettes became heavy, yet still without the
fatness found in Torii Kiyonaga (1752-1815).
Against the women, who had filled his first
works alone, he juxtaposed male figures who
were comical, grotesque caricatures. The artist
no longer wished to please through that ideal
gentility with which he had adorned his
women. He forced himself, by the presence of
these "ugly men", to flatter the public of the
time, whose taste was compared by Hayashi

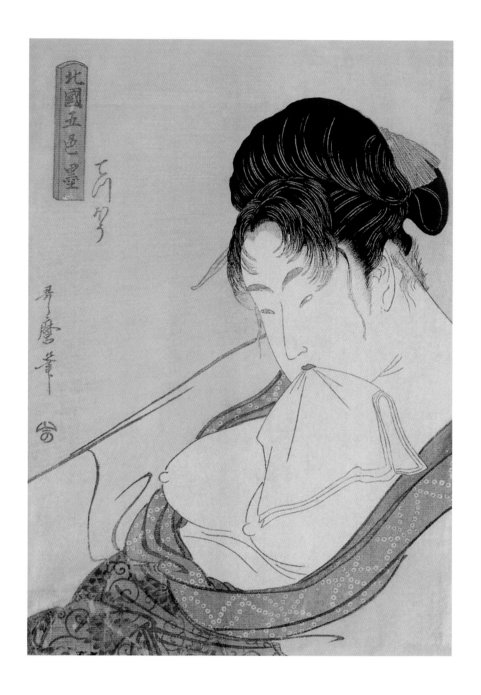

"Gun" Prostitute (Teppō), from the series *"Five Shades of
Ink in the Northern Quarter"* (Hokkoku goshiki-zumi),
1794-1795.
Ōban, nishiki-e, 37.9 x 24.2 cm.
Musée national des Arts asiatiques – Guimet, Paris.

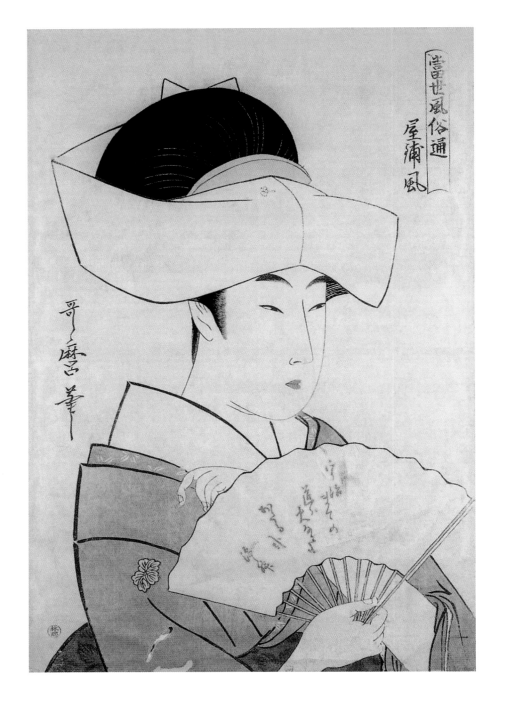

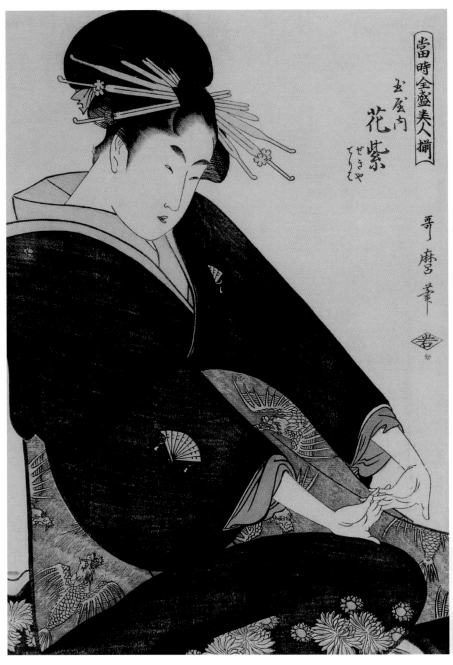

The Style of a Feudal Lord's Household (Yashiki-fū), from the series *"Guide to Contemporary Styles"* (Tōsei fūzoku tsū),
c. 1800-1801.
Ōban, nishiki-e, 37.5 x 25.5 cm.
Bibliothèque nationale de France, Paris.

Hanamurasaki of the Tamaya, [kamuro:] Sekiya, Teriha (Tamay uchi Hanamurasaki), from
the series *"Array of Supreme Beauties of the Present Day"* (Tōji zensei bijin-zoroe),
1794.
Ōban, nishiki-e, 54 x 41.5 cm.
Musée national des Arts asiatiques – Guimet, Paris.

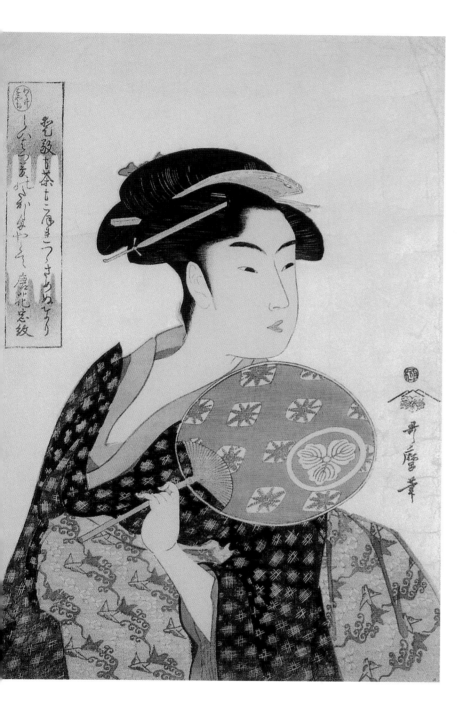

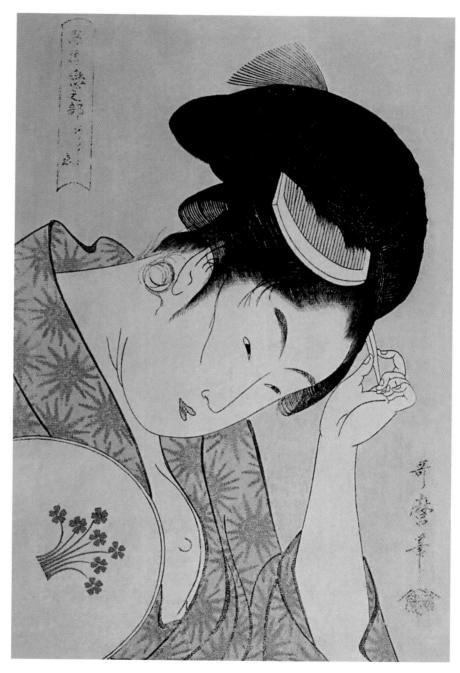

Takashima Ohisa (Takashima Ohisa),
1793.
Ōban, nishiki-e, 37.7 x 24.4 cm.
Musée national des Arts asiatiques – Guimet, Paris.

Obvious Love (Arawaru koi), from the series *"Anthology of Poems: The Love Section"*
(Kasen koi no bu),
1793-1794.
Ōban, nishiki-e, 37.5 x 25 cm.
Musée national des Arts asiatiques – Guimet, Paris.

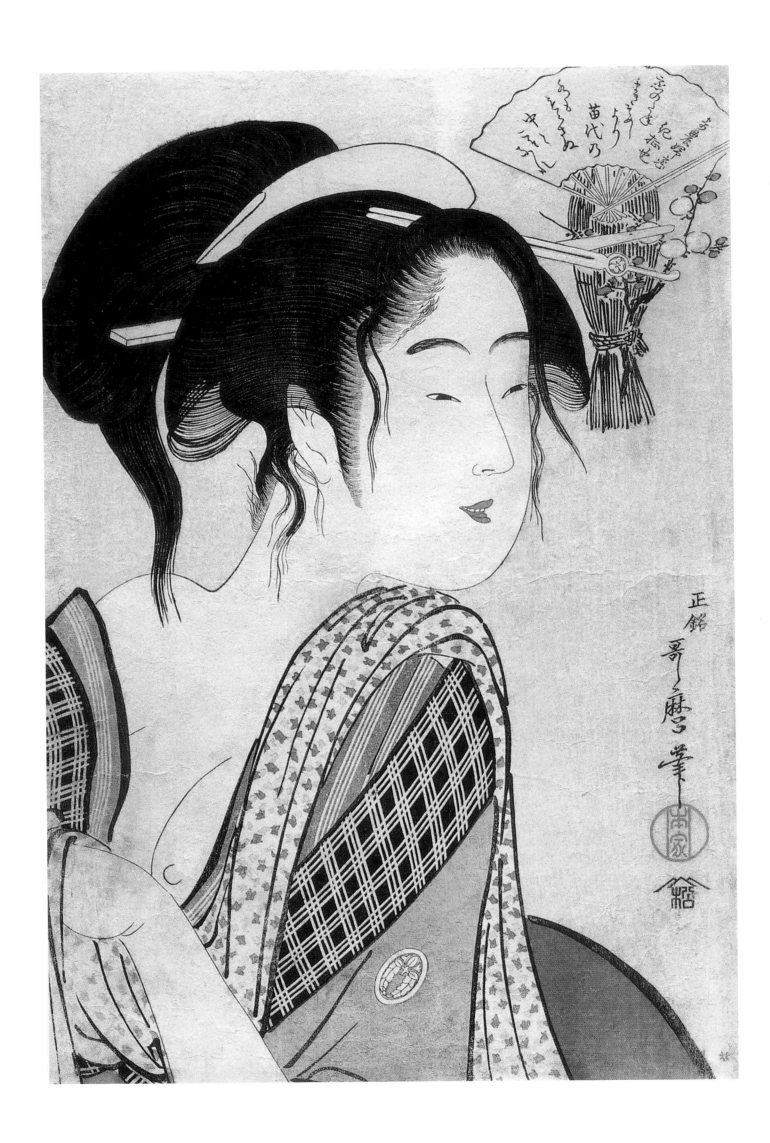

Tadamasa to the taste of certain collectors of modern ivories from Yokohama who, as he says, "prefer grimace to art", more interested in the drollness rather than the true beauty of the image.

Utamaro was not afraid to caricature the saints and the sages of the sacred legends of Buddhism, using the exaggerated features of famous courtesans. Banking on his immense popularity, he published a satire with images of a famous shogun, Toyotomi Hideyoshi (1536-1598) with his wife and five concubines. But this act of *lèse-majesté* led to his disgrace with the sovereign, who was very interested in the arts. The work was considered to be an insult against the shogunate; Utamaro was arrested for violation of the laws of censure and imprisoned. This experience was extremely humiliating for the artist. The jolly butterfly of the *Yoshiwara** emerged from his cell, exhausted and broken, no longer daring to put forth even the slightest audacity. He died in Edo, probably in 1806, on the third day of the fifth month of the lunar calendar. In the old copies of the *Ukiyo-e ruikō* (*Story of the Prints of the Floating World*), the date of

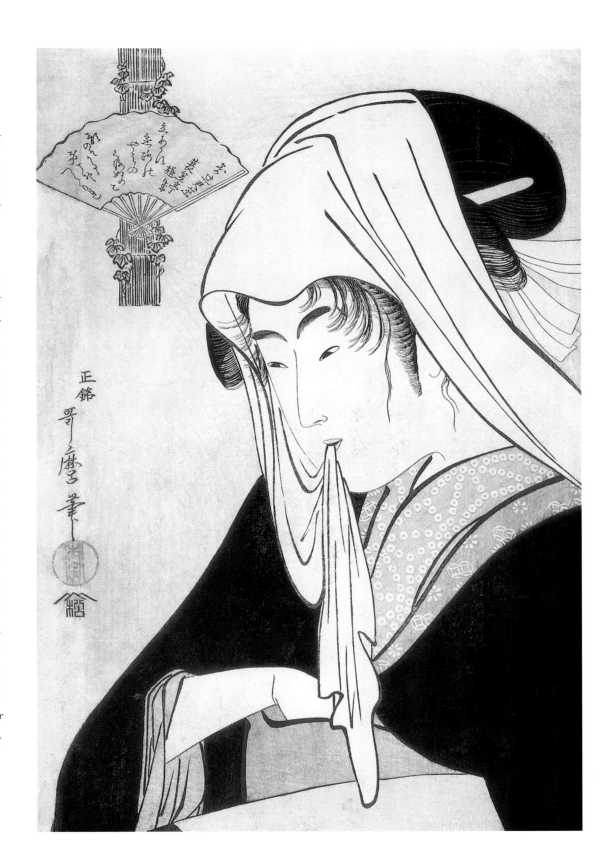

"Love for a Farmer's Wife" (Nōfu ni yosuru koi),
c. 1795-1796.
Ōban, nishiki-e, 36.9 x 24.5 cm.
Huguette Berès Collection.

"Love for a Street-Walker" (Tsuji-gimi ni yosuru koi),
c. 1795-1796.
Ōban, nishiki-e, 36.2 x 24.6 cm.
Huguette Berès Collection.

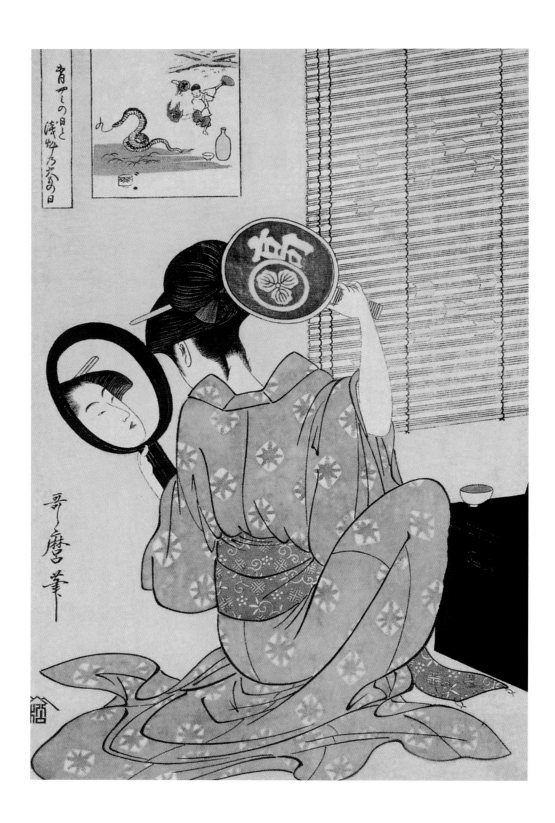

Utamaro's death is incorrect. The artist cannot have died on the eighth day of the twelfth month of the fourth year of the Kansei era (1792) since certain prints were still coming out in the beginning of the nineteenth century. The *Yoshiwara Picture Book: Annual Events*, or *Annals of the Green Houses* (pp. 195, 196, 197, 199) was published in 1804, and the plate representing a Japanese Olympus is dated on the first day of 1805.

The true inspirations for the manner and style of Utamaro were Kitao Shigemasa (1739-1820) and Torii Kiyonaga. From the latter Utamaro took the graceful elongation of the oval of his women's faces, a bit of the lazy softness at their waists, of the voluptuous undulation of fabrics around their bodies. This borrowing from Kiyonaga's drawing style is immediately obvious in two prints. One shows a teahouse by the sea, with a woman bringing his outer cloak, black with coats of arms, to a Japanese nobleman taking tea. A composition, which, were it not signed Utamaro, would be mistaken by any Japanese collector for a Kiyonaga. It must have been done in the Kiyonaga atelier between 1770 and 1775, at a time when the painter was

Takashima Ohisa (Takashima Ohisa), 1795.
Ōban, nishiki-e, 36.1 x 23.8 cm.
Musée national des Arts asiatiques – Guimet, Paris.

Beautiful Bouquet of Irises. The Courtesan Hitimoto.
Ōban, nishiki-e, 37.5 x 25.5 cm.
Bibliothèque nationale de France, Paris.

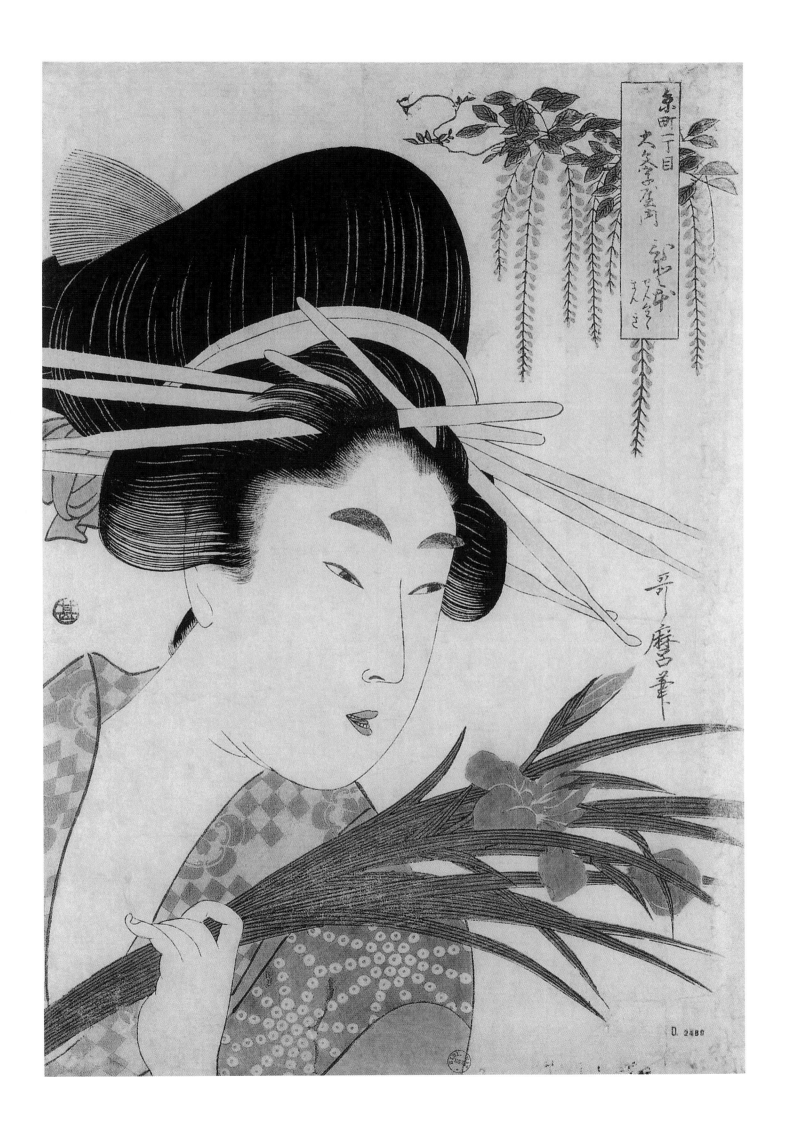

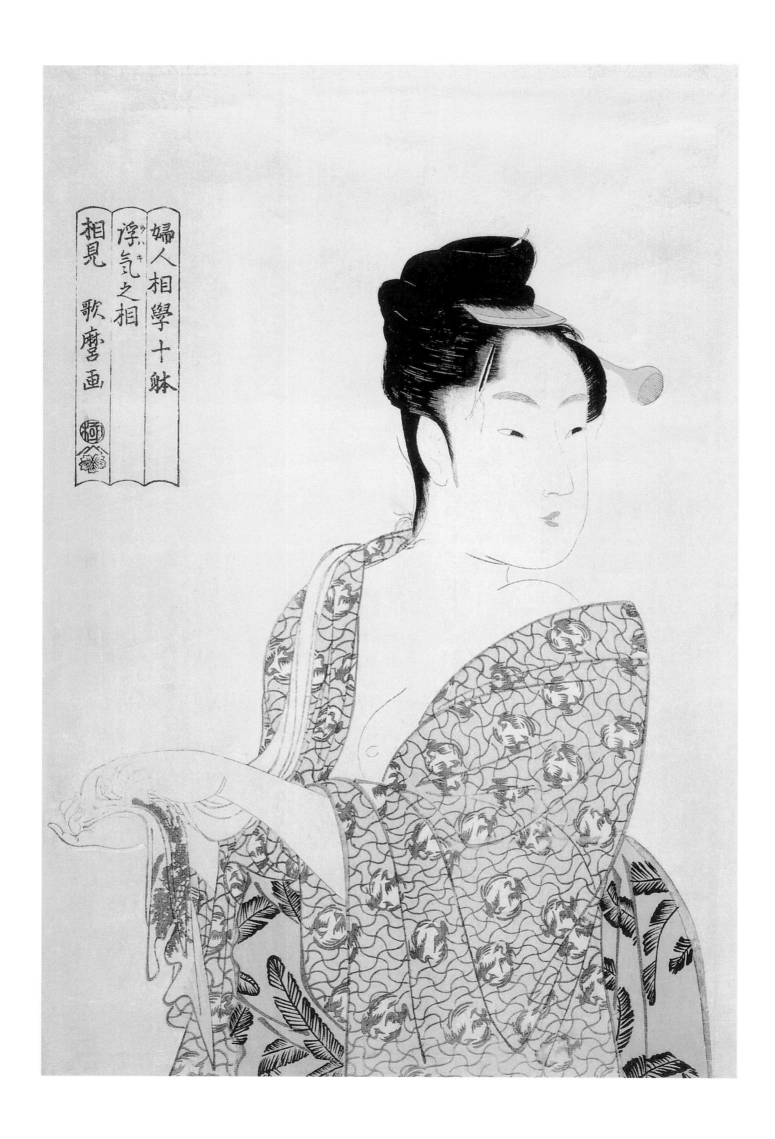

相　　浮　　婦
見　　気　　人
　　　　之　　相
　　　　相　　學
歌　　　　　　十
麿　　　　　　躰
画

20

barely twenty years old. The other shows a tall woman in a dress covered with cherry blossoms on a red background, to whom a figurine of wrestlers is being brought; it would date from 1775 at the latest. This relationship is also found in the six stunning prints of geishas celebrating the *Niwaka**, the *Yoshiwara** carnival, the first printing of which probably dates from 1775. These prints, even though more personal, are marked by the powerful style and the slightly Juno-esque proportions given to his women by the master of Utamaro, who had himself borrowed some of Kiyonaga's details such as the pretty, dishevelled kiss curls around the temples or the cheeks, which bring such a loving aspect to the faces.

While Utamaro shows a truly personal talent, certain of his works are clearly influenced by Kiyonaga or Heishi. For the works related to the end of his career, collectors are troubled by the borrowings from the latter and the resulting loss of quality. When considering this disappearance of the artist's original technique, they go so far as to wonder, in their more sceptical moments, if there was just one Utamaro or several.

Utamaro must have had a good many imitators during his lifetime, whether they were trained under him or elsewhere, and there were undoubtedly many more after his death. Among them, the new husband of Utamaro's wife figured prominently. After Utamaro's death, she married one of his pupils, Koikawa Harumachi II, who took the name of Utamaro II and continued, under that name, to fill orders taken by the late artist. Many prints bearing the signature of the master, with unimaginative compositions, expressionless heads, and jarring colours came to be included in the work of Utamaro. One must not only deal with the prints of his widow's husband and with the imitations which were being turned out during the peak of the artist's popularity, leading him at one point to sign his prints as "the real Utamaro", but one must also exclude a certain number of prints done in his own atelier by his pupils Kikumaro, Hidemaro, Takemaro and others, who had his permission to sign using his name. However, they were pale imitators and plagiarists.

Ukiyo-e, the schools of Kanō and Tosa

Utamaro has remained one of the most significant artists of the popular Japanese school, so poetically nicknamed "the floating world": the *Ukiyo*, from *Uki:* that which floats above, or overhead; *yo:* world, life, contemporary time. This term originated during the Edo period (1605-1868) to designate woodblock prints as well as the popular narrative painting (-*e:* painting). As defined by James Jarvis, the art of *Ukiyo-e** was a spiritual approach to reality and the natural conditions of daily life, communication with nature and the spirit of a lively and open-minded people, driven by a passionate appetite for art. The vigour and motivations of the *Ukiyo-e** masters and the scope of their accomplishments are proof of it. The true story of *Ukiyo-e**, according to Professor Ernest Fenollosa, is not the story of the technique of the block print, even though the block print was one of its most fascinating manifestations, but rather the aesthetic story of a particular form of expression.

The Fancy-free Type (Uwaki no sō), from the series "Ten Types in the Physiognomic Study of Women" (Fujin sōgaku juttai),
c. 1792-1793.
Ōban, nishiki-e, 36.4 x 24.5 cm.
The New York Public Library, New York.

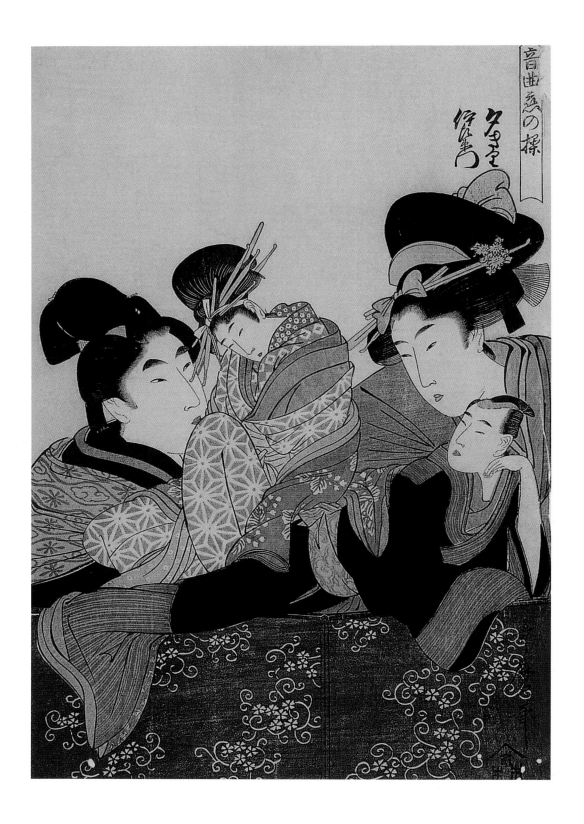

The arrival of the popular school of *Ukiyo-e** was the culmination of an evolution that had taken place over more than a thousand years, and which, to be understood, requires that we retrace the centuries and review its stages of development. Although the origins of Japanese painting are obscure and clouded by tradition, there is no doubt that China and Korea were the direct sources from which Japan took its art; and yet they were influenced, of course, in less obvious ways by Persia and India, those sacred springs of oriental art and religion, moving forward in concert as they always do. One of the special features of Japanese art is that it was always dominated by the religious hierarchy and by temporal powers. From the very beginning, the school of Tosa owed its prestige to the emperor and his retinue of nobles, just as later, the school of Kanō became the official school of usurping shoguns.

The history of painting in Japan, from the late fifth century until the eighteenth century, can be summed up in the succession of three schools. In the beginning was the Buddhist school, a school brought from the high

Yūgiri and Izaemon (Yūgiri Izaemon), from the series
"Love Games with Musical Accompaniment"
(Ongyoku koi no ayatsuri),
1801-1802.
Ōban, nishiki-e, 37.3 x 25.3 cm.
Staatliche Museen, Preussischer Kulturbesitz, Museum
für Asiatische Kunst, Berlin.

plateaux of Asia, from wise India, which brought its painting, along with the religion of Shâkyamuni, to China, Japan, and the whole of the Far East. This painting represents the human being in a kind of sacred stasis, avoiding all imitation, refusing to produce portraits, representing the face according to an artistic ritual defined by systematised abbreviations, and concentrating essentially on the details and the richness of clothing.

In China, the Ming dynasty (1368-1644) gave birth to an original style, which dominated the art of Japan for centuries. The ample calligraphy of Hokusai reveals this hereditary influence. His wood engravers, trained to follow the graceful, fluid lines of his work, which was so authentically Japanese, were occasionally disconcerted when he would suddenly veer towards a more angular realism. Two great artistic schools resulted: the school of Tosa and the school of Kanō. The Chinese and Buddhist schools dated back to the sixth century; the emperor of Japan, Heizei, founded the first imperial academy in 808.

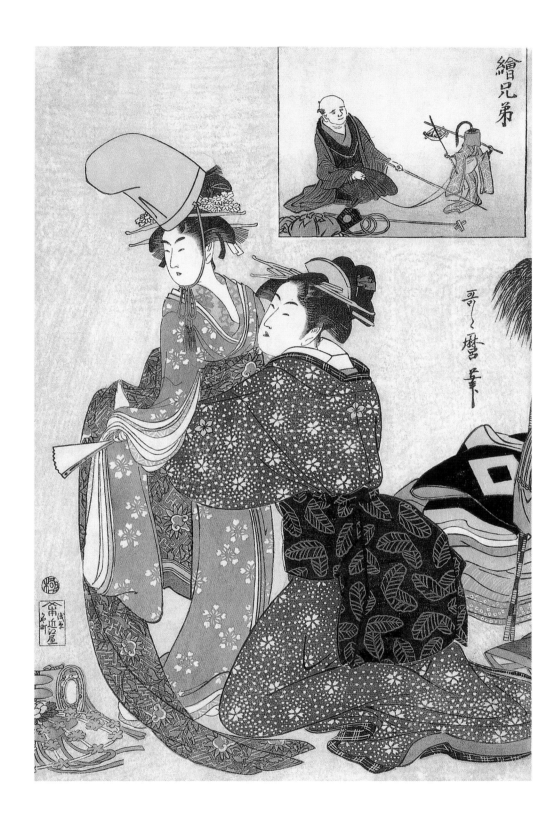

"Parody of a Monkey-Trainer" (Mitate saru-mawashi),
from the series *"Picture Siblings"* (E-kyōdai),
c. 1795-1796.
Ōban, nishiki-e, 38.3 x 25.1 cm.
The Japan Ukiyo-e Museum.

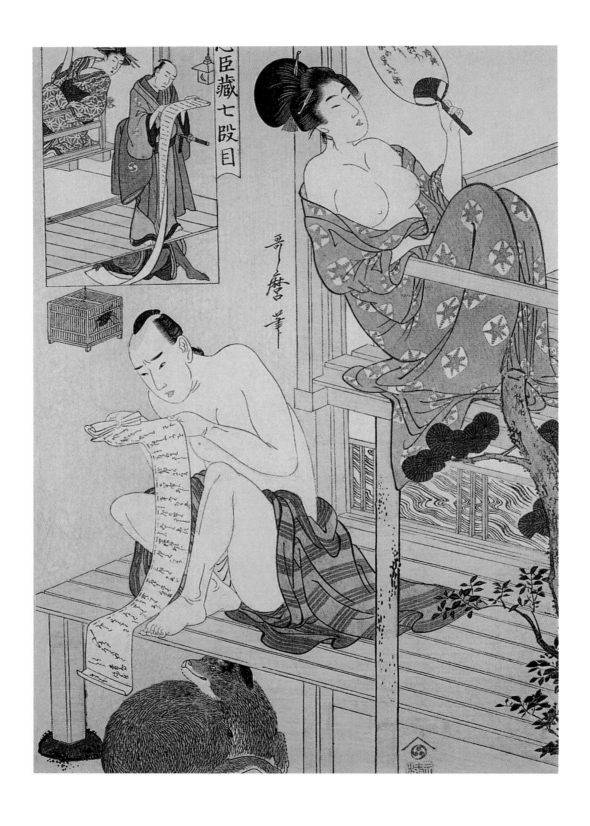

Act Seven from Chūshingura (Chūshingura Shichi-damme), from the series "*Chūshingura*" (Chūshingura), 1801-1802.
Ōban, nishiki-e, 36.4 x 25.1 cm.
The Art Institute of Chicago, Chicago.

The Chūshingura Drama Parodied by Famous Beauties (Kōmei bijin mitate Chūshingura).
Ōban, nishiki-e, 38 x 25.5 cm.
Bibliothèque nationale de France, Paris.

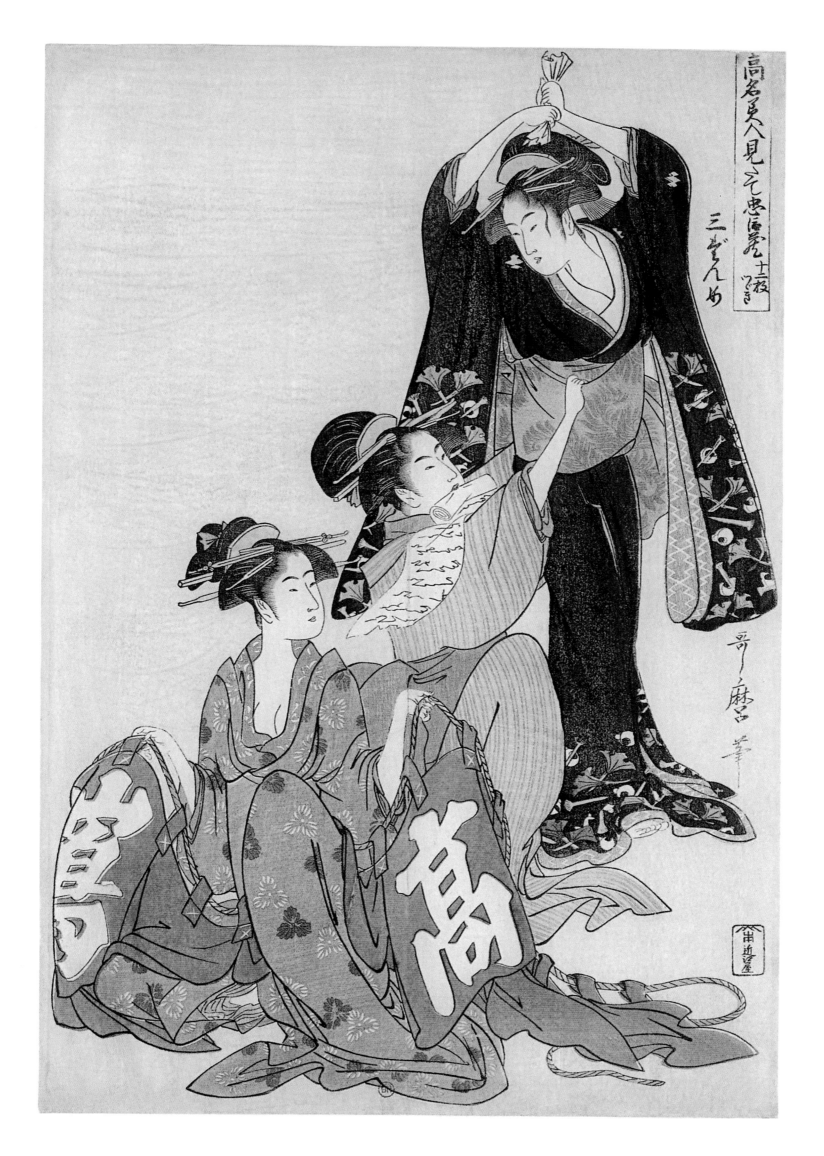

25

This academy, along with the school of Yamato-e established by Fujiwara Motomitsu in the eleventh century, led to the renowned school of Tosa which, with that of Kanō, its august and aristocratic rival, kept an uncontested supremacy for centuries, until at last they came to be challenged by the plebeian school of *Ukiyo-e**, inspired by the lower classes of Japan.

The school of Tosa was created during the feudal period by a member of the illustrious Fujiwara family, who was vice-governor of the province of Tosa. The school of Tosa represented, in a refined style of aristocratic art, the life of the nobility, both in battle and in amorous and artistic intimacy in the *yashiki**, and a revealing specimen of which is the illustration of the love story of *The Tale of Genji (Genji Monogatari)*, written by the woman poet, Murasaki Shikibu. The artists of the school of Tosa used very fine, pointed brushes and brought out the brilliance of their colours against backgrounds resplendent with gold leaf. It is also to this school of intricate designs and microscopic details that we owe those gilded lacquer objects and screens, the richness and beauty of which have never been surpassed.

The school of Tosa has been described as the "manifestation of an ardent faith, through the purity of an ethereal style", but in fact it was the embodiment of the taste of the Kyōto court and was put at the service of the aristocracy. It was the reflection of the esoteric mystery of Shinto and the sacred entourage of the emperor. The ritual of the court, its celebrations and religious ceremonies, the dances in which the *daimyos** took part, dressed in ceremonial costumes falling in heavy, harmonious folds, were depicted with a consummate elegance and a delicacy of touch, betraying in no uncertain terms a familiarity with the arcane methods of the Persian miniature.

The style of the school of Tosa was driven out by the growing Chinese influence, which reached its peak in the fourteenth century, owing to the rival school of Kanō, created by Kanō Masanobu (c. 1434-c. 1530). The origins of this school went back to China. At the end of the fourteenth century, the Chinese Buddhist priest, Josetsu, left his land and set out for Japan, taking with him the Chinese tradition. He founded a new dynasty, the descendants of which still represent the most illustrious tradition in Japanese painting. The school of Kanō constituted a bastion of classicism, which in Japan means, above all, holding to the Chinese models and to a traditional technique, avoiding subjects inspired by daily life. Whereas the school of Kanō absorbed the Chinese influence, the school of Tosa fought against it, thus tending towards an exclusively national art.

Chinese calligraphy is the basis for the technique of the school of Kanō. The Japanese brush stroke follows the Chinese calligraphic tradition, where dexterity, required by these audacious and incisive lines, gives the written sign an effect of drapery or breaks it down into abstract components. The school of Kanō is the school of daring innovation and technical bravura, with the brush pressed wide, with the fineness of a single bristle, with flourishes of the stroke, with the execution which in Japanese is called *gaunter*, rocky,

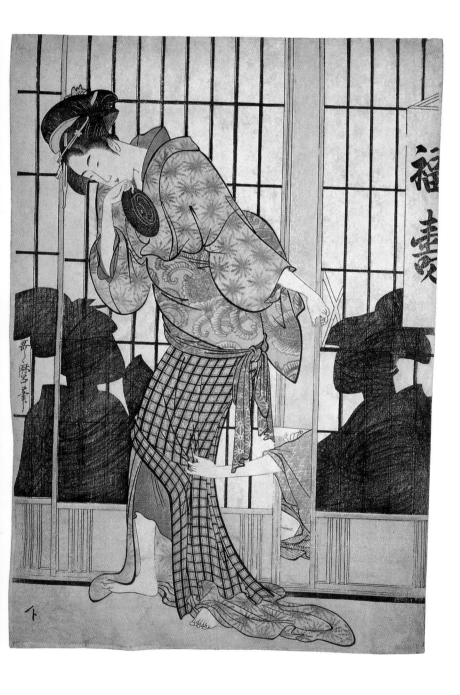

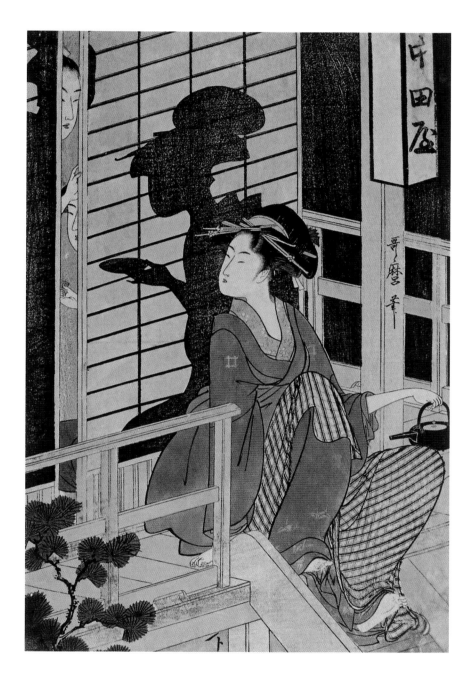

"The Fukuju Tea-House" (Fukuju),
c. 1794-1795.
Ōban, nishiki-e, 38.2 x 25.3 cm.
The British Museum, London.

The Nakadaya Tea-House (Nakadaya),
1794-1795.
Ōban, nishiki-e, 35.8 x 25 cm.
Musée national des Arts asiatiques – Guimet, Paris.

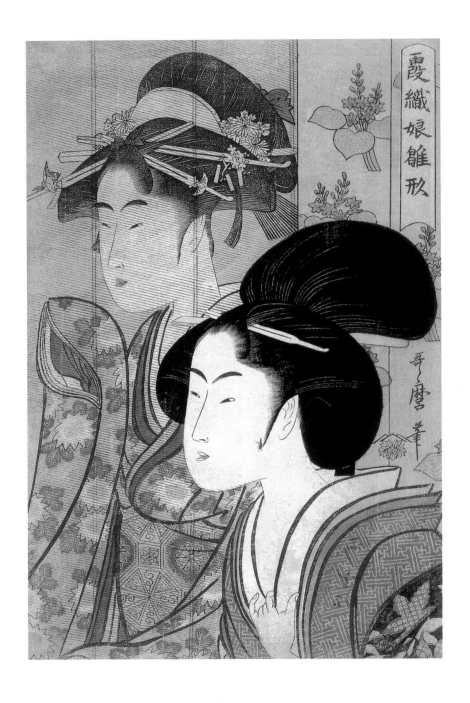

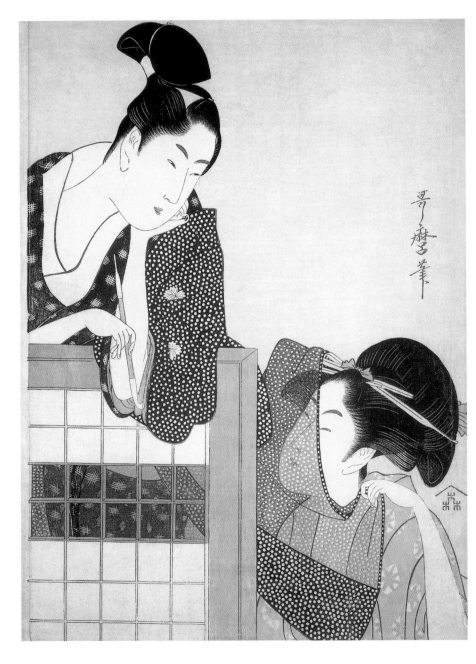

"Reed Blind" (Misu), from the series *"Model Young Women Woven in Mist"*
(Kasumi-ori musume hinagata), c. 1794-1795.
Ōban, nishiki-e, 36.8 x 24 cm.
Staatliche Kunstsammlungen Dresden, Dresden.

"Man and Woman beside a Free-Standing Screen" (Tsuitate no danjo),
c. 1797.
Ōban, nishiki-e, 37 x 25.9 cm.
Museum of Fine Arts, Boston.

chopped, rough, with angular contours, sometimes with an excess of the manner, of the "chic" of the Japanese workshop, typical of an aristocratic aesthetic.

The favourite subjects of the painters of the school of Kanō were primarily Chinese philosophers and holy men, and mythological and legendary heroes represented in various attitudes against very conventional backgrounds, made up of clouds and mist, alternating with emblematic elements. Many of the holy men and heroes of the school of Kanō show a striking resemblance to medieval themes, for they are often represented floating above masses of twisted clouds, wrapped in airy drapery, their heads encircled by a halo.

The early Kanō artists had reduced painting to an academic art and had destroyed naturalism until the time when the genius of Kanō Masanobu, who gave his name to the school, and that of his son, Kanō Motonobu (1476-1559), the true "Kanō", came along to add the warmth of colours and the harmony of composition to the Chinese models and their monochromatic monotony, regenerating and enlivening this style.

During the anarchistic period of the fourteenth century, Japanese art stagnated, but a renewal followed, very similar to the Renaissance in the West. In Japan, as in Europe, the fifteenth century was fundamentally an age of renewal. By the end of that century the principles of Japanese art were permanently fixed, as in Florence where, at almost the same time, Giotto was establishing the canons of art which he had himself inherited from the Greeks of Attica, through Cimabue, and which John Ruskin condensed into a grammar of art, under the title of the *Laws of Fésole*. It has been said that Japanese art in the nineteenth century was nothing more than a reproduction of the works of the great masters of the past, and that the methods and manners of the artists of the fifteenth century served as examples for generations thereafter. The prestige and influence of the fifteenth century were enhanced by Tosa Mitsunobu (1434-1525) and by the two great artists of the school of Kanō, Kanō Masanobu and Kanō Motonobu, of whom it was said that he "could fill the air with beams of light."

The two major schools, Tosa and Kanō, evolved separately until the middle of the eighteenth century, when the genius of the popular artists, coming together as the *Ukiyo-e** school, brought about the progressive merger of their traditions, absorbing the methods of the two rival schools, which, although divergent in their techniques and motivations, were united by their haughty disdain for this new art, which dared to represent the manners and customs of the common folk. Suzuki Harunobu (1724-1770) and Katsushika Hokusai (1760-1849), Torii Kiyonaga (1752-1815) and Utagawa Hiroshige (1797-1858) were the shining lights of these schools, artists whose genius narrated the story of their country, day by day, weaving a century of history into a living encyclopaedia, sumptuous in its form, kaleidoscopic in its colours.

The *Ukiyo-e** bridged the gap and became the representative of both schools, causing an expansion in this art which would never have

happened under its aristocratic rivals. Japanese art seems always to have been subject to these kinds of reciprocal influences. The school of Tosa, famous for its delicacy, the minutiae of its details and the brilliance of its colours, succumbed to the dynamic power of black and white from the school of Kanō. The latter, in turn, was modified by the bright colours introduced by Kanō Masanobu (1434-1530) and Kanō Motonobu (1476-1559). Later, the rich palette of Miyagawa Choshun (1683-1753) replaced the monochromatic simplicity of Hishikawa Moronobu (1618-1694), the inspiration for the Ukiyo-e* wood carvers.

The 1790s were a turning point in the development of Ukiyo-e*: from the point of view of technique, the colour block print was perfected, using successive printings onto the same proof using several blocks inked with different colours. These multicoloured xylographs printed on thick paper using the technique of embossing to enliven the white surfaces, are referred to as nishiki-e*. They were the avant-garde of an unconventional art which dealt with the populace and daily life. The realism of the poses, attitudes, and movements thus gave a nearly photographic view of the day-to-day existence of women under the Empire of the Rising Sun. The Ukiyo-e* block print, scorned by the arrogant Japanese aristocracy, became an artistic medium for the common folk of Japan, and the names of its artists were bandied about with familiarity in every atelier, much more so than the names of the classic painters of the schools of Tosa and of Kanō.

The time of Utamaro was the period which saw a great expansion in publishing, through the broadening of the public and diversification in the kinds of works offered. Thus, a market for illustrated books and books for "entertainment" (goraku) grew up, starting from the middle of the eighteenth century in Edo, the place of residence of the Tokugawa shoguns who wielded the actual political power, in Osaka, the great commercial centre for the eastern part of Japan, or in Kyōto, the imperial capital. The publishers of these works, organised into guilds different from those of the publishers of "serious" books, outdid each other in finding ingenious ways to meet the increasing demand from a public eager for illustrated romantic or humorous stories. This public included not only the lowest classes, whose literacy rate was probably high, owing to the "temple schools" (terakoya), but also educated warriors or merchants seeking clever entertainment and more subtle humour, or just beautiful picture books. Booksellers and publishers were always on the lookout for a talented Ukiyo-e* writer or painter who could assure them of a successful publishing run.

The Ukiyo-e* paved the way for the opening of Japan to other nations, by developing among the population an interest in other countries, in foreign knowledge and culture, and by promoting the desire to travel by means of books illustrated with diverse and varied scenes. It was to the Ukiyo-e* that the Japanese owed the progressive germination of an international conscience culminating with the revolution of 1868, which broke out as though miraculously. However, the ferments of this apparently spontaneous arrival of the Meiji era (1868-1912) were spread by the artists of the Ukiyo-e*.

"Miyahito of the Ōgiya, [kamuro:] Tsubaki, Shirabe" (Ōgiya uchi Miyahito, Tsubaki, Shirabe), c. 1793-1794.
Ōban, nishiki-e with white mica ground, 38.2 x 25.5 cm. Honolulu Academy of Arts, Honolulu.

"Appearing Again: Naniwaya Okita" (Saishutsu Naniwaya Okita), from the series "Renowned Beauties Likened to the Six Immortal Poets" (Kōmei bijin rokkasen), c. 1796.
Ōban, nishiki-e, 38.5 x 26 cm. Bibliothèque nationale de France, Paris.

Dressing the Hair (Kami-yui), 1794-1795.
Ōban, nishiki-e, 38 x 25.2 cm. Musée national des Arts asiatiques – Guimet, Paris.

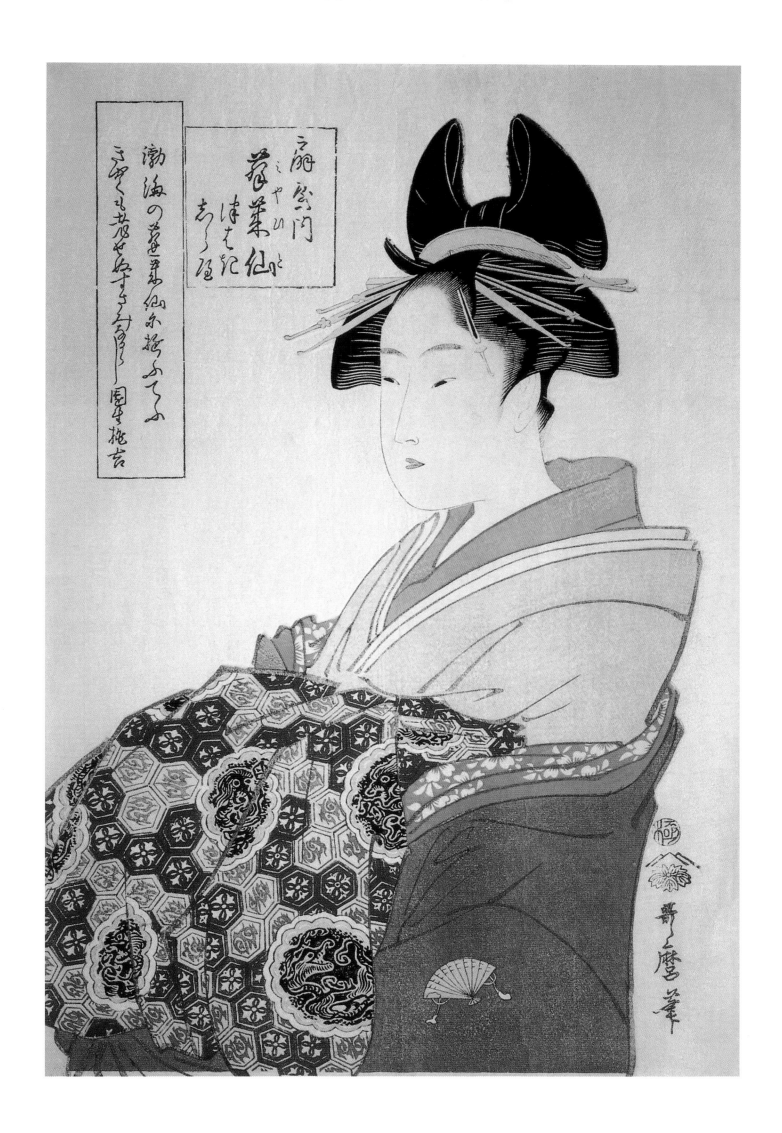

31

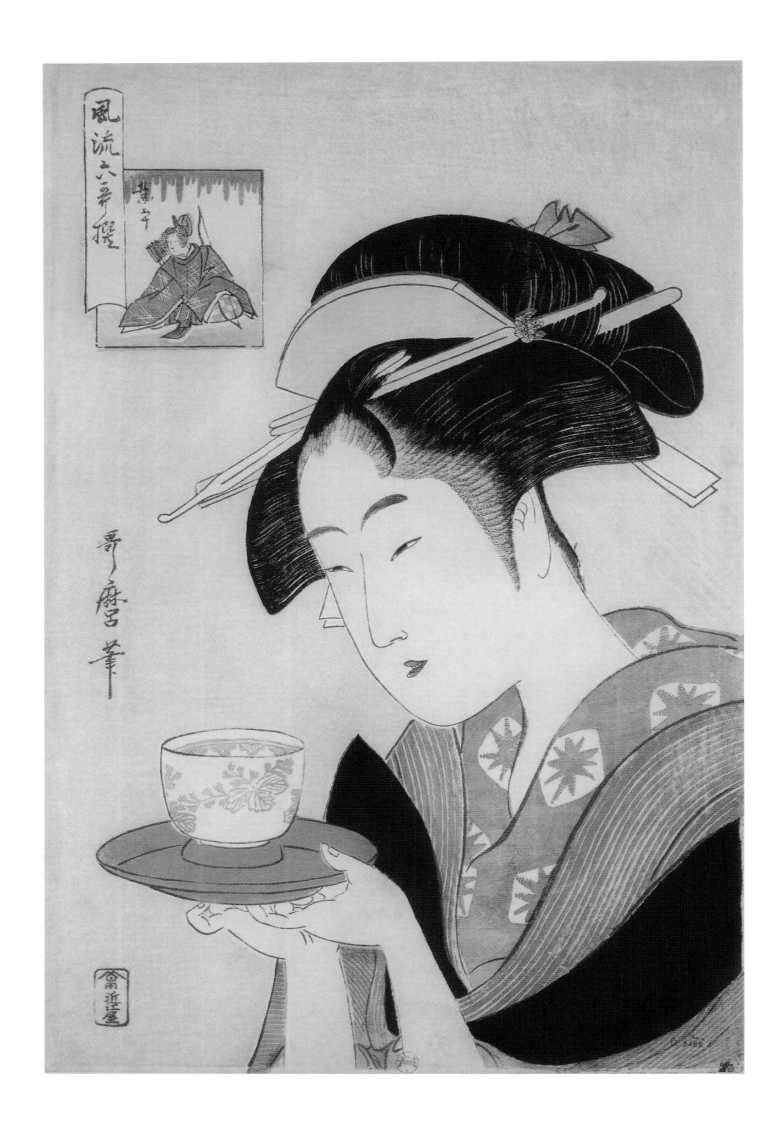

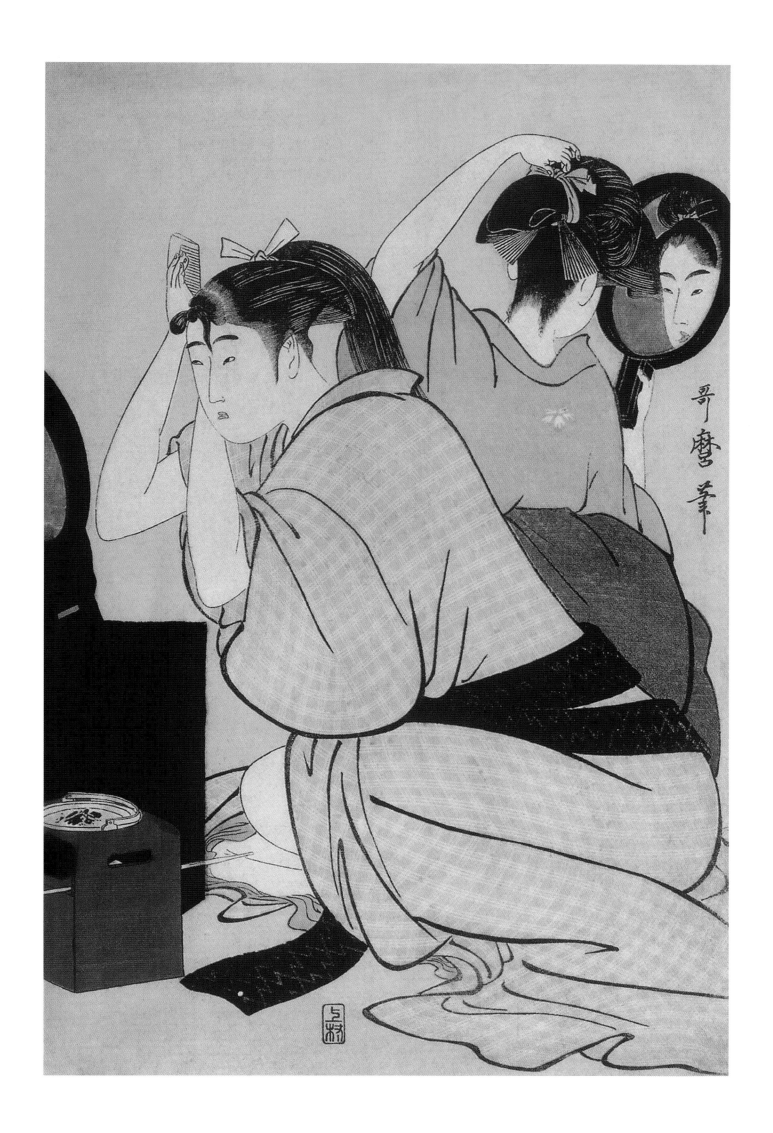

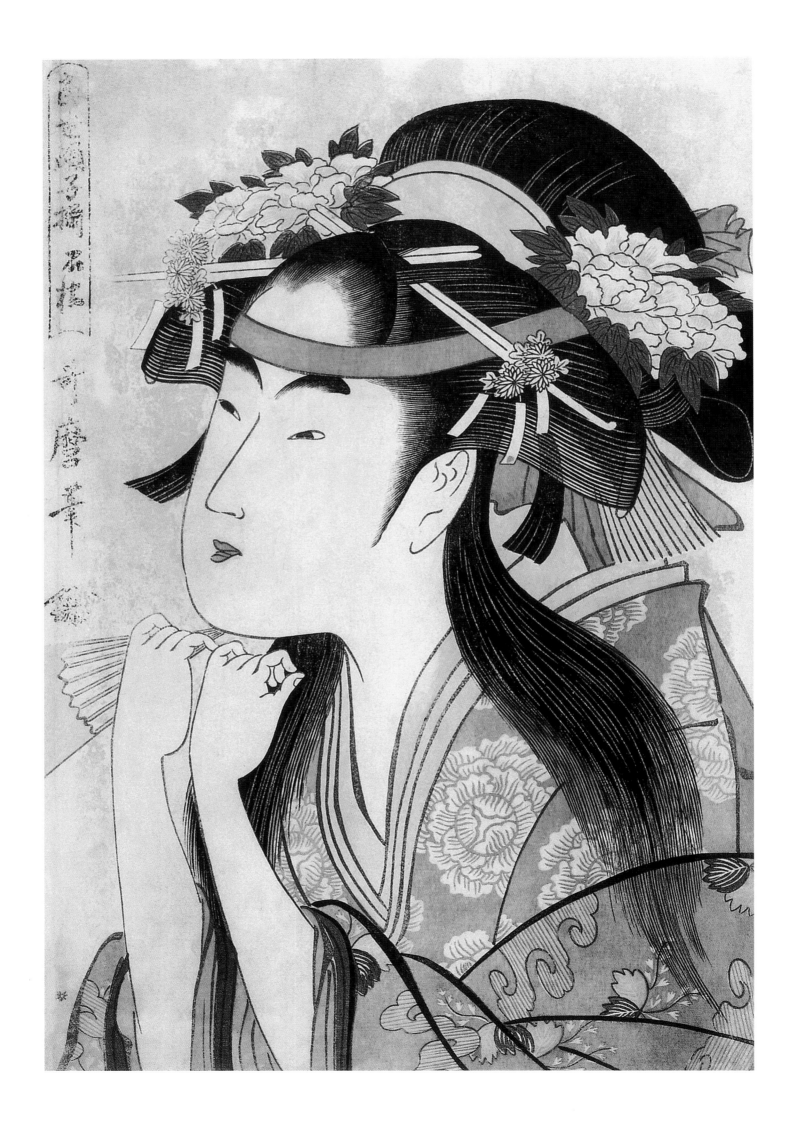

II. THE PICTORIAL WORKS

The work of Utamaro, which is diverse and ample, is in line with Japanese tradition, which however, he interprets in a very personal way. It includes pictorial works of various types: prints in a variety of numbers and dimensions, kakemonos*, makimonos*, surimonos* and several painted works, as well as illustrations for books and albums printed in black and white or in colours, including the famous ones for the shungas*. These works are, for the most part, prints for which traditional Japanese techniques were used and, less often, painted works.

Japanese painting traditionally takes one of three great forms: the kakemono* or the makimono*; the fan; and the design for printing, which has the appearance of a design for an engraving, done by the master to be cut into the wood block. The design itself is always done in Indian ink, the painter only experimenting with colours on a few black and white proofs pulled for himself and his friends. A few examples of fans painted by the master survive, including a very artistic one showing the full-length portrait of a Japanese lady, done in a cursory manner, but with great skill and charm, a fan which would have been displayed as a kakemono*. However, none of Utamaro's designs meant to be carved have come down to us.

It is particularly the prints, the kakemonos* and the surimonos*, which testify to the work of the master. The kakemonos* are large works, meant to be hung on walls; as for the makimonos*, they are works on a small scale meant to be held in the hand; finally, the surimonos* are luxurious versions of block prints. All these works were executed using a complex printing technique, elaborated and improved over the history of the Japanese print, brilliantly used by the Ukiyo-e* artists, who carried their beauty and refinement to the highest perfection. By the middle of the eighteenth century, techniques allowed these works to be printed in colour.

The Ukiyo-e* block print is like "the meeting of two surfaces marvellously arranged one upon the other, the rough grain of the mulberry-wood block and the smoothness of the paper, covered with a fine absorbent pile of plant origin. On the first, the colour may be applied almost dry, on the second, it can be transferred with a delicacy which leaves only a slight trace of colouring floating on the tips of the fibres. And from the interstices between these impregnated cilia bursts forth from its very bosom the full luminous quintessence of the paper, diffusing into the pigment an exquisite gilded light, forming a bi-dimensional surface alive with vibrations," according to Professor Fenollosa.

From a technical point of view, the process of wood engraving, with the appearance of being a simple art, in reality requires a proven talent. The steps in the production of prints, their design, engraving, printing, and publication are separate and carried out by different and highly-specialised individuals. These prints are the result of a triple combination, first of a marvellously prepared paper made from the bark of the blackberry bush (Kozo), diluted in rice milk and a gelatinous substance taken from hydrangea and hibiscus roots; second, of pigments, the secret alchemy of which is

"Stone Bridge" (Shakkyō), from the series "An Array of Dancing Girls of the Present Day" (Tōsei odorido-zoroe), c. 1793-1794.
Ōban, nishiki-e, 35.8 x 24.3 cm. Henri Vever Collection.

"Tomimoto Toyohina" (Tomimoto Toyohina), from the series "Famous Beauties of Edo" (Edo kōmei bijin), c. 1793-1794.
Aiban, nishiki-e, 33.6 x 23.3 cm. The Art Institute of Chicago, Chicago.

"Three Beauties of the Present Day" (Tōji san bijin), c. 1793.
Ōban, nishiki-e with white mica ground, 38.6 x 25.6 cm. The New York Public Library, New York.

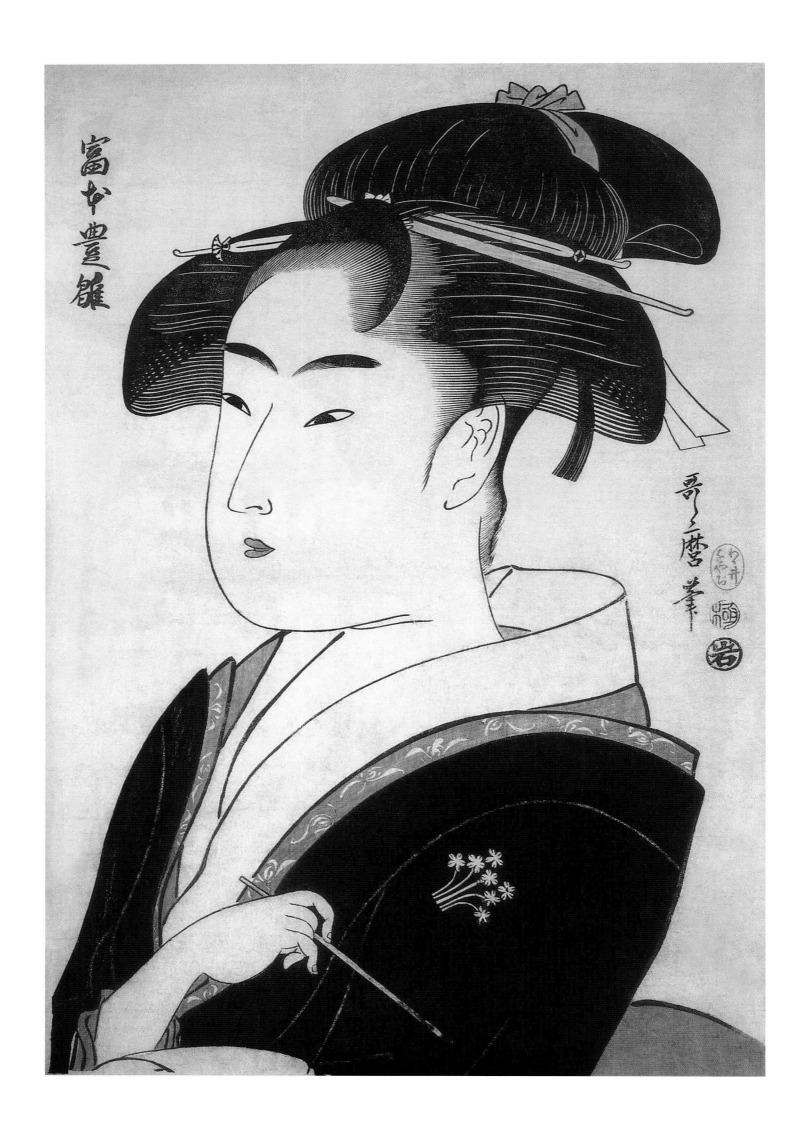

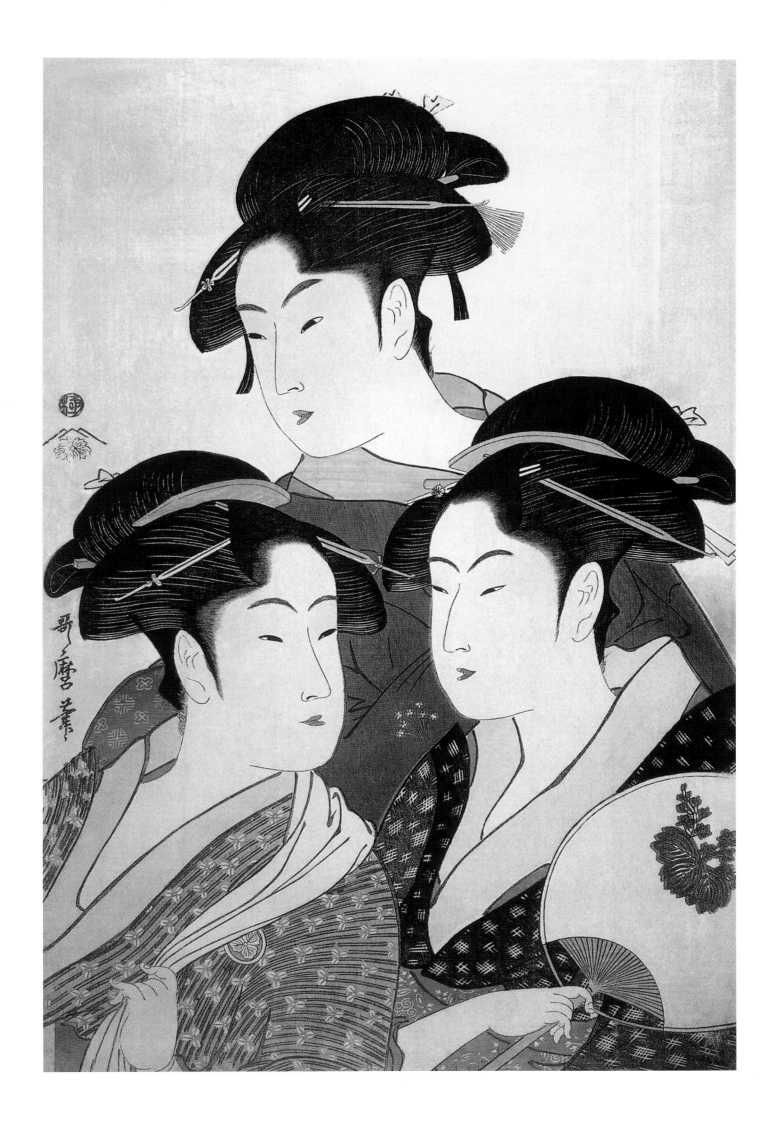

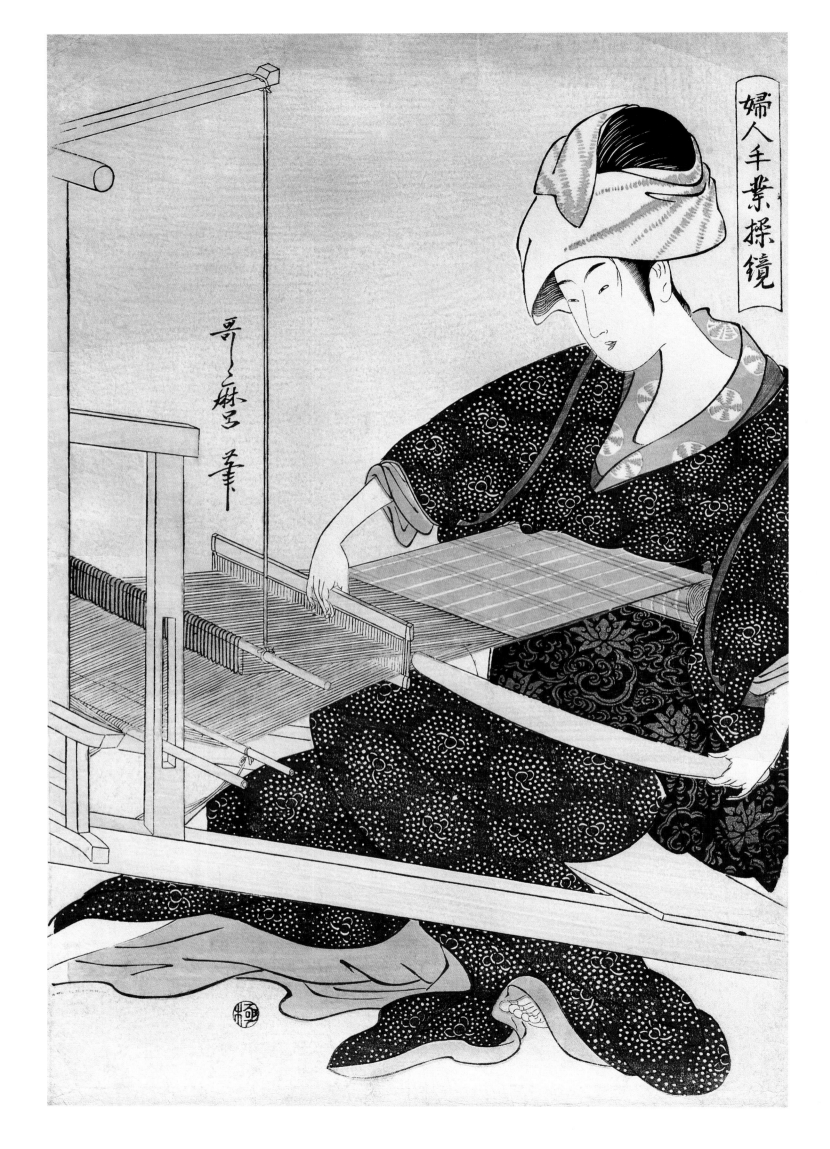

婦人手業操鏡

哥麿筆

unknown to any modern artist (hence, the early *tan-e* prints and *beni-e** prints [prints coloured by hand] can never be reproduced); and third, the application of these colours by the master printmaker – the magical hand of the orient whose fingers conceal the mysteries of the past.

These steps are as follows: the artist makes a master design in ink on rice paper. He then pastes this design face down against a wood block cutting away the areas where the paper is blank with a knife or small gouges, thus leaving the reverse of the design in relief on the block, but destroying the original in the process. After applying ink to the carved block, he places a sheet of damp paper over it and applies pressure to the back of the paper with a flat rubber until a uniform transfer of the imprint has been achieved. The paper used could in some cases be embossed (*karazuri**), or mixed with rice powder to accentuate the whiteness of the paper (*hosho**). The wood used was most often cherry. This gave nearly perfect copies of the original. The standard format for an *Ukiyo-e** were the *hosoban**, the *ōban**, the *chūtanzaku** or the *chūban**, but it is possible to find *Ukiyo-e** in other formats. The early *Ukiyo-e** produced between one and two hundred copies and were monochromatic, gradations being made as a result of the pressure applied to the wood block. Polychromy appeared later, red first of all (*beni*), then orange derived from lead compounds (*tan*). The appearance of colour complicated the printing technique insofar as each colour required its own piece of wood. For the polychrome prints the proofs were pasted to new blocks and the areas of the design to be coloured with a particular colour left in relief. The blocks served as stamps and each block printed at least one colour in the final image. Using a measured pressure, part of the colour was absorbed by the body of the paper and on the tips of the fibres the transparency was left to shimmer on its own, creating the impression of colour under enamel. The resulting set of wooden blocks was inked in the various colours and applied successively to the paper. The complete print held the patterns of each one of the blocks. In certain prints the coloured parts were applied with a brush after a single printing. This process is known as *beni-e**. When more than one block was used, as in multicoloured prints, the successive printings were aligned by marks made in the corners of the paper. The coloured inks applied to the early blocks were extracted using unknown processes, but the appearance of inexpensive pigments led to the decline of the most special character of this art.

The coloured prints of Utamaro are, as Edmond de Goncourt wrote, a "miracle of art" in which he brought these impressions to an absolute and unsurpassable degree of perfection. The influence of Utamaro, Hiroshige and other masters of *Ukiyo-e** revolutionised the sense of colour in the world of art. His keen sense of observation and his technical mastery are perceptible in his marvellous studies of women. He was the first Japanese artist to depart from the traditional treatment of faces. The academic style required the nose to be suggested by an aquiline, calligraphic stroke, the eyes by simple slits, the mouth by a curved flower petal. Utamaro mixed into this unnatural convention a slightly mischievous grace, a

Weaving on a Loom.
Ōban, nishiki-e.
Musée national des Arts asiatiques – Guimet, Paris.

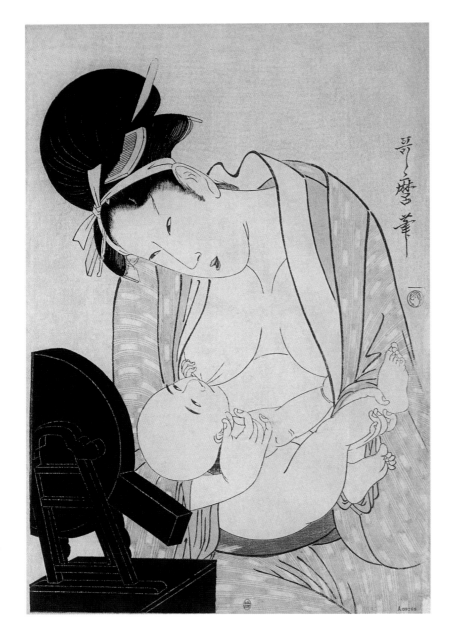

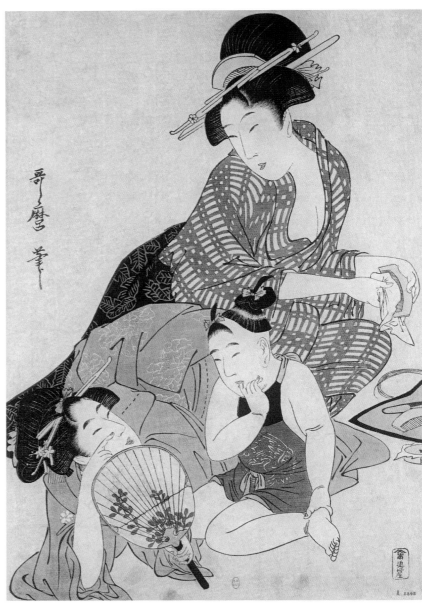

Mother Breastfeeding her Child.
Ōban, nishiki-e, 38.5 x 24.5 cm.
Bibliothèque nationale de France, Paris.

Two Young Women with a Child.
Ōban, nishiki-e, 36.8 x 25.1 cm.
Bibliothèque nationale de France, Paris.

Summer Bath, from the series *"Seven Episodes of Ono no"*,
early 19th century.
Ōban, nishiki-e, 38 x 25.5 cm.
Victoria & Albert Museum, London.

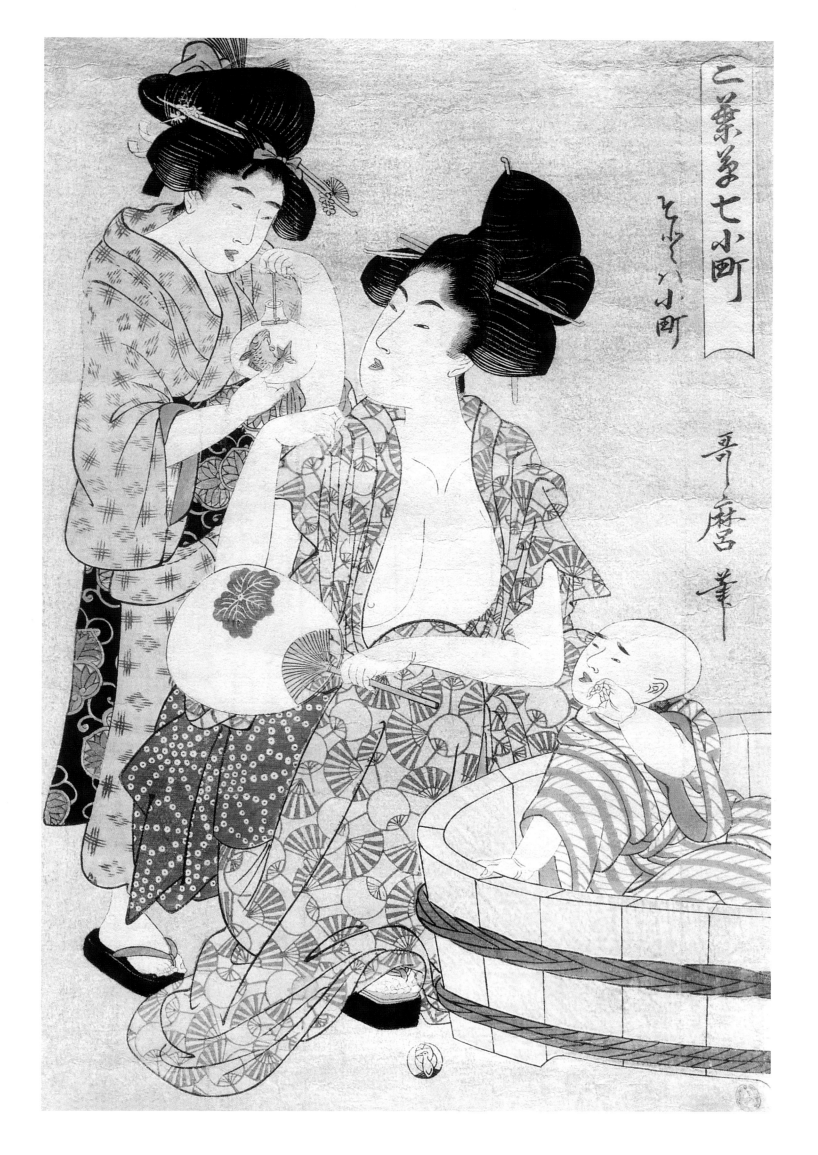

spiritual understanding. He kept the traditional lines but brought them closer to human shapes. None of the anatomical details, the graceful lines, the delightful contours of these Japanese women whether lying or standing, escaped his eye. Each of these "feminine figures" took on a true individuality; he was an idealist, who made "a courtesan into a goddess".

I. Prints (*Nishiki-e*)

Utamaro produced an enormous number of images in colour, large polychromatic prints. The *nishiki-e** is an *Ukiyo-e** combining more than two colours. In them Utamaro attains "the ultimate in beauty and luxury." These marvellous prints, generally made by using three, five, or even seven blocks, in this land of screens and sliding doors, are mounted side by side, one after the other, with no glass to protect such charming moving wall coverings from exposure to the air. Occasionally works by famous masters were incorporated into the border of a fabric, or sealed in lacquer. These prints were done in a variety of formats. They dealt with a wide range of themes, but the principal tendencies were representations of women from all classes, in all situations of daily life, or at the time of the high feasts and ceremonies which punctuate Japanese life, or even the representation of great myths and grand personalities of the country.

These graphic works were not originally meant for use by the general public; they were intended for refined collectors, men of letters, who, in Japan, lived in close company with artists, or for the women represented in *Utamaro*, and they remained luxury items. But in the nineteenth century their prestige diminished: in the hands of profit-motivated publishers and an undemanding mass audience, the quality of printing diminished and the discrete, muted, and harmonious colours gave way to garish and tawdry colourings. And although, in 1830, the painter Hiroshighe attempted to bring back the colourings of the eighteenth century, it was in vain.

Edmond de Goncourt had the discernment to note a tendency, in the painter of the women of the "green houses", to portray motherhood, to present the mother in maternal postures, such as breastfeeding. There is the tilted head of our Virgin over the divine *Bambino*; there is the ecstatic contemplation of the nursing mother; there is the loving embrace in her arms, the delicate wrapping of one hand around an ankle while the other caresses the back of the neck of the child clinging to her breast. He paints the mother rocking the child; bathing it in a wooden vat, the bathtub of that country; a comb between her teeth, gathering up his little queue; one hand through his loose belt, supporting his first steps; amusing him with a thousand little games; having him take a marble from her mouth; frightening him with a mask of a fox, that legendary animal in the nursery rhymes of the country. Even the Japanese encyclopaedia attests to the mythological dimension of this animal by asserting that when the fox blows on the bones of a horse that he is eating, it ignites a fairy fire which illuminates him, so that he then lives one hundred years and salutes the Ursa Major before being transformed.

"Geisha" (Geigi), from the series *"Komachi and his Children"*, c. 1800.
Naga-ōban, nishiki-e, 53.1 x 25.2 cm.
The Metropolitan Museum of Art, New York (left and right sheets) and Honolulu Academy of Arts, Honolulu (centre sheet).

"Husband and Wife Caught in an Evening Shower" (Fūfu no yū-dachi), from the series *"Three Evening Pleasures of the Floating World"* (Ukiyo san saki), c. 1800.
Naga-ōban, nishiki-e, 51.4 x 23.3 cm.
The Art Institute of Chicago, Chicago.

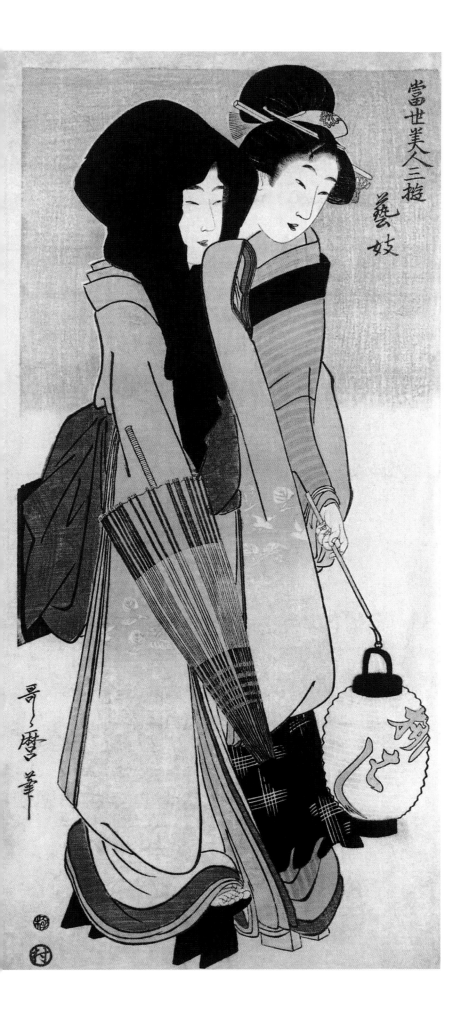

当世美人合三撰
藝妓

哥
麿
筆

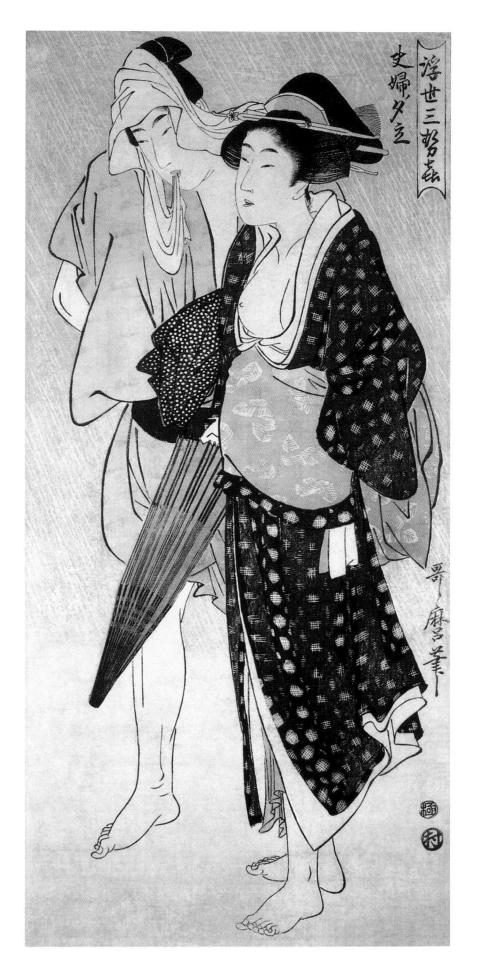

浮世三努志
夫婦夕立

哥
麿
筆

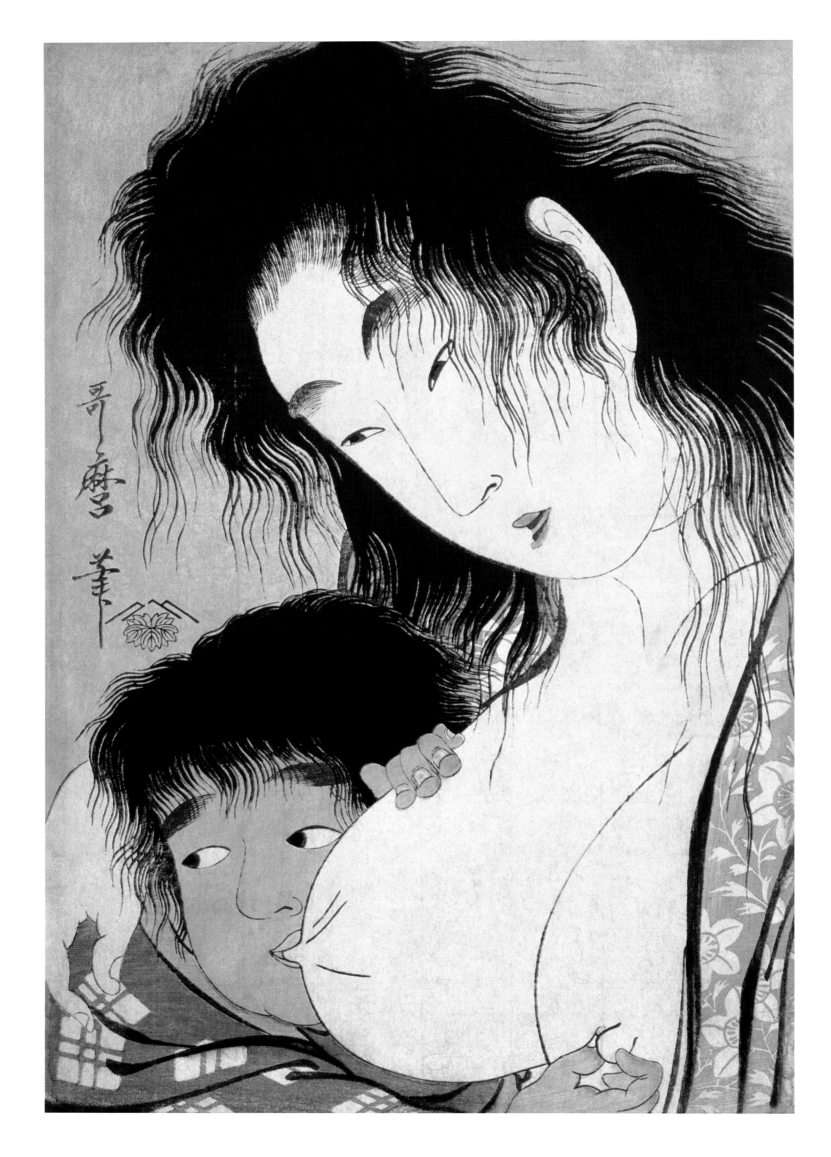

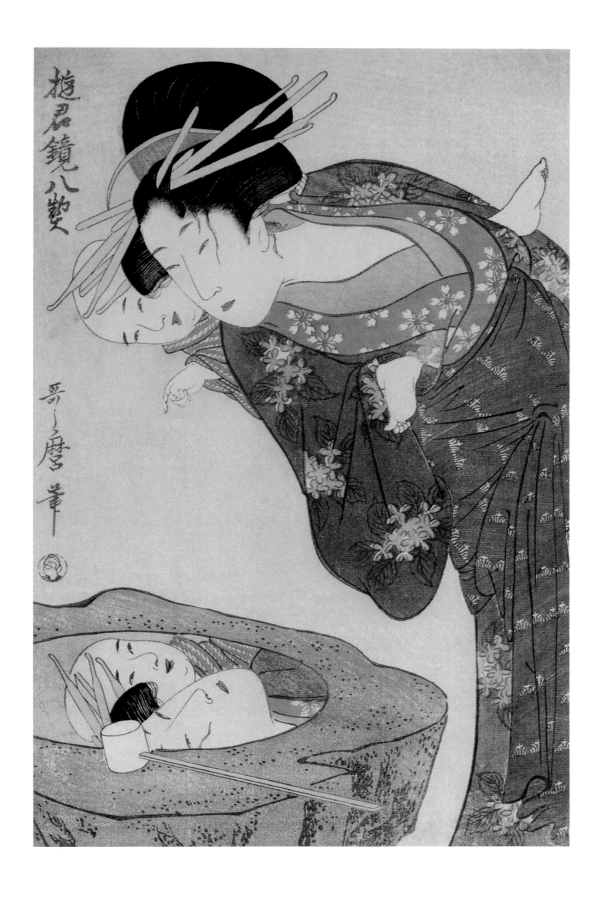

"Breastfeeding" (chibusa), from the series *"Yamauba and Kintarō"*, c. 1801-1803.
Ôban, nishiki-e, 37.5 x 25.4 cm.
Musée national des Arts asiatiques – Guimet, Paris.

"Water-Basin Mirror" (Mizu kagami), from the series *"Eight Views of Courtesans with Mirrors"* (Yūkun kagami hakkei), c. 1798-1799.
Ôban, nishiki-e, 38.2 x 25.5 cm.
Musée national des Arts asiatiques – Guimet, Paris.

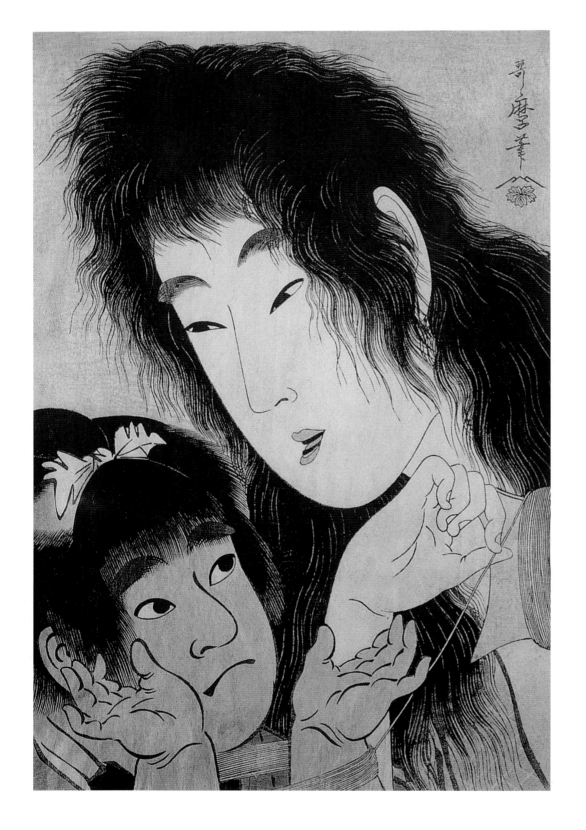

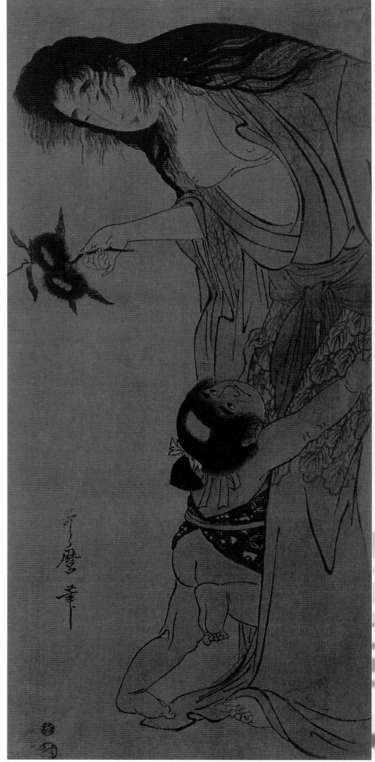

Among all these scenes, there is one of a marvellous realism: the scene in which a Japanese mother is helping her child to pee, the mother's two hands holding the calves of the two spread legs of the child, while, in a gesture typical of infants, his two tiny hands flutter absently above his eyes. In these images of mother and child, in which the existence of the two is, so to speak, not yet completely separate and where, from the womb of the mother, the child seems to have gone directly onto her lap or onto her shoulders, one plate stands out: a mother has her child on her back, leaning forward over her shoulder, and both are looking at themselves in the water collected in the hollow of a tree trunk. Their faces appear to draw closer, to unite, almost to kiss, in the reflection of this natural mirror. Among these expressions devoted to motherhood, one series shows pudgy little children as they caper about above their mothers' heads, children with chubby arms and legs, with folds of fat at their knees and wrists, who appear in their fleshy nudity, dressed only in a little apron.

Several other series are dedicated to the depiction in images of childhood in the woods, of an heroic child, with mahogany-coloured skin, seen in the *Ehon Sosi* fearlessly holding a bear cub by the tail and violently pulling it towards him. This future hero, who was nursed, nourished, and brought up by a woman with a wildly-dishevelled mop of black hair who could be mistaken for a Geneviève de Brabant in her cave-dwelling days. Here is the story, no doubt legendary, of this little tyke, named Kintaro. Minamoto no Yorimitsu (944-1021) was one day hunting on the mountain of Ashigara, in the province of Sagami. Not catching any of the sparse game, he pushed on to the more remote parts of the mountain, and there he found a boy with the muscular body of a young Hercules, with very red skin, playing with a bear. Questioned by Yorimitsu, the boy went to fetch his mother. The woman, uncoiffed and dressed in leaves, explained in noble language and in the manner of the court that she did not wish to identify herself. Therefore she is given the name of Yamauba (mountain mother). And yet the mountain

mother agreed to Yorimitsu's request when he asked her to let him take charge of the child, telling him that he was the son of a great general of Minamoto clan, killed in a war against Taira clan. Thus, she had raised the boy in the mountain to be a hero.

When the child was grown, he took the name of Sakata no Kintoki after the lands with which he had been rewarded by Yorimitsu, who had made him one of his four highest officers. In the mountain of Oyeyama, and in the province of Tampa, there lived a great devil, an outlaw named Shuten-doji, who pillaged the neighbouring provinces, shamelessly carrying off young maidens and, with his band of devils, routing the soldiers of the provincial governors. Complaints arrived at the court and Yorimitsu was appointed to lead an expedition against the brigand. But instead of taking a whole battalion with him, he took just Kintoki and his three high officers, disguised as pilgrims. Having made the brigands drunk on sake and dancing with them, and while Kintoki hand wrestled with Shuten-doji, holding his hands

Yamauba and Kintarō,
c. 1796-1804.

"Yamauba Holding Chestnuts, and Kintarō" (Kuri o motsu Yamauba to Kintarō), from the series *"Yamauba and Kintarō",*
c. 1804-1805.
Naga-ōban, nishiki-e, 23.6 x 51.7 cm.
Musée national des Arts asiatiques – Guimet, Paris.

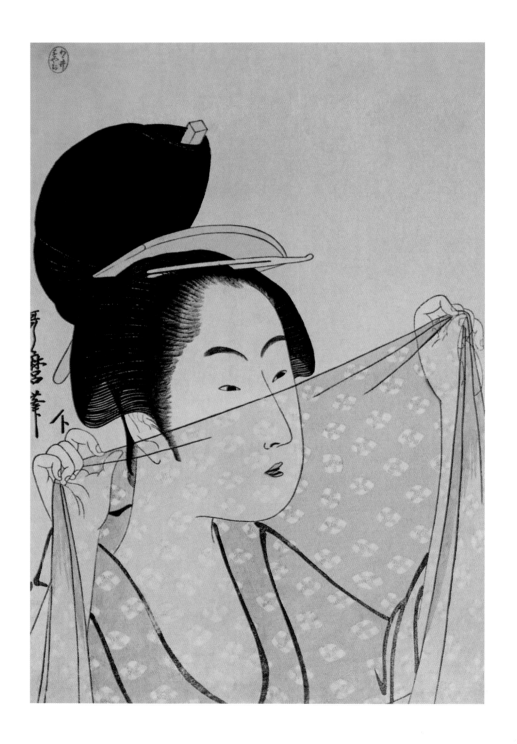

and laughing, Yorimitsu drew his sword like lightening and cut off his head so quickly that, on the other side of the room people were still dancing without suspecting anything. A general melee ensued, but the five heroes, among whom was Kintoki, accomplished feats of prowess and overpowered the devils who were demoralised by the death of their chieftain, burning their hideout and returning the captive women to their homes.

Kintoki is also the hero of another adventure. When Yorimitsu fell ill as a result of a wound inflicted by a monstrous spider, he set out with three of his comrades to slay it.

We must also mention Momotarō. Along with Kintarō, this other legendary boy is honoured by Japanese children who fill their albums with depictions of his feats and adventures. The fable tells the story of an old couple. One day, while the man was cutting wood and the woman was washing laundry in the stream, there rose up from the water a huge red thing which the old woman recognised as an enormous peach: peach *momo*. She waited for her husband to cut it

"Woman Holding up a Piece of Fabric"
(Nuno o kazasu onna),
c. 1795-1796.
Ōban, nishiki-e, 38 x 25.5 cm.
Musée national des Arts asiatiques – Guimet, Paris.

open. […]. Great was the astonishment of the old couple to find a beautiful boy inside, whom they named Momotarō (peach child). The child soon became a tall charming youth. But in those days, the people who lived on the coast were being eaten by the horrible inhabitants of a neighbouring island. One day the young man, accompanied by his dog, his monkey, and his pheasant, set sail for the island. Once there, he and his companions began to accomplish such marvels that the king of the island agreed to stop the cannibalistic expeditions. Ever since this promise, the inhabitants of Japan have been able to live unmolested.

Let us look at some of these marvellous prints.

Series of the *Large Heads*:
Among the prints dedicated to women, there is a series of some one hundred prints, the collection of the *Large Heads*, where the head of a woman is depicted almost life-sized with a part of the upper torso. These prints, in which the head is always depicted with a traditional hieratic quality featuring the fine

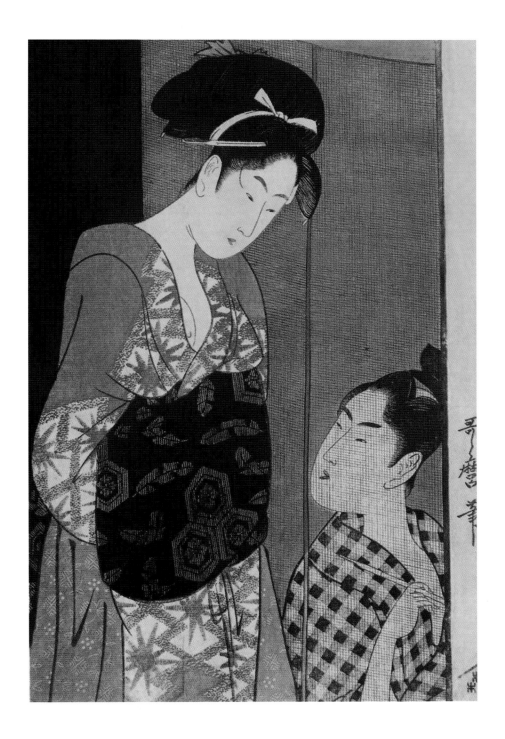

"Mosquito-Net" (Kaya), 1797.
Ōban, nishiki-e, 37.6 x 24.8 cm.
Musée national des Arts asiatiques – Guimet, Paris.

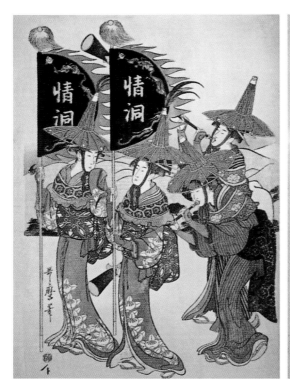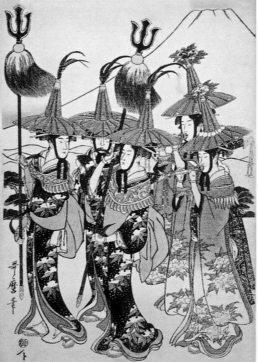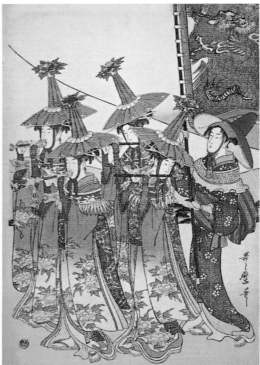

arched eyebrows and the typical beauty so highly prized in Japan, distinguish themselves through the bit of the dress seen covering the shoulders and bust of these women, or by a fan or a screen which they hold in their fingertips. Their dimensions and print quality are admirable, and the embossing sets off the white of a chrysanthemum, of a cherry blossom petal against a blue or mauve dress, or the white of the pattern in a border, and creates a *trompe-l'œil* with the relief of its embroidery. These prints of the *Large Heads*, done for the most part around 1795, are interesting not only for their beauty, but for the information they reveal about the imitations, the plagiarism, and the thefts of the artist's signature by

his colleagues: Utamaro, as a warning to the public against the counterfeits circulating under his name, signed this series "the real Utamaro".

*Nishiki-e** in seven panels

These works made up of seven contiguous sheets are not numerous, but among them should be mentioned:

Parody of the Procession of a Korean Ambassador (pp.50-51):
A long line of women on foot and on horseback are bearing one of their own on a litter resembling a shrine: all the women are wearing strange, pointed green hats and harmonious

dresses, in which the blue, green, mauve, and yellow recall the decoration on Chinese green family porcelain, hues which so greatly influenced the watercolours of the Japanese masters leading up to Utamaro.

*Nishiki-e** in six panels

The Six Tamagawa:
Women walking in the countryside, where a child is wading in a stream near a washerwoman beating her laundry with a stick.

*Nishiki-e** in five panels

The series of works composed of five contiguous sheets has many more examples:

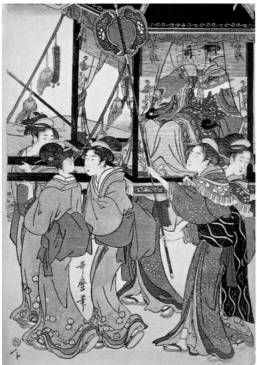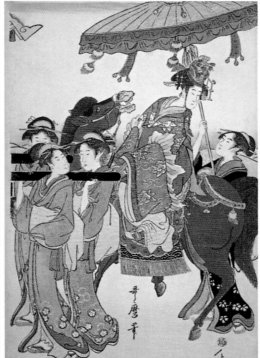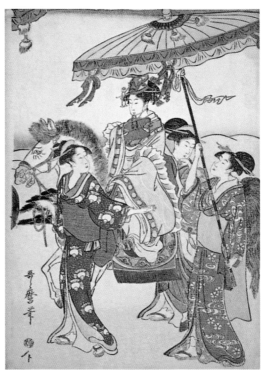

The Boys' Feast Day:

A woman leans over an album, near another woman, a brush in her hand ready to paint: both are being watched by a child in a room where a revolving easel with a little parasol holds a *kakemono** representing, in blood red, the terrible *Shōki,* the exterminator of devils, a kind of patron saint of boys. This exterminator of devils has his own legend. Chung Kwei, the hunter of devils, in one of the favourite myths of the Chinese, was reputed to be a supernatural protector of the emperor Xuanzong (713-762) against the evil spirits who haunted his palace. His story is told as follows in the *E honko jidan:* the emperor Genso came down with a fever. In his delirium, he saw a little demon who was

stealing the flute of his mistress Yokiki (Yang Guifei) at the same moment a hardy spirit appeared, seized the demon and ate it. When the emperor asked him his name, he answered: "I am Shinshi Shōki, of the mountain of Shunan. During the reign of emperor Koso (Kao tsu) of the Butoku period (618-627), I was unable to reach the rank to which I aspired in the high office of the State. Out of shame I killed myself. But at my funeral, I was posthumously promoted, by imperial order, to a high honour and now I am trying to do justice to the favour which was bestowed upon me. This is why I want to exterminate all the demons in the land." Genso woke up; his illness had disappeared. He then ordered Godoshi to paint a picture

of the exterminator of devils and to distribute copies of it throughout the empire.

Year-end Fair at Asakusa (pp. 52-53):

The market which is held during the last ten days of the year takes place before the great gate of the temple of Asakusa. A crowd is walking through mountains of tubs, sifters, and household utensils, over the top of which here and there are visible, carried on heads, New Year's day presents typical of Japan: a lobster on a bed of ferns, an object made of twisted straw to keep devils out of the houses, etc. In the midst of the crowd, two little girls avoid being separated and lost by each holding one end of a length of cloth tightly in her hands, and a small boy lifts a

"Parody of the Procession of a Korean Ambassador" (Mitate Tōjin gyōretsu),
c. 1797-1798.
Ōban, seven sheets, nishiki-e.
The Art Institute of Chicago, Chicago.

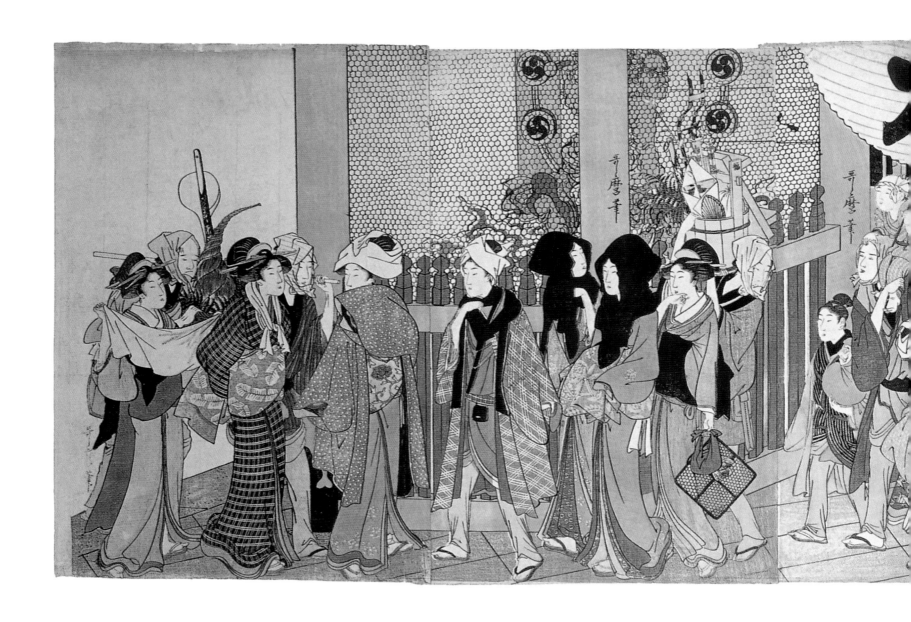

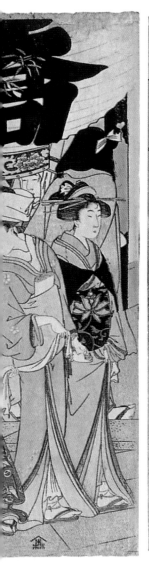
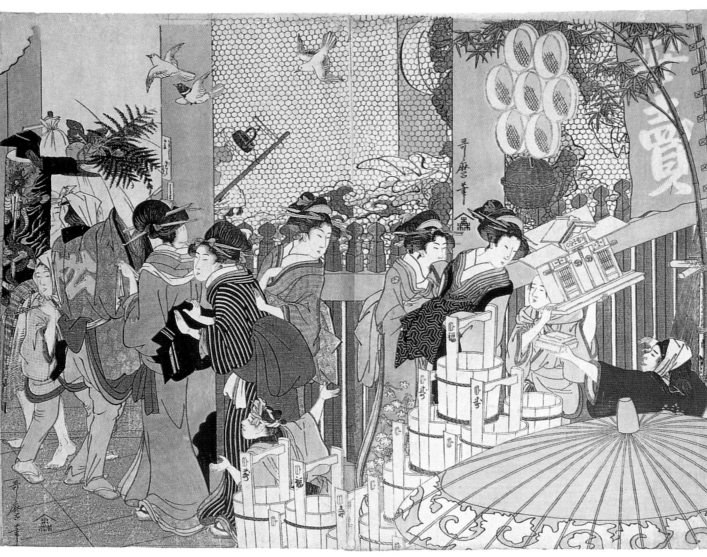

"Year-End Fair at Asakusa" (Asakusa toshi no ichi),
c. 1800-1801.
Ōban, five sheets, nishiki-e, from left to right: 38.7 x 25.2 (1), 38.5 x 24.8 cm (2), 38.5 x 75.1 cm (3-5).
The Art Institute of Chicago, Chicago.

little pagoda over his head, a toy pagoda for sale.

The Rainstorm:

This shows a torrential, drowning rain laying waste to the countryside. A young girl plugs her ears at the noise of the far-off thunder. A boy in tears holds his little arms up to his mother, imploring her to pick him up. Umbrellas are being hastily opened all around, and in the central panel, a pair of lovers run along under the same umbrella, the girl in the same charming running motion as the Atlas of the Tuileries Garden in Paris. The couple are being followed closely by a friend. This scene offers a surprisingly real, understandable, and, one could even say, ethereal, depiction of people engaged in a frantic race.

House-cleaning (pp. 56-57):

Servants in their morning dress are doing a major house cleaning, which takes place around the end of December. Amongst overturned furniture and screens, they are chasing away mice in a great flurry of brooms, feather dusters, and mop water. The fourth panel represents a woman trying to lift a sleepy young man onto his feet because it is time for him to leave. As she pulls him up by the underarms, he makes limp attempts to attach his sword to his belt. The fifth panel shows an old man being awakened, so ridiculous in his contortions and stretching that one woman runs away laughing

Also worthy of note:

The Street in Edo Suruga-chō, in front of the Silk Shops:

Shopfronts covered by curtains, under the raised portions of which can be seen, in the background, the display of fabrics spread before the purchasers seated in a circle on the floor.

The Flowers of the Five Festivals:

Five women, under a violet canopy sown with cherry blossoms, have in a vase or a hanging urn flowering branches of the festival season.

The Stroll of Noblewomen and Children, under blue Parasols:

Behind the noble women and children walks a domestic carrying a lunch pail in a sack and a cask of sake.

The Musicians:

Five women are kneeling on a purple mat, playing the *shamisen**, the *biwa**, the *komabue**, the *koto**, and the *kotsuzumi**. It is a most charming composition surmounted by an ornamental band in excellent taste, pink and scattered with white cherry blossoms.

Porters:

In the street, women, children, and, in the middle, on the back of the porters, clothing trunks containing deliveries made by the shops (work probably composed of five panels).

Opening Night of the Sumida:

In a night sky filled with stars, fireworks burst, and on the water, a multitude of women's boats crowds one another as the boatmen quarrel.

Women on a Terrace:

Japanese women are seated on a terrace on the bank of a river on the opposite shore of which is a large bridge on stilts in a green landscape. Lying, sitting on their heels, and kneeling, these women read, take tea, and play music.

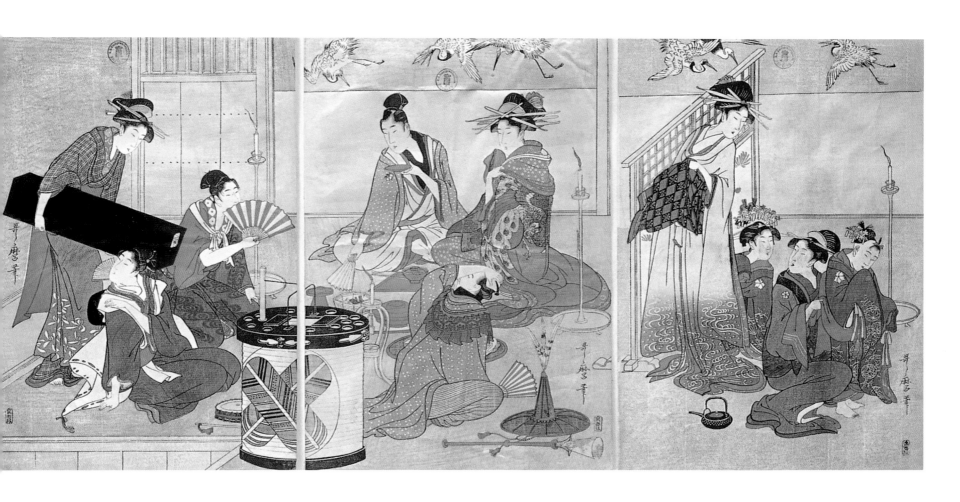

Niwaka Festival Performers in a Yoshiwara Tea-House (Hikite-jaya no nikawa-shū),

c. 1800-1801.

Ōban triptych, nishiki-e, right sheet: 37.9 x 25.5 cm; centre sheet: 37.7 x 25.4 cm; left sheet: 37.8 x 25.3 cm.

Staatliche Kunstsammlungen Dresden, Dresden.

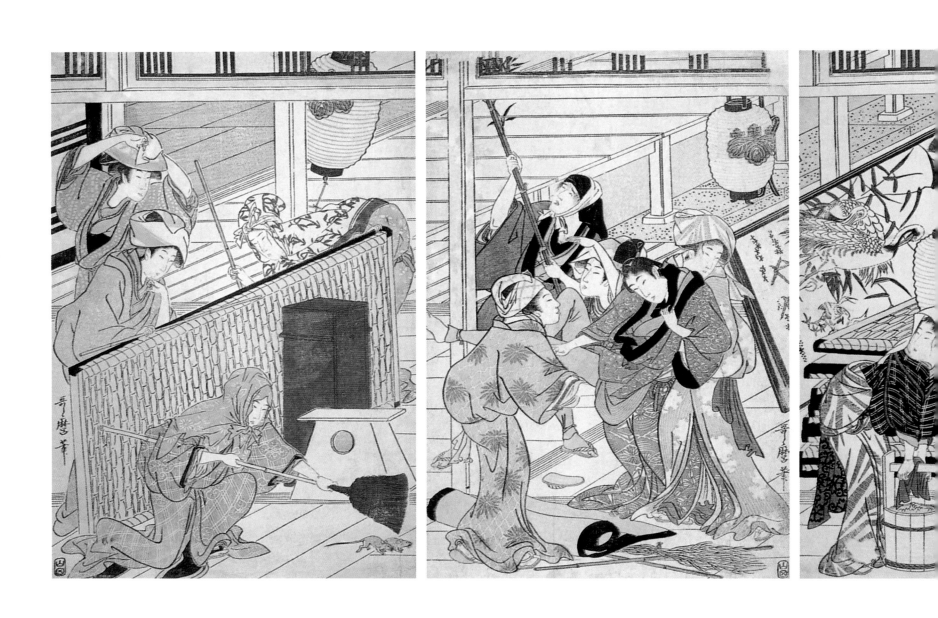

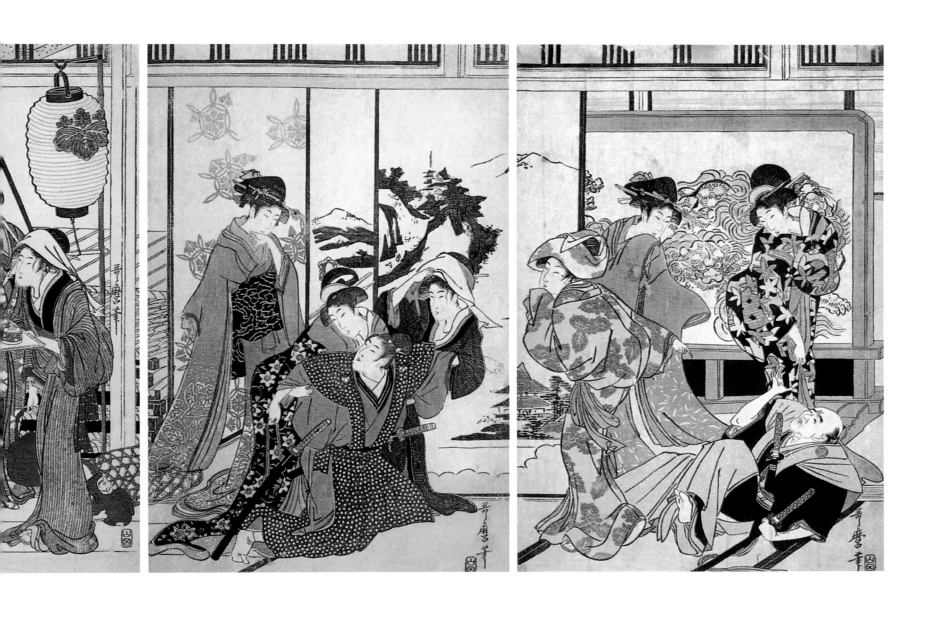

"House-Cleaning" (Susuhaki),
c. 1797-1799.
Ōban pentatych, nishiki-e.
The British Museum, London.

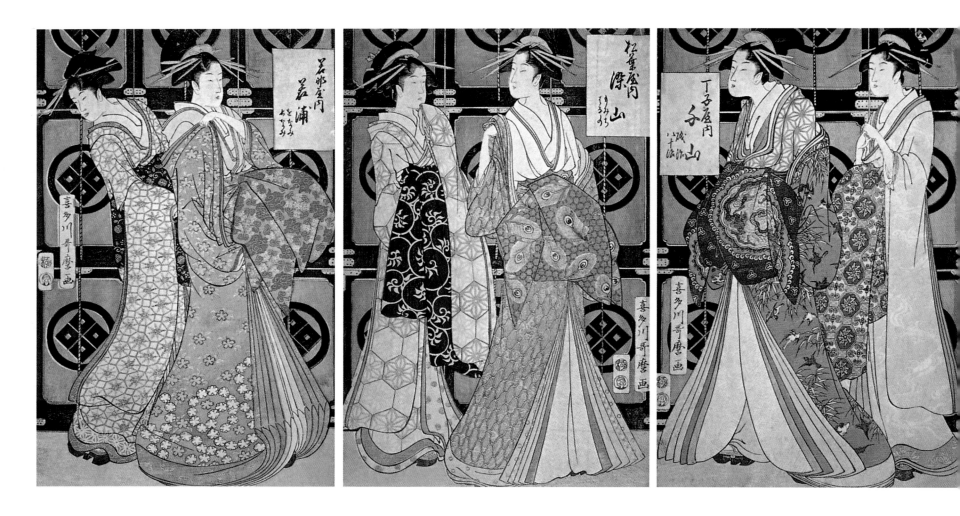

"Courtesans Processing in Front of Stacked Boxes" (Tsumimono mae no yūjo), 1795.
Ōban triptych, nishiki-e, right sheet: 37.5 x 24 cm; centre sheet: 37.5 x 23.7 cm; left sheet: 37.5 x 24.6 cm.
Chiba City Museum of Art, Chiba.

Procession of Children:
A joyful march of children, one of whom carries an iron lance decorated with a tuft of feathers (work no doubt composed of five panels).

Singers and Flowers of Edo:
(work probably composed of five panels).

*Nishiki-e** in three panels

Utamaro's three-panel compositions, those triptychs so highly favoured by Japanese artists, are very numerous. These beautiful pages have, in the eyes of the educated collector, the seductive charm of the "art print". They seem not to have suffered for having been massively reproduced mechanically. The designs of the great master seem to have kept, in their interpretation by the printer, their clarity, their lucidity, and their aqueous quality so reminiscent of the watercolour! When put side by side with modern prints, what a contrast between their harmonious greens, blues, reds, yellows, violets and these greens which assault the eyes, these harsh blues, these muddy reds, these ochre-tainted yellows, these calico violets! What an enormous difference between their luminosity and the dull, shallow look of these images in which the rough colourings look as though they were made with cheap powders.

Let it suffice to cite this one example of *The Dragonfly in the Poppies*, for the *Picture Book: Selected Insects* (pp. 234, 236, 237), not the print in the book, which is itself very beautiful in the early editions, but one of the very first proofs, a test proof, perhaps. This is not printing, this is a drawing in all its finesse and lightness, with the "human touch" aspect of a true drawing, rather than something reproduced many times over. In the same way this plate, showing two women and a little girl at the foot of a bridge, does not resemble so much a print as it does a watercolour, where the delicate relief of its embroidery, highlighted with a bit of gold, and its embossing, have become accessories to art. There are in these astonishing works so gentle a fading away of colour, and so tender a diffusion of their hues, that they appear to be the colours of a watercolour still wet from the artist's brush, or the languidly luminous colours of Fragonard's miniatures of children, dashed off on ivory medallions.

In this enormous and incredible output of admirable prints, one must linger over these series with silver backgrounds, with mirrors before which women are dressing, mirrors with frames and little stands, lacquered in true lacquer. There are also those prints with a thousand details, with meticulous execution, rendered by a thousand tiny strokes, the roots of the lush hair on the temples and the forehead, that hair which in modern prints is but a jumbled, murky mass; and then those prints in which, in the silver coating of the backgrounds, adding to these images something like the reflection of pale moonlight, the women, with their discrete colouring, have skin the colour of tea-roses and appear in dresses of deep blue, currant red, or of a greenish golden yellow, dressed in colours of a delicacy unequalled in the coloured prints of any other country.

Backgrounds always received great attention from Utamaro. He never gave his women the bare whiteness of the paper as a background,

enveloping them sometimes in a straw yellow or orange with little clouds of dark, glistening mica dust to break its flatness, sometimes against a greyish shade, which in his work, has something of a beach, moistened by the sea, but from which it has retreated. Rather than leave his backgrounds blank, he made them undulate with a wave of a violet or tobacco shade. Sometimes, as in the series of which we have just spoken, the backgrounds around the figures show a silvery sheen such as might have been left by a snail, but which was made using silver or silver-white extracted from the ablet fish. His backgrounds may also have the look of oxidised metal, reminiscent of those in the works of his predecessor, Shiraku: bizarre, strange, surprising backgrounds, with daring colouring on metal, backgrounds which truly make one want to say that in these paper images, the painter wished to reproduce the multicoloured patina of Japanese bronzes. This search for what can be used to punctuate a background was so important and taken to such lengths of inventiveness in Utamaro's work, that in one outstanding print, that of the *Mother giving a warm Bath to her Child*, the lower part of the plate is artistically dusted with ground charcoal, used in heating a bath.

Some of these beautiful prints stand out by showing several different stages of the same composition. For example, in *House-cleaning* (pp. 56-57), there are three different versions of colouring: a first one, in which the contours outlined by the thinnest lines contain a combination of faded colours, almost entirely in the green and yellow range; a second, which introduces hints of blues and violets; and a third, with naturalistic colours, is still quite harmonious, but with a less distinctive polychromy.

Another most curious print is *The Princess, Having Left her Imperial Chariot, Walking in the Countryside*. It is a print dominated by violet and which, in this first stage of colouring, seems to be an attempt by the printer to give the impression of a plate printed using gold, where all the tones are yellows or brownish yellow, against which the beautiful blacks of the lacquered wheels of the imperial chariot stand out sharply. In the second set, the results, which in fact were achieved by technical means through the thickness of the absorbent paper, reveal a deep colour which has penetrated and passed through the paper. Here, the major part of the colouring has been absorbed and held inside, and the only part of it which shows is that which shines through the silk of the Japanese paper, like colours under a glaze.

But this is not all: there is in these prints a breaking down of the colour which further encourages the illusion of a watercolour-like wash, with hues broken by the brush, a decomposition brought on not only by air, sunlight, and exposure. This is an intentional diminishment, prepared in advance by substances mixed with the colours — herbal extracts, and trade secrets which have been lost but which have created such pale pinks, such deliciously yellow greens suggesting old moss, such languidly delicate blues and iridescent mauves: a decomposition which, in the flat areas, where colour is most important, brings about veinings, marblings, "agatisations", like those seen in malachite, turquoise, and gem stones, and prepares

"The Embankment at Mimeguri" (Mimeguri no dote), 1799.
Ōban triptych, nishiki-e, right sheet: 38.1 x 25.5 cm; centre sheet: 38.4 x 25 cm; left sheet: 38.3 x 24.7 cm.
The New York Public Library, New York.

On Top of and Beneath Ryōgoku Bridge [bottom] (Ryōgokubashi no ue, shita), 1795-1796.
Ōban triptych, nishiki-e, right sheet: 38.2 x 24.8 cm; centre sheet: 38 x 24.9 cm; left sheet: 37.9 x 25.3 cm.
The Art Institute of Chicago, Chicago.

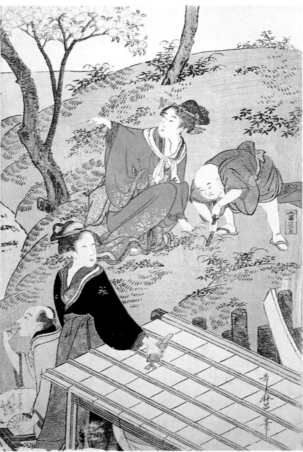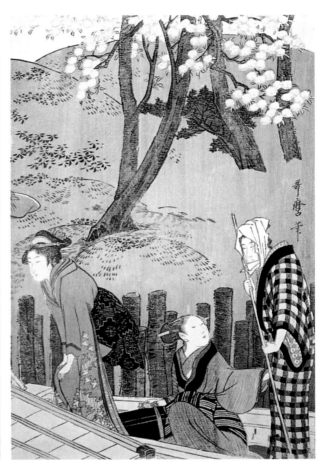

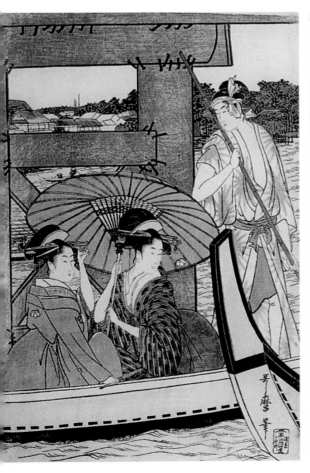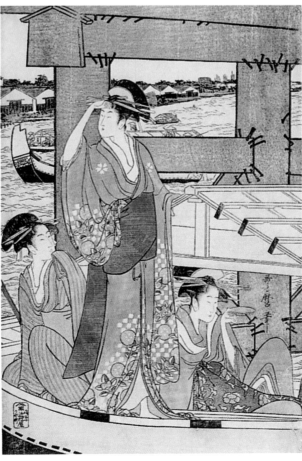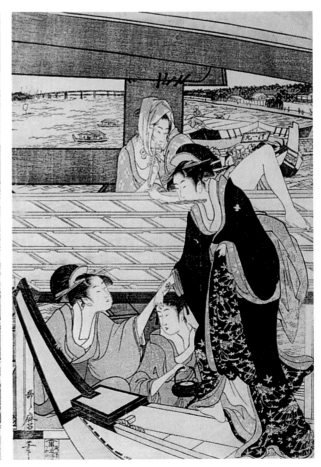

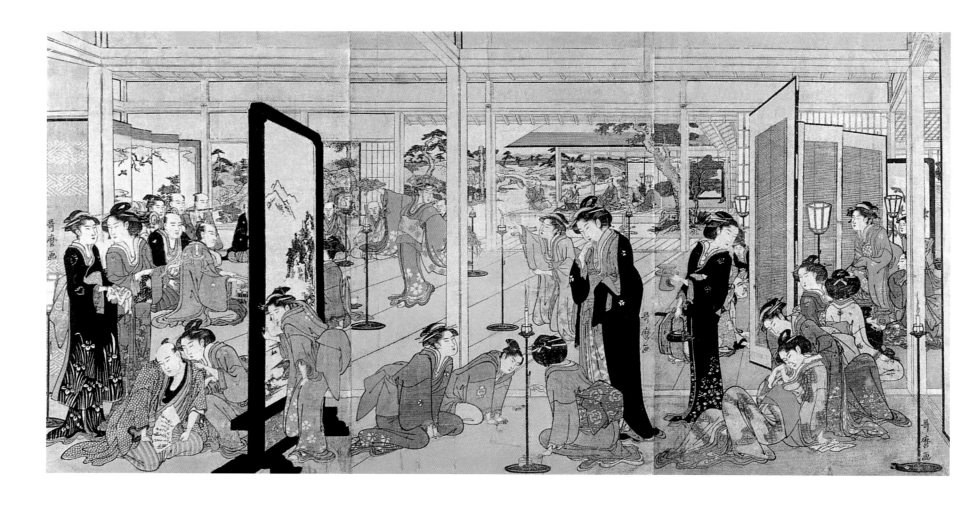

"Santō Kyōden at a Daimyo's Mansion" (Daimyō yashiki no Kyōden),

c. 1788-1790.

Ōban triptych, nishiki-e, 37.5 x 73.2 cm.

Musées Royaux d'Art et d'Histoire, Brussels.

those extraordinary underlying effects, so beautifully nuanced and almost shifting, which go beyond the immobility of a uniform tint, to enhance and complement the ornamentalism and the richness of a robe's embroidery.

In the pursuit of general harmony, the printer may sometimes go even further: he may soil the print which he is pulling, adding smudges which resemble the mark which might have been made on a colour print by rubbing against a black and white print which was not yet dry. But as these smudges are never found anywhere but on depictions of land or buildings and never on women's faces or skin; it is obvious that these smudges are the intentional work of the printer, on instructions from the painter.

To cite a few examples in various types of scenes:

New Year's Day:
The scene is indoors, where lots are being drawn using a somewhat unusual method; a woman holds out a skein of intermingled strings with untied ends and the prize is won by whoever chooses the piece of string to which it is attached. In the rear, a woman is bringing a prize to replace the one being drawn, and women can be seen on a temporary platform, hanging pine boughs, gourds, and bits of poetry.

The Wedding:
A *daimyo** and a noblewoman sit facing each other. In front of the bride are three cups, from each of which she must drink three times. This number three has a particular meaning, since when multiplied it gives the number nine, seen in Japan as the most powerful number for reproduction. While a woman in the rear carries away the two bottles of sake offered to the *kamis**, another woman beside the bride brings a platter on which there is a dried fish which is not eaten, but nonetheless served superstitiously as a good luck token for the newly-weds. A third woman is bringing soup in lacquered bowls decorated with gold while a fourth woman heats sake in a long-handled teapot.

"Santō Kyōden at a Daimyo's Mansion" (p. 62):
In a palace with many wings and in the middle of gardens, the scene shows many figures seen slightly from above. For example, a dancer in a red dress with a hat of flowers on her head and in each hand, dances with outstretched arms. She is being watched appreciatively by women in the foreground and, in the middle ground, by the *Daimyo** and his circle. This composition of the dance of a geisha in a palace of *daimyos**, in which Utamaro has included his colleague, Santō Kyōden, seems to have been printed in colour from a drawing based on an actual scene from Japanese life, which is rather rare in the master's production. In the right-hand panel, a woman is lying on the floor in a pose of tragic collapse, as though about to faint, near a letter which she has dropped beside her. In the left-hand panel, the writer-painter Santō Kyōden (he wears his name on his sleeve) fans himself with a fan on which is written: "It is good for a poet to be clumsy, for if his verses were good enough to shake heaven and earth, he would be truly very unfortunate!" This *kyōka**, written on the fan, is a light-hearted little poem, a bit of irony which mocks a lyric poem of the seventh century claiming that the true poet had the power to "make, by his verses, heaven and earth tremble."

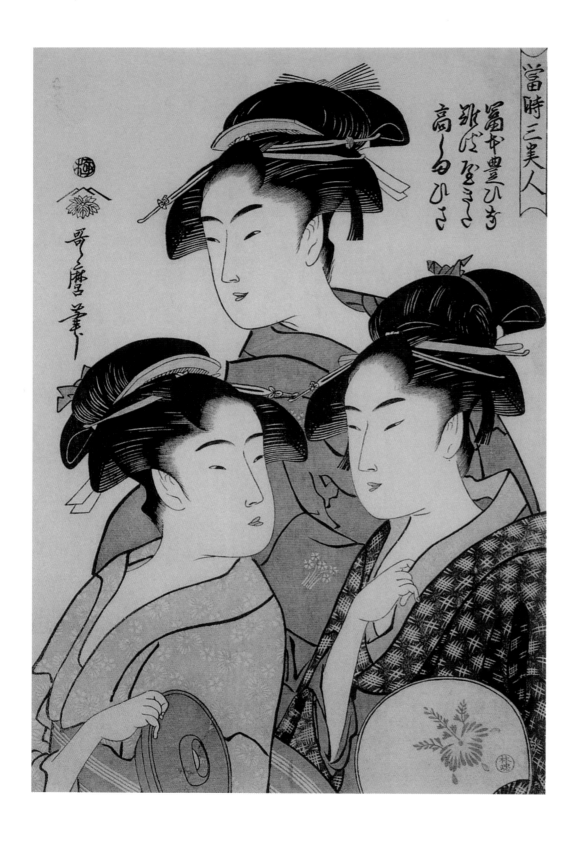

當時三美人

冨本豊ひな
浪花や北
高しまひさ

The fan, decorated with gold leaves, with paintings of birds and flowers, or with *kyōka**, was in general use among Japanese of both sexes and in all stages of life. The best and most artistic amongst them were made in Kyōto. The fan has an interesting origin. During the reign of the Emperor Tenji, around the year 670, an inhabitant of Tomba, watching bats fold and unfold their wings, had the idea to make folding fans which were known, at the time, as *kuwahori*, which means "bat". There are two types of fan in Japan: one, called *sensu*, which can be folded, and the other, round in shape, which does not fold, and which is made from bamboo or *chamœ cyparis obtusa*. Yet another type of fan, a very luxurious one, used by dancers either to keep time or to extend their graceful gestures, is called *uchiwa*, and is sometimes made of silk. During the Kuwambun period, a priest named Gensei, famous for his artistic taste and his poetry, began on his own to make fans of a remarkable perfection in Fukakusa which acquired a great reputation and which were known by the name of *Fukakusa uchiwa*.

Three Beauties of the Present Day: Tomimoto Toyohina,
Naniwaya Kita, Takashima Hisa (Tōji san bijin Tomimoto
Toyohina, Naniwaya Kita, Takashima Hisa), c. 1793.
Aiban, nishiki-e, 32 x 21.6 cm.
Chiba City Museum of Art, Chiba.

Young Woman Peeling a Peach for her Child.
Ōban, nishiki-e, 38 x 24.5 cm.
Bibliothèque nationale de France, Paris.

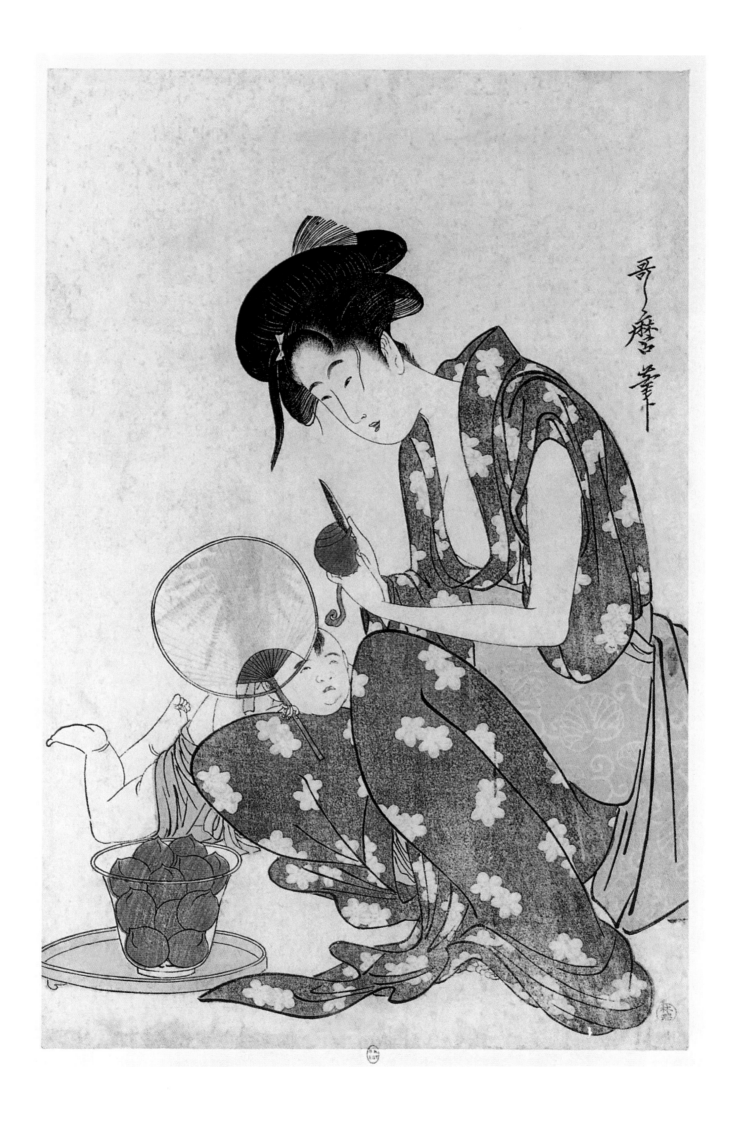

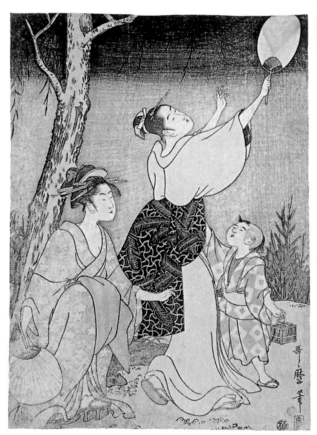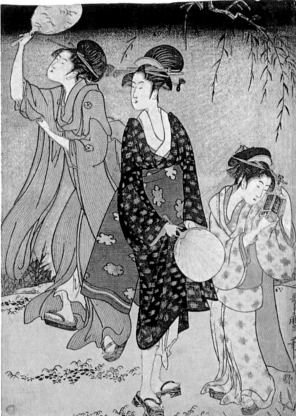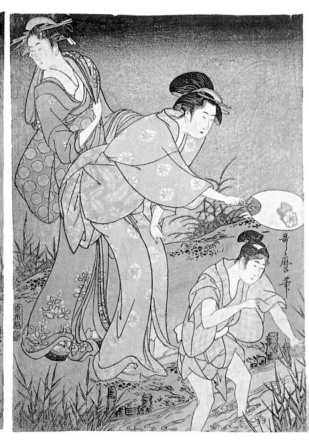

"Catching Fireflies" (Hotaru-gari),

c. 1796-1797.

Ōban triptych, nishiki-e, right sheet: 35.6 x 23.7 cm; centre sheet: 35.6 x 24.3 cm; left sheet: 35.6 x 24.8 cm.

The Metropolitan Museum of Art, New York.

Japanese Prince, holding a Basket of Shellfish, with Women carrying Salt:

This is the illustration of a story or legend about a prince exiled on an island where he became the lover of two sisters who carried salt from the sea, and whom he was tragically forced to abandon when he was called back and restored to his rightful place. The struggle between his love and his duty to his rank was the subject of some most touching scenes in a novel entitled *Matsukase Murasame* (the names of the two women of the sea). This romantic and sentimental incident also inspired many plays.

Catching Fireflies (p. 66):

In this well-balanced composition, six young women, in suggestively loose costumes, amuse themselves in the chiaroscuro of the pale shadows of a warm August evening. With their round fans they are swatting fireflies from the tree branches, with a naively awkward grace. A little girl with bare legs has ventured into a stream to find glow-worms shining in the reeds, while a little boy and a little girl carry the boxes which will hold the captives, peering into them with curiosity.

The Civilisation of Brocade Prints, a Famous Product of Edo (pp. 68-69):

A first panel shows the interior of a shop, its walls covered with *kakemonos**, its ceiling hung with colour prints suspended from strings, where a travelling merchant buys prints being shown to him by a woman. The second panel opens into a workshop, where a woman is carving wood with a chisel which she strikes with a mallet. Another woman, leaning on a table, prepares to trace the lines of a block, and a third woman, sitting on her heels in a corner, is sharpening tools on a whetstone. In the third panel, we see in the back room, in one of these allegorical scenes of which the Japanese are so fond, Utamaro, in the figure of a woman, showing another woman, presumably the personification of the publisher, a drawing to be engraved.

Edmond de Goncourt mentions another three-panel composition on the same subject. This picture shows the wall of a shop covered with coloured images, in the middle of which are suspended three *kakemonos**, while a kneeling man unwraps a package of prints, a woman sitting on a platform between two or three painted sheets, an inkpot, and a brush, arranges one of her hairpins in a moment of distraction, and a child on her lap holds out to her a piece of paper which is still blank.

Women at the Beach of Futami-ga-ura (p. 71):

Futami-ga-ura in Ise is a place famous for its sunsets. Near two sacred stones, linked by a cable made of straw, and known as *Meoto-Iwa* (rocks of the couple), symbolising conjugal bliss and fertility, young newly-weds have come to offer prayers, and women are walking barefoot in the waves, holding up their long dresses with both hands.

Women Overnight Guests - Triptych (p. 71):

This is an unusual composition showing three women standing in front of a mosquito net, under which three other women, partially visible and partially obscured behind the net, are preparing for bed while chatting with the women in the foreground. Here we see one of the frequent attempts (and a very successful one from the brush of the artist) to contrast

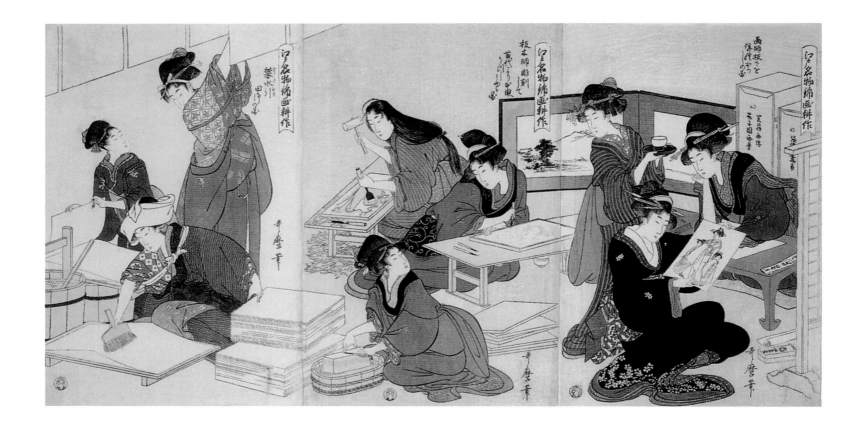

Artist, Block-Carver, Applying Sizing (Eshi, hangi-shi, dōsa-biki), from the series *"The Civilisation of Brocade Prints, A Famous Product of Edo"* (Edo meibutsu nishiki-e kōsaku), c. 1803.
Ōban triptych, nishiki-e, right sheet: 38.5 x 25.6 cm; centre sheet: 38.3 x 25 cm; left sheet: 38.2 x 24.8 cm.
The Art Institute of Chicago, Chicago.

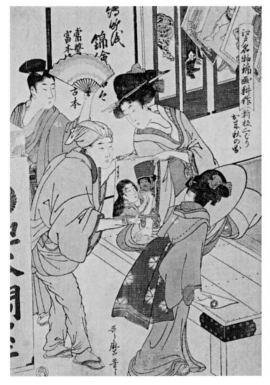 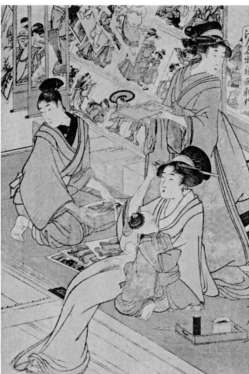 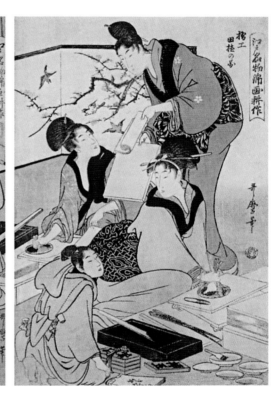

"Woodblock Printer, [Print Shop], Distributing New Prints" (Suri-kō, mise-saki, shimpan-kubari), from the series *"The Civilisation of Brocade Prints, A Famous Product of Edo"*

(Edo meibutsu nishiki-e kōsaku),

c. 1803.

Ōban triptych, nishiki-e, right sheet: 37.2 x 24.8 cm; centre sheet: 37.2 x 25.3 cm; left sheet: 37.2 x 24.3 cm.

The British Museum, London.

women in full light with women in a green shadow, women reduced nearly to pretty silhouettes behind a paper screen. Utamaro was very fond of this kind of contrast and of these figures or partial figures, shown in the half-light. For example, in the colour print of *Drying Clothes* (p. 92), he has a child leaning over for a kiss towards the face of his little sister, a face which is oddly purple coloured, owing to the great swath of violet thread through which her face is seen.

The Cranes of Yoritomo:

Here we see a group of young women under a rose-coloured sky full of white cranes fluttering in the air, a poem attached to their legs. One woman hands the little strip covered with writing to another who is holding a crane which she is about to release. This composition recalls in an allegorical way an incident in the life of Minamoto Yoritomo (1147-1199), who, having heard that storks lived a thousand years, had a thousand storks released one day, with the date and the year of their release attached to their legs. In Japan it is claimed that some of these storks were found as late as the sixteenth century.

Abalone Divers (pp. 72-73):

Among the triptych images, one of the scarcest and most sought after is undoubtedly that of the women who dive or fish for abalone, an edible shellfish. This triple print is the composition with the most straightforward interpretation of the female nude, as the Japanese painters understood and represented it. It is a female nude with a perfect understanding of its anatomy, but a nude simplified and, reduced in its forms, presented without details and with the elongations of a "model" by strokes that could be called calligraphic. The left panel shows a naked woman, her lower body hidden by a piece of red cloth, lying on the edge of a bank, one leg already in the sea, with a shiver going through her body which is supported by her two hands well back behind her and with one foot in the air, drawn back as though needing to be convinced to enter the water. Above her head a second diver leans over her and points with her extended arm to something in the deep. The middle panel shows a seated diver with a blue calico thrown over her shoulders, combing her dripping wet hair, while a naked child stands nursing at her breast. In the right panel, another woman holding a knife for opening shells in her mouth, with both hands wrings out the end of a soaked cloth which is wrapped around her waist, giving a graceful twist to her torso, while a shopper kneels to select a shellfish from her basket. These tall, long women, with their white bodies, their harsh, black, stringy hair, with these bits of red around them, in these pale and light green landscapes, are images of a very high style, and they have a charm which is arresting, surprising, even astonishing.

Abalone Divers (p. 74):

This composition represents in its first rectangle two women undressing in a boat; in the second, a diver climbing back into the boat assisted by her colleague, and in the third, the diver swimming in preparation to dive under the water, while on the shore strolling women watch the divers. In this colour print, the women are small, dainty and thin, and seem, with the thin delicacy of their bodies, to be almost enveloped in their damp black hair. When in the water they seem to have something of the vague fluidity of those

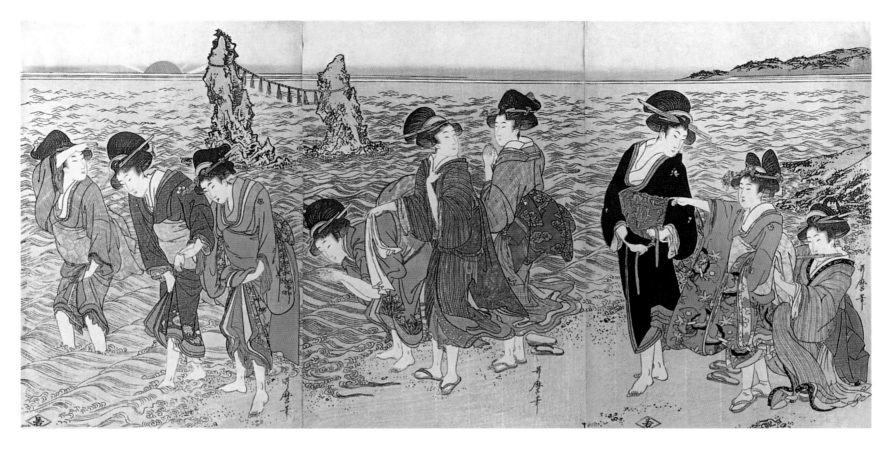

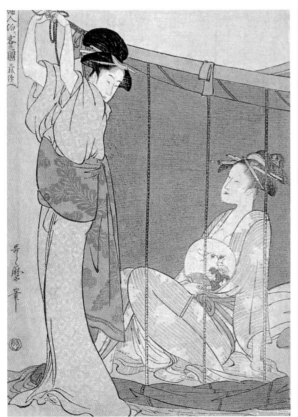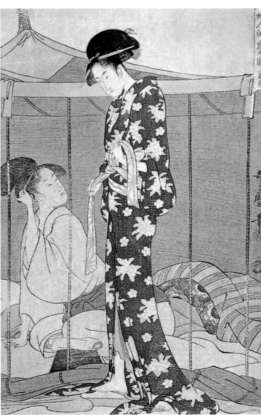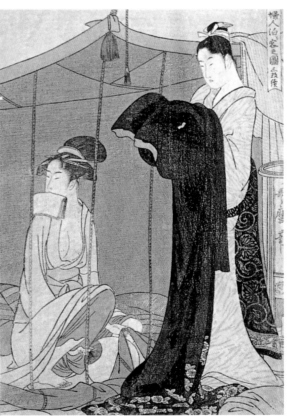

"Women at Futami-ga-ura Beach" (Futami-ga-ura), c. 1803-1804.

Ōban triptych, nishiki-e, right sheet: 36.8 x 24.8 cm; centre sheet: 36.7 x 25 cm; left sheet: 37 x 25 cm.

The Metropolitan Museum of Art, New York.

"Women Overnight Guests" (Fujin tomari-kyaku no zu, sammai-tsuzuki), c. 1794-1795.

Ōban triptych, nishiki-e, right sheet: 36.7 x 24.8 cm; centre sheet: 36.8 x 23.5 cm; left sheet: 36.5 x 24.8 cm.

Keiō Gijuku, Takahashi Seiichirō Collection.

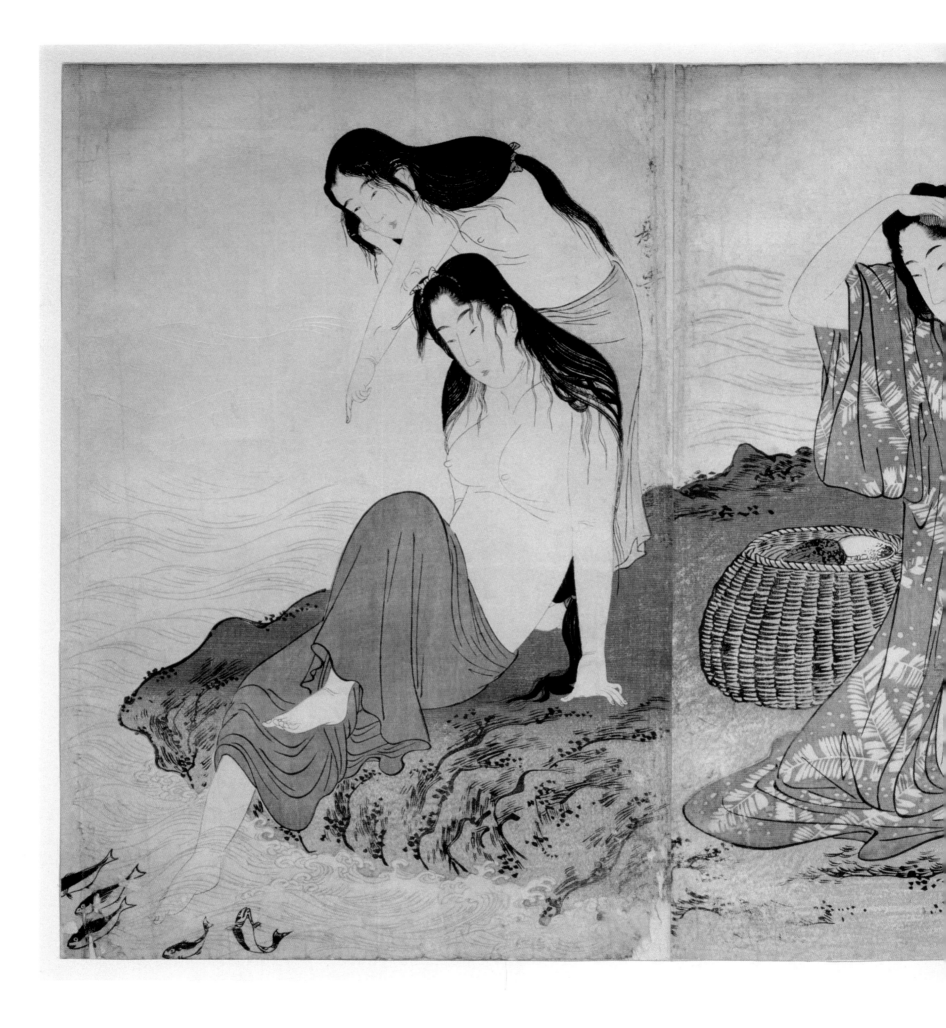

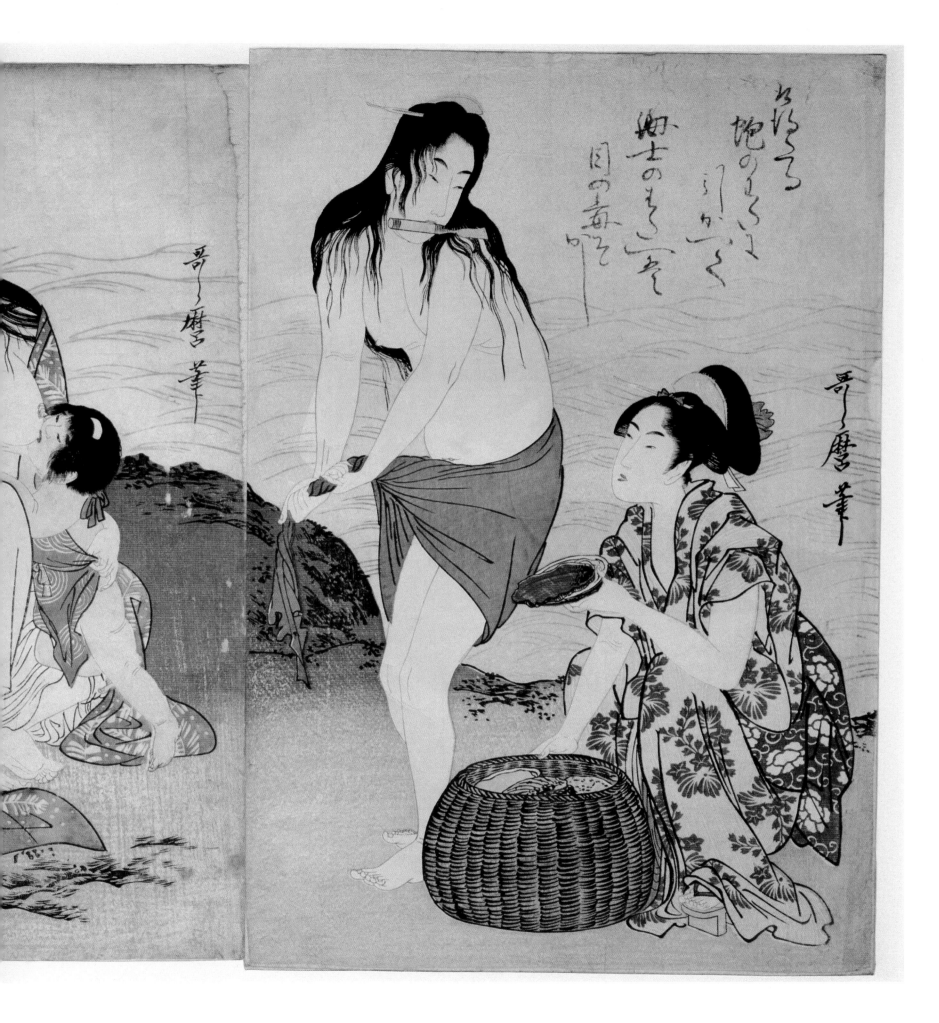

"*Abalone Divers*" (Awabi-tori),
c. 1797-1798.
Ōban triptych, nishiki-e, 37.2 to 38.2 x 73.9 cm.
Musée national des Arts asiatiques – Guimet, Paris.

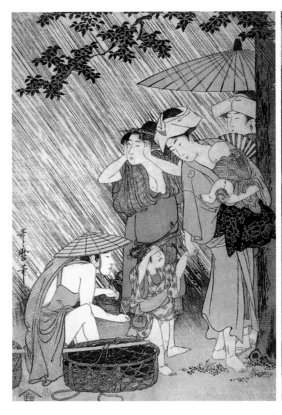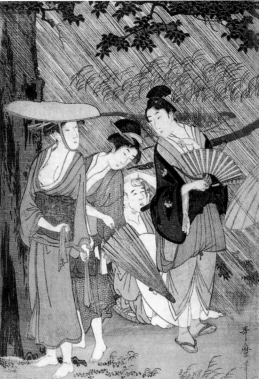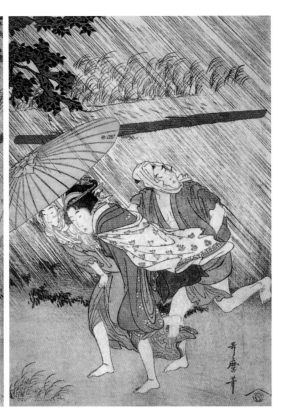

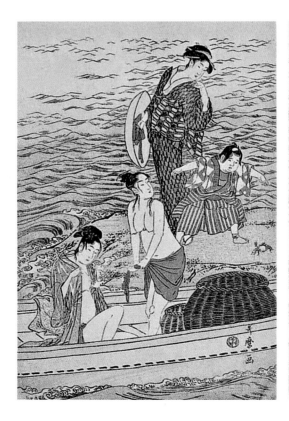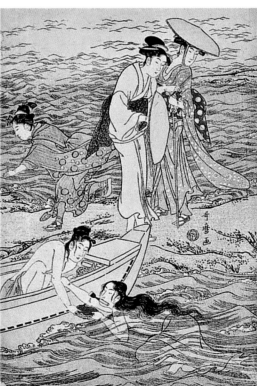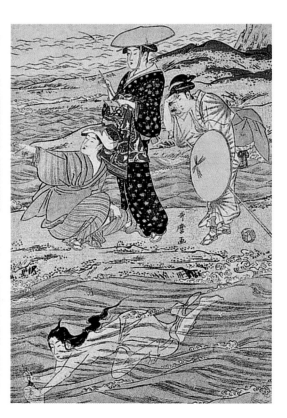

"Sheltering from a Sudden Shower" (Ama-yadori), c. 1799-1800.
Ōban triptych, nishiki-e, right sheet: 37.6 x 24.7 cm; centre sheet: 37.6 x 24.6 cm; left sheet: 37.6 x 24.8 cm.
Tokyo National Museum, Tokyo.

"Abalone Divers" (Awabi-tori), c. 1788-1790.
Ōban triptych, nishiki-e, right sheet: 37.8 x 25 cm; centre sheet: 37.8 x 25.1 cm; left sheet: 37.8 x 25 cm.
The British Museum, London.

long-haired apparitions by which the Japanese represent dead souls coming back to haunt the earth.

The Pleasures of Hideyoshi with his Five Wives in the East of the Capital:
Utamaro sometimes alluded to powerful men with the tip of a light and witty brush. In this series dedicated to Hideyoshi, a popular hero of the sixteenth century and conqueror of the Koreans, one panel shows him paying court to a young noble, recognisable by the coat of arms on his sleeve. The painter paid for meddling in politics, however. The publication of *The Pleasures of Hideyoshi* was a disaster. This three-part print depicts the simian-headed hero handing back the sake cup that he has just emptied, at the same time as a kneeling man is presenting him with his official wig, the *kammuri*, the headwear of the highest rank. Beneath the trees in flower, in an enclosure of silken curtains covered by his coats of arms done in violet, with a regal carriage and surrounded by other women, his legal wife approaches the illustrious warrior; she bears in her hand a closed fan, and in her hair, which is loose and spread over her shoulders, she wears two large bouquets of gold and silver chrysanthemums. This seemingly innocuous illustration was in fact a representation of Hideyoshi's libertine and amoral life. [This representation] is a scathing reference to Ienari, the eleventh shogun of the Tokugawa family who reigned in Utamaro's latter years, and who seems to have been a kind of Louis XV in that he was both a voluptuary and patron of the arts much as the French monarch had been. Utamaro was sentenced to prison by the authorities in Edo, an imprisonment from which he emerged weakened and ill.

Among the three-part prints, still others might be mentioned:

The Wedding Day after the Ceremony:
The bride is changing her dress in front of a large, lacquered mirror standing on the floor, in the midst of women preparing her new costume.

Seven Women from the Court of a Daimyo:
Seven women, elongated and elegant, wear the kind of coronet made by a strip of silk rolled around their hair. They have stopped in the countryside where a curtain of verdant iris, with flowers of every colour, rises as high as their waists, hiding the lower part of their dresses. It is a composition in the noblest style and of the greatest rarity.

"Banquet beneath the Cherry Blossom" (p. 77):
In a landscape made pink with the blossoming of cherry trees, a large circle of noblewomen is gathered under a violet tent. In the rear centre, a rich *norimon** has been set on the ground, and in the right foreground a servant is in charge of a cask of sake.

Princess boarding a Boat before crossing a River:
Her large trunks of clothing already on the boat, the princess is about to step on, escorted

by a woman carrying a censer and another woman carrying a bag of perfumes and a little ceremonial sword.

Beautiful Woman descending from a Carriage (p. 77):
A princess steps down a little ladder, alighting from a large, imperial chariot with lacquered wheels and silk hangings, as a woman presents her with a fan. She is being watched by two women, one of whom is recumbent on a terrace, and by the prince, who is just visible through a lowered shade.

Visit by one Woman of Nobility to another Woman of Nobility:
Two noblewomen walk towards each other in front of the entrance to a dwelling set in a small garden, in the middle of which grows a large chrysanthemum bush.

Rest on a Terrace on the Banks of the Sumida:
Here one sees a young prince surrounded by women, one of whom is carrying away his outer garment. One can also see, through the fine

black cloth, a sealed letter, perhaps meant for the woman removing the garment.

Princess taking the Air:
A princess comes out of her *norimon** to take a breath of fresh air, while one of her servants puts slippers on her feet, and another servant opens a parasol over her head.

Daimyo on horseback:
A *daimyo** on horseback with a falcon on his wrist is crossing a small stream with an escort of women, one carrying his lance, another his sword, and the last one another falcon. In the distance Fujiyama is visible.

Interior of a Dairaio:
Interior of a *dairaio* where a company of women is enjoying the dance of a young prince in a black robe and a violet pant-skirt, his fan lowered over his hip.

Daimyo on a Boat:
The scene shows a flat boat, propelled over the water by a man pushing a long bamboo

pole; in the middle, a *daimyo** with a falcon on his wrist is surrounded by women, one of whom is turned around to give a kiss to the infant that she is carrying on her back.

Japanese Ladies escorting an Imperial Chariot:
In the front walks a princess over whose head a lady-in-waiting holds open a luxurious parasol; in the escort, one notices another woman carrying a quiver of arrows on her back.

Stroll with a Child Daimyo:
A young *Daimyo** carrying a sparrow on his wrist in place of the falcon to come, is being taken for a walk by two women. One of the women carries the boy's small sword under her arm. In the right-hand panel, a merchant carrying two baskets hanging from either end of a yoke over her shoulder, shows an aubergine to one of the women.

"Parody of an Imperial Carriage scene" (p. 78):
A princess who has stepped down from her imperial chariot, hands out a strip of paper

filled with poetry to a young man kneeling a few steps away. This poem must be a declaration of love and, in his shyness, the young man has had a sort of erotic swoon and is being held up by one of the princess' ladies-in-waiting who leans over him.

Noble Dance:
Schizuka, the mistress of Yoritomo, acts out a character dance to the accompaniment of the musicians' tambourines and flutes, a red fan matching the colour of her dress hanging from one hand, and the other arm raised to wave a scarf which floats over her head. The unusual aspect of this work, to keep it from being too historical, is that Yoritomo, the woman's famous lover, is replaced by the figure of another woman who is meant to represent him.

Three Groups, each with a Man and a Woman, seen from the Waist up:
This composition is an allusion to the voyage of Narihira (825-880), a great nobleman and poet who travelled to the east from Kyōto, to go to Mount Fujiyama at a time when the city of Edo did not exist.

Musashi Moor (pp. 80-81):
In the midst of tall, unkempt grasses, a group of women is out for a stroll carrying lanterns and apparently looking for a man whom another woman attempts to hide behind herself. An episode probably taken from the novel in which Agemaki hides Sukeroku.

Springtime Celebration when People go out into the Countryside to find Pine Shoots:
In the midst of women loaded with green tree branches, two little girls are arguing and pulling on a large pine bough.

Walk in the Countryside to admire the Cherry Trees in Blossom:
This is a print from the early days of Utamaro, before he had come into his own, in which we do not yet see the slimness in the cut of his women and their long oval faces.

Women watching the Current:
On the bank of a rushing stream, a group of women has come out of a house to look at the water full of cherry blossoms. Amongst those who have stayed inside is a little girl, tall for her age, holding a doll in her arms.

Women looking out from a Terrace:
At the time when the peonies are in bloom, a group of women on a terrace observe a stream which seems to flow with these flowers, as so many of them are carried away by the current.

Music, Gaming, Painting, Writing: the Four Enjoyable Pastimes:
There are women seated on their heels among admiring children, in front of *kakemonos** spread on the sand of a small garden. In a pavilion one woman writes a letter beside another playing music. In a distant pavilion two Japanese men are gambling.

Occupations of Private Life:
In the midst of women busy at various tasks, a young boy and a girl in one corner of the room are playing *sugoro-ku* — a game something like backgammon.

The Dance of Skill:
Two kneeling women are trying to pick up a goblet which is on the ground, in the middle of a big loose loop of a silken rope that they are twirling. The loser must dance until she can

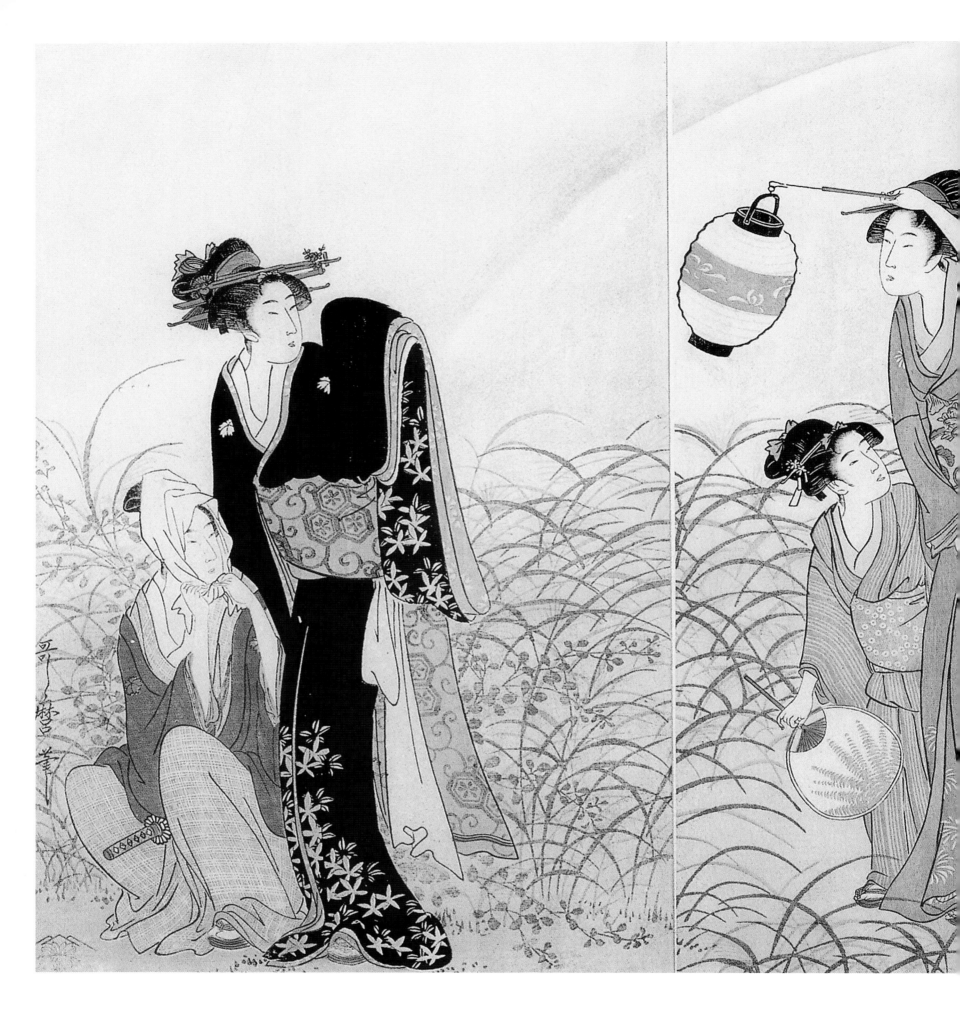

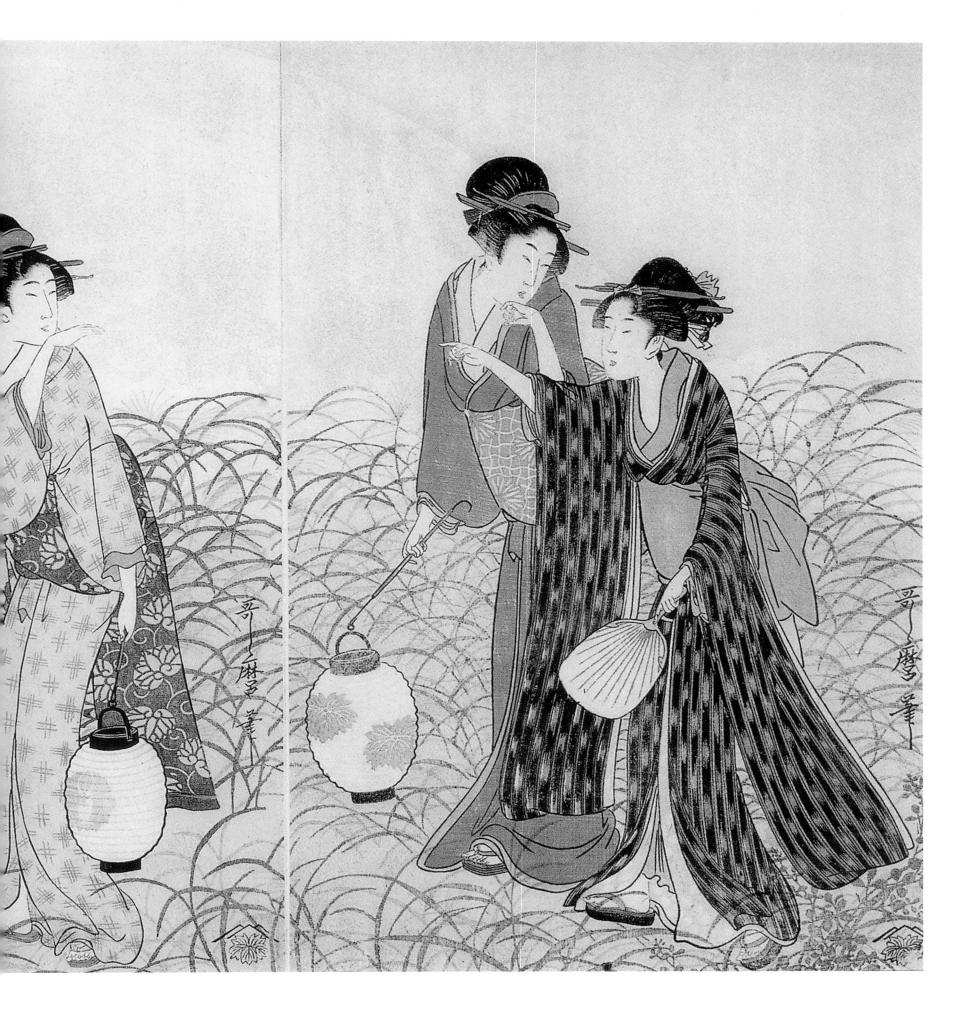

Musashi Moor (Musashino),
c. 1798-1799.
Ōban triptych, nishiki-e, 37.2 x 72.6 cm.
Musée national des Arts asiatiques – Guimet, Paris.

grab the goblet as the cord spins around and whips her wrist if she misses.

Fishing at Iwaya, Enoshima (pp. 82-83):
The scene is of a busy beach at the seaside with boats full of people passing by. In a corner, a fisherman smoking his pipe watches a fish nibbling at his line. In the middle panel, a boy is playing with a crab which he is dangling from the end of his line.

Fishing:
A river where, in two boats, there are men and women with fishing poles, and in the air a grey fish wriggling on a hook.

Stroll in the Environs of Kamakuro:
The scene shows a woman in a *kago** which has been set down on the ground.

Women in the Countryside:
We see Japanese women in the countryside, one of whom is holding her child gently against her breast, while a small man throws his hands into the air out of astonishment at a flight of birds which fills the entire sky.

Picking Persimmons (p. 87):
Women are making persimmons fall from tall trees using a hooked bamboo pole.

On top of Ryōgoku Bridge (p. 86):
Nine elegant women, including one who is holding a child playing in her arms, are standing or leaning against the railings of the bridge, chatting, fanning themselves, and watching the river flow by below.

Enjoying the Evening Coolness on the Banks of the Sumida River (pp. 84-85):
This is a night scene with its dense, deep, and mysterious darkness of the kind that the Japanese masters loved to represent. This composition presents the scene of a night-time stroll on a beach, where the women's summer dresses brighten the darkness accentuated by a patch of black lacquer. Behind them, the murky water is crossed by an interminable trestle bridge, illuminated like a magic lantern, and a dark blue sky twinkling with stars so numerous that they seem to be snowflakes.

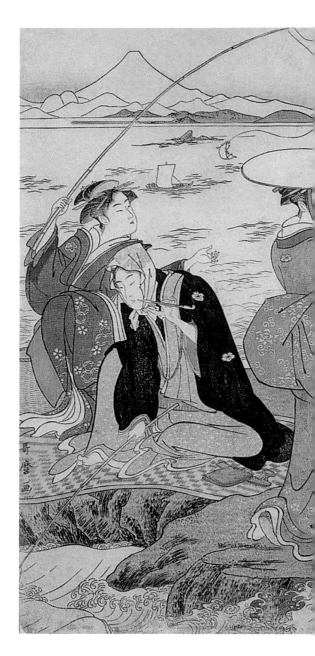

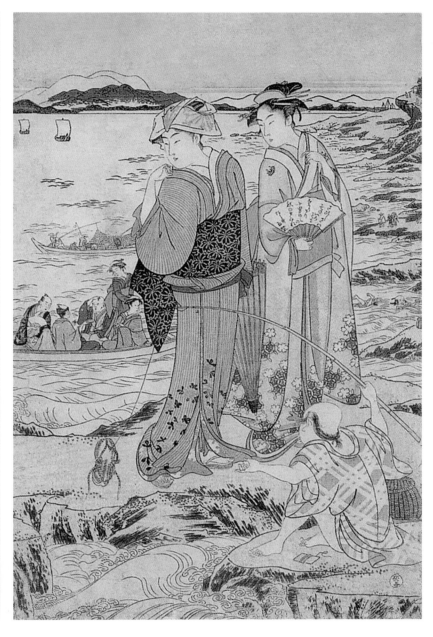
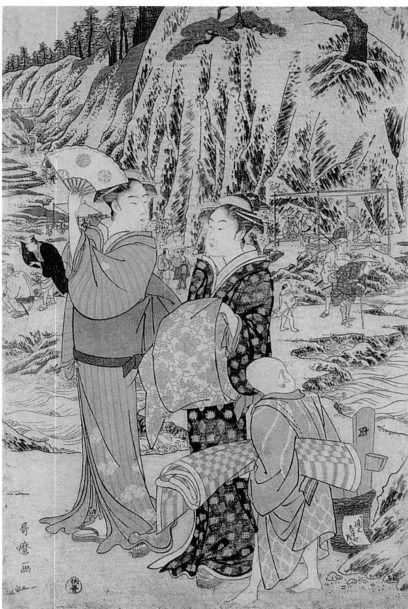

Fishing at Iwaya, Enoshima (Enoshima Iwaya no tsuri-asobi), c. 1790.
Ōban triptych, nishiki-e, right sheet: 37.1 x 24.9 cm; centre sheet: 37.2 x 25.4 cm; left sheet: 37.3 x 24.9 cm.
The British Museum, London.

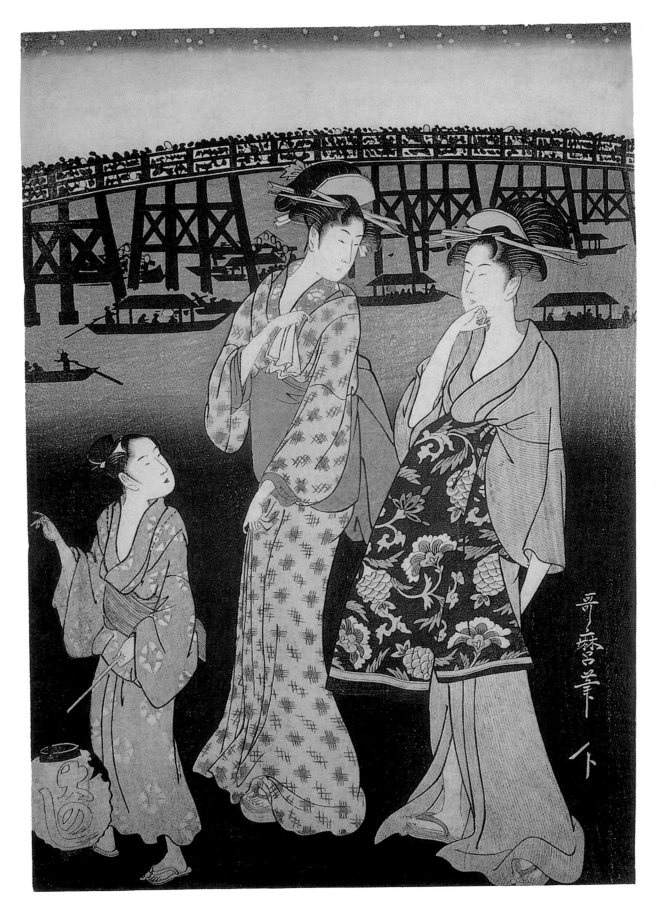

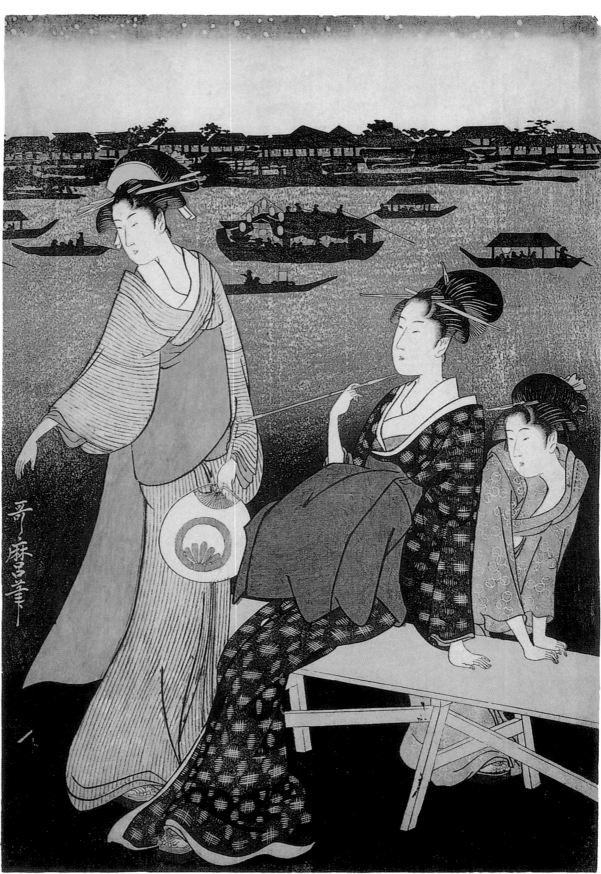

"Enjoying the Evening Cool on the Banks of the Sumida River" (Ōkawa-bata yūryō),
c. 1795-1796.
Ōban triptych, nishiki-e, right sheet: 36.3 x 24.6 cm; centre sheet: 36.5 x 24.8 cm; left sheet: 36.5 x 25.2 cm.
Museum of Fine Arts, Boston.

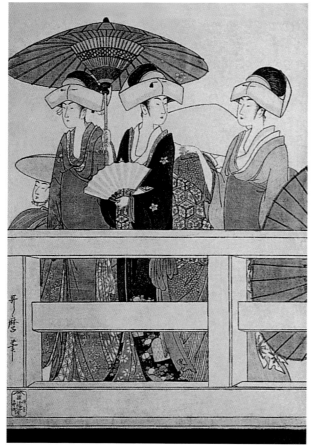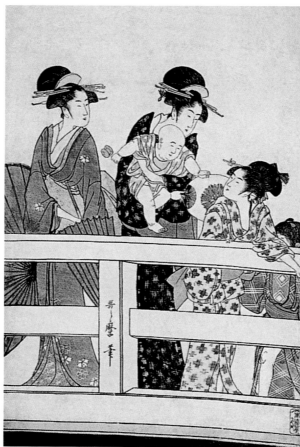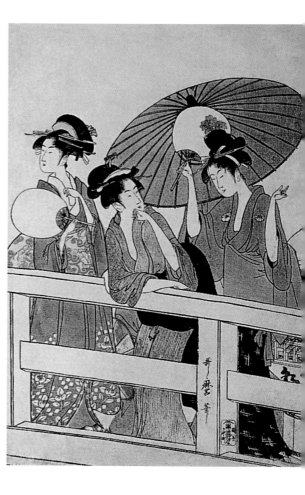

On Top of and Beneath Ryōgoku Bridge [top] (Ryōgokubashi no ue, shita),
c. 1795-1796.
Ōban triptych, nishiki-e, right sheet: 38 x 25.8 cm; centre sheet: 38 x 25.4 cm; left sheet: 38 x 25.3 cm.
The Art Institute of Chicago, Chicago.

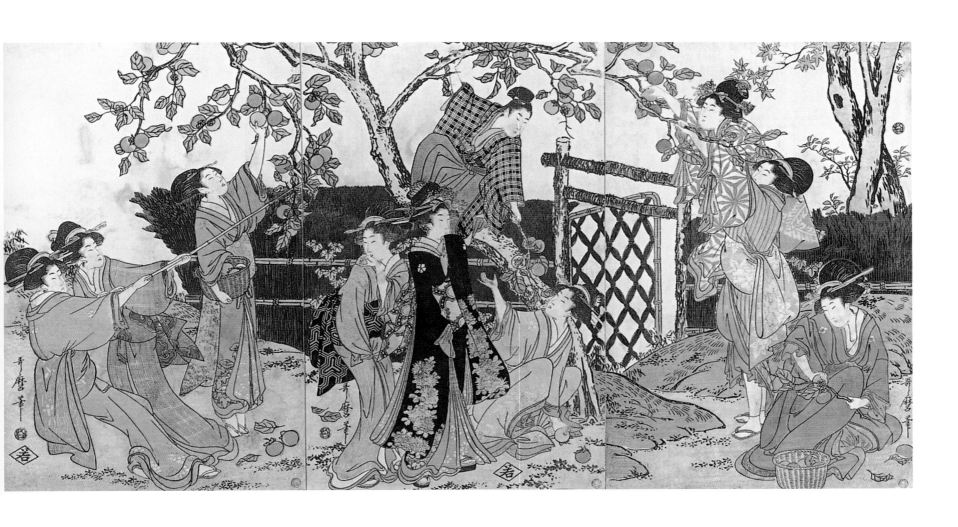

"Picking Persimmons" (Kaki-mogi),

c. 1803-1804.

Ōban triptych, nishiki-e, right sheet: 38.3 x 24.9 cm; centre sheet: 38.3 x 24.6 cm; left sheet: 38.3 x 24.7 cm.

The Metropolitan Museum of Art, New York.

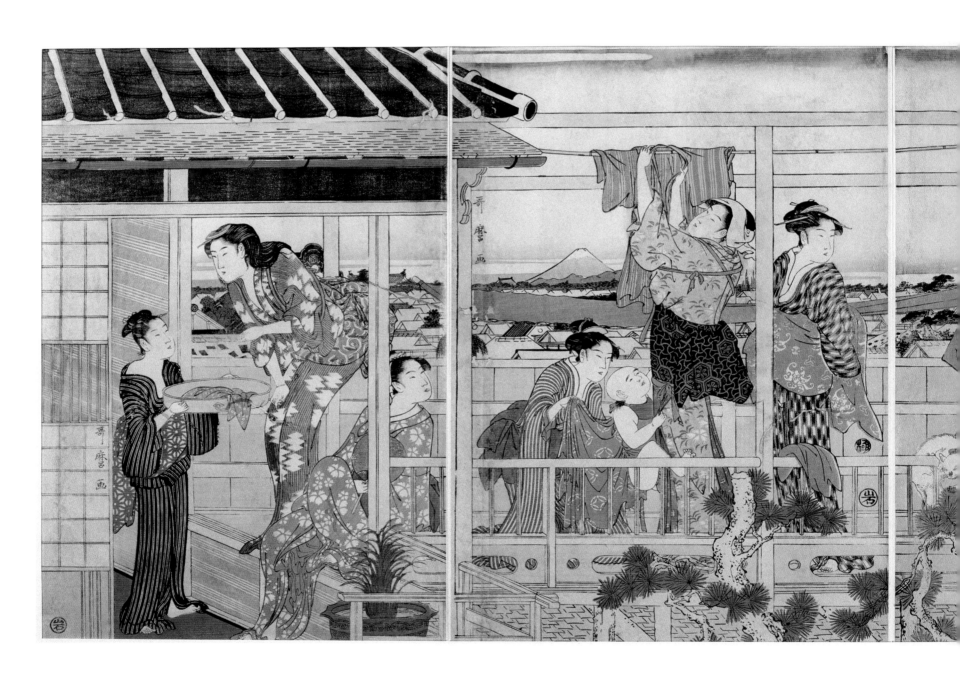

"Drying Clothes" (Monohoshi), c. 1790.
Ōban triptych, nishiki-e, right sheet: 36 x 25 cm; centre sheet: 36.8 x 25.8 cm; left sheet: 36.8 x 25.8 cm.
The Art Institute of Chicago, Chicago.

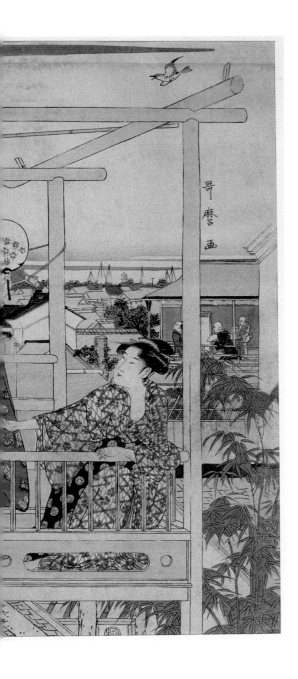

Drying Clothes (pp. 88-89):
An open gallery giving onto gardens, is full of women, one of whom is dressing a child, while a servant standing outside the door hands one of the women a basin and a red cotton towel to wash the child's face.

Women on the Beach:
On a beach at the edge of the sea, in the middle of which appears a little green island, women are walking, one leaning on a tall bamboo pole. To the right, a man is refastening his shoe; to the left, a woman is smoking in a *kago** which has been set on the ground. Sitting next to the little vehicle, another woman lights her tiny pipe.

Scoop-net (p. 90):
A scene on a boat, alongside which a fishing boat has been drawn. The fisherman's wife offers fish to the travellers occupying the cabin, on the roof of which lies the boatman, fanning himself with a large fan.

Woman Fishing:
A woman is fishing from a large boat being propelled by a boatwoman; she is accosted by a woman casting her fishing net from a smaller boat.

Little Girl in a Boat:
Scene on a boat, on which a naked girl is tying a cloth around her hair, getting ready to dive off the boat into the water where other children are already swimming.

The Children's Classroom:
This composition is inspired by the play entitled *Tenarai Kagami.*

Children playing War:
A little boy pretends to be a warhorse, another carries a flag, yet another brandished the ensign of a general: a cluster of little gourds on the end of a lance shaft hang down around a large gourd stuck straight on the end [of the lance] (probably taken from a tryptich).

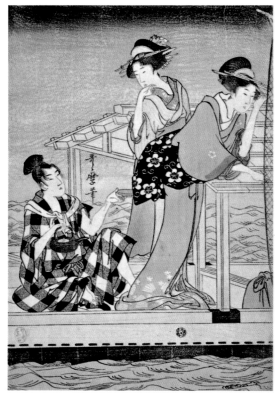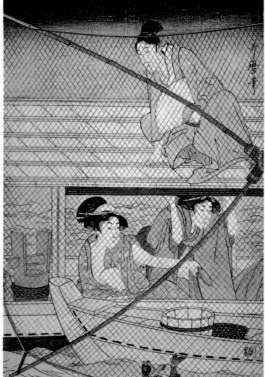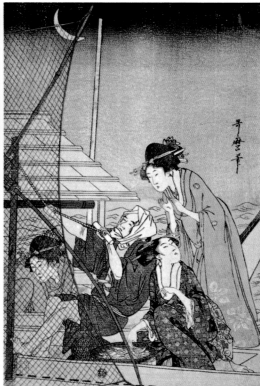

Kitchen Scene (p. 91):

In the only two printed panels that are known of this composition, a woman is blowing on the fire through a piece of bamboo, a second lifts a teapot from a stove, the boiling water making a cloud of steam, and another peels an aubergine. The third panel is lost.

Woman near a Stove:

A woman near a stove surrounded by flasks and bottles, is blowing glass out of the end of a bamboo pipe; another woman brings her a box full of small rods. Print probably taken from a triptych.

Making White Sake, Sake for Ladies, Mild, Barely-fermented Sake:

A rice press, from which the fermented rice is seen splashing out, is being tightened by enormous wooden arms that two women, pushing hard, are turning in the manner of a team of horses.

Idealised Factory:

The representation of a factory, somewhat idealised, since the manufacturing takes place in a palace where two women, acting in the role of a team of work horses, look quite like allegories dressed in the finest robes of the Empire of the Rising Sun.

Washing and stretching Cloth (p. 92):

A long strip of violet cloth stretched between two trees, is drying in the sun; one of the dyers is cleaning up, and a passer-by feels the cloth as she goes by. Above the cloth, a child who is held by his mother tries to kiss his sister, whose face appears purple through the cloth.

The Saltwater Carriers (Shiokumi):

The water carriers are picturesquely arranged with their curved rod that holds two buckets and their reed petticoats that look like big grass skirts. In the distance, on the other side

"*Scoop-Net*" (Yotsude-ami),
1800-1801.
Ōban triptych, nishiki-e, right sheet: 37.9 x 24.8 cm; centre sheet: 37.9 x 24.9 cm; left sheet: 37.8 x 25.2 cm.
The British Museum, London.

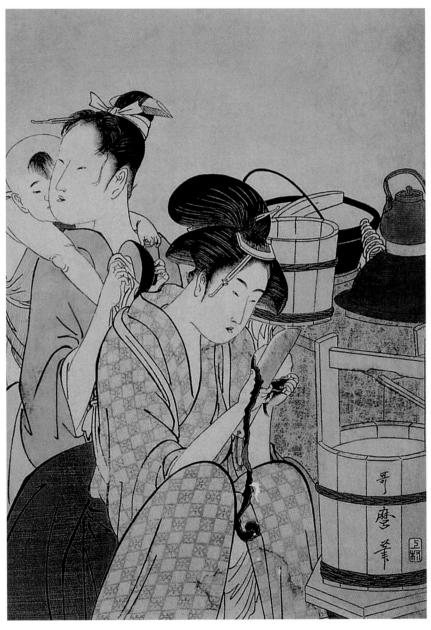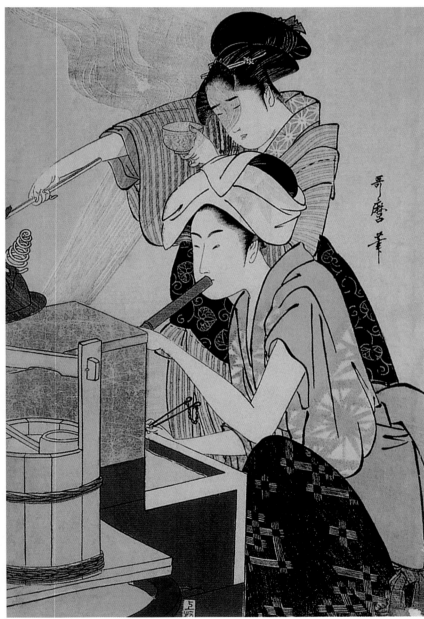

Kitchen Scene (Daidokoro),
1794-1795.
Ōban diptych, nishiki-e with metal fillings and mica, right sheet: 36.3 x 24.7 cm; left sheet: 36.3 x 25 cm.
Staatliche Museen, Preussischer Kulturbesitz, Museum für Asiatische Kunst, Berlin.

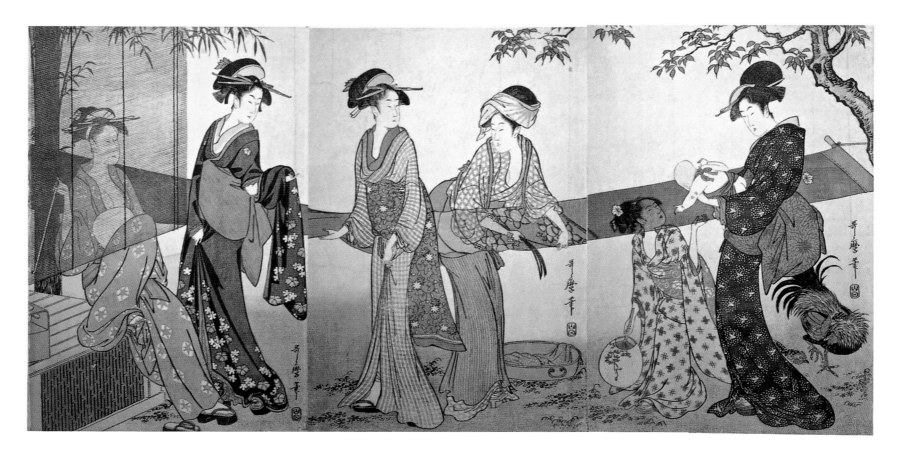

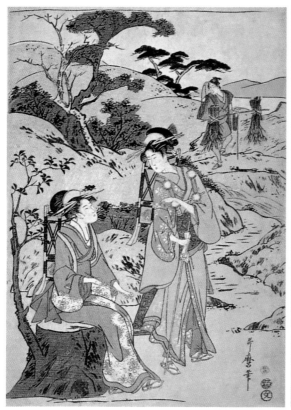
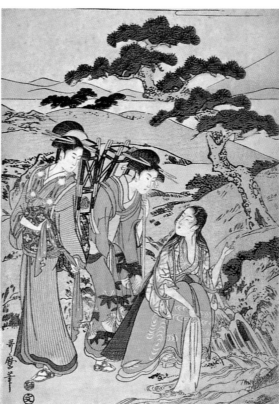
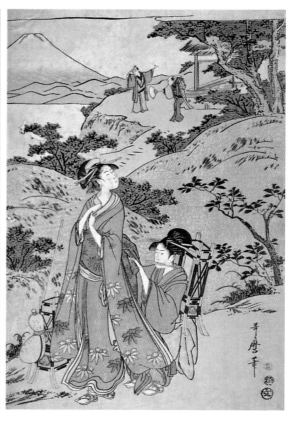

"Washing and Stretching Cloth" (Arai-bari), c. 1796-1797.
Ōban triptych, nishiki-e, 38.1 x 77.1 cm.
The New York Public Library, New York.

Parody of the Legend of Mount Oe (Mitate Ōeyama), c. 1795-1796.
Ōban triptych, nishiki-e, right sheet: 38.1 x 25.7 cm; centre sheet: 38.1 x 25.6 cm; left sheet: 38.2 x 25.7 cm.
Tokyo National Museum, Tokyo.

of the water, the roofs of the salt works where they are taking their seawater are visible.

Collecting Poetry:
One of the panels shows a woman copying a poem with a brush. The title of the composition is written on a large *makimono** at the top of the panel.

Interior with Recumbent Figure:
An interior where a woman is lying with her upper body raised, leaning on one hand in a graceful movement; a panel in which a long quotation from a poem is seen in a red frame running horizontally. (Panel which is presumed to have been taken from a triptych.)

The Snow, the Moon, the Flower:
In one compartment there is a woman who still has the brush in her hand with which she has just written down a poem, while nearby her friend is stretching gracefully, her hands turned backwards and her arms pulled tight along her sides. In another compartment, a woman is reading a letter which a servant has brought her.

Sake or *Those Who Have Drunk Too Much, Seven Different Types (of Drunkenness):*
Below a woman leaning on a cask surrounded by esparto ware, a representation of various types of drunkenness is shown: morose, talkative, dancing, hallucinating — playing music with a fan and a broom — and even bawdy drunkenness, represented by a skinny old man feeling the nipples of a fat, slovenly-looking woman in a third and rare panel, bringing the number of drunkards to eight instead of seven.

Women Bringing Casks of Sake:
Women bring casks of sake, while at the centre another a woman dances with her fan, and beneath, creatures with red hair, *shojo*, the genies of sake, are crouched like animals, lapping up huge bowls of the Japanese beverage.

Chinese Beauties at a Banquet (p. 95):
A celebration on a terrace overlooking a bay with a very jagged coastline. Near a tray of refreshments, a woman and a man face one another, playing a Japanese game in which they count on the fingers of both hands.

This is a very imaginative composition in the Chinese spirit, in which the colouring, restricted almost exclusively to the three hues of yellow, green, and violet, is the colouring of the green family porcelains.

Women Talking:
In a mountainous landscape several women are carrying small bamboo cases on their shoulders; one of them is chatting with a washerwoman at the edge of a stream. This is a composition which refers, under the veil of allegory, to the death of the terrible bandit, Shuten-doji of the Oyeyama, killed by Kintoki and his heroic friends, disguised as priests. Indeed, what these women are carrying on their backs are the cases in which those same priests carried Buddhas and other religious figures.

The Three Cups:
Allegorical composition showing *sennin*, men and women of long life.

Springtime Occupations:
This piece alludes to the seven gods of the Japanese Olympus. The Japanese Olympus is

made up of Benten, Bishamonten, Daikokuten, Ebisu, Fukurokuju, Hotei, Jurōjin, the seven *kamis**: Benten, the goddess of arts and manual dexterity, shown with a golden crown on her head and typically playing the *biwa**, the four-string mandolin; Bishamonten, the god and protector of soldiers, usually depicted in breastplate and helmet and holding in his left hand a small pagoda, said to contain the souls of the faithful, whose defence is his mission; Ebisu, the Father Bountiful of Japan, with his hundreds of fish, crabs, molluscs, edible seaweed, and his twenty-six species of mussels and shellfish, the god of the sea, the protector of fishermen, recognisable by his oversized *derrière* in chequered pants, his wide, clown-like laugh, and his fishing pole from which there hangs a *tay*, Japan's favourite fish; Daikokuten, the god of wealth, holding a gavel and sitting on a sack of rice; Fukurokuju, the god of longevity, an old man with a white beard, his forehead pointed and grown disproportionately high from his continuous meditation, leaning on a walking stick; Hotei, the god of childhood, carrying a cask on his back full of treats for the children who have been good, a figure often represented with eyes all around his head to look out for bad children; and finally Jurōjin, the god of prosperity, most often shown riding a stag, wearing a square headpiece, and unfurling a long roll, an edict of happiness for all.

The True Brush of Daikokuten:

One panel represents Daikokuten, who sits on a little table, painting his portrait on a *kakemono.** He is surrounded by women, one of whom kneels and rolls up a portrait of the deity, while standing over him is another elegant and charming woman about to hand him a sheet of paper so that when he has finished the one he is doing, he can begin another portrait for her.

Year of good Harvest:

A satirical composition showing the gods diverting themselves by acting in a play.

The Marriage of the Goddess Benten:

A caricature work depicting the marriage of the goddess as a figure with a big head, in the middle of six grotesque mannequins, representing the other six gods. All have a "womanish" laugh, a laugh which turns their faces into a *musume**, a figure representing the libidinously comical faces of certain small ivory masks.

The Gods of the Japanese Olympus:

On the right side of the print, a little girl pats the huge paper belly of a representation of Ebisu, while a young woman presents it with a brown pottery flask of sake which has his portrait moulded into it. On the opposite side, a Fuyorokuju, whose gigantic forehead is made of an amphora with a teapot on the top, a Fukorokuju cobbled together from bits and pieces by children, while in the centre, the goddess Benten is playing a *shamisen**.

A Gathering of Women in a large Pleasure Boat:

In this allegorical composition, various symbols on the boat, including its prow made from a gigantic sculpted and painted *Hōō** and the seven women who are on board, represent the seven gods and goddesses of the Japanese Olympus.

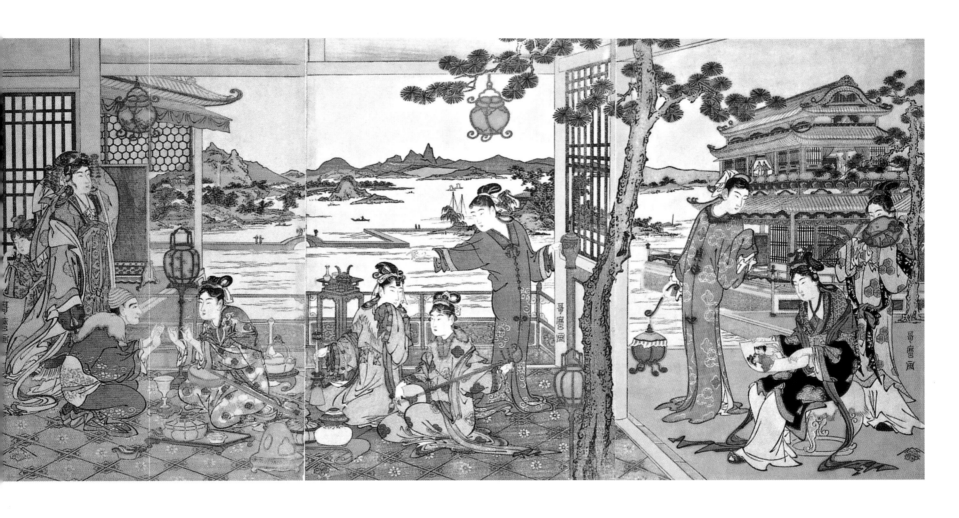

"Chinese Beauties at a Banquet" (Tō bijin yūen no zu),
c. 1788-1790.
Ōban triptych, nishiki-e, right sheet: 38.1 x 25.2 cm; centre sheet: 38.1 x 25.1 cm; left sheet: 38.1 x 25.3 cm.
The Art Institute of Chicago, Chicago.

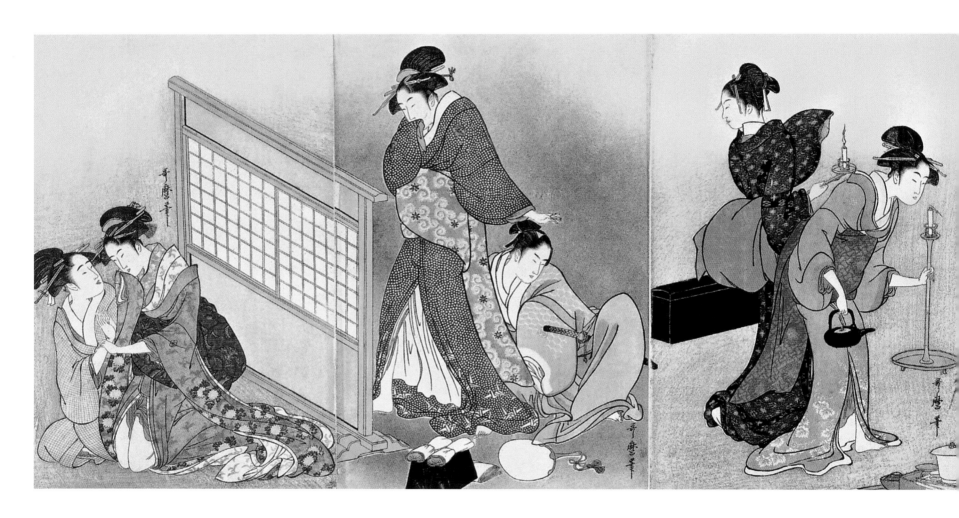

Double Pillow (Futatsu-makura),

1794-1795.

Ōban triptych, nishiki-e, 57.9 x 92.8 cm.

Musée national des Arts asiatiques – Guimet, Paris.

Women on a Boat:

A decorative boat with the prow ending in a dragon, full of women again representing the Olympus. They each carry the attribute of a god: one with Daikokuten's gavel in her hand, another Jurōjin's turtle, and one carrying a long bamboo pole over her shoulder, a screen and a message box, the attribute of a different god. This composition is similar to the last one but differs in its details.

Children on a Boat:

A boat with a hull ending in a head of *Hōō**, and containing a Japanese Olympus, shown as children representing Daikokuten, Bishamonten, etc. The boat, mounted on wheels, is being drawn by women, one of whom, crouching off to one side, is nursing an infant, a Hotei with breasts. This print, inspired by a large child's toy, is interesting because of its date: "New Year's Day, 1805". Utamaro died in 1806.

Modern Musicians:

One of the musicians is holding the ivory plectrum with which she is going to play.

The Anteroom of a Teahouse during the Niwaka:

With a courtesan and a Japanese man sitting in the rear of a room, a group of geishas, dressed as young boys with their hair cropped, is standing in the right foreground, while a *taikomochi** squats on the ground, wiping his forehead and chatting with the courtesan, having laid beside him his disguise, his trumpet and his Korean hat, a pointed green hat with feathers on the top.

Courtesans Gathered in the Main Room:

In the first proofs, the background is blank, whereas in the reprints, the background has been filled over the three panels by the large *Hōō**, which we see Utamaro painting in the final print of the second volume of the "Green Houses".

Grand Festival of the First Night:

Two courtesans in a corridor are looking into the large room where the celebration is going on; one woman is sitting on her heels in a chamber to one side, seeming to listen to the music.

Morning Parting at the Temporary Lodgings of the Pleasure Quarter (p. 101):

Goodbyes are being said by a woman to a man whose head and torso only are visible as he goes down the stairs. In the middle panel, one woman is chatting with a friend as she attempts to raise a male servant from the floor by prodding him in the back. In the right panel, a woman converses through a mosquito net with a man smoking his pipe; a tall, elegant woman, half hidden by a screen, is listening to their conversation.

Flower Boat:

A flower boat filled with women sitting in the cabin, while on the roof the boatman is smoking, his bare thigh and leg immodestly propped over the railing.

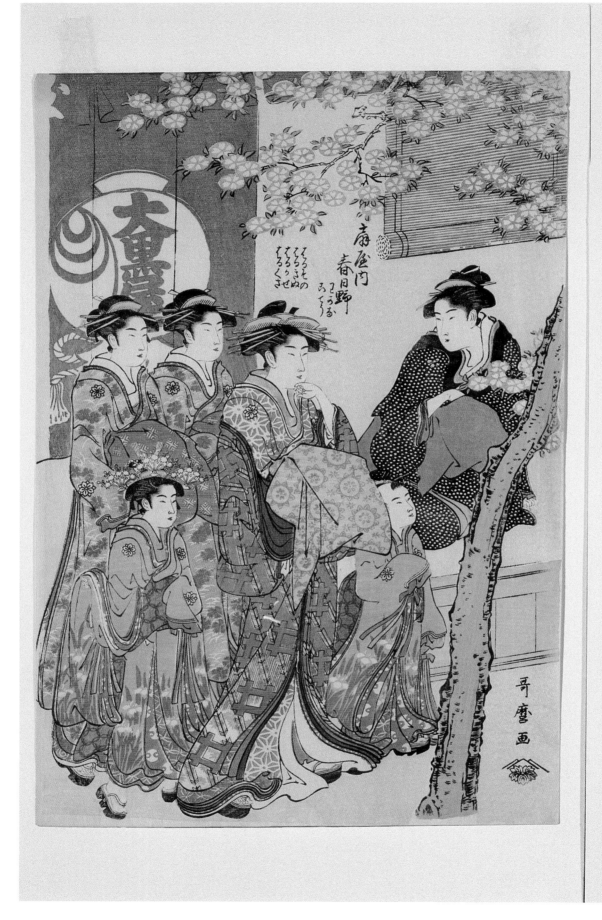

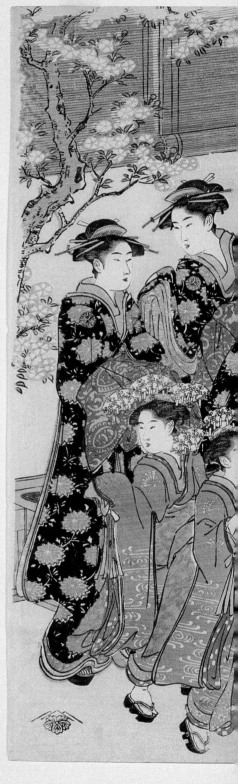

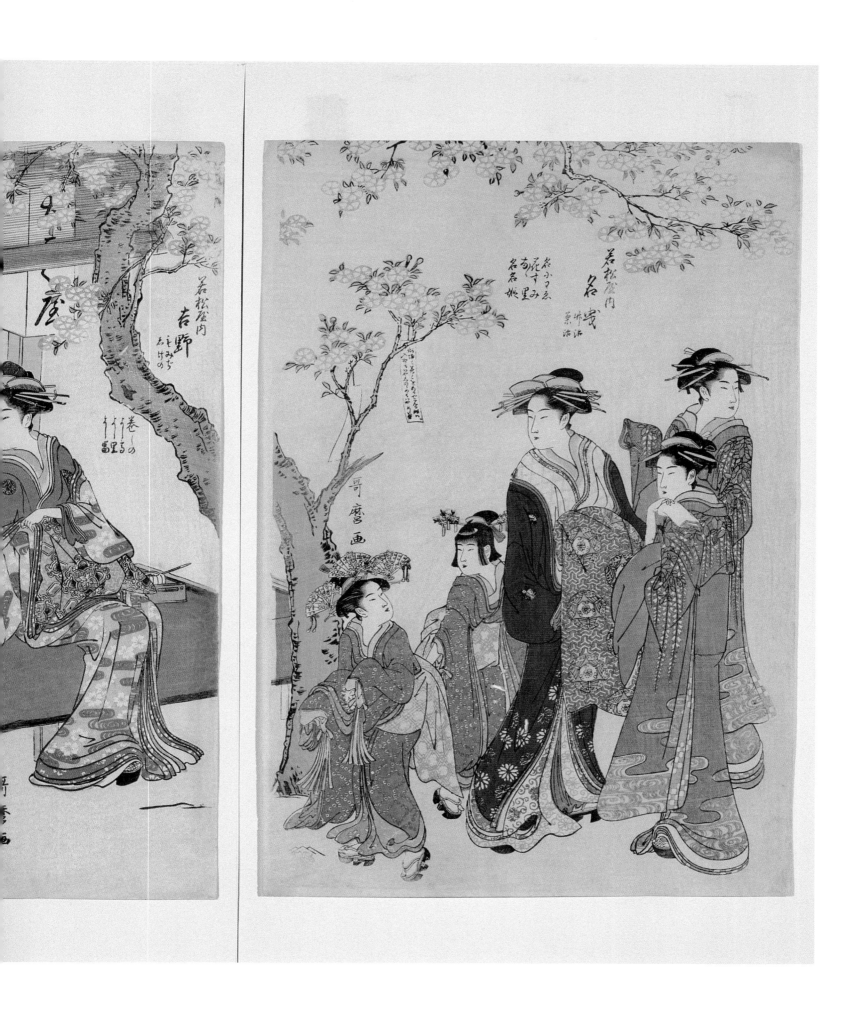

Courtesans Strolling under Cherry Trees in Front of the Daika, c. 1789.

Ōban triptych, nishiki-e, each sheet: 39.1 x 26.4 cm.

Brooklyn Museum of Art, New York.

Courtesans:

Seen from the waist up, two courtesans hold several dolls representing famous wrestlers of the day on lacquered trays. Each wrestler has his name written on his loin cloth: one is named Hiraishi, the other Raidu (triptych print or perhaps a series of three for an album).

Complete Illustrations of Yoshiwara Parodies of Kabuki (p. 102):

In the garden of a "green house" a woman has brought a black lacquered tray on which, for the amusement of the courtesans, a large doll is holding an open parasol, a slightly satirical representation of a well-known actor.

Courtesans beneath a Wisteria Arbour (p. 103):

Women of a "green house" are preparing illuminations: some put lights in red lanterns, others are hanging them from a trellis covered with wisteria in bloom.

Pleasure-boating on the Sumida River (p. 104):

Near a bridge lit with lanterns, the river is covered with boats carrying women, one of whom in the foreground, is leaning over the water, washing a red lacquered sake bowl.

Also worthy of mention are: *Preparations for a New Year's Day Celebration*; *Portraits of Famous Beautiful Women of Today (Respectable Women)*; a composition printed on a yellow background; *Three Ways to Teach Children to Read*; *Three Women Compared to Three Philosophers*; *Three Poets (represented by women)*; *Modern Girls with a Good Future.*

One- or two-panel *Nishiki-e**

The Three Natures:

One panel represents three faces of women: laughing, crying, angry. These women, no doubt a little tipsy on sake, illustrate the Japanese proverb which says "When one has drunk, one's true nature comes out." We see one woman squatting on her heels, making a monkey dance on top of a screen as two children watch. Writing in red, scattered over the picture, informs us that according to a local superstition this dance keeps smallpox out of the houses. (Single panel, which could also be part of a series which was not finished, or a separate print.)

Pair of Courtesans:

(Composition made up of two panels).

2. Albums (series of prints in colour)

After his large compositions, Utamaro composed several series of colour prints for albums, of six, seven, ten, twelve, twenty, or even more plates. Some appeared at the same

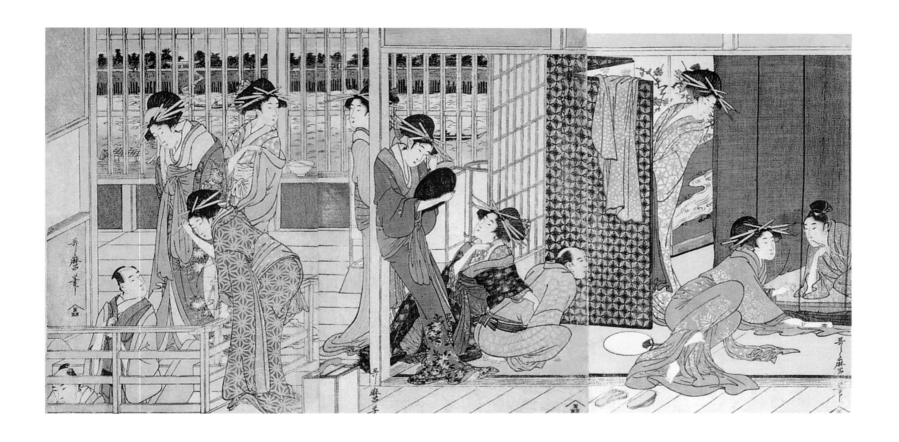

Morning Parting at the Temporary Lodgings of the Pleasure Quarter (Karitaku no kinuginu),
c. 1801.
Ōban triptych, nishiki-e, right sheet: 37.3 x 24.3 cm; centre sheet: 37.9 x 24.9 cm; left sheet: 37.5 x 23.2 cm.
Honolulu Academy of Arts, Honolulu.

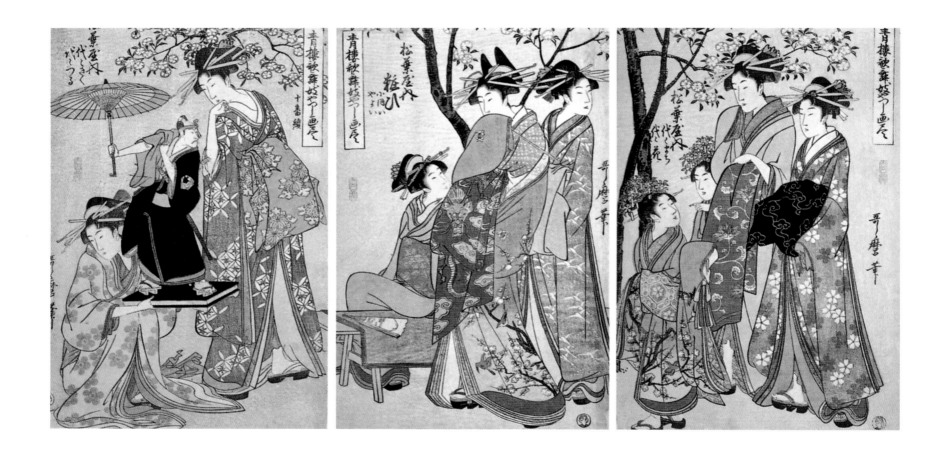

"Complete Illustrations of Yoshiwara Parodies of Kabuki" (Seriō kabuki yatsushi e-zukushi, jūban-tsuzuki), 1798.
Ōban triptych, nishiki-e, right sheet: 35.8 x 24.2 cm; centre sheet: 35.9 x 23.7 cm; left sheet: 36 x 24.4 cm.
The British Museum, London.

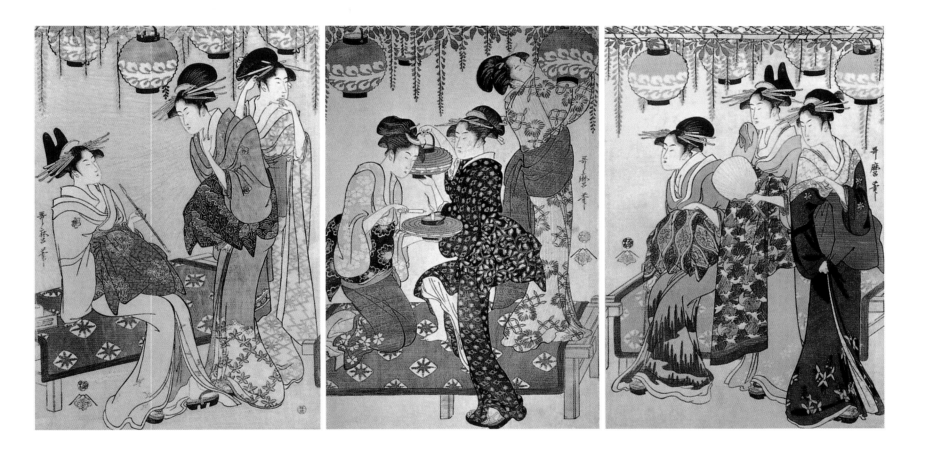

"Courtesans beneath a Wisteria Arbour" (Fuji-dana shita no yūjo-tachi), c. 1795.
Ōban triptych, nishiki-e, right sheet: 38.6 x 25.9 cm; centre sheet: 36.6 x 23.9 cm; left sheet: 37.4 x 25.8 cm.
The Metropolitan Museum of Art, New York (right and left sheets) and Honolulu Academy of Arts, Honolulu (centre sheet).

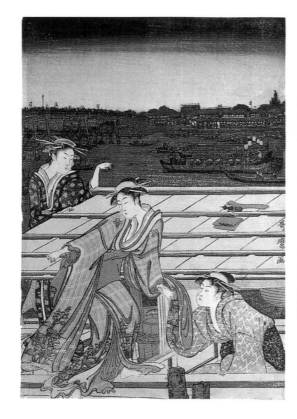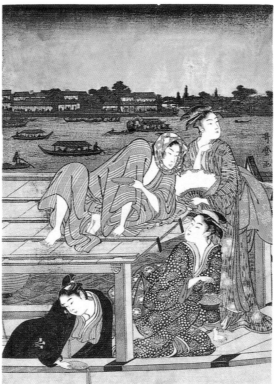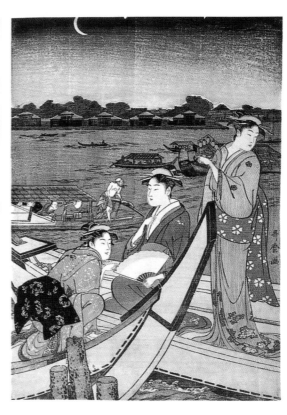

"Pleasure-Boating on the Sumida River" (Sumidagawa funa-asobi),

c. 1788-1790.

Ōban triptych, nishiki-e, right sheet: 36.9 x 25.2 cm; centre sheet: 37 x 25.4 cm; left sheet: 37.1 x 24.6 cm.

The Art Institute of Chicago, Chicago.

time as the large works, but most were produced later. There are all *nishiki-e** made up of several sheets.

In these series, to a greater degree perhaps than in the large works, the Japanese woman appears in the business of her daily occupations around the house and gardens. She is seen gilding her lips; shaving the fuzz from her face with a typical Japanese razor, using both hands to put the knot in her waistband which is worn behind when she is a respectable woman, and in front when she is a courtesan, and while doing so, oftentimes holding some illustrated novel between her chin and neck; folding silk, a corner of the silk in her mouth, which she loves; arranging irises in a basket; bathing a bird; smoking a tiny pipe of chased silver; putting on ivory fingernails to pluck the *koto**; painting a *kakemono** or a *makimono**; writing poetry on paper strips which she will hang on the first cherry trees in blossom; shooting with a bow in a room with arrows stuck by their points near at hand; playing at hiding her face behind a mask of Okame, with its big cheeks and hearty laugh.

This is not just a simple record on paper with an inspired brush stroke, of the woman at her work; it is, in its ultimate reality, the restitution taken from life of movements, poses, and the familiar gestures of the activity depicted, and the catching of specific expressions which define a whole people, a whole epoch. Here we see the Japanese woman in all the intimate movements of her body: lost in thought, when she leans her face against the back of her hand; listening, when kneeling, with her palms pressed against her thighs, she shows, with her face tilted to one side, the charmingly fleeting aspects of a lost profile; contemplating, as she lies looking lovingly at flowers; leaning back, as she alights softly, half seated on the railing of a balcony; reading, with a book held close to her eyes and both elbows leaning on her knees; primping, as she holds a small metal mirror in one hand while with the other she absently pats the back of her neck, which we can see in her mirror; cradling a bowl of sake in her hand; delicately touching with her shrivelled, simian fingers the lacquerware, porcelain, and small *objets d'art* of her native land, and

finally the woman of the Empire of the Rising Sun in all her languid grace, crawling coquettishly on floor mats.

As one looks through these thousands of images, these women come alive in their reverie which lends them such charming poses behind the *shōji**; this girl sitting in front of a house, leaning back on her spread hands, one leg raised on the trunk she is using as a seat, the other hanging down, her shoe having fallen off; this pretty musician, followed by her *shamisen** carrier, walking towards the house where she is to play her music, walking with a kind of frightened grace, in this black night, under a sky with stars which resemble falling snow; these two girls stretched out full length on the floor, elbows planted, opposite hands clasped, trying to see who can push the other friend's hand down; these two little girls telling each other secrets, one arm over each other's shoulder and their two free hands joined in front of them in a gesture of prayer.

We admire this parade of elegant women, with their upper bodies amply draped, their dresses

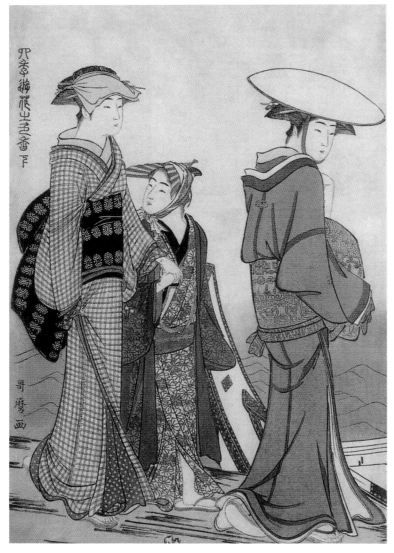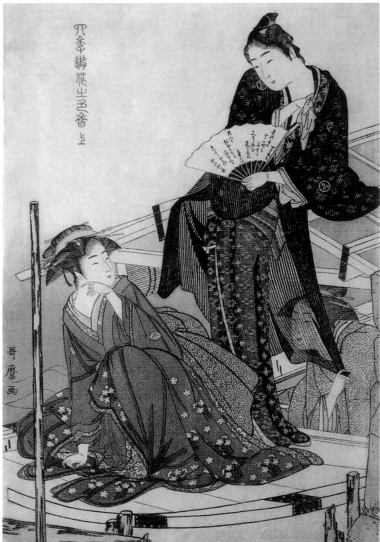

"Pleasures of the Four Seasons, Colours and Perfumes of the Flowers [left and right]" (Shiki [no] asobi hana no iroka, jō, ge),
c. 1783.
Ōban diptych, nishiki-e, right sheet: 37 x 24.7 cm; left sheet: 37 x 24.5 cm.
The British Museum, London.

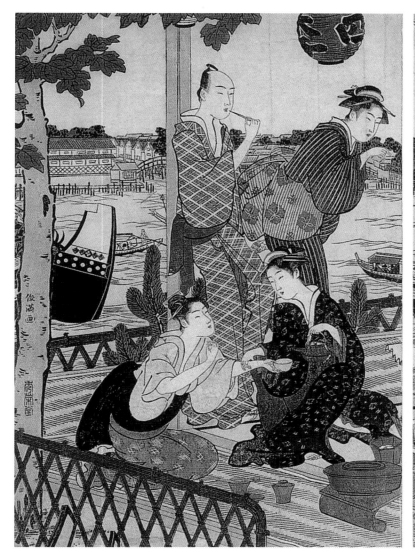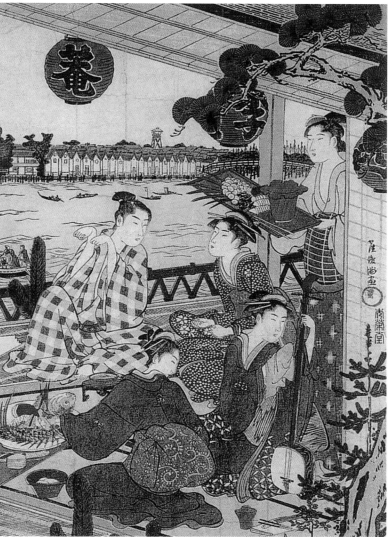

"The Restaurant Shikian",
c. 1787-1788.
Ôban diptych, nishiki-e, 36.3 x 25.3 cm.
The British Museum, London.

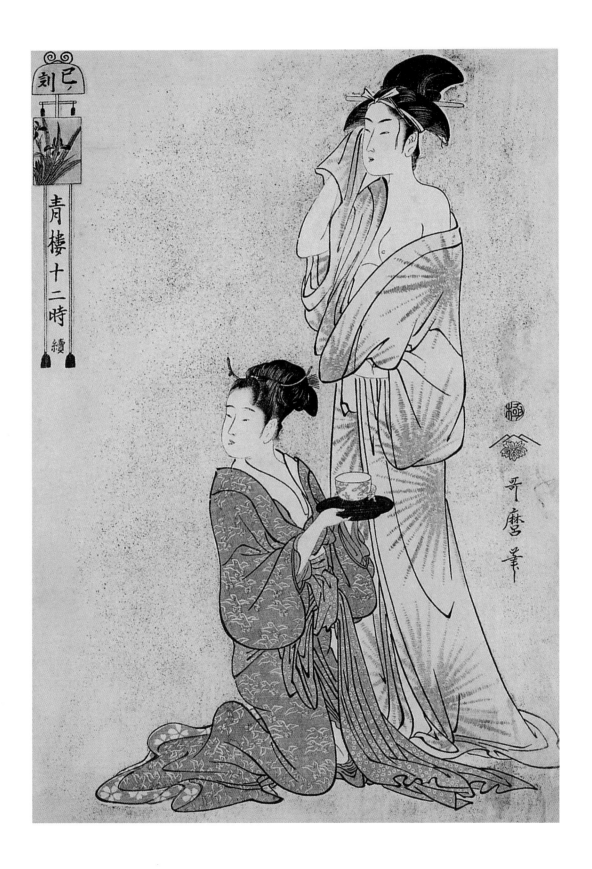

wrapped around their waists and thighs so tightly that it gives them the "curvature of a sabre", these dresses which flare at the floor, spreading and turning around their feet in wavelets and liquid undulations.

The Twelve Hours in Yoshiwara (pp. 108, 109, 110, 113, 192):

This series is the most visually appealing. The twelve-hour day of Japan corresponds to twenty-four hours in Europe: the hour of the mouse, which is midnight; the hour of the bull, which is two o'clock a.m.; the hour of the tiger, four a.m.; the hour of the rabbit, which is six a.m.; the hour of the dragon, which is eight a.m.; the hour of the serpent, which is 10 a.m.; the hour of the horse, noon; the hour of the sheep, which is two p.m.; the time of the monkey, which is four p.m.; the hour of the rooster, which is six p.m.; the hour of the dog, which is eight p.m.; the hour of the wild boar, which is ten p.m. Utamaro has symbolised these twelve Japanese hours through elegant poses and charming groups of women.

"Hour of the Snake [10 am]" (Mi no koku), from the series
"The Twelve Hours in Yoshiwara" (Seirō jūni toki tsuzuki),
c. 1793-1794.
Ōban, nishiki-e with metal fillings, 37.7 x 24.8 cm.
The Art Institute of Chicago, Chicago.

"Hour of the Cock [6 pm]" (Tori no koku), from the series
"The Twelve Hours in Yoshiwara" (Seirō jūni toki tsuzuki),
c. 1794.
Ōban, nishiki-e, 38.3 x 25.5 cm.
Honolulu Academy of Arts, Honolulu.

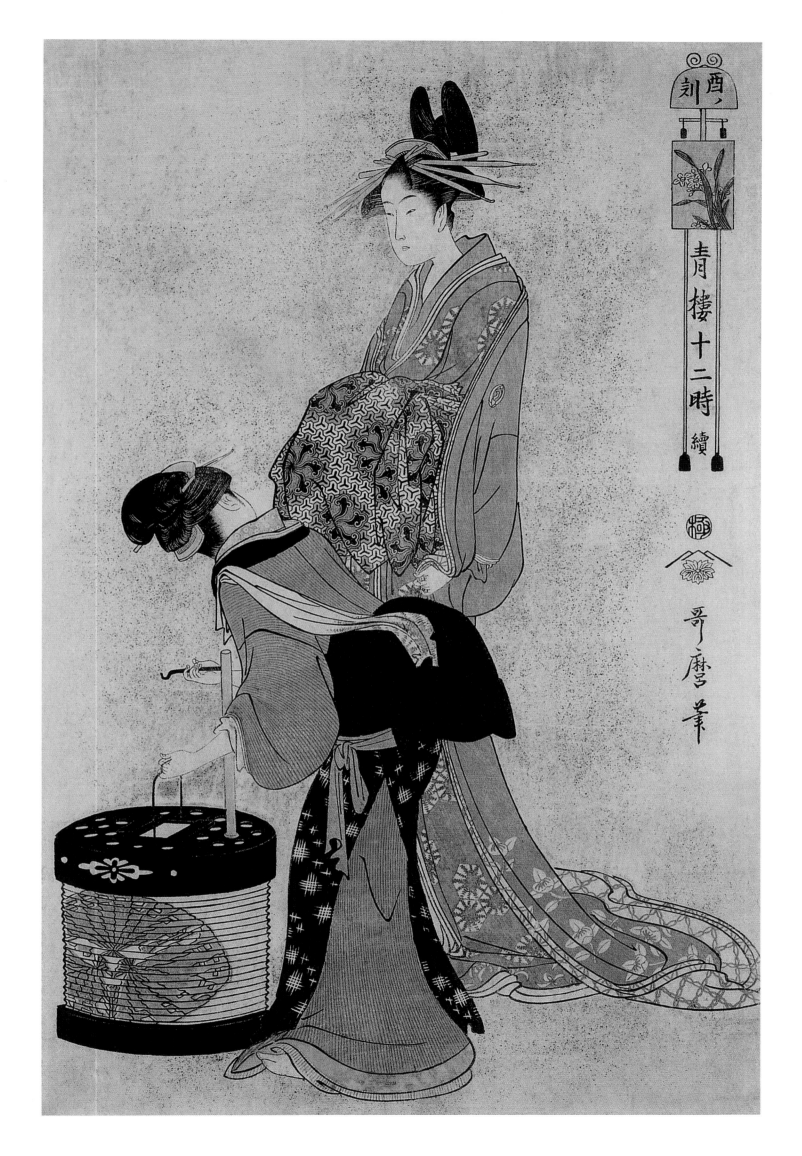

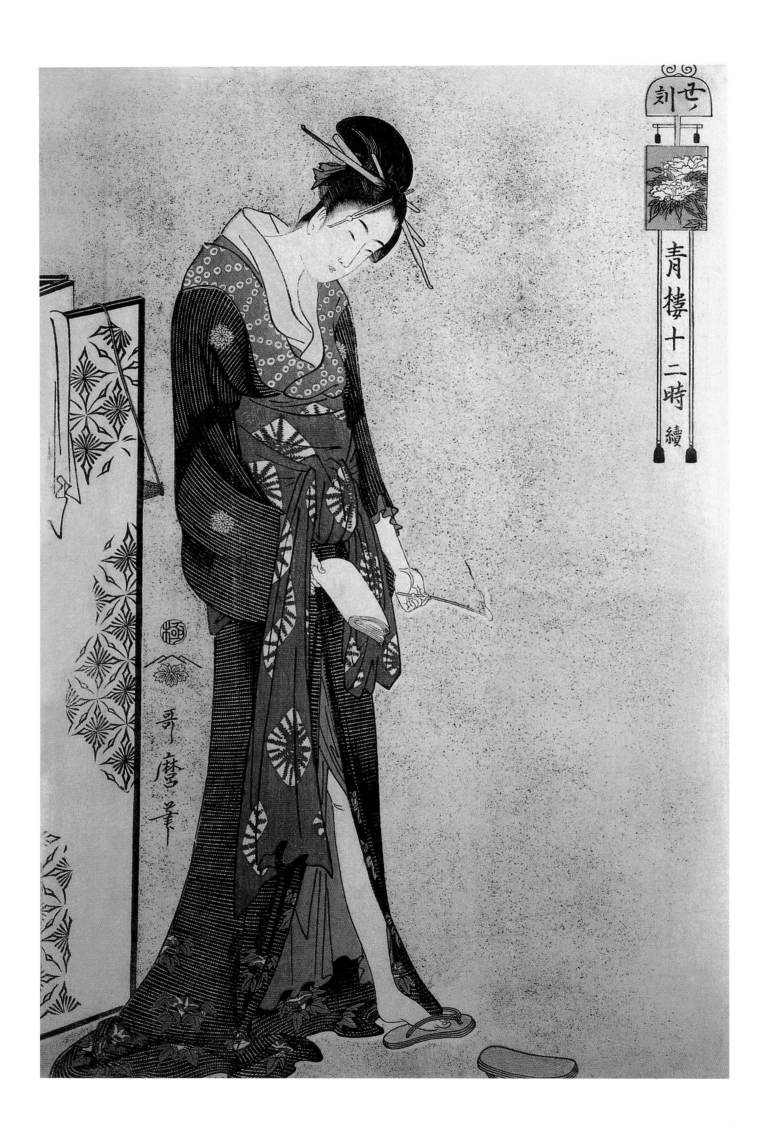

Never did Utamaro have a more delicate linearity to his women than in this series. Here is woman in her graceful movements, those beautiful eastern dresses, clothed in the glowing colours of the anemone, painted with a refined taste in clothing and a personalised selection of silks, in soft and shimmering colours. Pinks of such a delicacy that they seem to appear through a gauze, mauves blending so prettily into a dove grey, greens, like the green shade of water, blues coloured only with that hint as in a linen washed in bluing, and a whole range of indescribable greys, greys which seem tinted with distant, very distant, reflections of bright colours.

Indeed the Japanese woman has a taste for colours which are most refined, most artistic, and the farthest removed imaginable from the European taste for bold colours. The whites that the Japanese woman wants on the silk that she wears are "eggplant white" (greenish white) and "fish-belly white" (silver white). The pinks are "rosy snow" (pale pink) and "peach blossom snow" (light pink). The blues are "bluish snow" (light blue), "sky black" (dark blue), and "peach blossom moon" (blue pink). The yellows are the colour of honey (light yellow), etc. The reds are jujube red, "smoking flame" (brownish red), and "ashes of silver" (ash red). The greens are tea green, crab green, shrimp green, the "heart of onion" green" (yellowish green), and "lotus shoot green" (light yellowish green), all of them ambiguous and enchanting for the eye of the colourist, with lovely hues that we in Europe would consider impure.

The trousseau of a Japanese bride with any fortune at all includes twelve ceremonial dresses: a blue dress embroidered with sprigs of jasmine and bamboo for the first month; a sea green dress with checks and cherry blossoms for the second month; a red dress scattered with willow branches for the third month; a grey dress on which the cuckoo, the bird of conjugal good fortune, is painted or embroidered for the fourth month; a drab yellow dress, covered with iris leaves and aquatic plants for the fifth month; an orange dress on which watermelons are embroidered for the sixth month when the rains and the ripening of these melons begin; a white dress dotted with *kunotis*, bell-shaped crimson flowers, the medical and edible roots of which are considered by gourmets to be like salangane swallow nests, for the seventh month; a red dress scattered with mimosa or Japanese plum leaves for the eighth month; a violet dress decorated with flowers of the mayweed for the ninth month; an olive dress scattered with representations of harvested fields crossed by paths for the tenth month; a black dress embroidered with characters alluding to ice for the eleventh month; a crimson dress covered with ideographical symbols referring to the harshness of winter for the twelfth month. If, then, there are these twelve dresses, one for each month, in the trousseau of a wealthy Japanese bride, what else could a grand courtesan wear but the luxurious and original dresses painted by Utamaro for a wardrobe of the *Yoshiwara**?

Utamaro painted violet dresses, blending to pink at the bottom, where birds run along the branches of trees in bloom, violet dresses, across which, woven in white, zigzag the insect characters of the Japanese alphabet, violet dresses, across which the wild lions of Korea charge, in colours of old bronze;

"Hour of the Ox [2 am]" (Ushi no koku), from the series *"The Twelve Hours in Yoshiwara"* (Seirō jūni toki tsuzuki),
c. 1794.
Ōban, nishiki-e, 36.6 x 24 cm.
Musées Royaux d'Art et d'Histoire, Brussels.

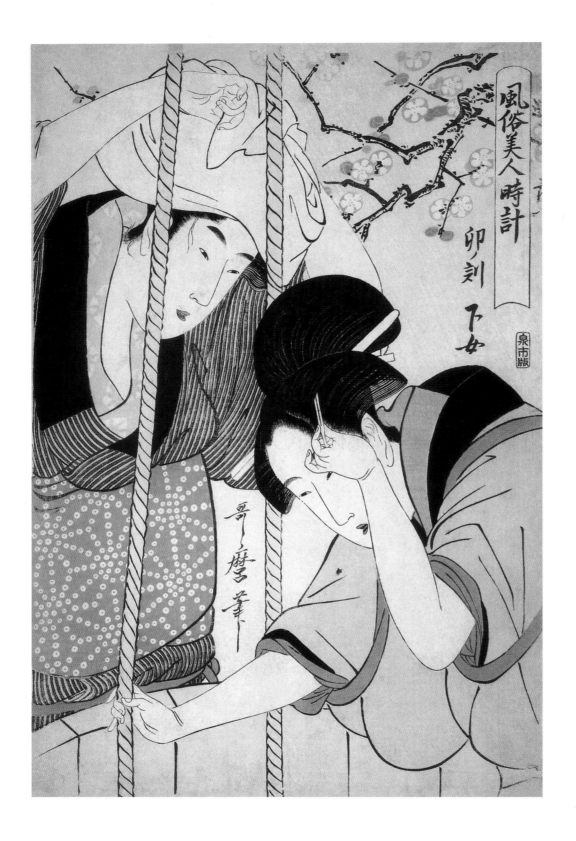

mauve dresses, in a slightly ochred tone, bedecked with white irises on their green stems; blue dresses, in that fresh blue which the Chinese named "blue of the sky after the rain", under wide, pale-pink peonies; grey dresses, overrun with twigs and tendrils of whitish bushes, which give them the appearance of dresses painted in *grisaille*; pea-green dresses embellished with pink cherry blossoms; green dresses in the green of clear water flowing beneath pawlonia flowers, which are the arms of the ruling family; flowers with violet stems and three wide white petals; crimson dresses, crossed by waterways, with processions of mandarin ducks running around the hem; dresses of a tawny brown with clusters of wisteria dangling over them; black dresses, which make such a splendid counterpoint in this display of colourful dresses, black dresses abloom with spiked caladium leaves covered with snow; black dresses where *tay* roses, in woven baskets, are interspersed among screens and symbolic sceptres of power; dresses, dresses, and more dresses, where there are flights of heraldic cranes, trellises

"Hour of the Hare [6 am], Servant Women" (U no koku, gejo), from the series *"Customs of Beauties Around the Clock"* (Fūzoku bijin tokei),
c. 1798-1799.
Ōban, nishiki-e, 39.1 x 25.5 cm.
Tokyo National Museum, Tokyo.

"Hour of the Dog [8 pm]" (Inu no koku), from the series *"The Twelve Hours in Yoshiwara"* (Seirō jūni toki tsuzuki),
c. 1794.
Ōban, nishiki-e, 36.4 x 24 cm.
Staatliche Museen, Preussischer Kulturbesitz, Museum für Asiatische Kunst, Berlin.

imitating cages where birds flutter, Grecian keys mixed with fans, heads of Dharma drawn in Indian ink, little tufts of crosshatching, the sort of dress favoured in Utamaro's drawings and one which he used for the portraits of the women he loved: indeed, all those things and those beings from nature, living and inanimate, and which earn these costumes the right to be called picture-dresses.

Nor should we forget the pretty light dresses on which there are reproductions of those ubiquitous starfish, painted in all colours; those dresses with white backgrounds streaked with vague and ill-defined bands of pink which the Japanese use on lacquer ware and fabrics, the crimson clouds at sunset; that other one where flocks of azure-tinted birds fly. On his coloured dresses Utamaro put sashes with muted tones, very often green, with designs in an old gold yellow, the hues of which are related to old, faded fabrics and which sometimes tend towards a certain green, known in Japan as *Yama bato iro*, the colour of mountain doves and which historically only the mikado had the right to wear.

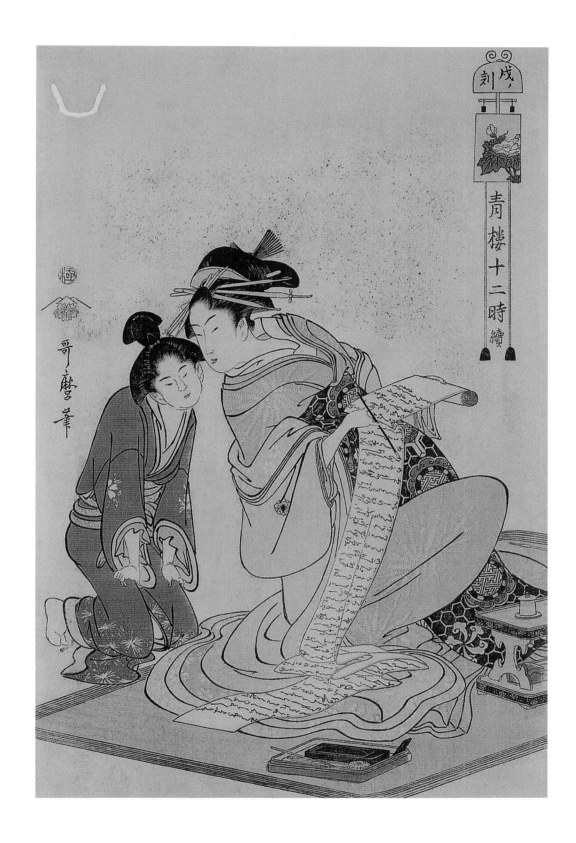

"Blackening the Teeth" (Kane-tsuke), from the series
"Ten Types in the Physiognomic Study of Women"
(Fūjin sōgaku juttai),
c. 1802-1803.
Ōban, nishiki-e, 37.1 x 25.4 cm.
Hiraki Ukiyo-e Museum.

The Interesting Type (Omoshiroki sō), from the series
"Ten Types in the Physiognomic Study of Women"
(Fūjin sōgaku juttai),
1792-1793.
Ōban, nishiki-e, 37.2 x 24.8 cm.
Musée national des Arts asiatiques – Guimet, Paris.

113

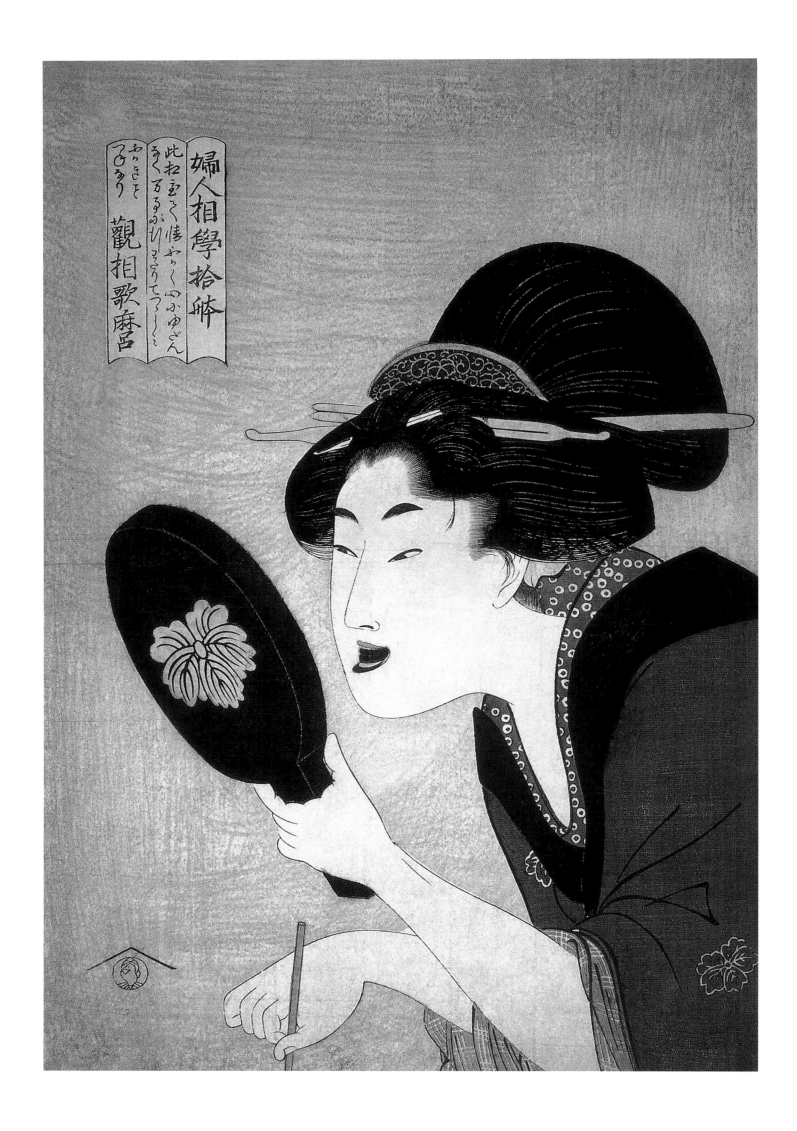

114

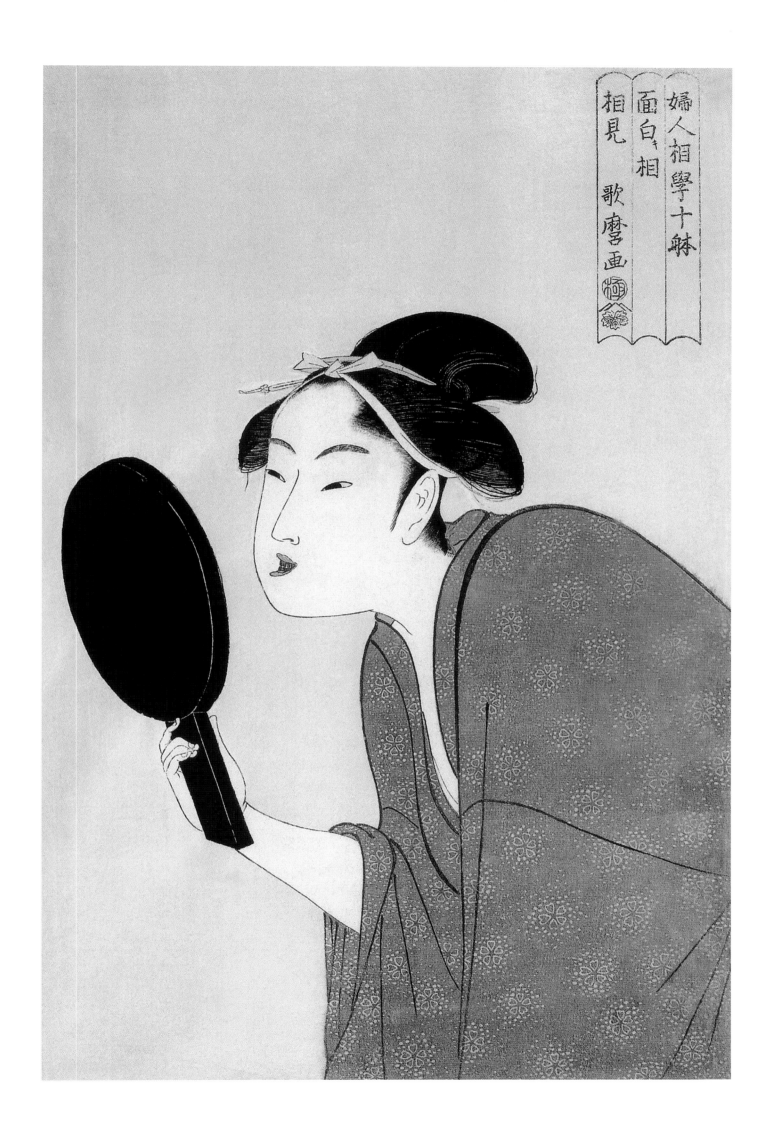

婦人相學十躰
面白相
相見　歌麿画

115

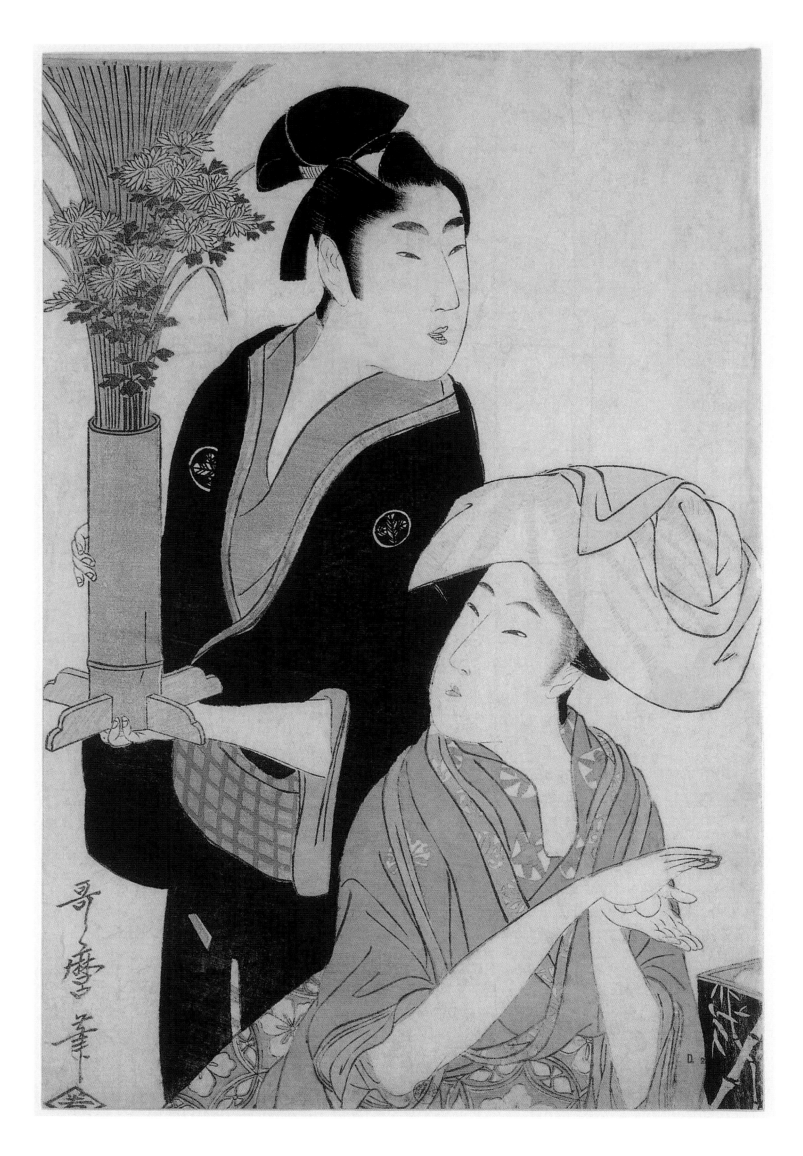

When Utamaro was called upon to make luxurious costumes, his perfect sense of fashion led him to take particular care and artistry in avoiding the flashy and the gaudy in this country where bright colours in clothes were reserved for children. When he decorated a dark-coloured dress with butterflies, instead of brightly coloured butterflies, he put tawny or ochre butterflies on it, to harmonise with the background. When he decorated it with peonies, he never chose them in a single colour and softened their whiteness with a crimson tint; and, when he decorated it with arabesques, he found a way to neutralise the bombastic quality of the decoration by using a sombre tone for the arabesques against a neutral ground. He achieved his favourite motifs on dresses, again with restraint in ornamentation, with a few flower blossoms, looking like petals carried back in a fold of a sleeve, or on a shoulder, from a stroll under trees in bloom.

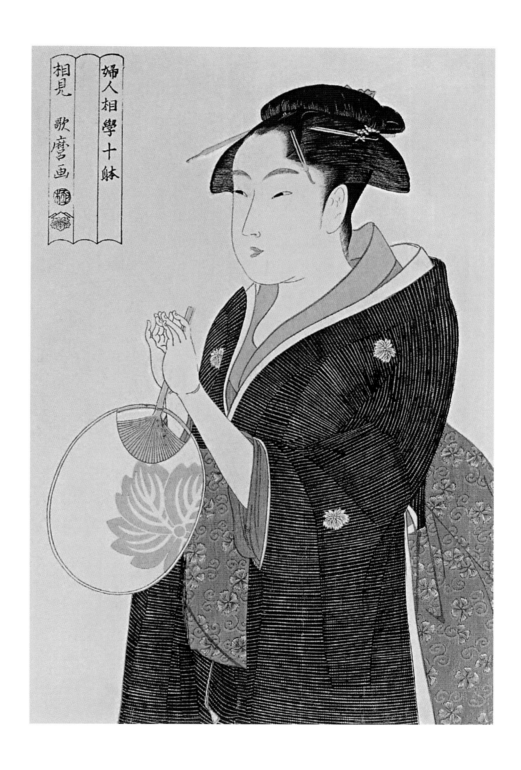

Couple with a Vase of Bamboo.
Ōban, nishiki-e, 36.8 x 24.5 cm.
Bibliothèque nationale de France, Paris.

Woman Holding a Round Fan (Uchiwa o motsu onna),
from the series *"Ten Types in the Physiognomic Study of Women"* (Fūjin sōgaku juttai),
1792-1793.
Ōban, nishiki-e, 35.5 x 24.2 cm.
Musée national des Arts asiatiques – Guimet, Paris.

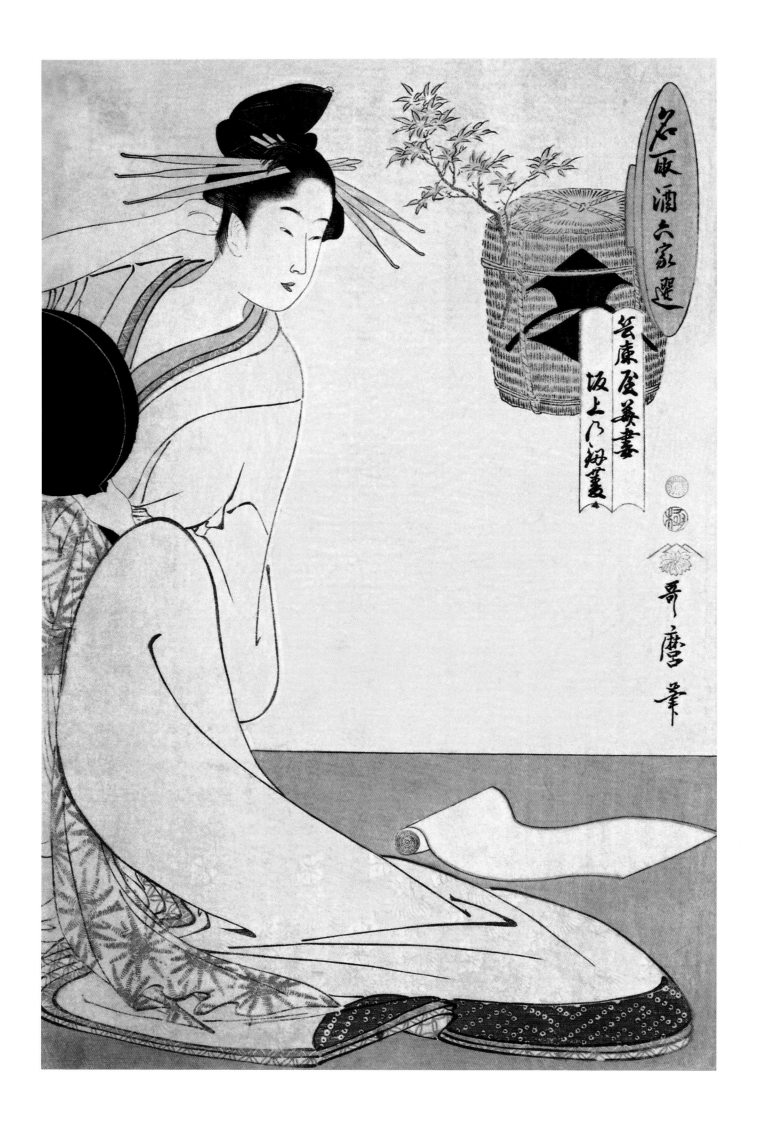

The Peers of Saké Likened to Select Denizens of Six Houses (pp. 118, 119):

Next to *The Twelve Hours in Yoshiwara* (pp. 108, 109, 110, 113, 192), which have nothing specifically to do with the "green houses" and show twelve poses by courtesans in the morning, evening, daytime and night-time, the series of *The Peers of Saké* is one of the most perfect. It is a very original series, each page of which includes, in the upper portion, a cask of sake in its woven casing, on which the sign of the maker is boldly stamped in black, framed on the left by a branch of flowering shrub and on the right by a red lacquered bowl bearing an inscription. Below, rather in the manner of our heraldic figures supporting an escutcheon in a kneeling or crouching position, is a *Yoshiwara** beauty from the year 1790. These six women, with their soft colourings, stand out against a yellow background above a crimson mat. In no other country do there exist prints of such a deliciously languid harmony, in which the colourings seem to be made of what is left of colour in the glass of water in which a brush was rinsed. These colourings are not really as much colours as they are clouds which remind us of these colours.

"Hanazuma of the Hyōgoya, Kembishi of the Sakagami" (Hyōgoya Hanazuma, Sakagami no Kembishi), from the series *"The Peers of Sake Likened to Select Denizens of Six Houses"* (Natori-zake rokkasen),
c. 1794.
Ōban, nishiki-e, 37.4 x 24.1 cm.
The Metropolitan Museum of Art, New York.

"Shizuka of the Tamaya, Yōmeishu of Mangan-ji" (Tamaya uchi Shizuka, Manganji Yōmeishu), from the series *"The Peers of Sake Likened to Select Denizens of Six Houses"* (Natori-zake rokkasen),
1794.
Ōban, nishiki-e, 54 x 41.5 cm.
Musée national des Arts asiatiques – Guimet, Paris.

Utamaro is not only regarded in Japan as the founder of the school of life painting. He is not only considered to be an admirable painter of birds, fish, and insects. He is admired as one of the great masters of painting of Springtime scenes, painting which, in Japan, signifies not only the painting of the renewal of nature, but what we in Europe would call "light" painting. There is a rare album, dated 1790, entitled *Foughen-zō*, meaning "walks during cherry blossom time", which gives an idea of this kind of painting, where pretty strolling ladies are set amidst the blossoms of flowering trees in the province of Yoshinoyama. Related to this series are the albums *The Young God Ebisu* (pp. 200-201), *The Silver World* (pp. 217, 218, 221, 222, 225) and *Moon-mad Monk or Crazy Gazing at the Moon* (pp. 246-247, 249, 250-251).

In Utamaro's work there are many compositions in which the artist's imagination shows great cleverness. One can, for example, cite the series of *The Four Sleepers*. Here is an interesting series in which the small vignette in the upper right of the print, acting as the trademark for the series, imitates the ink drawing by an old master being interpreted and caricatured by Utamaro in his colour print. Thus, in one of the prints, the vignette represents a priest sleeping with two children lying at his feet and, behind him, a tiger, while Utamaro's composition represents a woman sleeping with two drowsy children at her feet, and a cat behind her (series composed of three prints). In this series Utamaro uses the small image in the background to replicate an old master drawing, which he cleverly parodies in the main scene of his composition, the kind of scene which is not unlike the scenes from ancient history, interpreted by the powerfully burlesque pencil of Daumier.

One may also cite that series in which Utamaro, unlike Grandville giving human silhouettes to animals, gave humans a disturbing similarity with certain animals, based on his extensive study of animals and through approximation and distortion. Finally, one may cite that very different series, in which at the head of each scene is a pair of eyeglasses with one lens saying "Parents' Wishes" and the other "Teachings", of which the true translation is "Advice from Parents" and which seems to be a series of minor events from private life, done as though under the authority of those elder eyes and with the intention of pleasing and delighting.

At times Utamaro abandons the representation of real life and ventures into charming and fanciful works of the imagination. There is a series done by him made up of about a dozen sheets entitled *Profitable Visions in Daydreams of Glory* (p. 121). It is a series of dreams by a little girl, a prostitute, an old servant to a samurai, dreams which are depicted in the upper portion of the print (the series had an unknown number of views). This series shows, behind and above the head of the sleeping person, the action in the dream they are dreaming. A dream which arises, not from their heads, but from the area of the heart, and a bit like a phylactery emerging from the mouth of one of our saints and which, in this very Japanese imagery, expands into the shape of a kite. We see the sleep of a little

Dream of the Courtesan, from the series *"Profitable Visions in Daydreams of Glory"* (Miru-ga-toku eiga no issui), c. 1801-1802.
Ōban, nishiki-e, 37.7 x 24.5 cm.
Bibliothèque nationale de France, Paris.

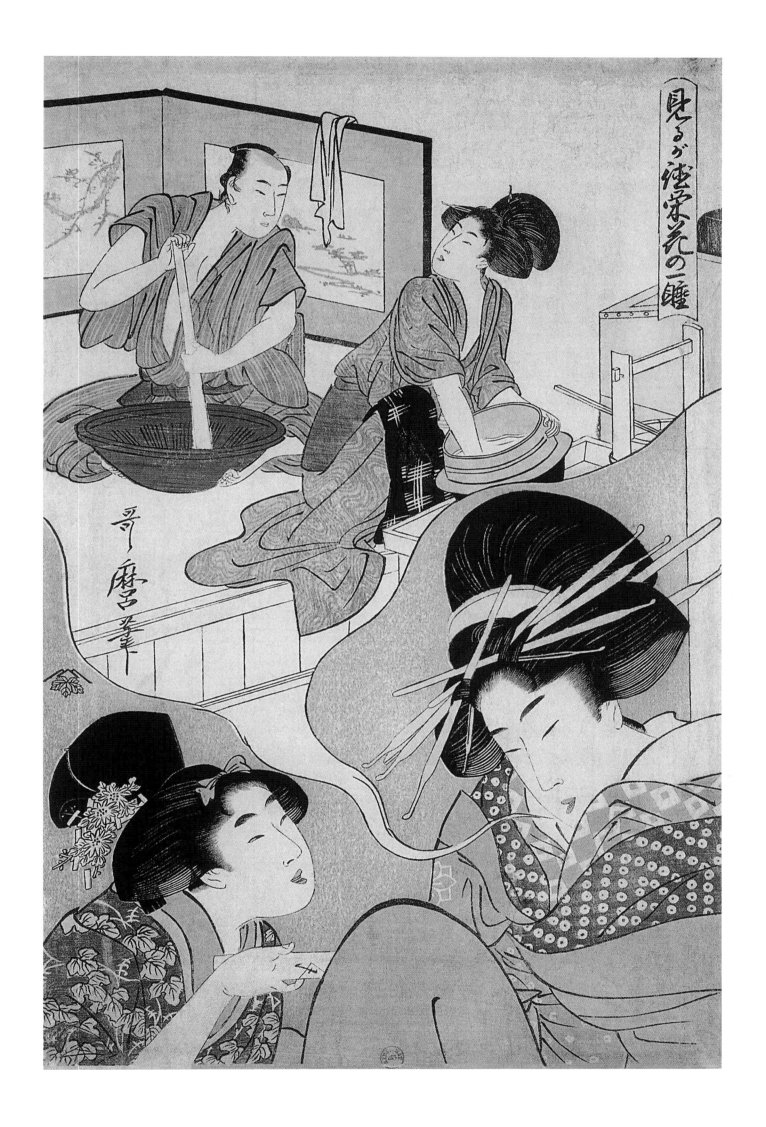

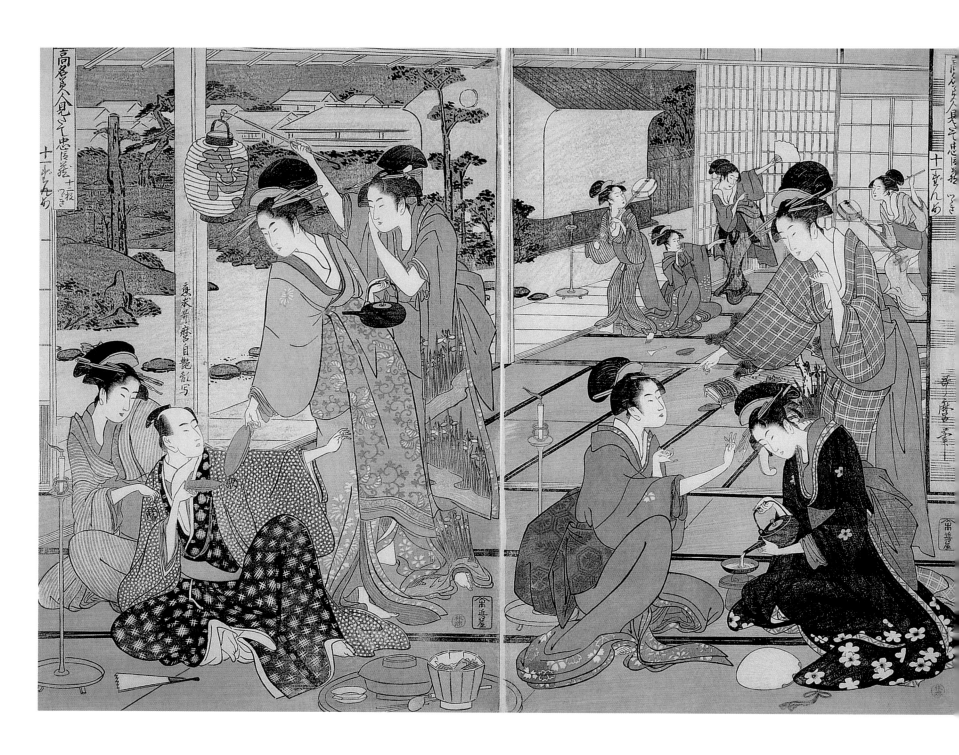

Act Eleven (Jo-ichidanme), from the series *"The Chūshingura Drama Parodied by Famous Beauties"*,
1794-1795.
Two sheets from a composition of twelve sheets, nishiki-e, right sheet: 39.1 x 25.9 cm; left sheet: 39.2 x 25.7 cm.
The Art Institute of Chicago, Chicago.

girl visualising a sumptuous buffet which she eats hungrily; we see the sleep of a charming young lady, whose face appears through the screen covering her eyes and who is dreaming that she has become a princess, whose *norimon** is travelling through the countryside escorted by a large contingent of ladies-in-waiting and servants. We see the sleep of a *Yoshiwara** courtesan transport her into a little room, where the now former prostitute is engaged in household work with the man she loves. We see the sleep of an old servant to a samurai taking him back to the good times, when he was being propositioned in the street by a bawdy hooded girl. This humorous series includes not only dreams by human beings: there are animal dreams as well. We are shown the sleep of an old cat, dreaming of the spry and thieving days of his youth, in which he devours the fish cooked for his master's meal in spite of the latter's efforts to pull it out of his mouth, and the enormous bamboo switch brought by the wife to beat him.

Looking through Utamaro's *The Twelve Hours in Yoshiwara* (pp. 108, 109, 110, 113, 192) (series of twelve prints), one is taken by the sixth plate, which represents a gracefully-elongated woman dressed in a pale robe, covered in designs resembling starfish, of a blue which is diluted and as though under water; a woman, to whom a kneeling *musume** is offering a cup of tea, and whose frail neck, voluptuously thin and consumptive shoulder, and small pointed breast are revealed by the falling cloth. One cannot help wondering, "Was the man who drew this woman supposed to be a lover of women's bodies?" And one replies, "Yes, he died of exhaustion because of it." It's true: Utamaro died in his house by the Benkei bridge from the excesses of pleasure. Obliged, without reprieve and without resting, to honour his incessant commissions, delayed by his time in prison, and overindulging in pleasure, Utamaro wore himself out.

The portrait as it is done in Europe, a portrait representing the exact features, the strict outlines, and the particularities of a face, is just not done in Japan, with the possible rare exception of a portrait of a priest or an important bonze. One must therefore not expect to encounter a portrait, either printed or drawn, of the face of a Japanese person. Fortunately the painters occasionally had an urge to leave behind not an image of their face, but a sort of silhouette of their person. For example tradition has it that two or three prints by Hokusai are representations of the master.

For the image of Utamaro, there is nothing better than the difficult scenes, such as the second print of a series called *The Chūshingura Drama Parodied by Famous Beauties* (p. 122). In this series of twelve prints we are shown, at night in a garden of the *Yoshiwara**, a man surrounded by courtesans handing an empty sake cup to a woman leaning over him. Marked on the post at the foot of which the man is seated are the words "By request, Utamaro has painted his

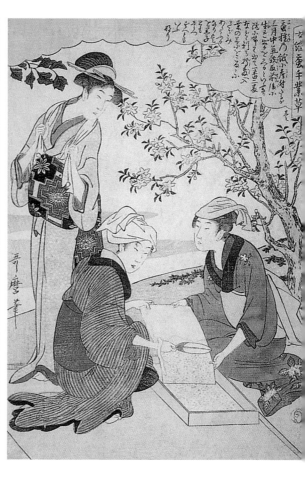

"Women Engaged in the Sericulture Industry, Nos. 1-3" (Joshoku kaiko tawaza-gusa, ichi, ni, san),

c. 1798-1800.

Three sheets from a composition of twelve sheets, nishiki-e, right sheet: 37.3 x 24.6 cm; centre sheet: 37.3 x 24.2 cm; left sheet: 37.3 x 24.7 cm.

The British Museum, London.

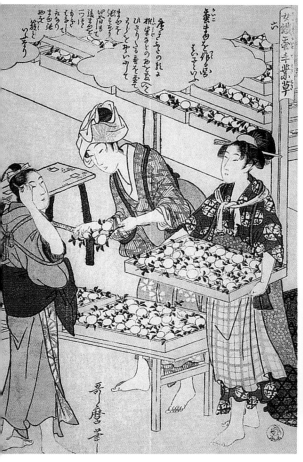 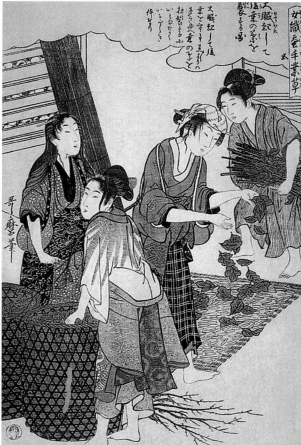 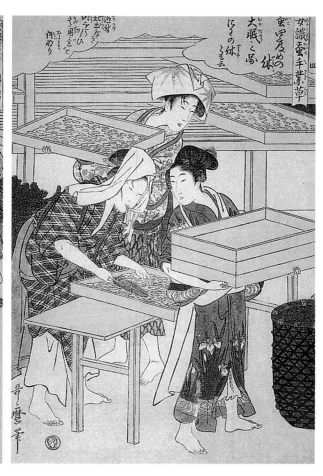

"Women Engaged in the Sericulture Industry, Nos. 4-6" (Joshoku kaiko tawaza-gusa, shi, go, roku),

c. 1798-1800.

Three sheets from a composition of twelve sheets, nishiki-e, right sheet: 37.5 x 24.5 cm; centre sheet: 37.5 x 24.7 cm; left sheet: 37.5 x 24.8 cm.

The British Museum, London.

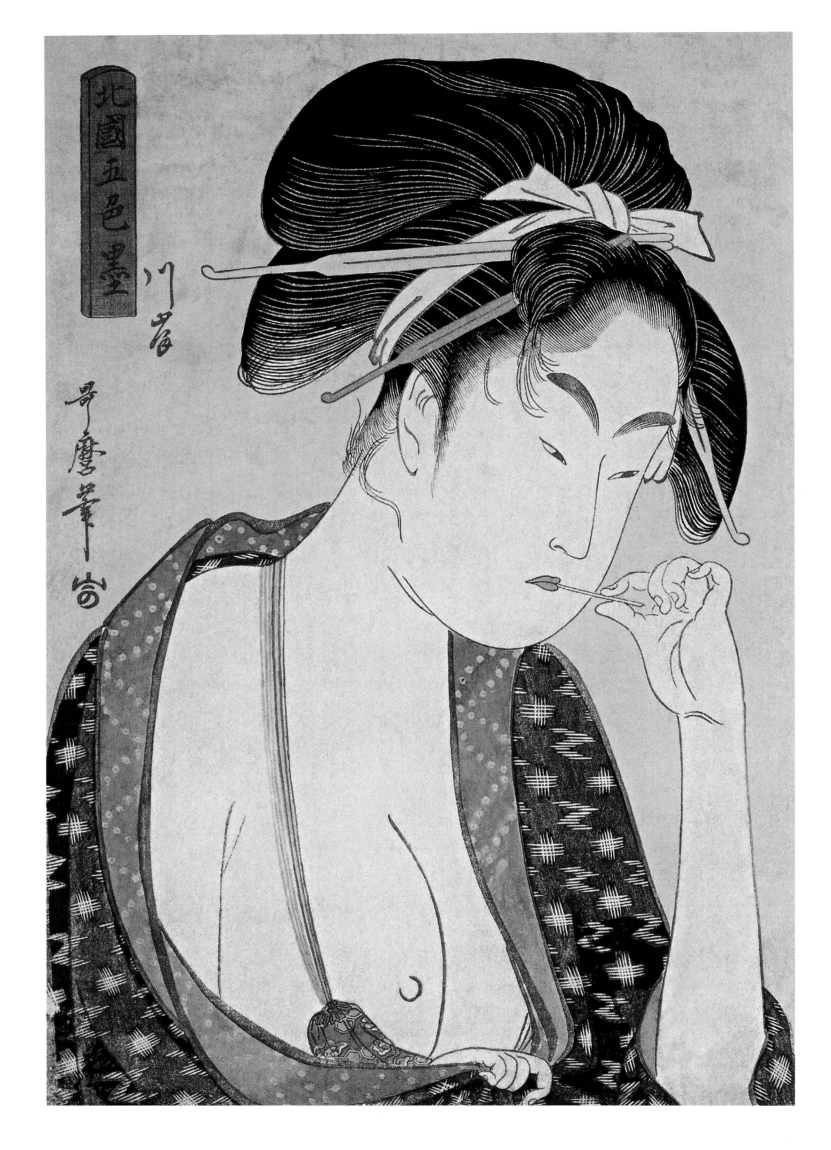

own elegant face." The inscription is right. Whereas it may not be his actual face, drawn as it is with the usual hieraticism of the figures in these prints, it is the man himself, elegant, fashionably styled with his hair pulled up on the top of his head and so well combed on the sides, posing theatrically in the reserved distinction of his apparel, of his outer robe, this black robe covered with white dots which give it the look of the plumage of a guinea hen, — and on his upper chest can be read in the two small circles of yellow silk, on one side, *Uta*, and on the other, *Maro*.

In this beautiful set of prints Utamaro acts as the spokesman for the preface of the story of the *ronin* which states: "a nation in which the feats of nobility and courage by its gallant samurais were not spread far and wide, would be comparable to a dark night where not a single star is seen shining through the darkness." He alters it with his allegorical penchant for representing everything by the graceful charms of a woman. In the dynamic groupings and elegant arrangements of the women, amidst light-coloured fabrics, one woman's black dress stands out with a nearly theatrical power.

Women Engaged in the Sericulture Industry (p. 124-125):

This series (whose title can also be translated as *The Women Who Work with Silkworms*), although not of the quality of *The Twelve Hours in Yoshiwara* (pp. 108, 109, 110, 113, 192) and *The Peers of Saké Likened to Select Denizens of Six Houses* (pp. 118, 119), became very popular in Japan. It is a pictorial monograph depicting in twelve prints how silkworms are raised.

As they say in Japan, the first concern of the silkworm breeder must be to select good egg sacks, and he should prefer the cartons which contain those coming from Yonesawa, Yamagawa or Neda. Those of the highest quality can be recognised by the uniformity in the size of the eggs, which should be of a violet-black colour, and by their adherence to the carton, which can be touched without causing them to fall off. To make the eggs open, the cartons are taken out of the boxes, around the 20th March. The hatching of the eggs, which by then have taken on a bluish colour, takes place around the 30th March.

The first panel shows the workers, delicately shaking the worms onto a sheet of paper, which is then covered with millet bran. The second and third panels show the mulberry leaves being picked and then chopped to feed the worms, five times a day. Then comes the first dormant phase which takes place ten days after hatching, when the worm begins to turn white. During this dormant phase the paper containing the worms is covered with a layer of rice bran, over which is stretched a net that the worms crawl up on as they awaken. There follow in the pictures second, third, and fourth dormant phases, where, after three days, the worms are given whole mulberry leaves to eat. Then, when the workers see that the worms are ready to spin, when they see them coming over the edge of

"Moatside Prostitute" (Kashi), from the series *"Five Shades of Ink in the Northern Quarter"* (Hokkoku goshiki-zumi),
1794-1795.
Ōban, nishiki-e, 37.6 x 25.6 cm.
Musée national des Arts asiatiques – Guimet, Paris.

the tray, they pick them up in their hands and put them in the *mabushi*, loose straw, which gives them the greatest ease for spinning. In the last images of the series we witness the silkworm enclosing itself in the cocoon, the metamorphosis of chrysalis into moth, the laying of new eggs which a woman is directing onto paper, with a string attached to the moth's leg, and at last the plunging of the cocoons into boiling water and the various processes through which they become a length of fabric.

One Hundred Fantastic Tales:
One of the prints represents a room where a Japanese man is hiding his face on the floor, under the sleeves of his robe, at the sight of two larva-like creatures: one with wild black hair and parts of its skeleton piercing its sickly flesh, the other with immense empty eye sockets, in which there are two little black spots, sticking out a bloody tongue which emerges from the hole of its mouth, like a flame blown by the wind (a series of an unspecified number of prints).

"High-Ranked Courtesan" (Oiran), from the series
"Five Shades of Ink in the Northern Quarter"
(Hokkoku goshiki-zumi),
1794-1795.
Ōban, nishiki-e, 36.4 x 25.5 cm.
Musée national des Arts asiatiques – Guimet, Paris.

Compositions Alluding to the Hundred Criers:
Compositions with captions in the upper portions alluding to the *Hundred Criers*. The caption is written on a fan with representations of a crab and a toad. Men are shown closely imitating them by their poses, contortions, and facial expressions as the crab, the toad, etc.… beneath unkempt-looking women with their breasts exposed (series of an unspecified number of prints).

The Five Festivals of Family Life:
In former times in Japan there were five major celebrations. They were New Year's Day, on the third day of the third month, Girls' Day, the fifth day of the fifth month, Boys' Day, the seventh day of the seventh month, the Day of Married Couples or Marriageable People, the ninth day of the ninth month, and the Feast of Chrysanthemums, or the celebration of retirement from common life to enter a philosophical or poetic life (series of five prints).

The Festival of Lanterns:
This is a collection of a smaller format than the other series of prints. The Festival of Lanterns

"Young Woman from a Low-Class Brothel"
(Kiri no musume), from the series *"Five Shades of Ink in the Northern Quarter"* (Hokkoku goshiki-zumi),
1794-1795.
Oban, nishiki-e, 37.4 x 24.8 cm.
Musée national des Arts asiatiques – Guimet, Paris.

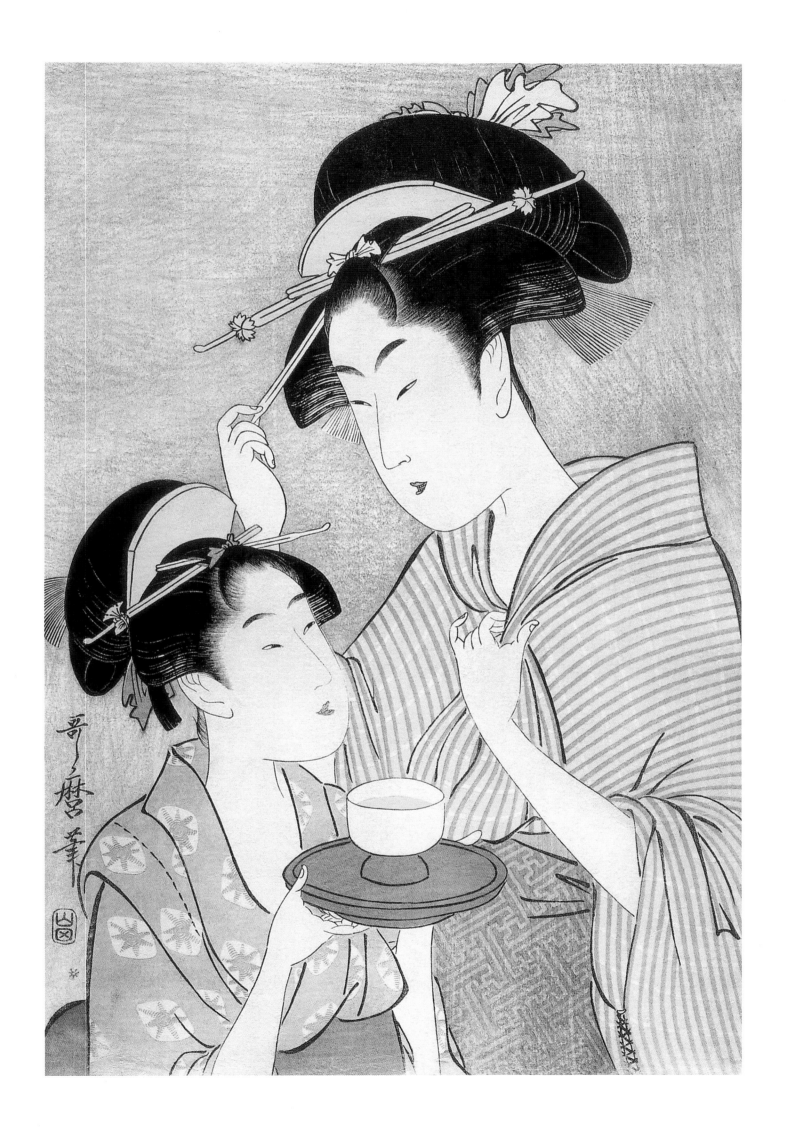

takes place on the thirteenth, fourteenth and fifteenth days of the seventh month. It is, in informal speech, "the festival of spirits", or *O-bon*, and in this respect is similar to the Christian All Saints' Day. In the main room of every house an altar is set up, spread with reeds, above which are hung the *ihai* or little pictures of those who have passed on, in the hope that their spirits will return to visit the places where their earthly life had been spent. A cord is strung across the altar with various foods, such as millet, water beans, chestnuts or aubergines hanging from it. On the thirteenth, around sunset, an *ogara* is lit: a stem of hemp which has been soaked, then dried; the flame, which only lasts a moment, is called *mukai-bi*, the flame of compliment. Its purpose is to welcome the spirits on their arrival. On the evening of the fifteenth, another stem of hemp is lit: this is the *okouri-bi*, "the flame of farewell", the adieu bid by the living to the spirits of their parents and their ancestors (series of an unspecified number of prints).

The Women Who Work with Silkworms:

There is one printing in which the clouds at the top of the panel, bearing the Japanese characters of the captions, are yellow, and with colourings almost entirely in the green, yellow and violet range, and another printing where the shadings are pink, and the colours more varied than in the previous series. There are even differences of design in the patterns on the women's dresses (series of twelve prints, making up both an album or a band of twelve prints, which can be assembled one after another).

The Twelve Trades:

1. A woman selling toothpaste; 2. A woman teaching writing; 3. A woman painter; 4. A woman quilting silk; 5. A woman spinning at a wheel; 6. A woman making balls; 7. A woman embroidering silken appliqué onto dresses; 8. A seamstress; 9. A dyer; 10. A maker of *dengaku* (food); 11. A weaver (series of eleven prints, but which must certainly have been twelve).

Children disguised as Six Poets:

In this series of six prints from 1790, the colours are muted and softened: the reds slightly brick, the yellows a bit marigold, the mauves a bit rust, the green slightly olive. One detects here a certain similarity with the colours sought after in tapestries under Louis XIII.

Scenes of Japanese Life:

This series is made up of prints representing screens, with, at the bottom of each, the loose coils of a thin red cord and its large, showy tassel knot. One of these screens shows a fishmonger, stripped to the waist, a large knife in his hand, cutting off a piece of fish for a woman playing with one of her hairpins while she waits. (series of prints of an unspecified number).

Geisha playing the Shamisen:

An unusual series on plain paper and crepe paper, where, against the cream coloured background, are scattered delicate cherry

"Hour of the Dragon [8 am]" (Tatsu no koku), from the series *"Sundial of Young Women"* (Musume hi-dokei), c. 1794-1795.
Ōban, nishiki-e, 38.6 x 25.5 cm. Musée national des Arts asiatiques – Guimet, Paris.

"Two Beauties, One Holding a Teacup, the Other Fingering her Hairpin" (Chawan to kanzashi), c. 1797.
Ōban, nishiki-e, 37.6 x 25.4 cm. Huguette Berès Collection.

"Picture-Riddle" (Ōgiya Hanaōgi), c. 1795.
Ōban, nishiki-e, 36.4 x 25.2 cm. The New York Public Library, New York.

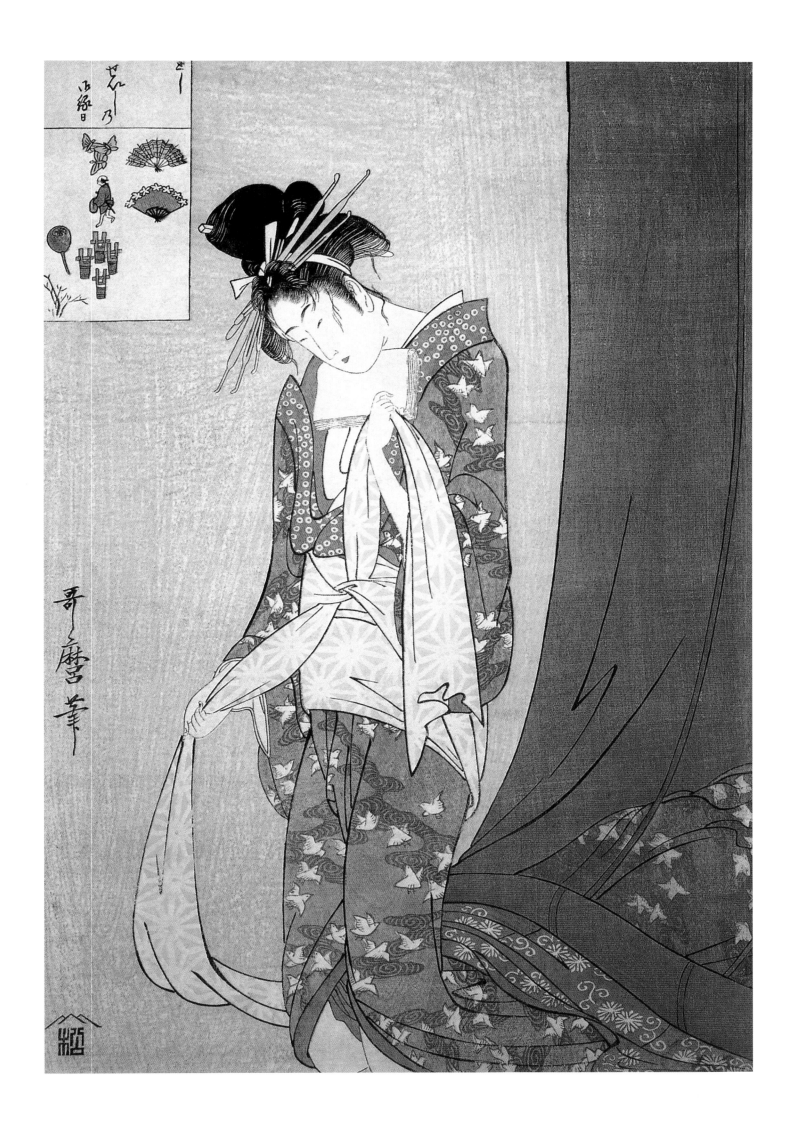

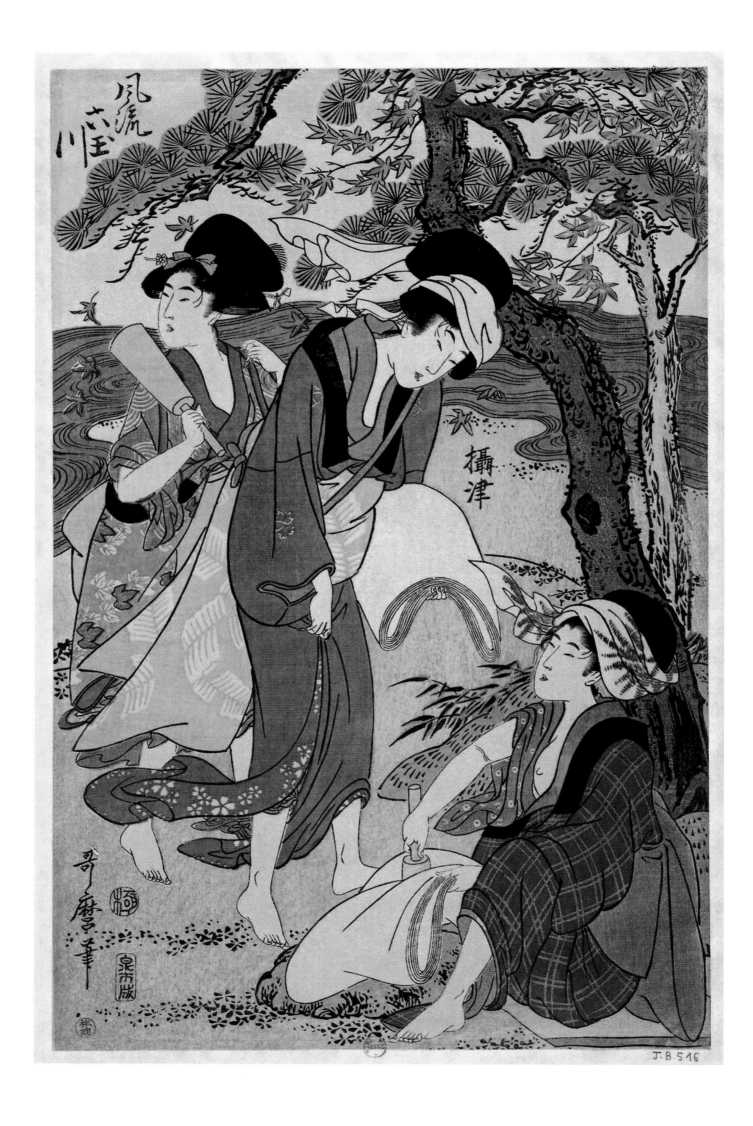

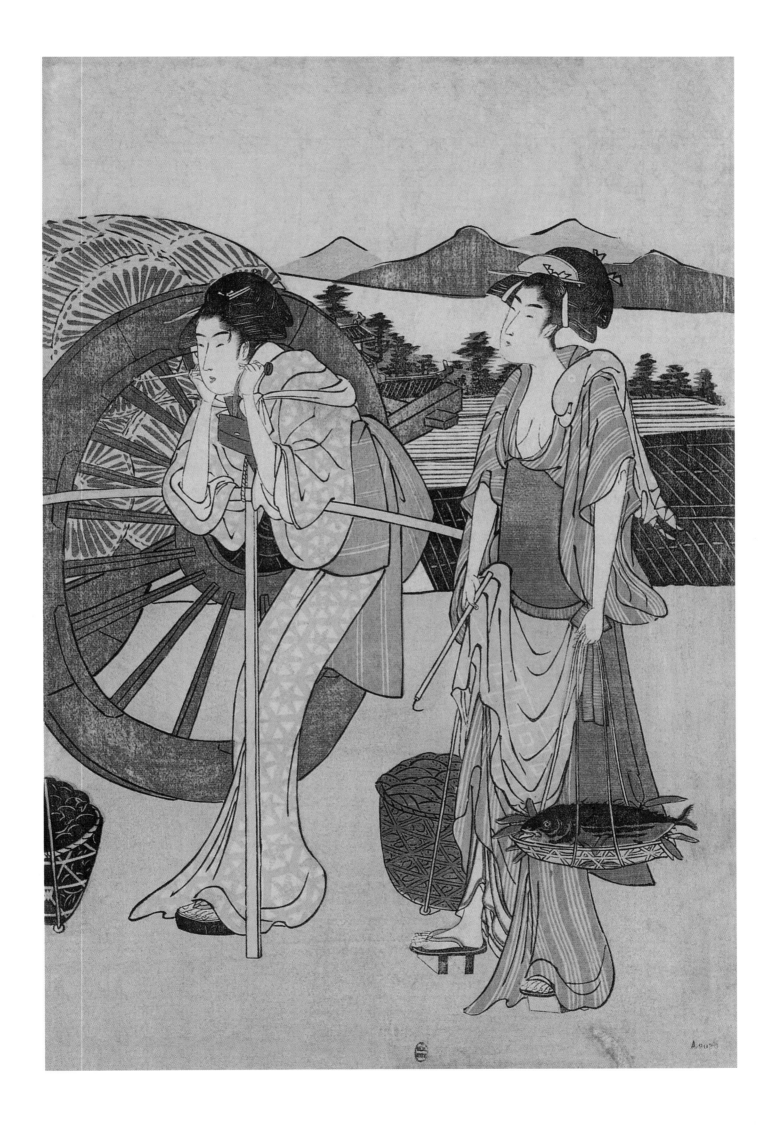

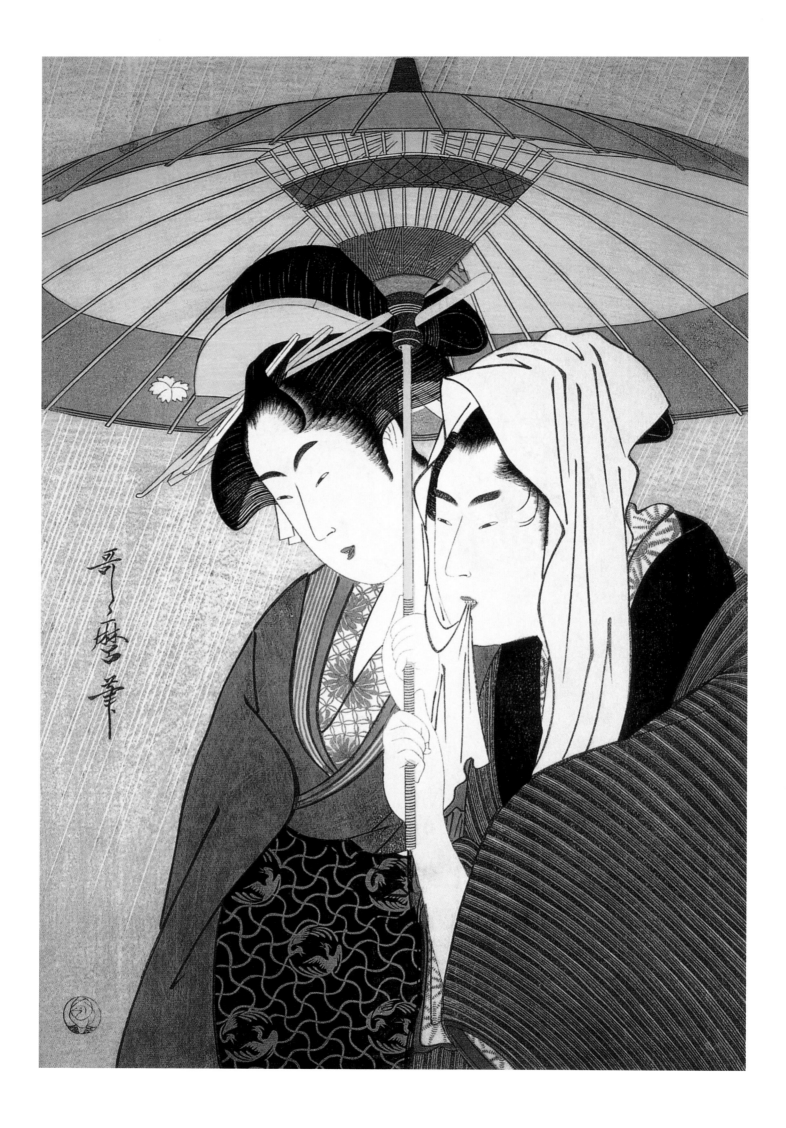

blossoms, among which run, rather like insects, the characters of a poem (series of prints of an unspecified number).

Musician:

A female musician, who is being affectionately held around the waist by a man, plays a *shamisen** with one hand. The artist's hand leaves her instrument for a moment to fend off a threatening kiss. This is the only print in the series where the vignette at the top represents a Chinese man and woman playing the same flute together (series of prints of an unspecified number).

Courtesans:

This untitled series bears as its identifying mark the symbol of one of the "green houses", where white characters stand out on a blue background, or, if the background is red, there is always an escutcheon with white characters on a blue ground (series of prints of an unspecified number).

Courtesans and Geisha, Compared to Flowers: Nothing could be more tender than the loving attitude of two women in one of these prints, where one kneels and holds in her hands the wrists of the other, her arms over the other's shoulders, gently relaxing her body as she leans over her back and neck (series of prints of an unspecified number).

Six Beautiful Heads from Edo, Compared to the Six Streams of the Tamagawa River: Courtesans pictured against an embossed white background, the pattern of which represents flowing water. Above each woman there is a small fan illustrated with a view of the Tamagawa (series of six prints each different from the first).

The Seven Komati of the "Green Houses": Second series. Portraits of famous courtesans, whose names are given above each one of them, and who are called Schinowars of Tsuruya, Kisegawa of Matsubaya, Tukigama (falling water).

Might this Kisegawa of Matsubaya, very often depicted by Utamaro, have been a favourite of the artist? (series of seven prints).

Also worthy of mention:

The Beauties of the Present Day in Summer Dress: A woman in a light-coloured dress is peeling a watermelon, a seasonal treat, which a child has just brought her (series of prints of an unspecified number).

The Fifty-three Stops on the Tōkaidō Road, each one compared to a Woman's Life: Series in which each vignette shows, inside a circle, a charming little landscape with the caption below; the main view represents two honourable women, seen from the waist up (series which must have included fifty-five views).

The Benches at Eight Famous Places: In well-known scenic spots in Japan, the benches

The Washerwomen, from the series "*The Six Tanagawa Rivers, Settsu*", 1804.
Ōban, nishiki-e, 37.6 x 24.4 cm. Bibliothèque nationale de France, Paris.

Return from a Fishing Trip. Ōban, nishiki-e, 38 x 25 cm.
Bibliothèque nationale de France, Paris.

"*Man and Woman under an Umbrella*" (Kasa sasu danjo), c. 1797.
Ōban, nishiki-e, 38.9 x 26.6 cm. The Art Institute of Chicago, Chicago.

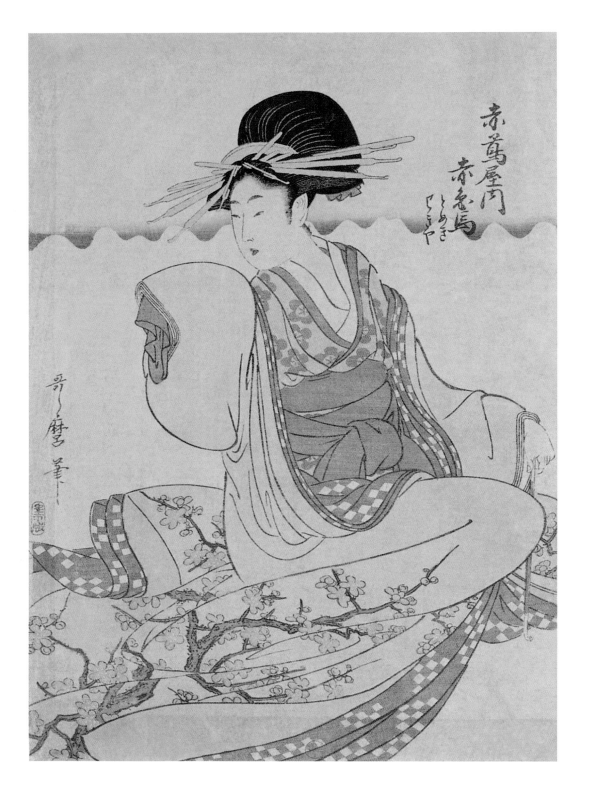

are under a kiosk where tea is served (series of prints of an unspecified number).

Eight Pictures of Trysts:
Representations of pairs of lovers (series of eight prints).

The Pleasures of the Four Seasons:
Groups of two figures seen from the waist up (series of four prints).

The Six-Needled Pines:
Group of women seen from the waist up, reminiscent of scenes where lovers meet under the evergreens (series of six prints).

The Seven Women Poets:
Series of women, in yellow medallions, on embossed white paper, with a very delicate technique (series of seven prints).

The Great Warrior Sakata-no-Kintoki (Kintarō) and his Mother Yamauba:
Series of prints representing the frightening woman of the wild with her shapeless black hair and her mahogany-coloured infant (several series).

The Courtesan Akakinba from the Akatsutaya House, Sitting and Holding a Pipe,
c. 1804.
Ōban, nishiki-e, 35 x 23 cm.
Bibliothèque nationale de France, Paris.

Women's Amusements at the Five Festivals of the Year:

One of the prints represents a woman looking at an enormous lantern on which, painted very cleverly, a man disguised as a cat can be seen dancing to the sound of the music being played by a geisha (series of five prints).

Insert Embellished with Poems from the Five Festivals:

The insert is the little vignette, which is the signature of the series, and which, in each print, contains in this case a poem instead of an image (series of prints of an unspecified number).

The Forty-seven Ronin:

In this series, one print shows the episode of the clothing and weapons supplier suspected of treason (series of prints of an unspecified number).

Twelve Scenes from the Forty-seven Ronin:

This is a series of large medallions, each containing three heads, depicted in the manner of caricatures (series of twelve prints).

"Parody of the Third Princess" (Mitate Onna San-no-miya), from the series *"Picture Siblings"* (E-kyōdai),
c. 1795-1796.
Ōban, nishiki-e, 37.5 x 24.2 cm.
Bibliothèque nationale de France, Paris.

The (Immoral) Life of Taikō:

In one print we can see Taikō trying to seduce a young boy, whose family is clearly identified by the coat of arms on his sleeve (series of prints of an unspecified number).

The Way to Dance:

One print in this series represents a woman holding the strings of a small wagon in front of which a child is dancing (series of prints of an unspecified number).

Proverb of the Jewel-Children:

This series, which is different from the series of the *Jewel-Children*, contains in the small vignette in the upper portion of the print the story of the young Sakata-no-Kintoki (Kintarō) and of his mother Yamauba (series of prints of an unspecified number).

Mothers and Children:

Series of prints in very soft colours, inside large medallions with a yellow background, around which the white paper is embossed with small streaked designs (series of prints of an unspecified number).

New Designs in Five Different Colours. (Women with grown Children):

The series takes its name from the imitation of a piece of fabric placed above the scene which is like a sample of what the child is wearing (series of five prints).

Children's Marionettes:

Above the heads of two children a woman is lifting a puppet, which could be, with its noble head-dress, the mocking representation of a high government official (series of prints of an unspecified number).

Parents Taking Pride in their Children's Abilities:

One print in this series represents a mother watching admiringly as her daughter writes a poem on a fan (series of prints of an unspecified number).

The Chosen Women (Ladies of the Court of a Daimyo):

This series has, at the top of each scene, a small square containing little everyday objects, which, when put together, might well form a rebus (series of prints of an unspecified number).

Model of Education for Women:

One of the prints in this series, which has a green fan as a vignette, represents a woman in front of a reel used for making cotton thread (series of prints of an unspecified number).

Twelve Trades Practised by Women:

Series of women seen from the waist up (series of twelve prints).

Beauty Contest:

Women busy with the details of making themselves beautiful (series of prints of an unspecified number).

Women at their Dressing Tables:

This series, one of the earliest in Utamaro's oeuvre, has something of the heaviness of Kiyonaga, but lacks his power (series of prints of an unspecified number).

Dyeing in Edo:

Series bearing the signature of Utamaro but

"Kamiya Jihei and Kinokuniya Koharu" (Kamiya Jihei, Kinokuniya Koharu), from the series *"True Feelings Compared: The Founts of Love"* (Jitsu kurabe iro minakami),
c. 1798-1799.
Ōban, nishiki-e, 38.4 x 24.4 cm.
Tokyo National Museum, Tokyo.

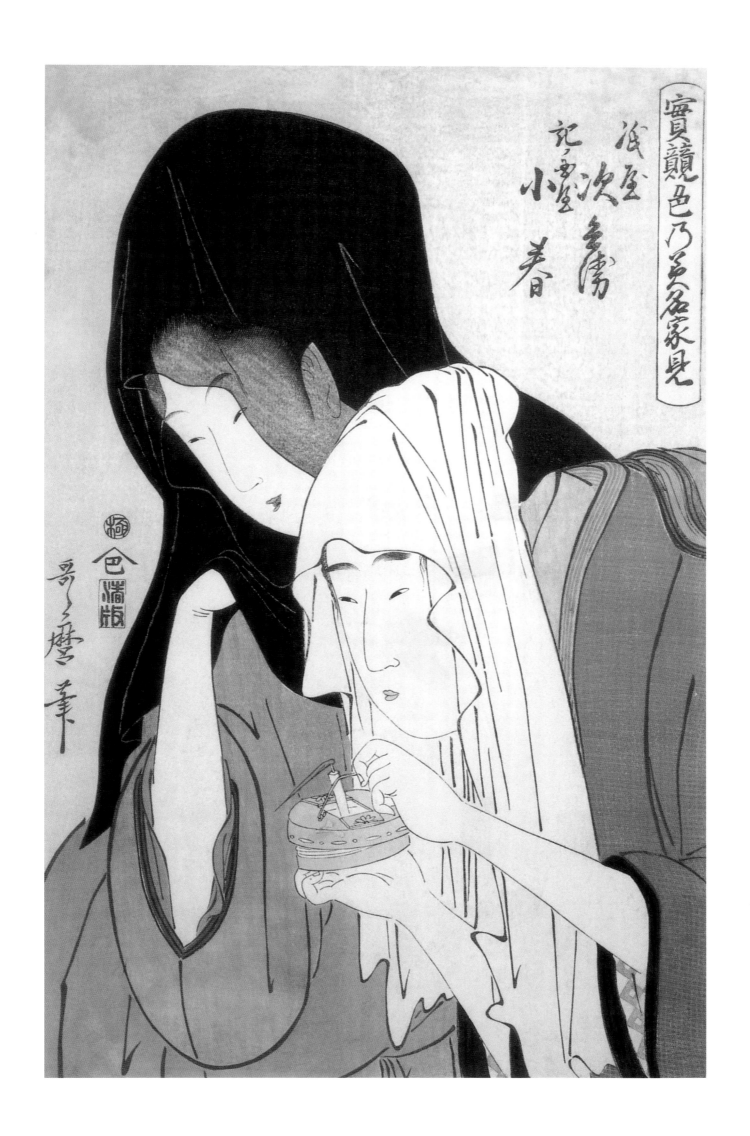

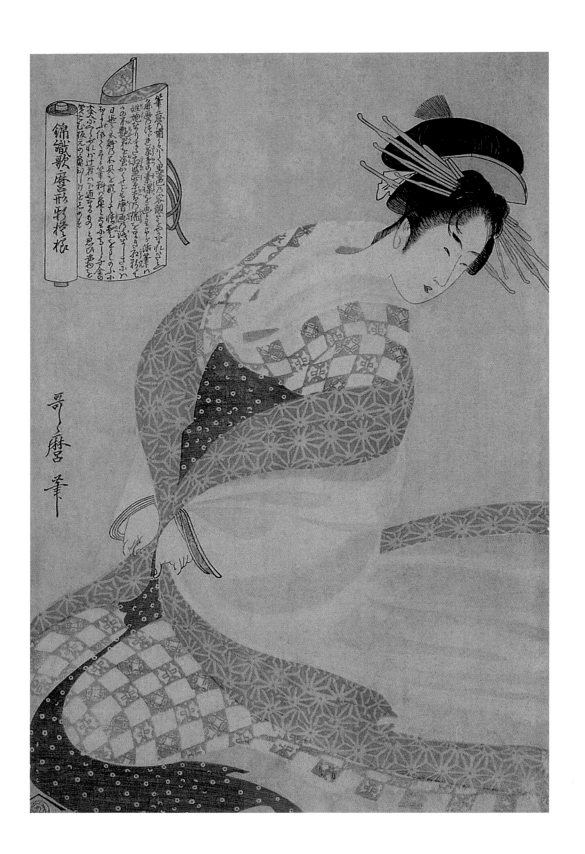

which may well be by his pupil, Kikumar (series of prints of an unspecified number).

Garments of Five Dresses:
A series of prints in which we see five dresses layered on a woman's body (series of prints of an unspecified number).

New Designs for Brocades:
Large heads of women on a yellow background (series of prints of an unspecified number, published around 1800).

Comparison of Hearts Loving Faithfully:
This series includes all the characters from all the famous novels and plays about love (multiple series of prints of an unspecified number).

Contest of Lovers' Faithfulness:
Groupings of men and women seen from the waist up (series of six prints).

The White Surcoat (Shira-uchikake), from the series
"New Patterns of Brocade Woven in Utamaro Style"
(Nishiki-ori Utamaro-gata shin-moyō),
1797.
Ōban, nishiki-e, 38.6 x 25.1 cm.
Staatliche Museen, Preussischer Kulturbesitz, Museum für
Asiatische Kunst, Berlin.

Anthology of Poems: The Love Section (pp. 15, 145):

Series of large heads of women on an orange background (series of prints of an unspecified number).

Six Love Poems:

One print in this series represents a young man taking the breast of a young woman and bringing it close to his mouth, as though he intended to nurse. But the infant she carries on her back is making a gesture of disapproval with his hand. (Series of six prints).

Travails of Love with the Caption: Clouds over the Moon:

The only print that I have found of this series represents a horrible old woman, an unbearable mother-in-law or lover's mother, railing against a young woman while she forcefully pulls her son by his neck away from his love tryst (series of prints of an unspecified number).

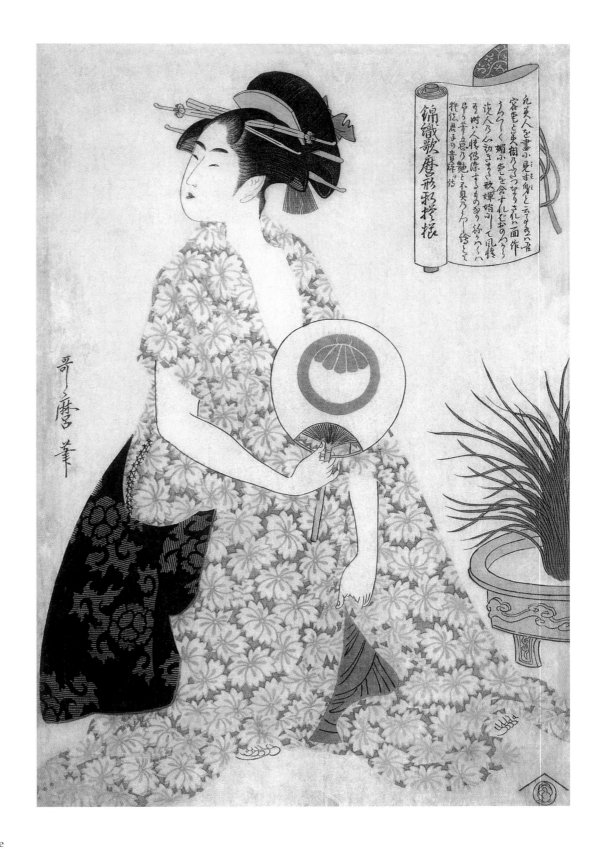

"Beauty Wearing a Summer Kimono" (Yakata bijin), from the series *"New Patterns of Brocade Woven in Utamaro Style"* (Nishiki-ori Utamaro-gata shin-moyō), c. 1796-1798.
Ōban, nishiki-e, 37.5 x 25.3 cm.
Chiba City Museum of Art, Chiba.

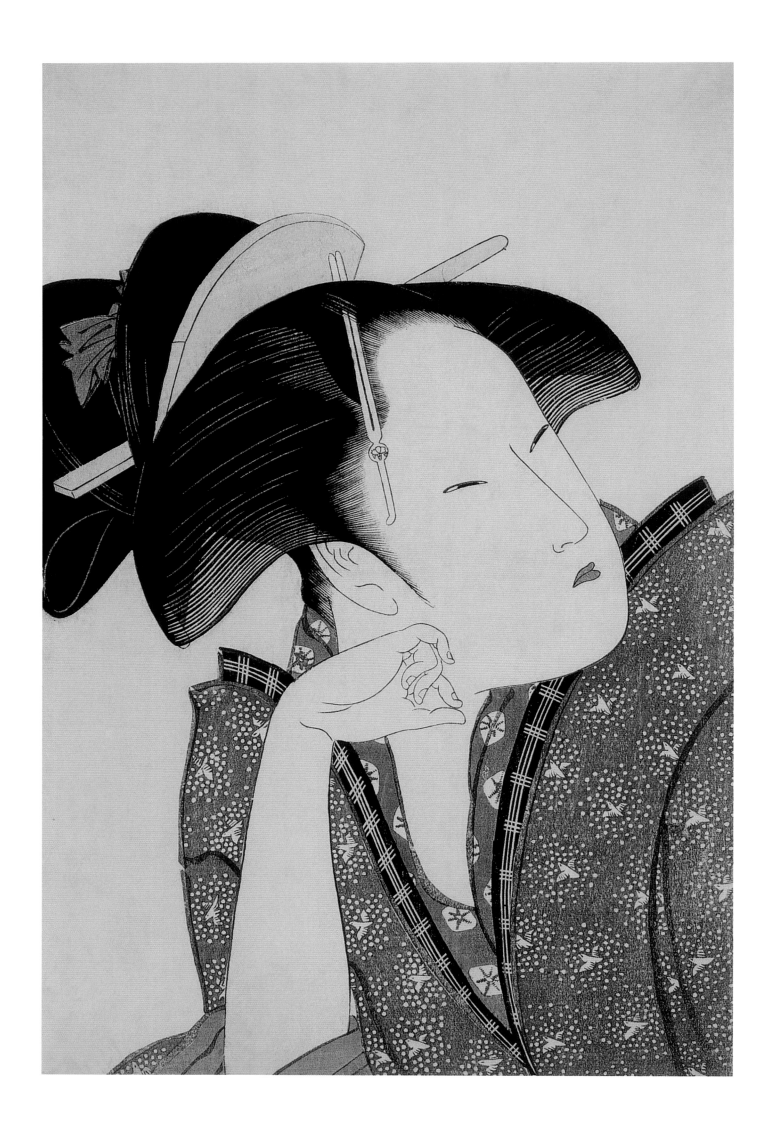

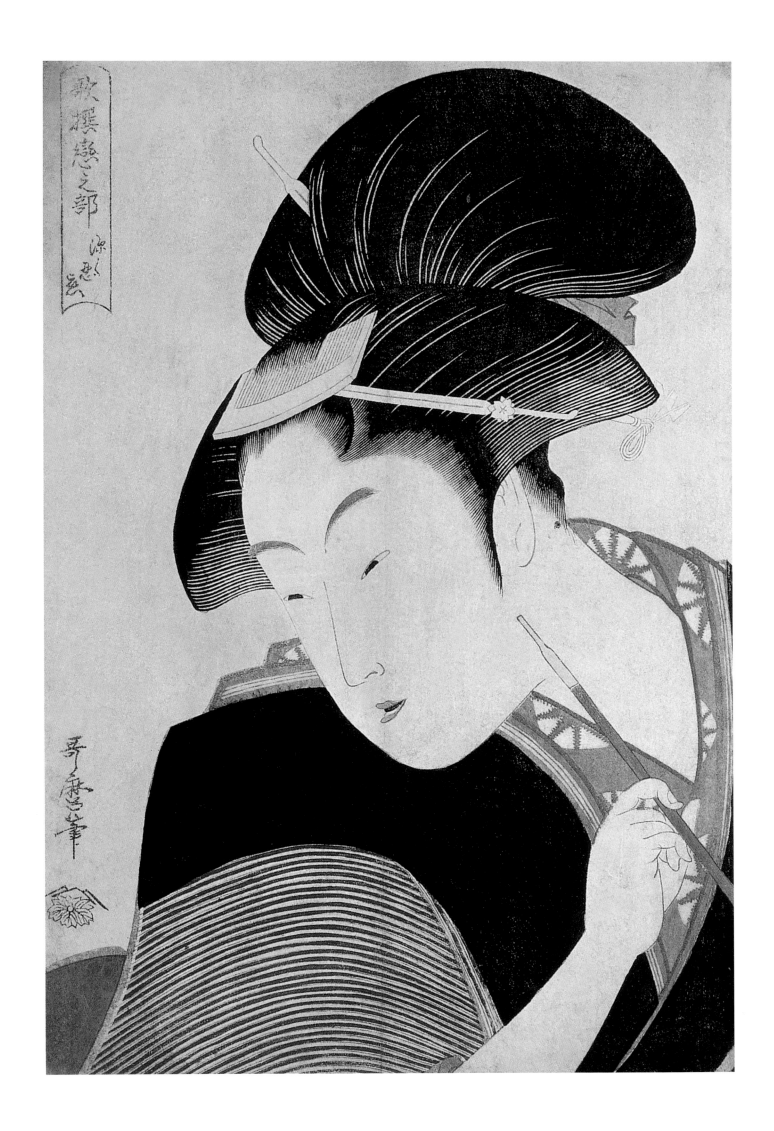

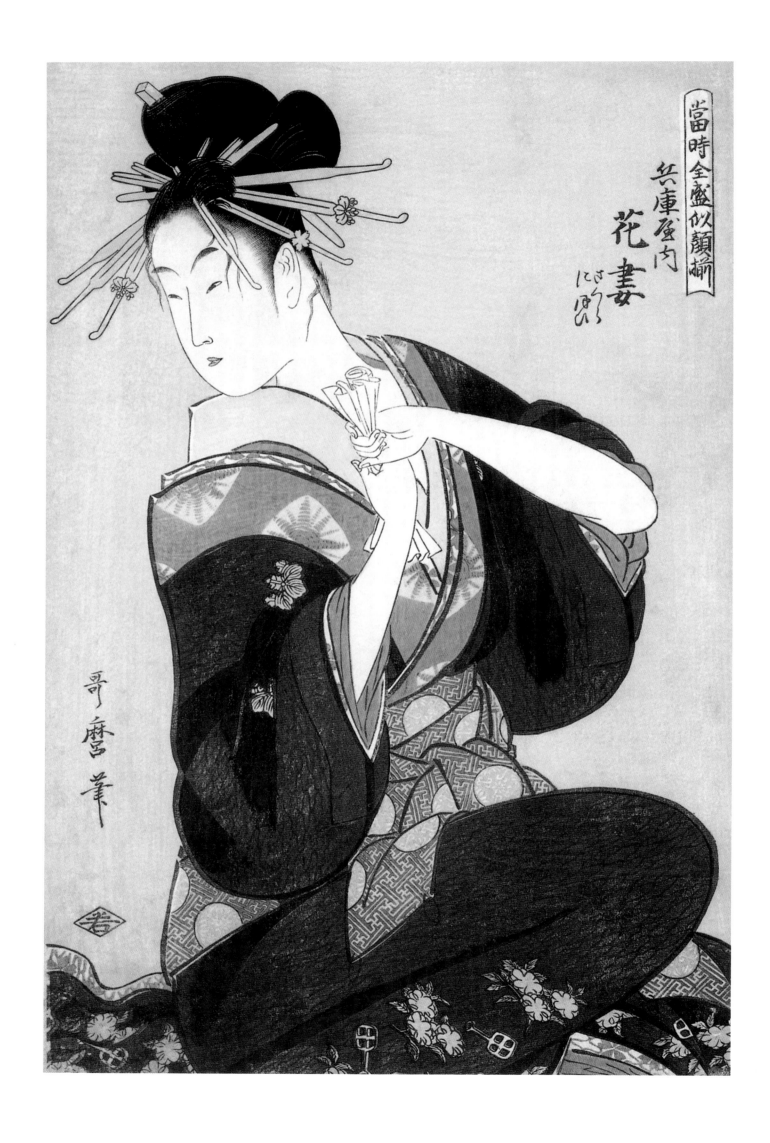

Eight Events in Life Compared to Eight Places in Japan:
One of the prints represents a woman nervously tightening her waistband, and has the caption: "Tempest in the Bedroom" (series of eight prints).

Lovers' Storm:
Groupings of several figures seen from the waist up (series of prints of an unspecified number).

Scenes of Love Depicted by Marionettes:
Compositions in which the two marionettes of the man and the woman appear to be on the edge of a theatre box with the heads of spectators looking down at them (series of prints of an unspecified, but probably very large number).

Five Faces of beautiful Women:
This series bears a magnifying glass at the top of the image (series of five prints).

The Ten Faces of Famous Beauties:
The best print is on a silver background (series of ten prints).

The Art of Choosing Women (Courtesans):
A series in which a signature vignette, pieces of split bamboo used in Japan for drawing lots, is at the top of the prints (series of eight prints).

The Childhood of the Geisha:
Geisha begin their lives as dancers, then become singers (series of prints of an unspecified number).

The Chosen Dancers:
A series of large heads of women on a silver background (series of prints of an unspecified number, but at the bottom of each print the dancer depicted is named).

Famous Beauties Associated with the Six Immortal Poets (p. 146):
Series with a yellow background (series of prints of an unspecified number).

Courtesan between her Two Kamuros:
Series bearing Utamaro's signature, in classic writing, with his stamp (series of prints of an unspecified number).

The Six Komati of the "Green Houses":
A first series of portraits of courtesans compared to poets (series of six prints).

Courtesans Compared to Six Views of the Tamagawa:
Second series, published between 1780 and 1790 (series of six prints).

Eight Women Compared to Eight Landscapes near the Yoshiwara:
Series in which the eight landscapes are represented in the little vignette in the upper part of the print (series of eight prints).

Female Geisha Section of the Yoshiwara Niwaka Festival (p. 153):
Geishas disguised, some with a Korean hat on their heads, others wearing a Chinese crown (series of prints of an unspecified number).

Festival of the Niwaka:
One of the prints shows the programme of the celebration, and lists the names of the singers: Kin, Foum, Iyo, Shima (series of prints of an unspecified number).

"Reflective Love" (Mono-omu koi), from the series *"Anthology of Poems: The Love Section"* (Kasen koi no bu), c. 1793-1794.
Ōban, nishiki-e, 38.2 x 25.6 cm. Musée national des Arts asiatiques – Guimet, Paris.

Deeply Hidden Love (Fukaku shinobu koi), from the series *"Anthology of Poems: The Love Section"* (Kasen koi no bu), c. 1793-1794.
Ōban, nishiki-e, 38.8 x 25.4 cm. Musée national des Arts asiatiques – Guimet, Paris.

"Hanazuma of the Hyōgoya, [kamuro:] Sakura, Nioi" (Hyōgoya uchi Hanazuma, Sakura, Nioi), from the series *"Array of Supreme Portraits of the Present Day"*
(Tōji zensei nigao-zoroe), 1794. Ōban, nishiki-e, 38.8 x 25.9 cm. The Japan Ukiyo-e Museum.

Festival of the Niwaka:
Series in a smaller format, with one of the prints depicting little Sakata-no-Kintoki (Kintarō) with his mother (series of prints of an unspecified number).

Courtesans:
Courtesans taking refuge in other houses (during a fire) compared to eight localities. A series with a yellow background and a small fan representing the locality (series composed of eight prints).

Among the other noteworthy series, the following must be mentioned: *The Six Women Poets*, *The Six beautiful Faces of Edo*, *The Five Feast Days*, without forgetting, among these series of colour prints, a second and third series of compositions inspired by *The Forty-seven Ronin*.

And, to make the list complete, let us mention:

The Four Poetic Elements: the Flower, the Bird, the Air, the Moon (series of four prints).
Summer Clock (series of twelve prints).
Flowers of Speech (series of prints of an unspecified, but probably very large, number).
Four Poems by Women Poets (series of four prints).
The Twelve Pictures of Scenes from the Forty-seven Ronin, Formed by the Most Beautiful Women (first set; series of twelve prints).
The Flowers of the Five Festivals (series of five prints).
The Seventh Sign of the Zodiac (series of prints of an unspecified number).
Contemporary Mores (series of prints of an unspecified number.).
The Forty-seven Years (second series; series of twelve prints).
Faithful Women in the Story of the Ronin (series of prints of an unspecified number).
The Pleasures of Spring (series of prints of an unspecified number).
The Seven Pleasures of Spring for Children (series of seven prints).
Children's Games in the Four Seasons (series of four prints).
Children Playing in the Play of the Forty-seven Ronin (series of twelve prints).
Jewel-Children: Seven Ways of Playing (series of seven prints).
The Sprouts of Two Leaves: Children Compared to Komati (series of seven prints).
Children Playing, Compared to the Seven Gods of Fortune (series of seven prints).
Children Disguised as Six Poets (series of six prints, published in 1790).
Eight Kinds of Tenderness (Mothers and Children) (series of eight prints).
Occupations of the Twelve Hours of the Day for Girls (Respectable Women) (series of twelve prints on a yellow background).
The Clock of the Fair Sex (series of twelve prints).
Seven Designs for Dresses (series of seven prints).
Summer Dresses (series of prints of an unspecified number).
Eight Women Compared to Eight Philosophers (series of eight prints).
Three Meetings of Two Pairs of Lovers (series of three prints).
The Five Festivals of Lovers (series of five prints).
Twelve Faces of Beautiful Women (series of twelve prints).
The Flowers of Edo (Singers) (series of seven prints).
New Selection of Six Flowers (Women of the "Green Houses") (series of six prints).

"Takigawa" (Takigawa), from the series *"Array of Supreme Portraits of the Present Day"* (Tōji zensei nigao-zoroe), 1794.
Ōban, nishiki-e, 38.6 x 26.1 cm.
Private Collection, Japan.

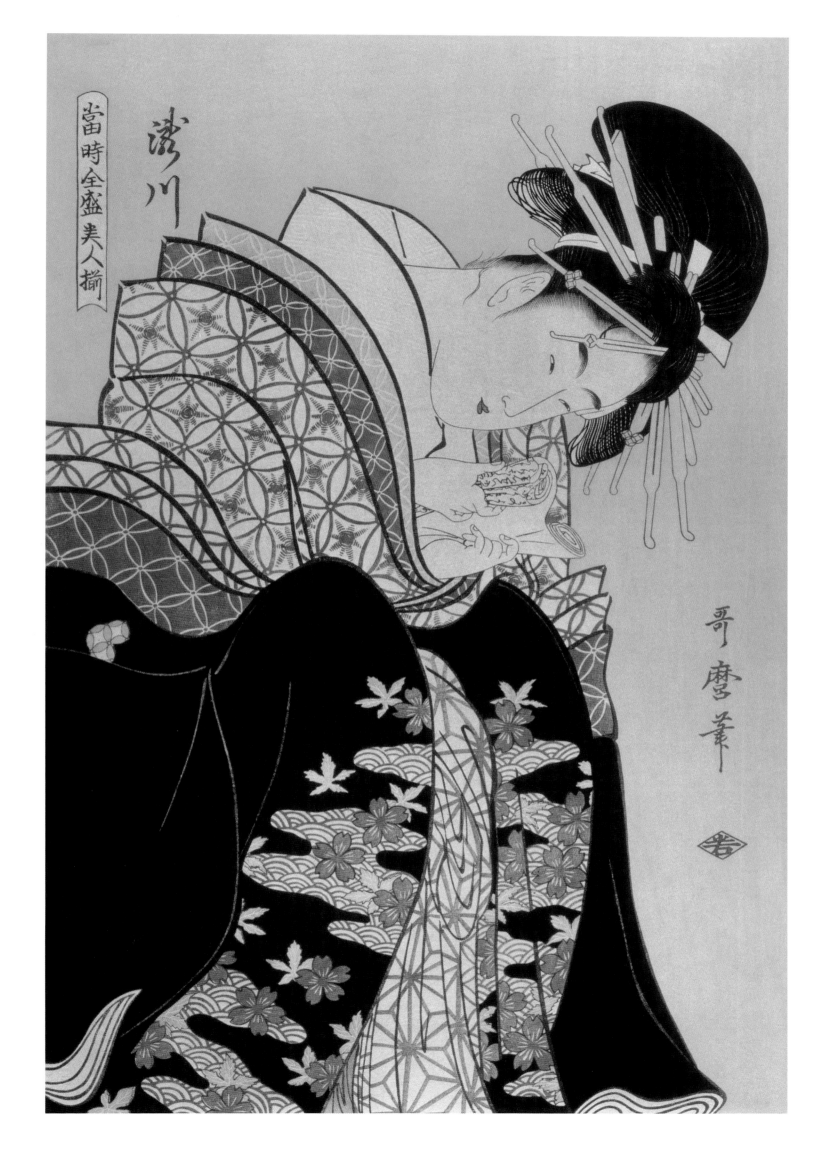

當時全盛美人揃

瀧川

哥麿筆

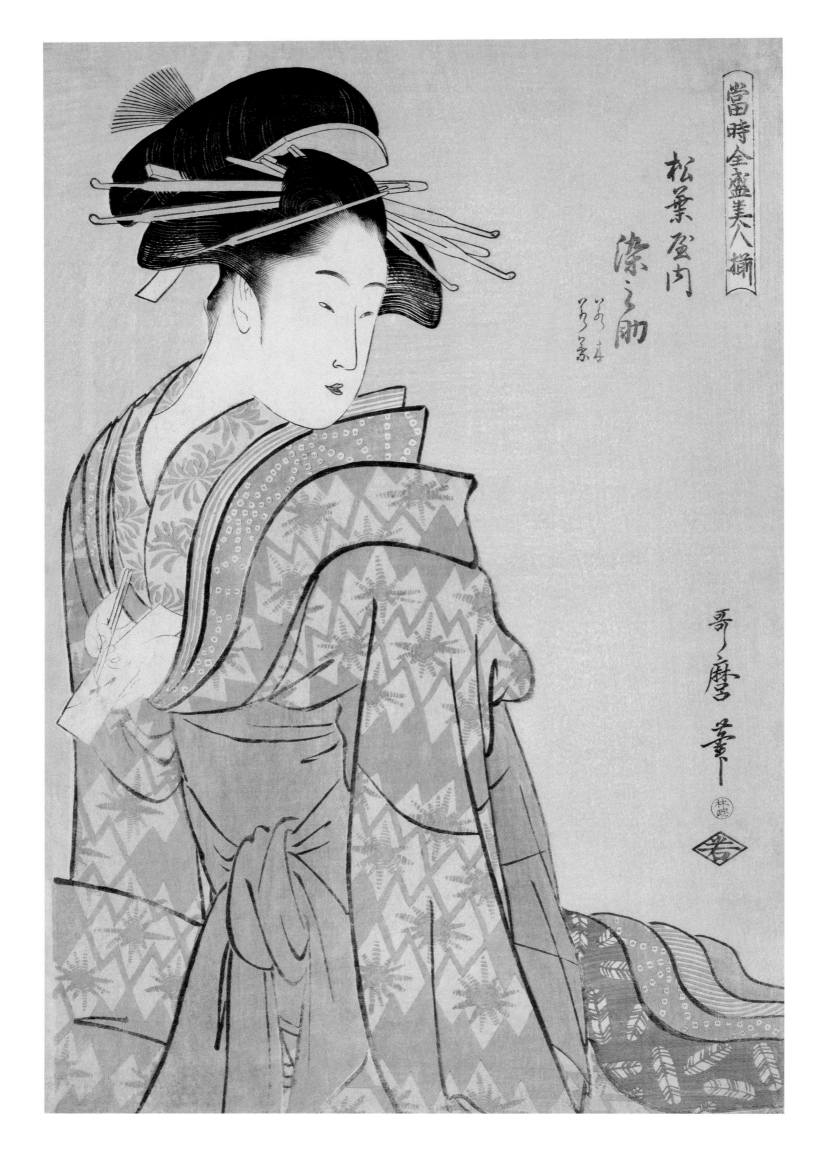

當時全盛美人揃

松葉屋内
染之助
わか
ゑ
もと

哥麿筆

150

Ten Different Conditions (Women of the "Green Houses") (series of ten prints).

Courtesans Compared to Six Poets (series of six prints).

Courtesans Compared to Women Poets (series of six prints).

Six Signboards from the Most Famous Sake Houses, Represented by Six Courtesans (series of six prints).

The First Outing in Her New Clothes (series of prints of an unspecified number).

The Beautiful Women at the Festival of the Niwaka of the "Green Houses" (series of prints of an unspecified number).

Theatrical Productions in the "Green Houses" (series of ten prints).

There are also numerous series of courtesans, untitled but including the name of a courtesan, such as the following:

Kisegawa (name of a river),

Kana-ōghi (fan of flowers),

Sameyama (coloured mountain),

Hinazuru (child of a stork).

Courtesans, among whom we again find Kisegawa, the woman whom Utamaro's brush so loved. An unusual series in which courtesans are depicted in a set of fans arranged vertically (series of prints of an unspecified number).

There are also a few series done in collaboration with other artists of the time, among which a series done with Katsukawa Shun'ei (1762-1819) where Utamaro, in each print, represents two women watching feats performed by strong men and wrestlers with gargantuan anatomies. In one of these prints we see the performer standing on one foot, his body almost horizontal to the floor, his hands pulled back and twisted above his back, picking up, in his mouth, a fan sitting on a stool. In another print a second performer, whose nose is attached to his ear by a string, detaches it without using his hands, through contortions and energetic grimaces of his face.

3. Kakemonos*

The kakemono* is a scroll held at the top by a thin piece of half-round wood and ending at the bottom with a cylindrical piece of wood of a larger diameter. Its tips are of ivory, horn, red sandalwood or lacquer, of ceramic or crystal, in colours and patterns appropriate to the work. These long, narrow strips are typically 25 centimetres by 60. The kakemono* are unrolled and hung on a wall. They are made only by experts. The kakemonos* of Utamaro are sometimes painted, but most are printed according to traditional techniques.

Painted Kakemonos*

The kakemonos* painted by Utamaro consist of watercolours of about ten paper or gauze strips (approximately the only kind of painting known in Japan). This painting shows the gentle light and harmony of subtle tones found in his printing, but in addition a boldness in the first stroke, which is quite remarkable, but which does not fully show in the colour prints. The kakemonos* painted by the master are rather scarce, but we can name the following:

The kakemono* of the woman attaching a mosquito net above her child asleep on the floor.

"Somenosuke of the Matsubaya, [kamuro:] Wakagi, Wakaba" (Matsubaya uchi Somonosuke, Wakagi, Wakaba), from the series "Array of Supreme Portraits of the Present Day"
(Tōji zensei nigao-zoroe),
1794.
Ōban, nishiki-e, 37.9 x 25.5 cm.
The Art Institute of Chicago, Chicago.

The *kakemono** of a Japanese lady unrolling a poem and the *kakemono** of a Japanese lady seen from behind, holding with an unseen hand her falling waistband and dress.

The *kakemono** representing, in a rapid sketch, a dancer doing a character dance.

The three-metre *kakemono**, which should perhaps be compared with another *kakemono** of approximately the same size, representing another "green house" in springtime, highlighted in gold, where more than forty women are depicted. Here we do not see the traits of the mature Utamaro so it could be a *kakemono** from the artist's youth (pp. 154-155).

Printed *Kakemonos**

Printed *kakemonos** are, in Japan, works of art for the homes of the common people, framed with an economical paper mounting, which does fairly well at imitating the arrangement, design, and brilliance of the silk fabrics which serve as mountings for the *kakemonos** done by the masters' hands. The printed *kakemonos** of Utamaro are almost always pyramidal in composition, where a man and a woman, one above the other and partially cut off by the narrowness of the paper, show only parts, or slices, of their bodies. In the limitless number of these *kakemonos**, which for the most part were hastily produced, without great variation in their subjects and intentionally repeating themselves with only a few insignificant changes, there are a few more carefully done and more successful, where the craftsmanship approaches that of the better *nishiki-e**.

There is a representation of a Japanese woman, seen from the back, who has a typical movement in her walk, her stomach forward, that traditional movement of the Japanese woman. She is lifting up with an unseen hand the heavy skirt and belt of her dress. An Indian ink stencil on absorbent paper and done in a fit, with the kind of fury that a European artist only occasionally puts into a charcoal drawing. Heavy black brushstrokes mixed with two or three slashes of vermillion, resembling the reverse of a red chalk drawing, where among the artistic daubing, at the bottom of the dress's train can be seen the roofs of temples atop cryptomeria sprigs, and, at the top, the thin nape of a woman's neck with little love curls, above which spreads her *coiffure*, looking like a great butterfly with its wings open.

On another *kakemono** from the same family, a dancer is interpreting a character dance, an ancient noble dance, in the archaic dress that goes with it. She is wearing a little hat in the shape of a bear cub, the *eboshi**, held on her hair, which falls over her shoulders, by a cord knotted under her chin. The dancer moving and swaying in the ample costume holds the fan, the *uchiwa*, in her two hands which are lowered against her hip. Another stencil done in Indian ink, on slightly darker paper, where the only colours are a reddish tint on the dress and the crimson of the ties of her hat and tassels of her belt.

One very superior *kakemono** represents a woman, her body twisting gracefully and with both arms raised, hanging a mosquito net above a child who is lying on his back with his legs in the air. The pleasant grey shade of

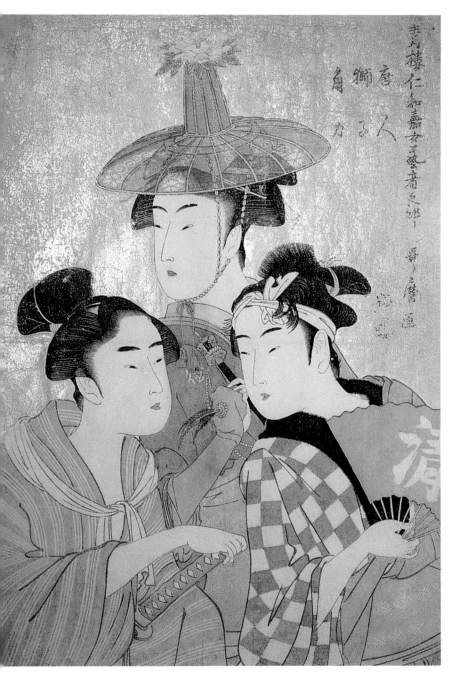

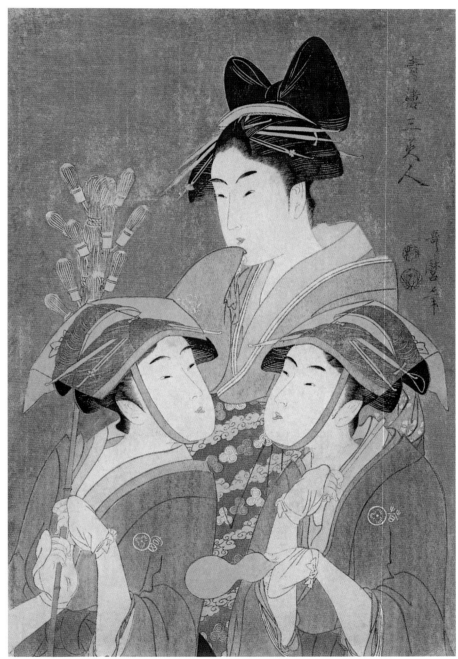

Korean, Lion Dancer, Sumō Wrestler (Tōjin, shishi, sumō), from the series, *"Female Geisha
Section of the Yoshiwara Niwaka Festival"*,
1792-1793.
Ōban, nishiki-e, 38.8 x 25.9 cm.
Baur Collection, Geneva.

"Three Beauties of Yoshiwara" (Seirō san bijin),
c. 1793.
Ōban, nishiki-e, 38.6 x 26 cm.
Honolulu Academy of Arts, Honolulu.

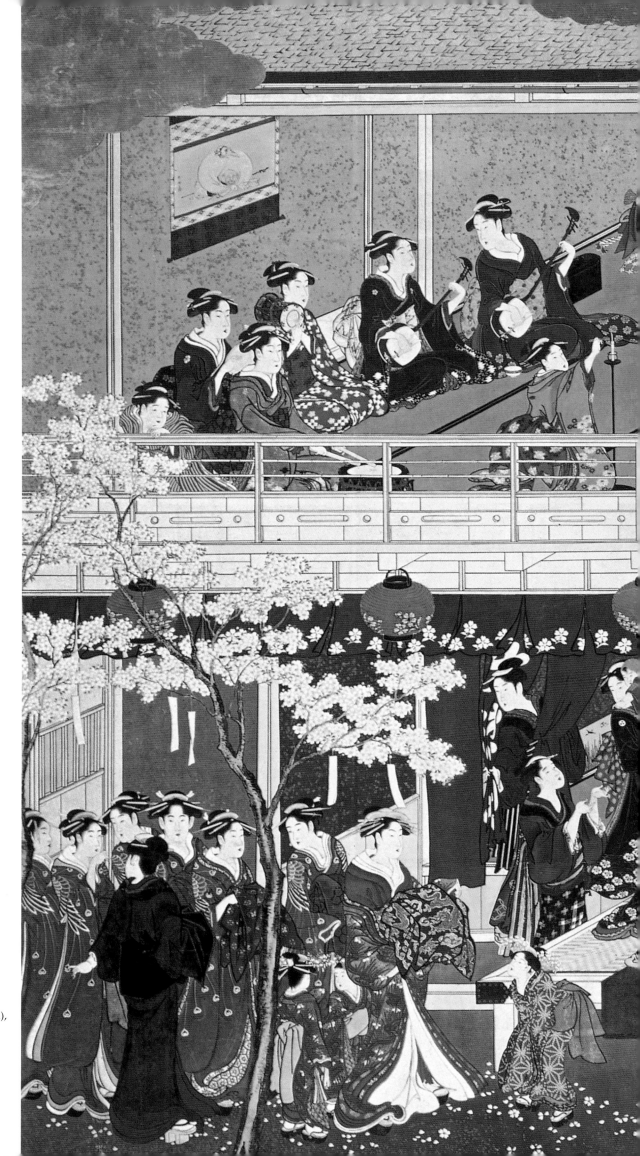

"Cherry Blossoms in the Yoshiwara" (Yoshiwara no hana),
c. 1793.
Ink, colour, gold and gold-leaf on paper,
203.8 x 274.9 cm.
Wadsworth Atheneum Museum of Art, Hartford.

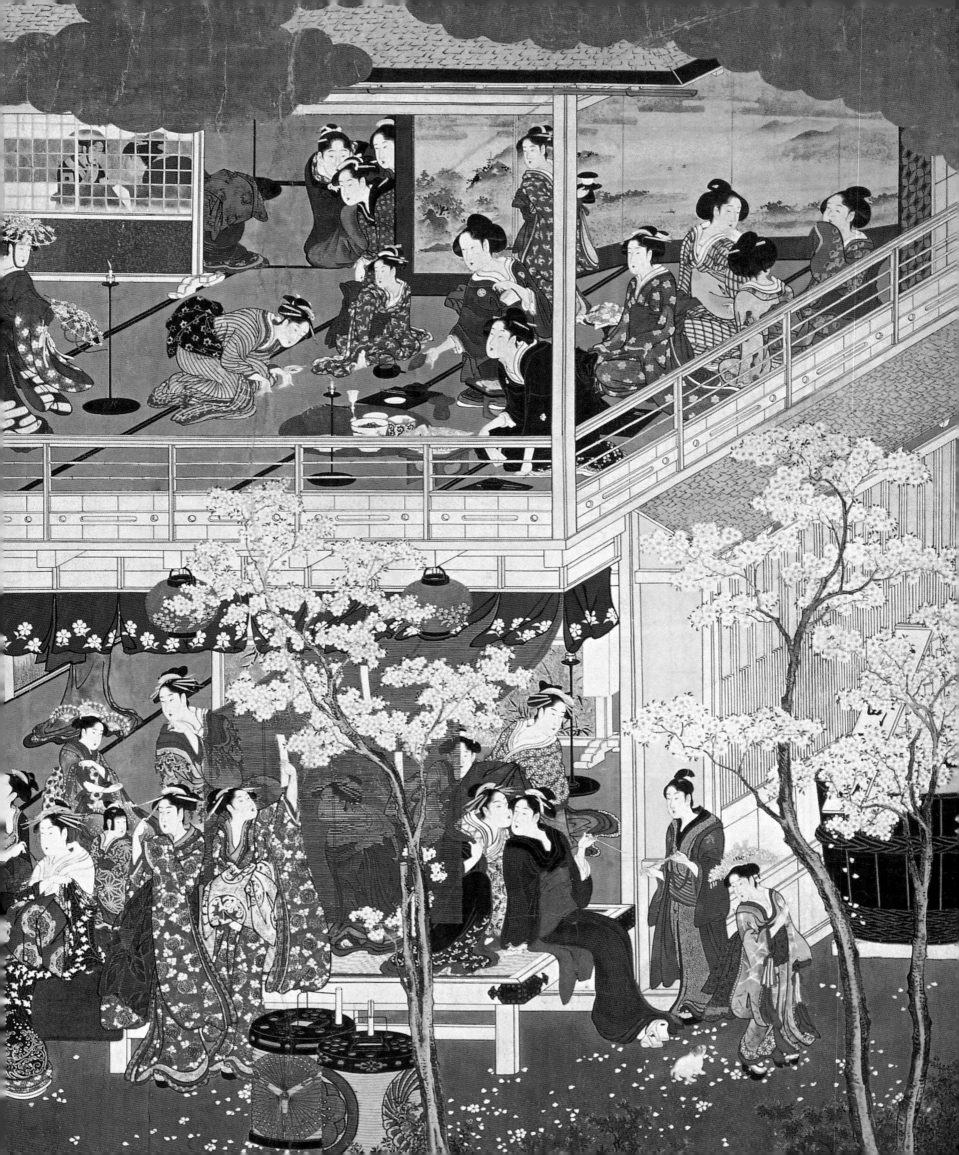

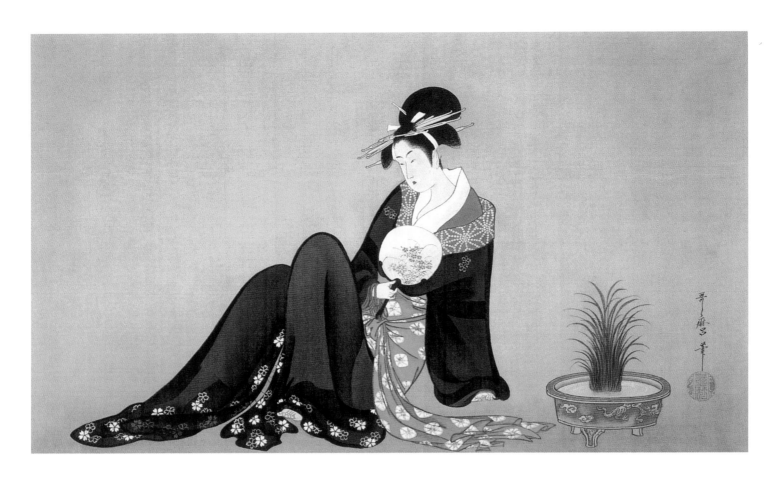

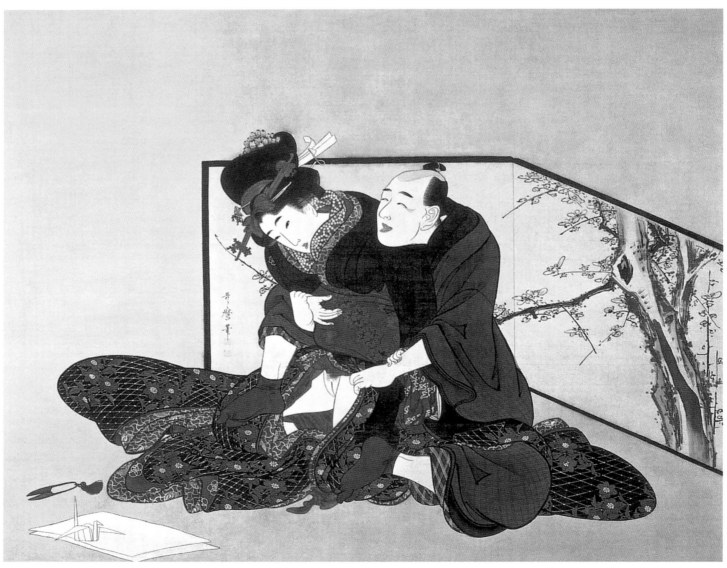

the paper is a foil for the green of the mosquito net, the touch of red on the child's smock, the powerful lacquer black of the woman's waistband decorated with a pattern of fern fronds shining against the matt background of the fabric. It is a *tour de force*, this juxtaposition of three hues against all these greys.

Another *kakemono** shows a Japanese woman unrolling a poem. She has that whitened face which gives nearly all the women of the *kakemonos** something of the look of a Pierrot. She wears a rust-coloured dress, along the bottom of which stems of white iris stand, and a black waistband decorated with flights of birds, of the same yellowish red as the dress. As in the preceding *kakemono**, the juxtaposition of a lacquer black and very diluted tints show a masterful talent.

We must also mention an enormous *kakemono** of three metres fifty wide by two metres forty high, the size of an entire wall, on which is a painting showing twenty-six women. It is a scene in perspective of the angle of an interior gallery of a "green house", overlooking a garden of snow-covered bushes, and showing courtesans, in charmingly-arranged groups, lazily lingering or rapidly ascending stairs, their feet bare under their sumptuous dresses. We see women playing with a little dog, carrying a tray of food, talking to one another from either end of a staircase, leaning over the railing with eloquent gestures, lost in thought, leaning against a wooden post with one arm around it, playing music, huddled around a brazier on which a teapot is boiling, while, in the background, one of them is passing by, carrying on her back a green sack containing bedding. A work in which we see once again Utamaro's figures, poses and graceful gestures, but done in a style which is glib, highly decorative, and lacking in transparency in its watercolours. It is an unsigned work, but which by its provenance must unquestionably be by the master, and this is why it has been said to be painted: worried by one of the many threats of imprisonment which Utamaro experienced as a result of publishing a satirical print, the artist hid for a certain time at the home of a friend in a distant province. This huge *kakemono** is said to be his thank-you gift for the hospitality he received there.

Some other printed *kakemonos**

On one *kakemono** there are two women whose attention is attracted by something happening on their right; one of the two holds at her side the large parasol hat which she has just taken off her head.

On another *kakemono** a woman is seen covering her mouth with her raised sleeve near a man who is squeezing or twisting a bit of fabric or paper in his hands.

On another *kakemono** a woman is standing at night, wearing a dove-coloured dress scattered with flowers, loosely open and revealing one of her breasts, above another woman sitting on her heels.

Or yet another *kakemono** representing a woman walking against the wind, one hand

Beauty Enjoying the Cool (Nōryō bijin zu),
c. 1794-1795.
Ink and colour on silk, 39.5 x 65.6 cm.
Chiba City Museum of Art, Chiba.

Man Seducing a Young Woman (Otoko to musume), 1801-1804.
Ink and colour on silk, 70 x 55 cm.
Tokushu Paper Mfg. Co., Ltd.

Woman at her Morning Toilette (Chōshō bijin zu),
c. 1801-1804.
Ink and colour on silk, 39.4 x 55 cm.
The British Museum, London.

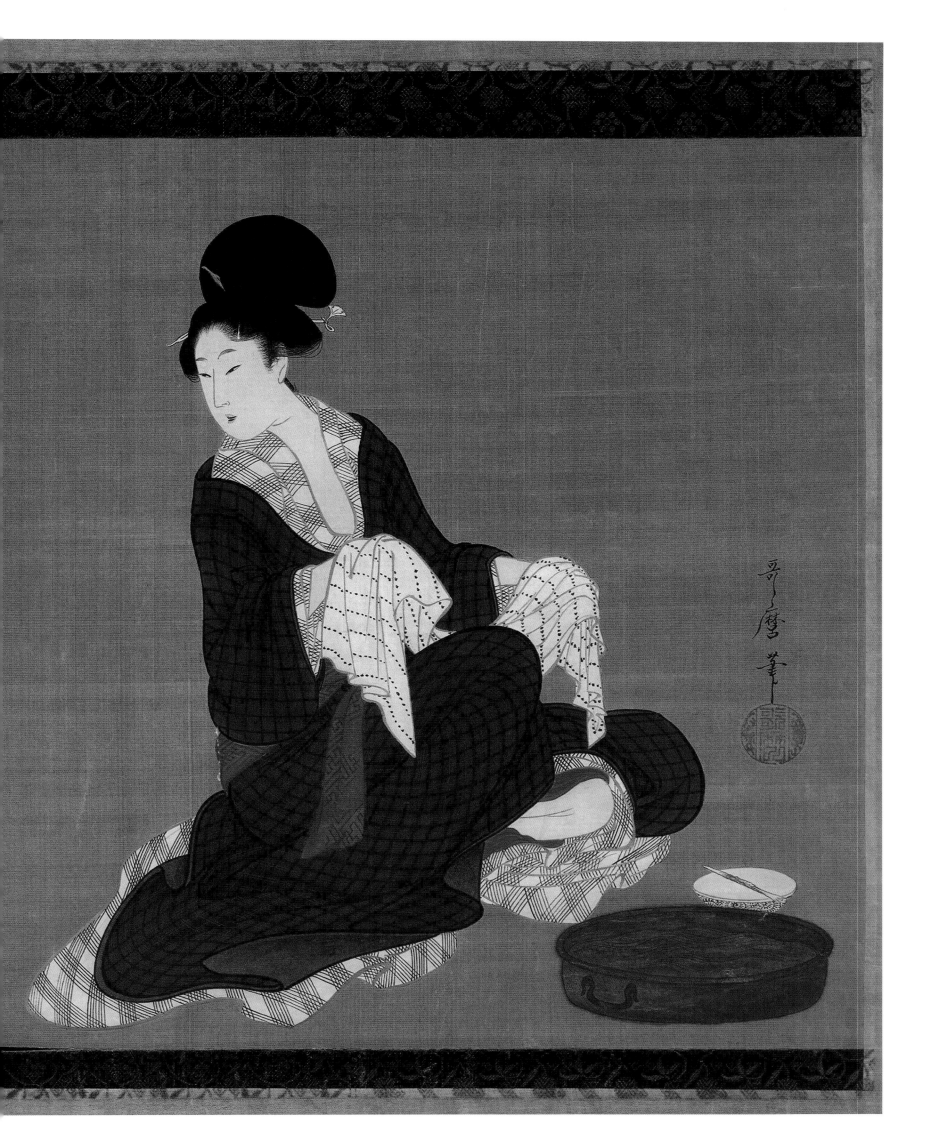

holding the black hood which is flying away, while gathering against her body the buffeted folds of her ample dress.

One *kakemono** shows an elegant Japanese woman in full length, in a mauve dress, on which are depicted two large *Hōō** with wings outstretched, and who has behind her a lacquered tray on an ornate stand.

On another *kakemono** a woman holds a child who is stretching his arms out to a little pinwheel, which another woman is spinning above his head.

A quite excellent printed *kakemono**, in very thick colours, shows a woman standing, leaning against a trellis, above another woman who is sitting on her heels playing with an overturned screen (collection of Mr Gillot).

Let us finish with four printed *kakemonos** of incomparable quality:

One *kakemono** shows a pretty geisha with silver pins in her hair, leaning on the neck of a *shamisen**.

One *kakemono** represents a woman leaning towards a girl who is carrying a child on her back; the print quality is equal to that of any of Utamaro's most delicate colour prints.

A *kakemono** where we see at a woman's feet a naked child, lying on the ground, who has wrapped his head in the train of the woman's dress of black gauze, so that his face shows as though tinted by the black flowered pattern of the diaphanous cloth.

A very unusual *kakemono**: in the upper portion a woman with a fish at the end of her line in the air, and in the lower portion a young man leaning out of the boat, filling a dish, with his torso reflected in the water; the most realistic reflection ever done by a Japanese artist.

4. Surimonos*

The *surimonos** are luxury prints, produced with great care on high-quality paper, with rare pigments, often with gold and silver highlights, parts in relief, embossing, and a high level of detail in the engraving. The slightest flaw in the printing resulted in its destruction. Their price was very high. *Surimonos**, specially commissioned from publishers or artists, were "private printings" of a limited number of copies; they were intended either to be presented on special occasions (birthday, New Year, congratulations on a marriage or homage to a famous actor), or for circles of poets or print collectors. The *surimonos** are generally in a reduced format, *shikishiban** (approximately 20 x 18 cm), sometimes smaller (15 x 10 cm), but there are some large pieces. Generally speaking one or more poems appear on the *surimonos**; they put the scene in context and explain its deeper meaning, and their graphic aspect contributes to the beauty and the balance of the design. Their subjects are more varied than in the "traditional" block prints.

Utamaro's *surimonos** are small prints which are of a higher quality than his *nishiki-e**. They are marvels of printing, done on paper that looks like the flesh of elderberries, in gently blended, harmonious colours, with an artistic embossing both intriguing and evocative and, in the midst of these

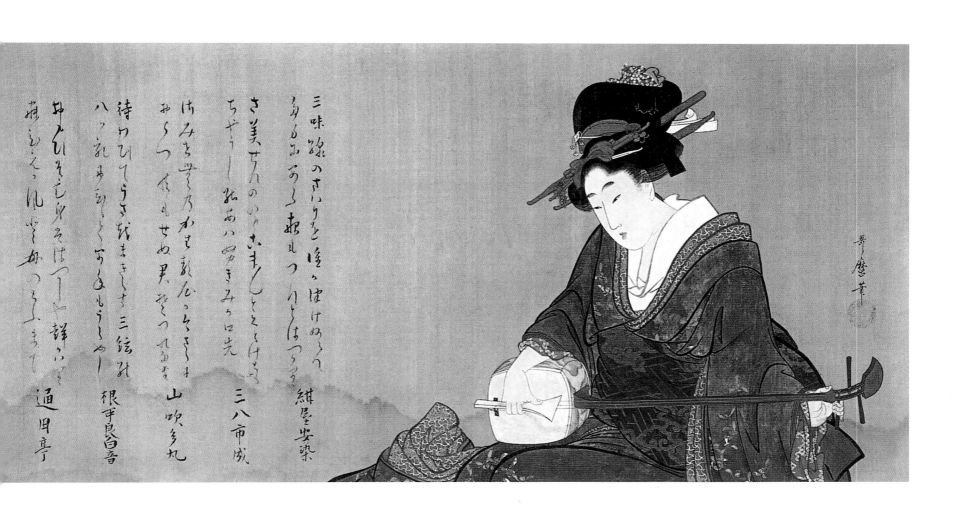

Beauty Playing the Shamisen (Shamisen o hiku bijin),
1804-1806.
Ink and colour on silk, 41.8 x 83.1 cm.
Museum of Fine Arts, Boston.

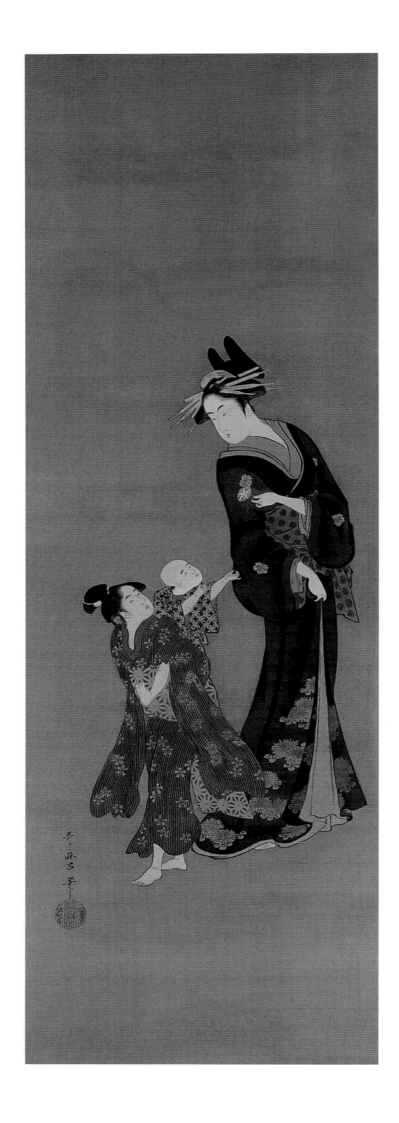

enchanted hues, the skilful, judicious, and dignified addition of gold, silver, and bronze. These pictures, done not for the general public but for sophisticated groups of art lovers and collectors, originated in the entertainments of tea societies and constituted the loose leaves of guest books. However, Utamaro, involved in his large colour prints, devoted very little of his work and his time to these images, and certain of these *surimonos** lack a personal feeling: the dainty little women could perfectly well be mistaken for the work of Hokusai.

Only a very small number of *surimonos** by Utamaro are known, amongst which we can mention:

A large *surimono** in which one sees the legendary, elderly Tagasago couple upon whom the Japanese call for important wishes, represented with their good luck attributes: the old woman with her broom, the old man with the sort of three-pronged pitchfork which was used to clean up pine needles.

Courtesan and Kamuro,
c. 1795.
Ink and colour on silk, 91.6 x 31.3 cm.
Chiba City Museum of Art, Chiba.

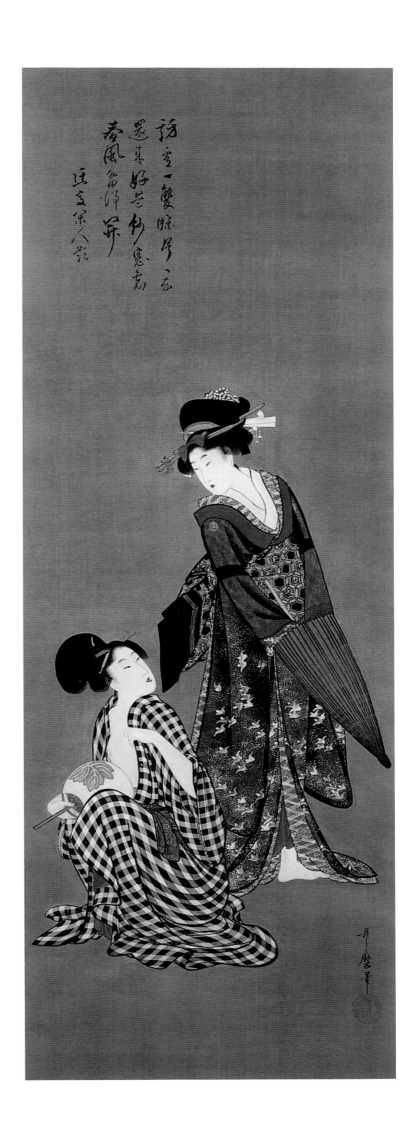

Another large *surimono** represents the only theatrical scene known to have been designed by Utamaro.

Yet another large *surimono** shows three women, a washerwoman and two courtesans, the washerwoman painted by Kitagawa Tsukimaro, one courtesan by Utagawa Kunisada, and the courtesan with the silver waistband by Utamaro.

A small, humorous *surimono** represents an animal trainer whose dancing monkey wears on its head a red paper "dance of the lion", as an enraptured child looks on.

On another small *surimono** of the same group, a little girl is petting the articulated head of a toy tiger while pretending to be afraid!

Among the small *surimonos** representing daily life, the themes are quite varied: a *New Year's Day Visit*, in which a woman is filling a cup of warm sake for her caller; another woman

Two Beauties,
c. 1800-1805.
Ink and colour on silk, 103.5 x 31.8 cm.
The Metropolitan Museum of Art, New York.

with her elbows on a small table is smoking and turning her head towards the song of a nightingale, perched in a tree growing against the house; a courtesan is chatting with her *kamuro**, or another courtesan is out walking with her two *kamuros**.

It is among those examples featuring the objects of daily life that we find the most perfect *surimonos**, in which the reality of the small, artistic items used by Japanese hands was rendered in a way which could be said to go well beyond mere success in the mass production of art. As an example: a bouquet of chrysanthemums, of all colours, in which the white flowers stand out embossed on the white paper, spreading out of an esparto-ware vase over the top of a partially unrolled *kakemono**, on which we can make out the picture of a woman, and next to that, the box which had held it.

Utamaro enjoyed the greatest of popular success. Early in this century, a traveller from the province of Iwaki, who was continuously on trips to the northern region for his business,

and who happened also to be very keen on prints, visiting collectors wherever he went, asserted that in all the provinces of Japan Utamaro was considered to be the greatest master of the empire, whereas Toyokuni was very little known.

Interesting testimony to this popularity can be seen in the artwork. One *surimono**, with all the characteristics of the work by the master but surely done by one of his pupils, illustrates this phenomenon. This *surimono** shows a large pleasure boat with its cabin full of women, elegantly portrayed in the manner which was the artist's own throughout his life. The boat is marked in large Utamaro characters, *The Utamaro Boat.* In the same vein as the story by the Japanese traveller and the image of the Utamaro boat, it is said that in the latter years of his life Utamaro's studio was constantly besieged by publishers placing orders with him, as though there were no other artist in all of Japan. Utamaro's talent was appreciated even in China, whose merchants sailed in and out of Nagasaki buying his colour prints in great numbers.

Among the artists who were his contemporaries, in addition to Toyokuni, who was Utamaro's rival and competitor, and who pursued the same goal of gracefulness in his works, there was another master with whom Utamaro sometimes has a great deal in common. Need we say the name of Yeishi, whose women appear as more naïve, more mystical, one might even say more religious. Indeed, they appear more like the women in western medieval miniatures, yet have the same slender elongations, the delicate little necks and thin forearms, as well as the oriental nonchalance in their poses and movements as the women of Utamaro. There is an even more striking similarly between the two artists. They are the only two who printed *nishiki-e** where the harmonious charm is achieved by using just the three colours of blue, green, and violet, on a yellow background, with a spot of black in a dress or waistband – a charm at once gentle and severe, a bitter-sweet charm. Prints such as *Little Daimyo Out Walking* or *A Sparrow on the Hand* illustrate this phenomenon.

The Three Stars of Happiness, Wealth and Long Life (Fukurokuju sansei zu), c. 1794.
Ink and colour on silk, 82.9 x 35.9 cm.
The Japan Ukiyo-e Museum.

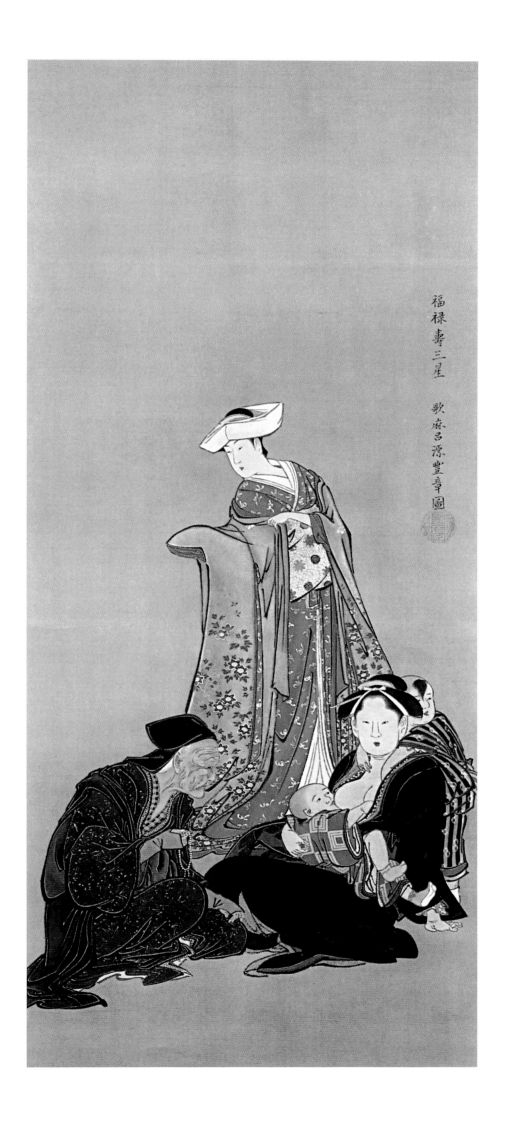

福禄壽三星

歌麿呂源豊章圖

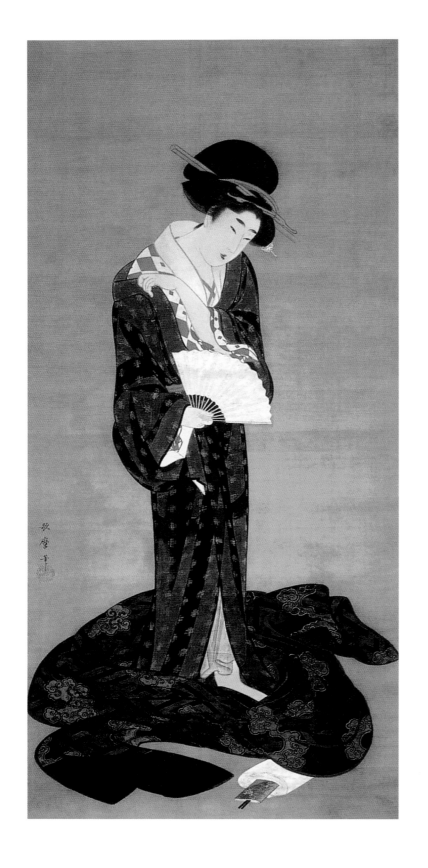

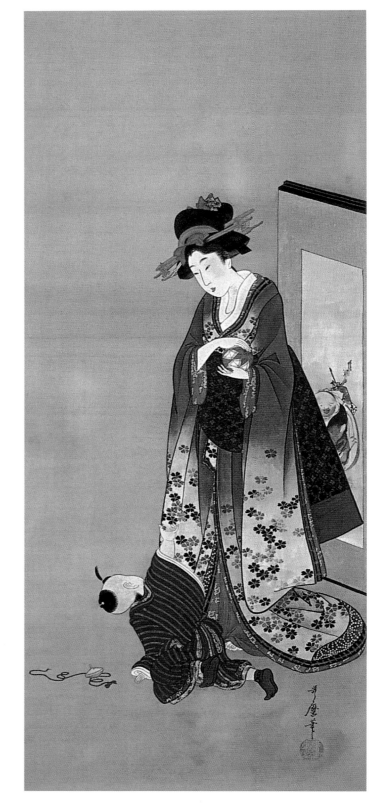

To these *surimonos** we must add the seven pages of that album or book not known to exist intact, from which Mr Gonse owns five prints and Mr Bing two. Very subtly coloured prints, with spectra sometimes limited to two or three hues, sometimes reduced to an endive-green in the landscape only.

1. *Horses Grazing, with One Horse Rolling on the Ground.*
2. *A Fisherman Smoking, While Watching Three Lines.*
3. *An Appearance of* Sennin *in the Sky, above a Woman Washing Clothes.*
4. *The Fox Trap.*
5. *A Daimyo* Sleeping on His Horse, Led by a Peasant.
(from the collection of Mr Gonse).
6. *A Washerwoman Striking a Flint to Light her Pipe.*
7. *A Japanese Nobleman Accompanied by his Jester.*
(from the collection of Mr Bing).

In the *surimonos** of the Bing collection, there are some in a rough style, similar to that of the Kyōto *surimonos**. One in particular represents an old man surrounded by children lying at his feet, a print looking very much like an Indian ink drawing with the barest hint of blue in the streaks of a rain storm.

Another *surimono** from the Gonse collection represents an elderly nobleman in Chinese dress, chatting with a warrior leaning on his lance in a snowy landscape. This sheet was perhaps part of *Famous Warriors*, a series published from 1775 to 1780, under the influence of Kiyonaga.

We should also add the *surimono** picturing New Year's wishes to the women of a "green house" who are listening from behind a screen, by the *manzai*, those joyous dancers whose clothes were decorated with storks and pine boughs — the two symbols of longevity — ,

and who, on New Year's day, run through the streets and houses, crying *Manzai manzai!* which means "Good wishes for ten thousand years of life!"

One must also mention two long prints, printed as *surimonos** (Gillot collection), one representing men measuring a huge tree with their arms stretched around it, the other showing a peasant woman nursing her infant, while an older boy fishes in a river. These two plates have a rather rudimentary technique with the figures sometimes treated in a perfunctory manner, but might well be part of the artist's work. According to E. de Goncourt they should be added to the series of seven prints of the Gonse and Bing collections.

Also in the Gillot collection there is a print of horses, slightly crimson, slightly blue, and not without a similarity to the horses of Delacroix.

Beauty Undressing (Kōi bijin zu), c. 1803-1805.
Ink and colour on silk, 117 x 53.3 cm.
Idemitsu Museum of Arts, Tokyo.

Young Woman with a Child (Musume to kodomo),1804-1806.
Ink and colour on silk, 96.6 x 40.5 cm.
Idemitsu Museum of Arts, Tokyo.

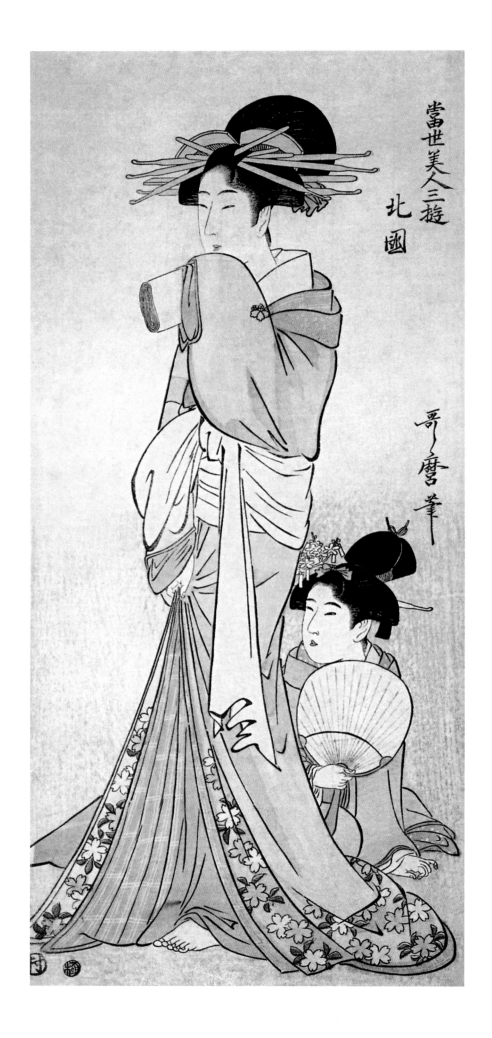

They gallop wildly under a sky crossed by a red cloud. The stroke is done with fat lines, broken and interrupted here and there, as on the lacquered boxes by Korin, with wide lines resembling a series of long dashes.

There is also a series of works printed like *surimonos** (Gillot collection), in an unusual format: they have the tall format of *kakemonos**, but they are not *kakemonos**.

One of these *surimonos** (32 x 15 centimetres) represents a fantastical apparition. Against the grey of the night, which ends in a solid black band at the top, a sort of half-man, half-ghoul, in the white robe of a ghost, his long shapeless hair blowing before him in the wind, angrily brandishes a skeletal hand above his head, while from his mouth comes a tongue zigzagging like the lash of a whip.

The second *surimono** (39 x 17 centimetres) represents a man with two swords, appearing to try to free himself from the clutches of a hooded woman clinging to his back.

Three Amusements of Contemporary Beauties (Tōsei bijin san'yū), from the series *Northern Quarter* (Hokkoku), c. 1800.
Naga-ōban, nishiki-e, 52.9 x 23.6 cm.
Tokyo National Museum, Tokyo.

The third *surimono** (32 x 15 centimetres) shows a man and a woman. The woman leans over the man's shoulder, and in a graceful movement extends her hand to open the umbrella that he holds in front of him.

These two latter *surimonos** are done in high style, with sober colourings, a bit tawny, a bit bistre, in that colouring from the master's prime, at the same time that he brings, in the decoration of his robes, a very recognisable archaism.

Let us also cite, in the Gonse collection, the works printed as *surimonos**: *Three Children dancing around a Lantern, A Beggar Showing a Sickly Arm to a Woman He Hopes Will Pity Him, A Vendor of Tea or Some Other Drink, Set Up under a Willow, in the Open Countryside.*

5. *E-makimonos**

The *e-makimonos** are long scrolls on which a composition plays out horizontally. These paintings on lengths of paper rolled around a

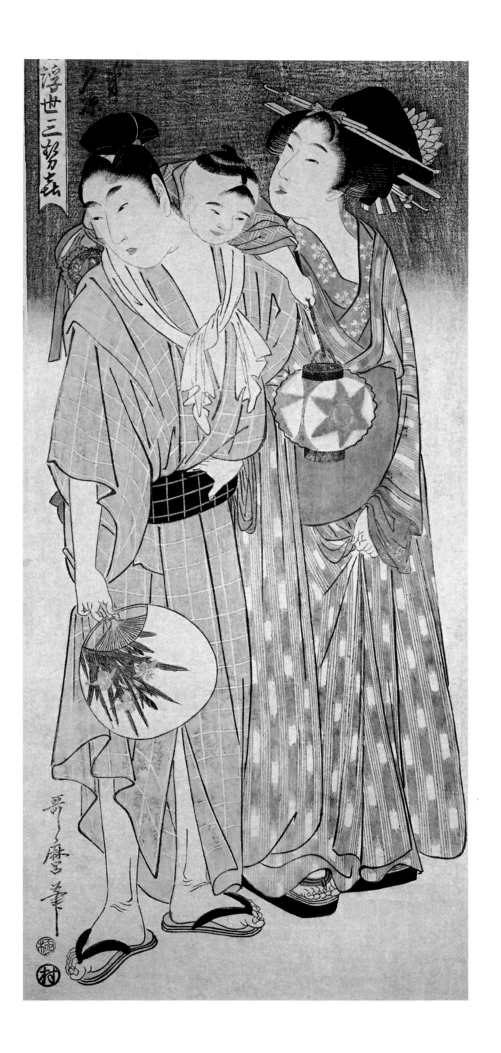

"Brothers and Sisters enjoying the Evening Cool" (Kyōdai no yū-suzumi), from the series *"Three Evening Pleasures of the Floating World"* (Ukiyo san saki), c. 1800.
Naga-ōban, nishiki-e, 50.8 x 23.1 cm.
Museum of Fine Arts, Boston.

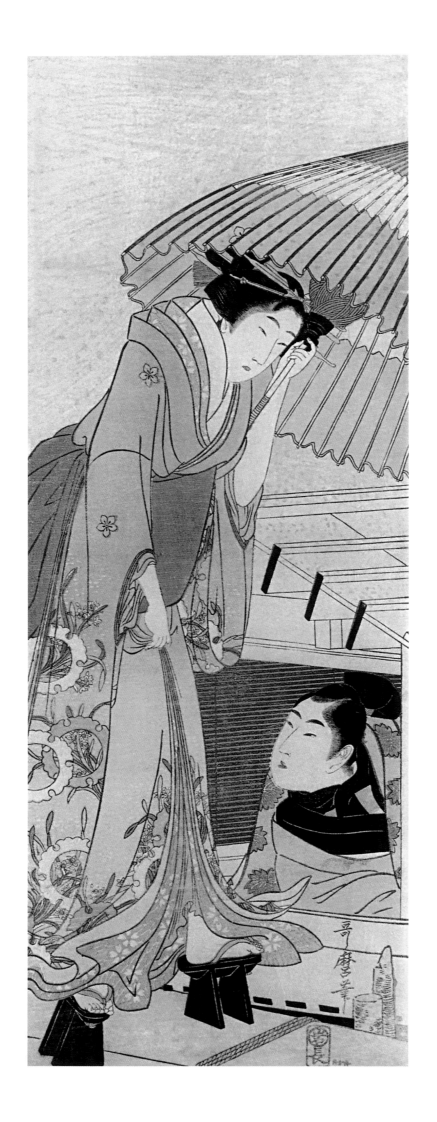

wooden dowel were used particularly to show religious texts, and had to be unrolled to be read. These scroll paintings could reach a length of some twenty metres by fifty centimetres wide and were read from right to left. This style of painting, which originated in the eighth century, reached its height in the thirteenth and fourteenth centuries and lasted until the nineteenth century.

Utamaro left several *e-makimonos**, on which he bestowed the finest qualities of his talent. One remembers in particular those erotic scrolls, thirty-five centimetres high by five metres wide, scarcely coloured on *écru* paper. These views are bathed in *grisaille* of a slightly mauve tonality, with a hint of discreet colouring here and there, and contain nine admirably executed scenes. The expressions, the poses, the movements are so natural and life-like that one forgets that this is an erotic scene; the finish and variety in the ornamentation of the dresses, the lacquer-black value in the women's loose hair are all remarkable.

Landing-Stage in the Snow (Yuki no sambashi), c. 1800.
Naga-ōban, nishiki-e, 51.9 x 18.9 cm.
The Metropolitan Museum of Art, New York.

Yaoya Oshichi and Koshō Kichisaburō
(Yaoya Oshichi, Koshō Kichisaburō), c. 1800.
Hashira-e, nishiki-e, 63.9 x 14.9 cm.
The Art Institute of Chicago, Chicago.

"Komurasaki of the Miuraya and Shirai Gompachi" (Miuraya
Komurasaki, Shirai Gompachi), c. 1800.
Hashira-e, nishiki-e, 64.2 x 14.2 cm.
The Art Institute of Chicago, Chicago.

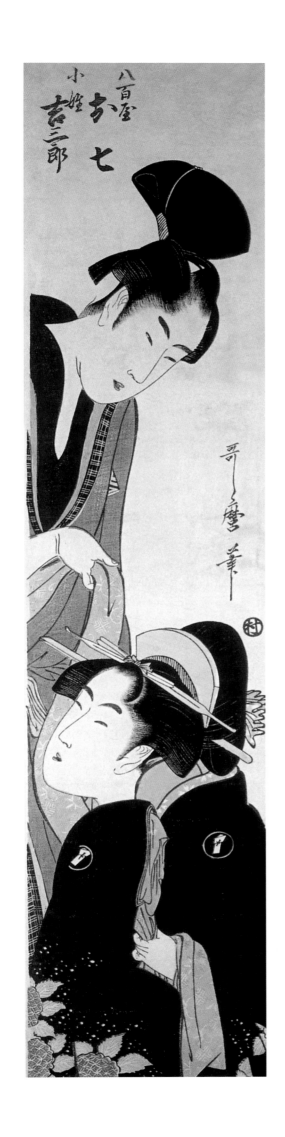

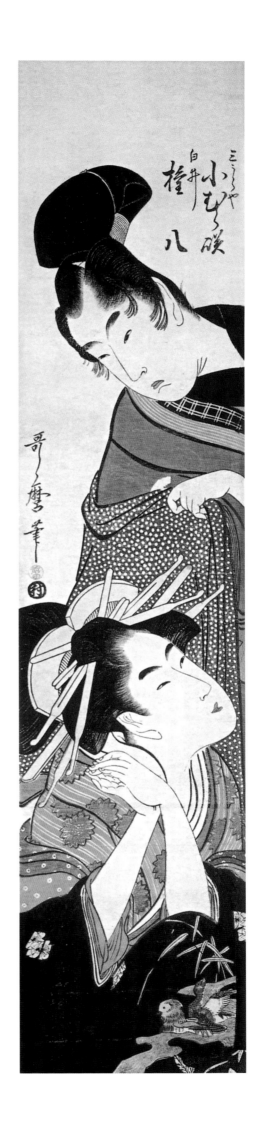

同 河童を釣るの法

III. THE BOOKS

The origins of the *Ukiyo-e** movement can be traced to the rise of the cities at the end of the sixteenth century. This led to the creation of a class of merchants and craftsmen, eager for stories and pictures which were anthologised in *ehon** or novels, such as the *Tales of Ise* (*Ise-monogatari*, 1608) by Hon'ami Kōetsu. The *Ukiyo-e** were often used to illustrate these books, but they progressively moved away from them and took the form of prints on single sheets (postcards or *kakemono-e*) or posters for the *kabuki** theatre. The sources of inspiration for these works were at first stories and works of art in the Chinese style. Many of these stories were based on city life and culture. These works were, generally speaking, commercial and widely distributed.

I. Little Yellow Books (Kibyōshi)

The first contact between the Japanese public and Utamaro's talent was in the illustration of popular novels, in these small-format books with yellow covers, printed in black and white on ordinary paper, printed in haphazard fashion, and which the Japanese call *kibyōshi**, yellow books, taking their name from the colour of their covers; cheap publications, sold widely, on which the artist worked from his earliest days, in 1783, until 1790. Utamaro went on to *nishiki-e** only after the *kibyōshi**.

These small, cheap books tell, for example, the story of *Aoto's Coin* by Kioden Kitao Masayoshi, (*The Sapeque of Aoto. Tamamighaku Aoto-gha-zeni*, a small book, in three volumes, published in 1790). Aoto-ga-Zeni, a legendary judge, one day lost a coin in a stream and decided to hire people to find it, which cost him a hundred times the value of the little coin that he had lost. After which he said, "What is paid to men is never lost, but what you leave in the stream does not bear interest." There is in this little book a witty rendering of the graceful poses and movements of women and, in a composition representing men and women wrestling, the artist begins to show certain knowledge of anatomical forms.

The success of these little books in black and white led the publishers to offer the public some series in a larger format and higher quality; in them, Utamaro's talent grew year by year. Of note among them were: *The Bouquet of Words*, 1787; *The Sparrow of Edo*, 1788, *The different Classes of the Japanese Population*, 1780; *The Harbour Basin of Surugha*, 1790. Utamaro let the years 1785, 1786 and 1787 go by without publishing any yellow books, but publication resumed in 1788. In 1785, Mitimaro and Yukimaro, trained by the artist, began to collaborate in illustrating yellow books.

The following are the other known little yellow books:

Tales for the Lighting of the Stove:
These are tales told on the little festival honouring the first use of the heater for the house and tea at the return of winter (small book in two volumes, published in 1789).

Brief History of a Smartly-dressed Gentleman: (small book in three volumes, published in 1781).

Ledger of Receipts for Lies: (small book in three volumes, published in 1783).

Strange Way to Fish the Kappa (facetious image),
18th century.
Bibliothèque nationale de France, Paris.

Young Woman on an Elephant, from the series *Prostitute's Sermon at a Stony Place: Words of a Woman from the South-East* (Tatsumi Fugen), Spring 1798.
Sharebon, one volume, 15.5 x 11 cm.
Bibliothèque nationale de France, Paris.

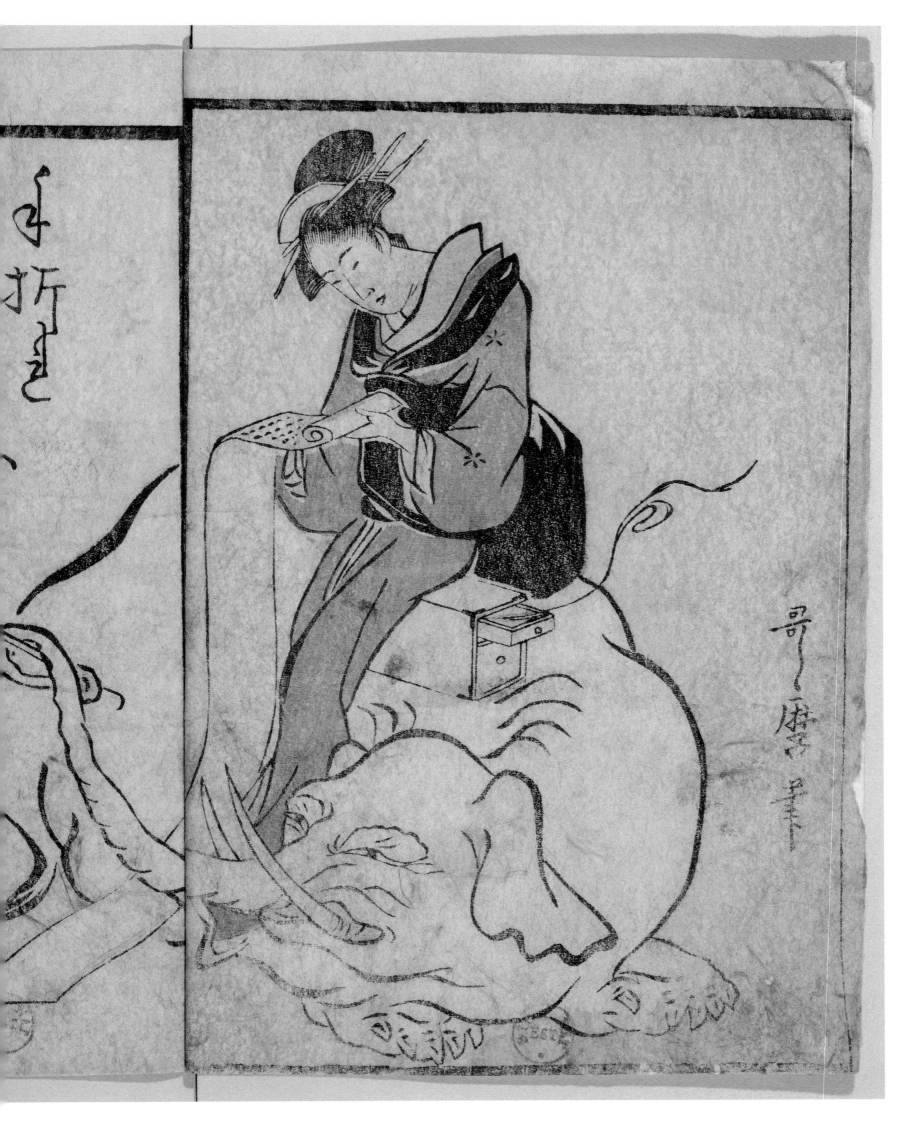

History of Since: (small volume published in 1784).

The Universe across a Hedge: (text by Sanva; small book in two volumes published in 1784).

Details on the Second Alliance of Kajiwara: (text by Shibō Sanjin; small book in two volumes published in 1784).

The Unknown Depth of Thought: (text by Shikibu; small book in two volumes published in 1784).

Military Skill of Nitta: (text by Sadamarou; small book in two volumes published in 1784).

The Snow Woman of the Yoshiwara (for the first day of the eighth month): (small book without date).

The Seventh of the Twelve Zodiacs: (small book in three volumes, published in 1789).

Story of the Longevity of Yutchōrō: (small book in three volumes, published in 1790).

Duties to the Master and to Parents are an Enjoyment: (small book, published in 1790).

Instruction on the Spot by Ear: (small book, published in 1790).

Tales of Passing Fancies that I Do Not Like to Hear About: (small book in three volumes, published in 1790):

Utamaro apparently then stopped publishing his little yellow books, which had gone on from 1783 to 1790, the year of *The Story of the Sapeque of Aoto*.

2. Small books (*Mangas*)

To the yellow books must be added the small books, also printed in black and white, in the format of the *mangas**. Among these books we find one entitled *Kannin Bukuro* (Sack of Patience) with the epigraph: "Do not let the cave of wrath explode." This is a peculiar little volume in which the human features of the people are replaced by characters, which the Japanese use to represent good and evil genies. One illustration shows a fisherman pulling a large number of these creatures from his net.

We could also name:

The Bouquet of Words:
(published in two volumes in 1787).

The Sparrow of Edo:
Illustrated poetry about famous places in Edo (published in three volumes in 1788).

Poetry on the Milky Way:

A fine volume with beautiful prints, illustrated with twelve prints (produced by the famous publisher Tsutaya Jūzaburō in 1790).

The Dance of Surugha:
Poetry about famous places in Edo (published in three volumes in 1790).

Scenes of Daily Life:
Poetry with rhythmical allusions (published in three volumes, without date).

New Spring: (probably printed in 1802).

3. Erotic Books *(Shungas)*

Every Japanese painter has an erotic work, his *shungas**. The painter of the "green houses", with his talent devoted to the grand prostitutes and to rich venal love, could not fail to have in his enormous output work with a libertine side, of images à la Jules Romain, an "inferno" in bibliographical parlance.

The erotic art of this culture is studied by those devoted to drawing for its fieriness and fury in these almost enraged copulations, for the fracas of these rutting couples knocking

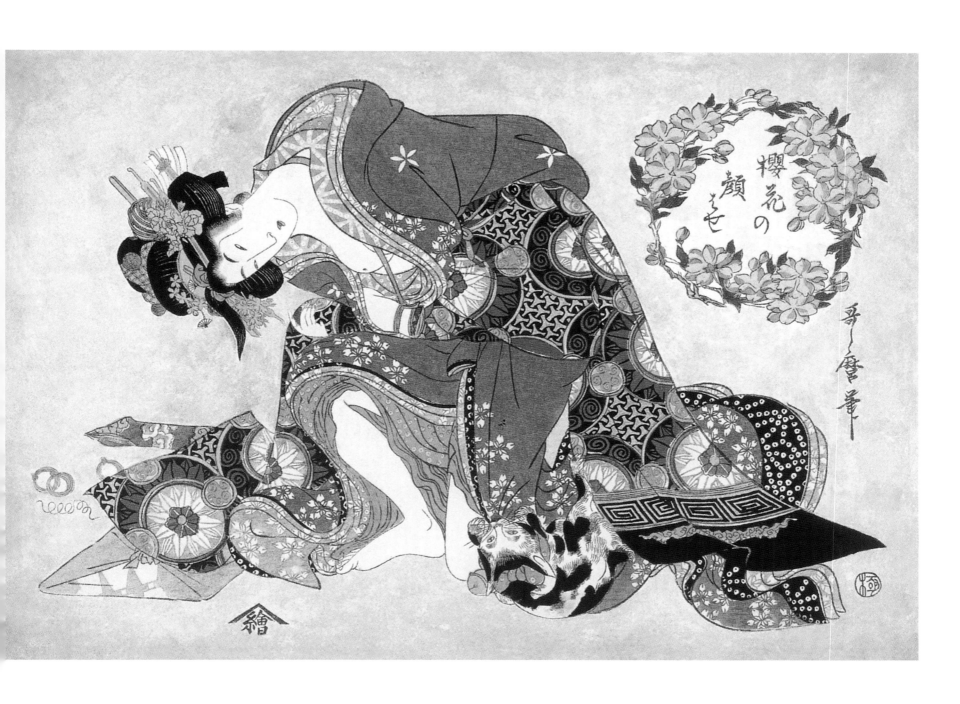

Courtesan in her Privacy, c. 1790.

Ōban, nishiki-e, 25.8 x 37 cm.

Musée national des Arts asiatiques – Guimet, Paris.

Lovers, from the album *Poem of the Pillow* (Utamakura), 1788.

Illustrated erotic book, one volume, nishiki-e, 25.5 x 37 cm.

The British Museum, London.

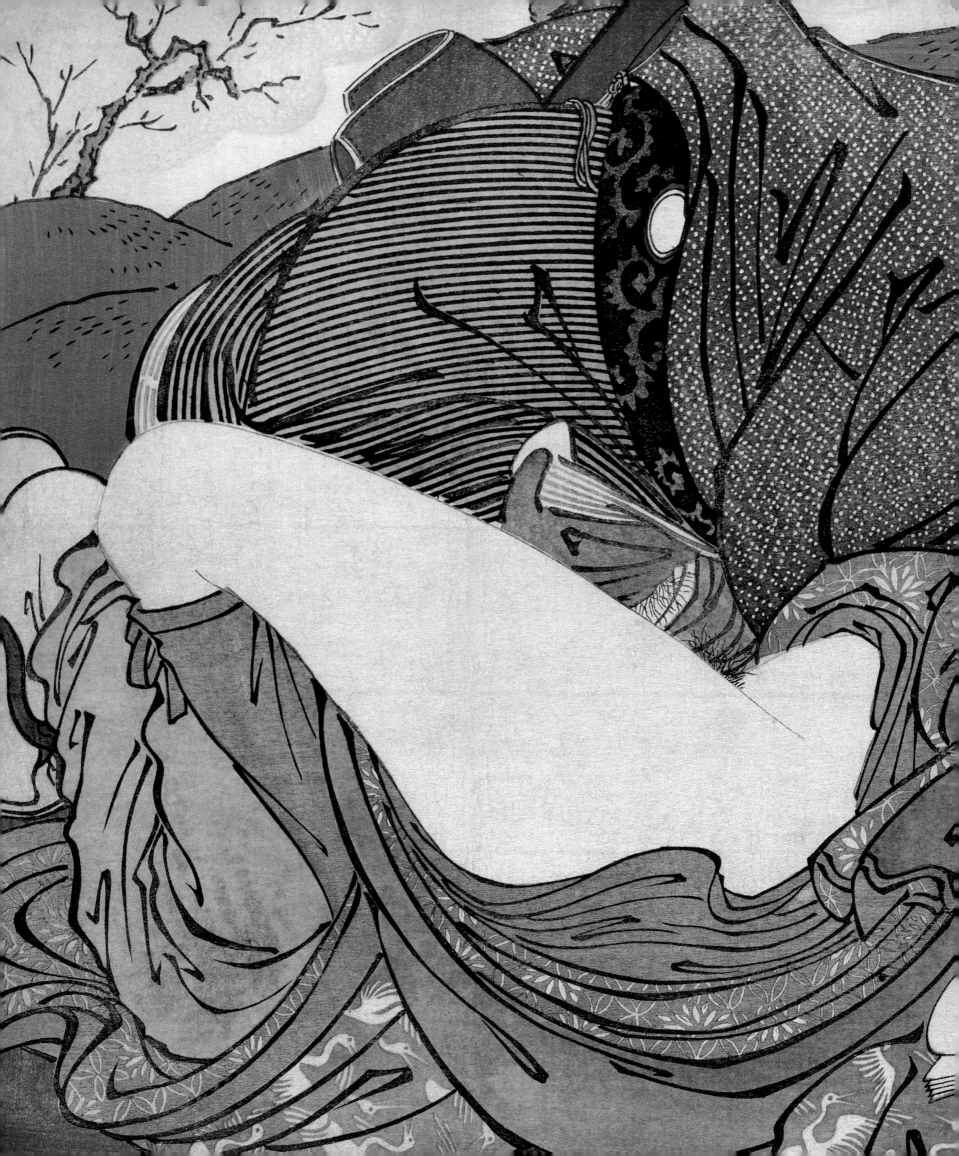

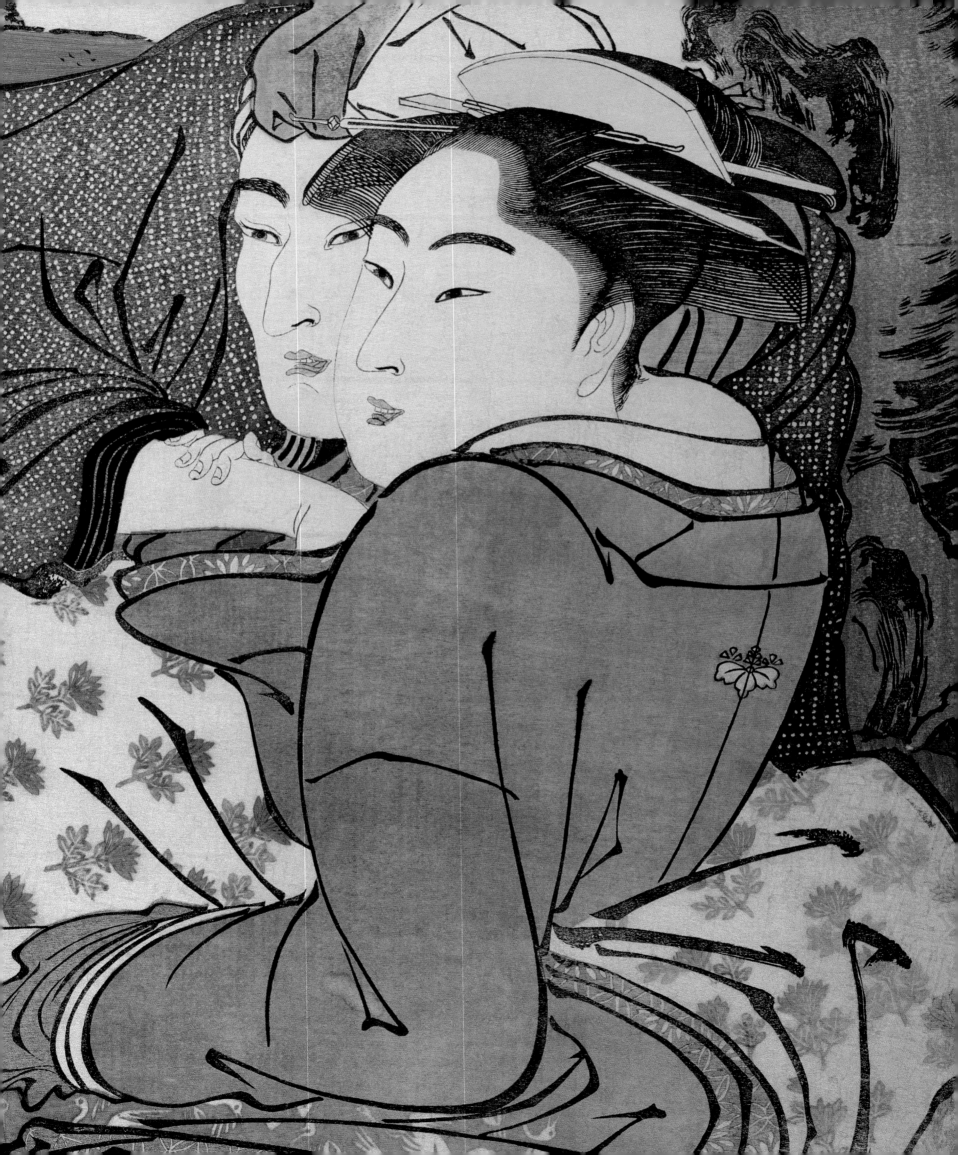

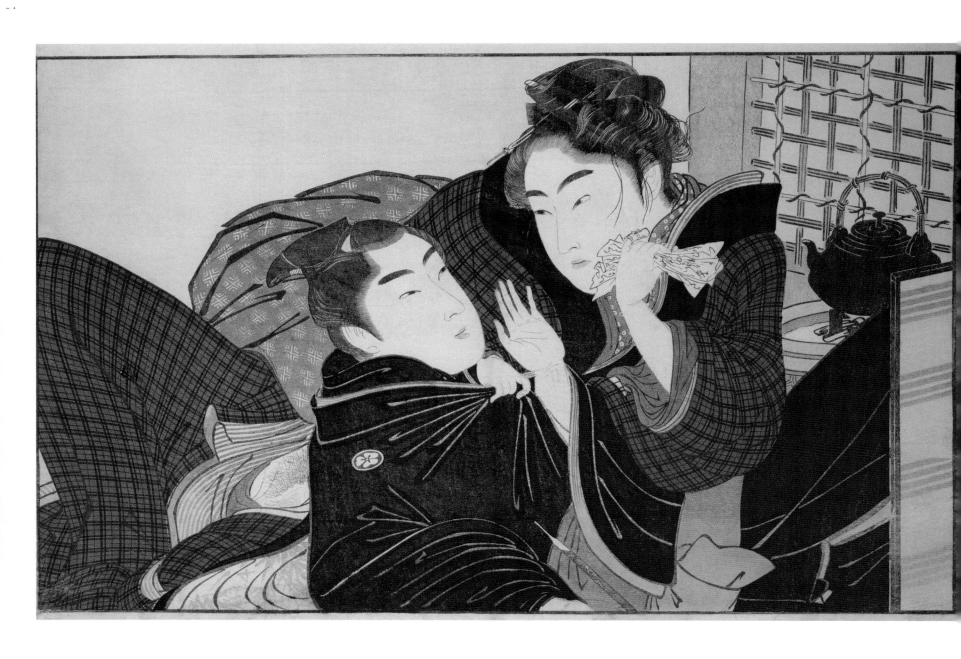

Woman Discovering a Letter Hidden in the Robe of her Young Lover, from the album *Poem of the Pillow* (Utamakura), 1788.
Illustrated erotic book, one volume, nishiki-e, 25.5 x 37 cm.
Victoria & Albert Museum, London.

over screens in the room, for the tangles of these bodies locked together, for the climactic frenzy of arms both hastening and delaying coitus, by the spasms of these feet with twisted toes, thrashing in the air; by these kisses by flesh-seeking mouths, for these swooning women, their heads rocking back on the floor, with the "hint of death" on their faces, eyes closed, under their painted lids, in sum, for this strength, this power in the line, which makes the drawing of a penis the equal of the Louvre's Hand by Michelangelo. And in the midst of these animal paroxysms of the flesh, delightful moments of contemplation, blissful abandonment, bowed heads worthy of our primitive painters, mystical poses, or the movements of an almost religious love.

Occasionally in these erotic works, there occur comically outlandish imaginings, such as the sketch showing the lascivious dream of a woman who has thrown back the covers from her overheated body and who sees before her a farandole of phalluses, swaying and dancing in Japanese robes, fanning themselves with enormous fans; a quite unusual composition, hatched from the brain and brush of an artist in an hour of libertine whimsy. Occasionally there occur horrifying illustrations, illustrations which terrify. As in the naked body of a woman who has swooned from pleasure, *sicut cadaver*, on rocks green with algae to the point that we do not know if she is drowned or alive, and whose lower body is being sucked in by an enormous octopus, with its frightening pupils in the shape of black crescent moons, while a small octopus eagerly devours her mouth.

In the strange book entitled *The Illustrated Encyclopædia for Children*, in which the illustrations are somewhat reminiscent of books by authors with a deranged imagination and outlandish concepts, those slightly mad books in which, to use Montaigne's expression, "the mind acting like a runaway horse gives birth to wild dreams," in this compendium which is at once astronomical, astrological, physiological, and heteroclite, there are kinds of philosophico-pornographic rebuses where the sexuality of humans turns into charts of the heavens and of earth, where the men are transformed into fantastic creatures from unknown planets, and where women's private parts become now an apocalyptic bird of prey, now a landscape with a distant Fujiyama.

Utamaro was the creator of a number of albums in black and white and in colour, where his artistic qualities were still present, but where the nudes of his courtesans lack the grace which they so embody when clad in their ample, flowing robes.

There are nonetheless several compositions worthy of the master. In the book entitled *The First Essay on Women*, there is a charming drawing of a woman, her arms wound well around her lover's neck and her head curved like a turtle dove rubbing the man's chest with the nape of her neck, while the lower parts of their bodies are locked in sexual union.

In *One Thousand Kinds of Colours* there is an amusing illustration. It is of a woman dropping her lantern at the sight of four feet sticking out from under a blanket, two of them very hairy, and with approximately this caption from the mouth of the woman: "How can there be four feet in one person's bed?"

We must mention a print taken from the erotic book entitled, *Poem of the Pillow* (pp. 178-179, 180, 182-183). This is a large album printed in colour, containing a frontispiece and eleven prints, including a portrait of Utamaro, with text. This is Utamaro's most beautiful erotic book, published in 1788. This picture shows Utamaro, having left the garden and entered the house, in much greater intimacy with one of the inhabitants of the establishment. This is a large horizontal composition, in which there lies a man on a bench in front of a balcony railing, over which peeks the green branch of a bush. His head, facing forward, is largely hidden by a woman seen from the back who is kissing him on the mouth and leaving visible only a bit of the man's cheek and chin, which her hand holds in a torturous and passionate grip.

Lovers in the Private Second-Floor Room of a Tea-House, from the album *Poem of the Pillow* (Utamakura), 1788. Illustrated erotic book, one volume, nishiki-e, 25.5 x 37 cm. Victoria & Albert Museum, London.

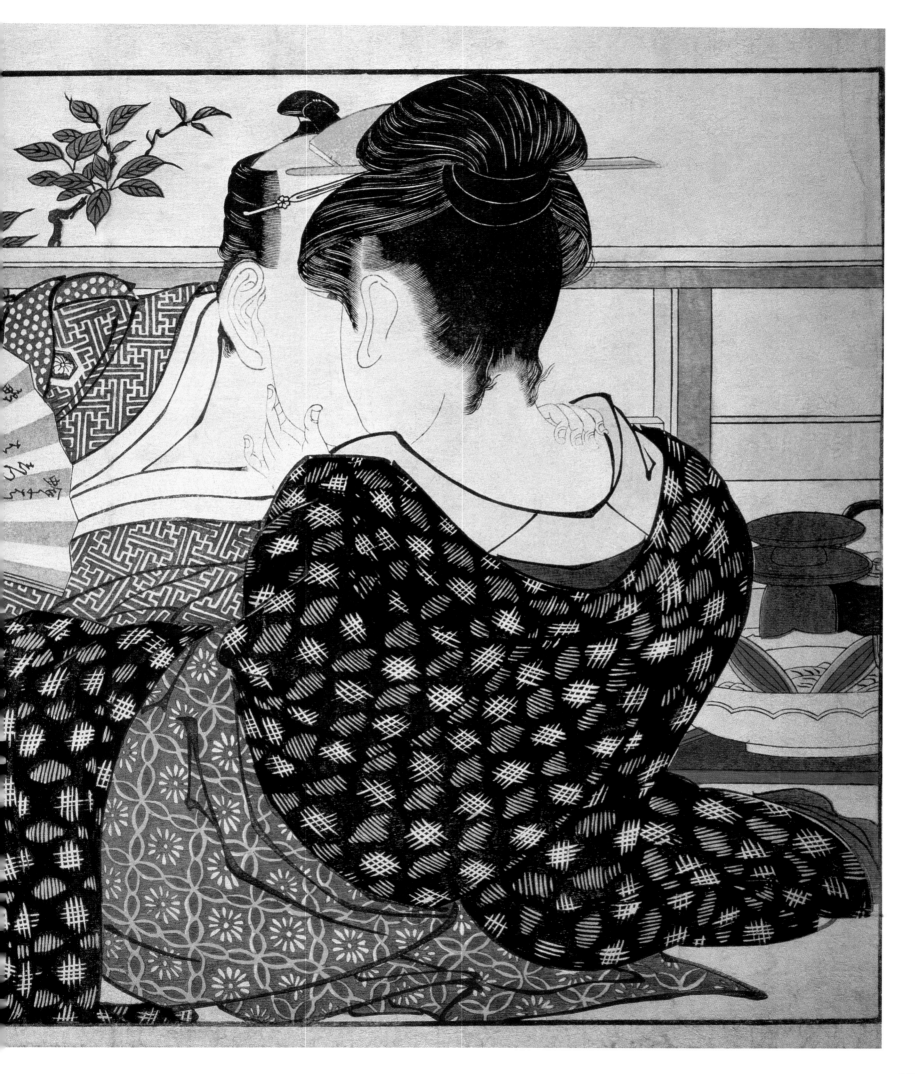

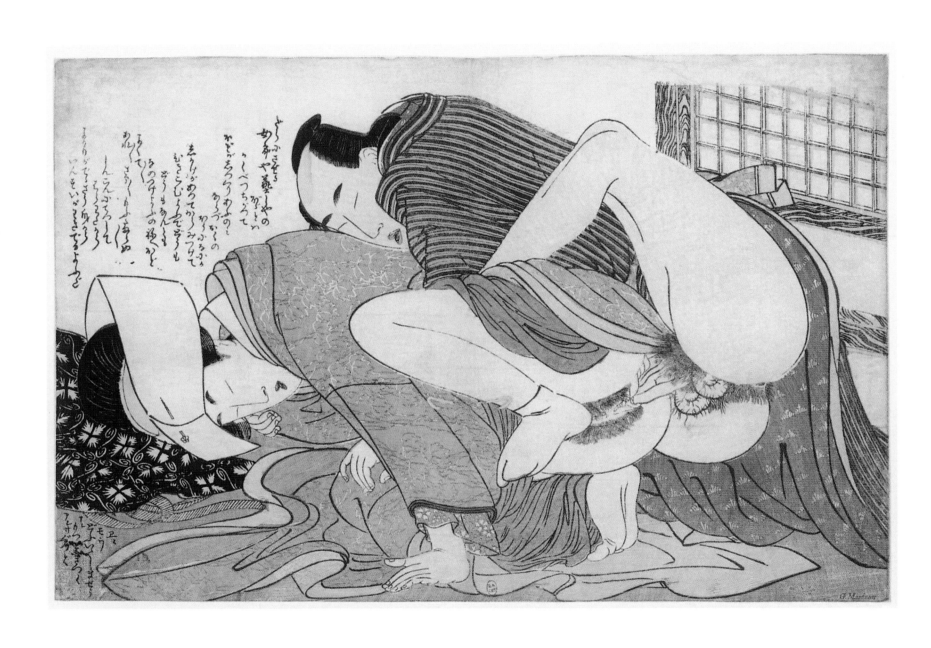

Page from the album *"Collection of Beauties"* (Komachi Biki), 1802.

Ōban, nishiki-e, 28 x 38.5 cm.

Bibliothèque nationale de France, Paris.

In this same poem a frightening print by Utamaro as a representation of lasciviousness shows a monster, an enormous man with deathly pale skin, covered with cork-screw hairs, his mouth hideously deformed by the paroxysm of pleasure, sprawled crushingly on the delicate and slender body of a young woman; a print where, in the orgasmic thrill of a human, the artist was surely attempting to portray the same thing in a toad: beyond all doubt, a reference to the series where the little fan placed in the upper part of each panel indicates the animal being imitated by a man through his positions and gesticulation. An illustration which almost shows the transformation of a man into a toad.

This wonderful print has a harmony with which no European print could compare, one in which the brightness of the naked bodies stands out so luminously against the colours of the silk clothing scattered carelessly by the lovemaking, and where the tawny patch of the *mons pubis* is so strikingly voluptuous against the barely pinkish white of the woman's skin.

The first print in this collection is an unusual composition. This Utamaro, who in his fantasy series cannot hold a candle to Hokusai, and who has nothing which can compare to the five terrifying heads of the latter, was the master of the fantastic in eroticism. Here is what this print represents: a divinity of the sea is raped under the water by amphibian monsters amidst the curiosity of small fishes who try to penetrate along with the monsters. Crouching on the bank of an island, a half-naked girl who is fishing watches the strange and troubling spectacle of the deep, appearing languid and susceptible to temptation.

In this erotic composition there is in the arrangement, the drawing and the colouring, something of an art in love with the depiction of this woman, her thick hair, her dainty neck, her deep-coloured dress, scattered with small light bouquets suggested with crosshatching. She is in love with the depiction of this man, his languid pose, his elegant sensuality, his voluptuous laziness, the suspended

animation of his fan bearing the little poem alluding to the situation of the artist, compared to a crane's beak, often seen on *netzkes* caught in a clamshell: "With his beak tightly held by the *amajouri* (shell), the bird cannot fly away." His fan is as grey as his robe, that robe imitating the plumage of a guinea-hen, which he was already wearing in his true portrait, in the last of the *Pictures of the Forty-seven Ronin Represented by the Most Beautiful Women.*

The illustration is not signed, nor does it carry any indication of the identity of the artist, yet that little intuitive something, that revelation, that little something which cannot be explained, but which is felt at the first sight of this print and which cannot be expressed in words or phrases, says that this was painted by Utamaro himself. A second portrait of Utamaro, in intimate conversation with a beloved courtesan of the *Yoshiwara**, perhaps that woman so often rendered by his brush, the beautiful Kisegawa, confirms this presumption: in spite of the anonymity, one

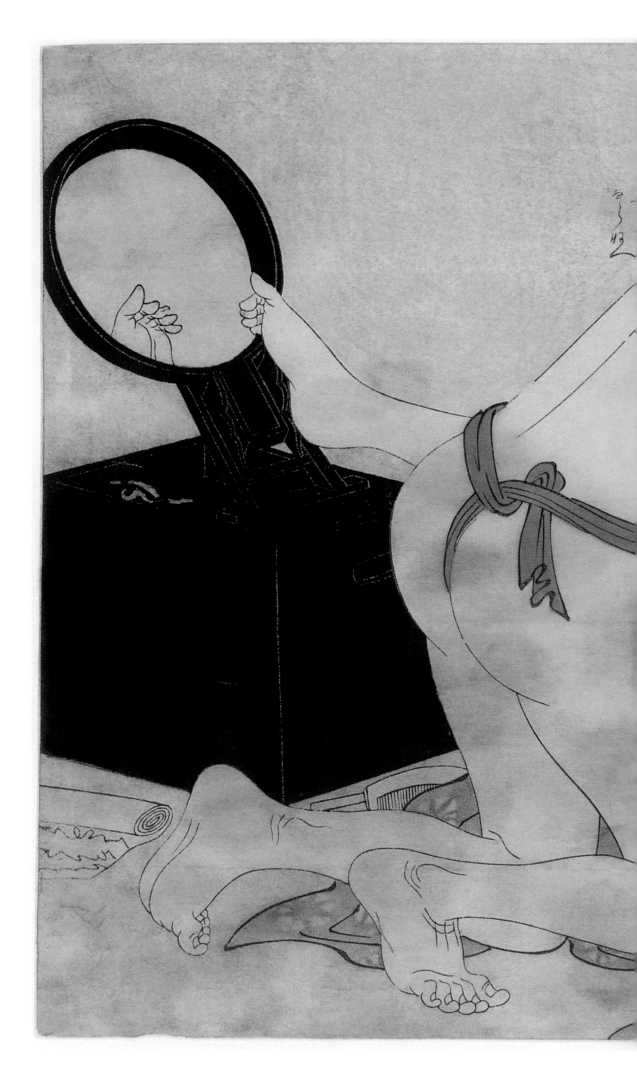

Page from the album *"Prelude of Desire"*, 1799.
Ōban, nishiki-e, 25 x 37.9 cm.
Bibliothèque nationale de France, Paris.

186

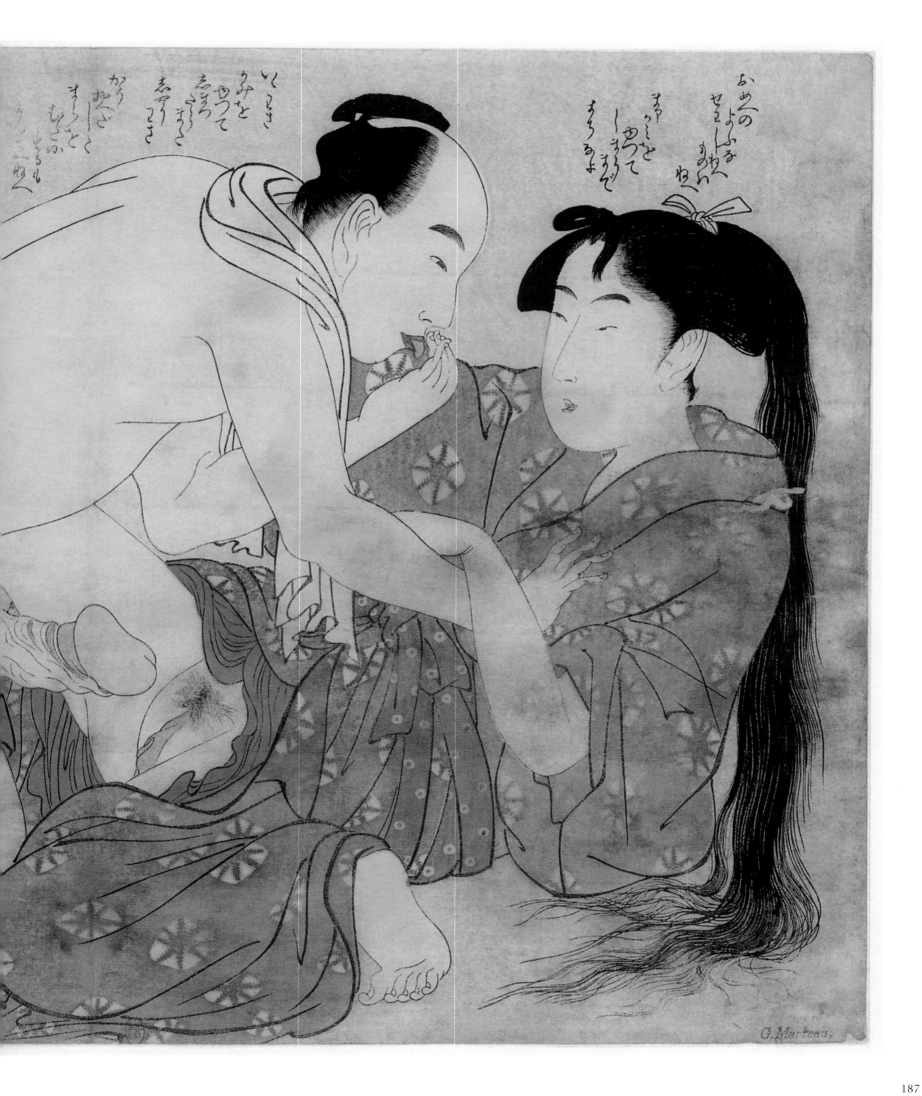

can see in this indiscreet print, the artist's face, hidden by a woman's kiss.

Other erotic books in colour:

Untitled Publication.
In this album, with the highly tormented poses and the dulled colours of the prints of the late eighteenth century, we see a woman who, even while making love, is redoing her hair, her comb held in her teeth (album composed of nine prints, published without date).

Untitled Publication.
In a large colour album, on backgrounds faintly tinted in grey, the bodies, drawn large, stand out in their whiteness amidst robes and fabrics which appear gently water-coloured. In one of the prints a woman with loose black hair raises her foot with its twisted toes into the air, where a mirror catches its reflection (album composed of thirteen prints, published without date).

Those Who Love to Laugh:
The frontispiece of each of the three volumes shows hands, with love tattoos on their forearms and wrists, fondling the private parts of men or women. One print represents a geisha, at the most crucial moment of carnal love, playing the *shamisen** (book in colour, in three volumes, published without date).

Untitled Publication.
Book in colour, of which the frontispiece shows an audience of phalluses in front of a theatre curtain, where a phallus is kneeling, doing his patter. Following this frontispiece two prints show marionettes introducing a series of erotic scenes (book in colour, published without date).

The Fallen Flowers:
(book in colour, in three volumes, published in 1802).

Erotic Books in Black and White:

Everybody Awake:
A book printed in black and white, where the Indian ink half-tones of the design are rendered by very delicate expanses of aquatint, in which appear very fine details as well as the microscopic flowers on the dresses. A first illustration shows a woman and a man looking at an erotic book behind which their mouths, blended in a kiss, are hidden. The last print in the book is exquisitely droll. A woman and child are looking at a faraway site with a large telescope, supported on a windowsill, looking out onto the countryside, and a man standing close behind the woman, with a wave of an eloquent hand toward the horizon, attempts to draw the child's attention to the beauties of the landscape, while... and as the Japanese characters, strung across the picture, have the man saying: "You must be happy with the telescope; it's good, isn't it?" and the woman answering: "Yes, very good, very good," and the child saying: "Mama, why are you making

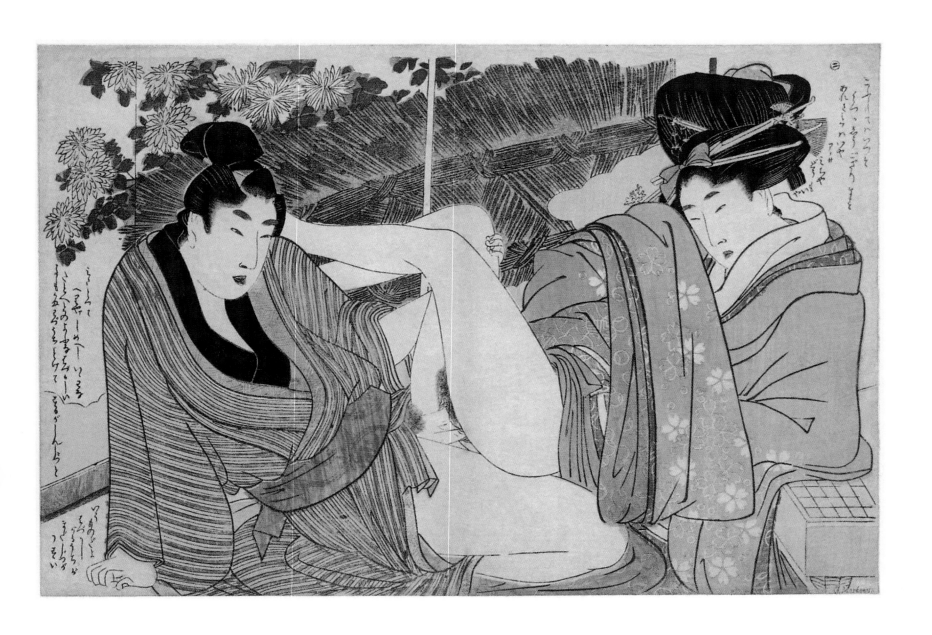

Page from the album *Collection of Beauties* (Komachi Biki), 1802.

Ōban, nishiki-e, 25.9 x 38.1 cm.

Bibliothèque nationale de France, Paris.

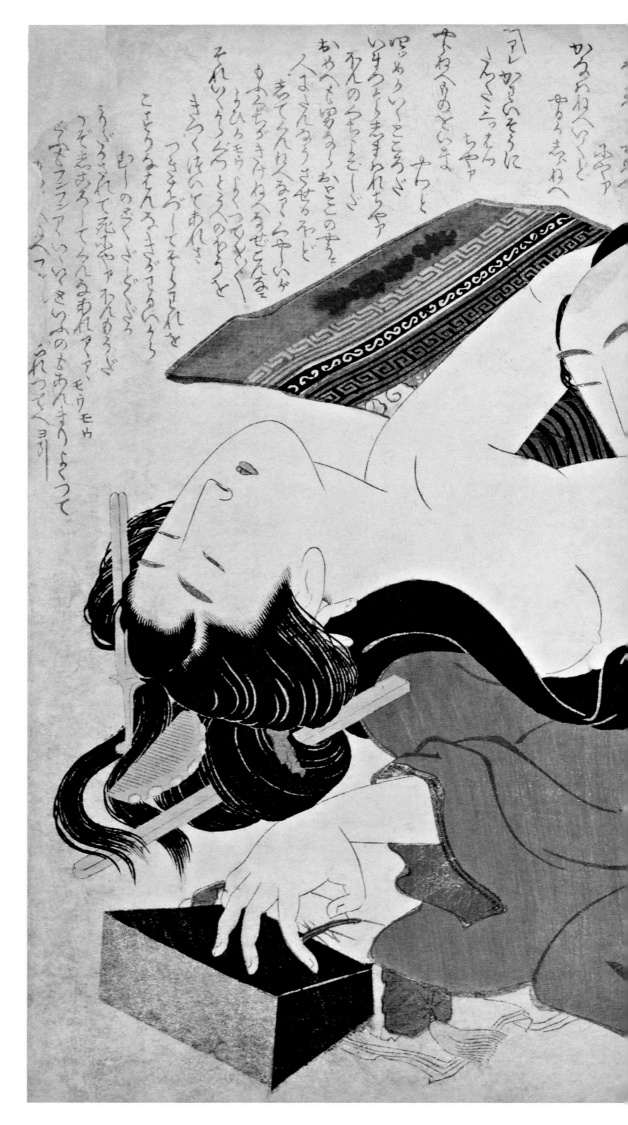

Erotic Scene, from the series *"Forms of Embracing"*
(tsui no hinagata).
Nishiki-e, 25.1 x 36.6 cm.
Musée national des Arts asiatiques – Guimet, Paris.

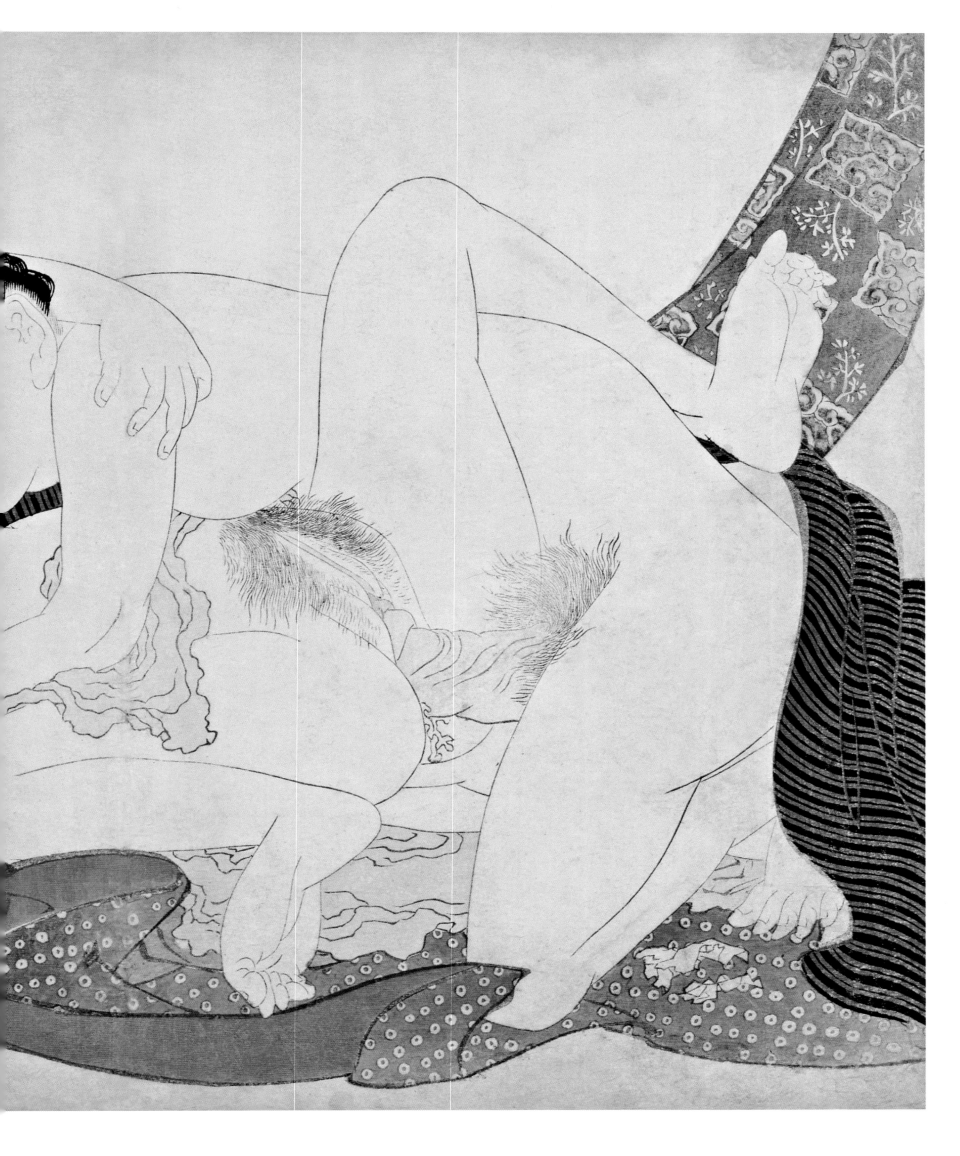

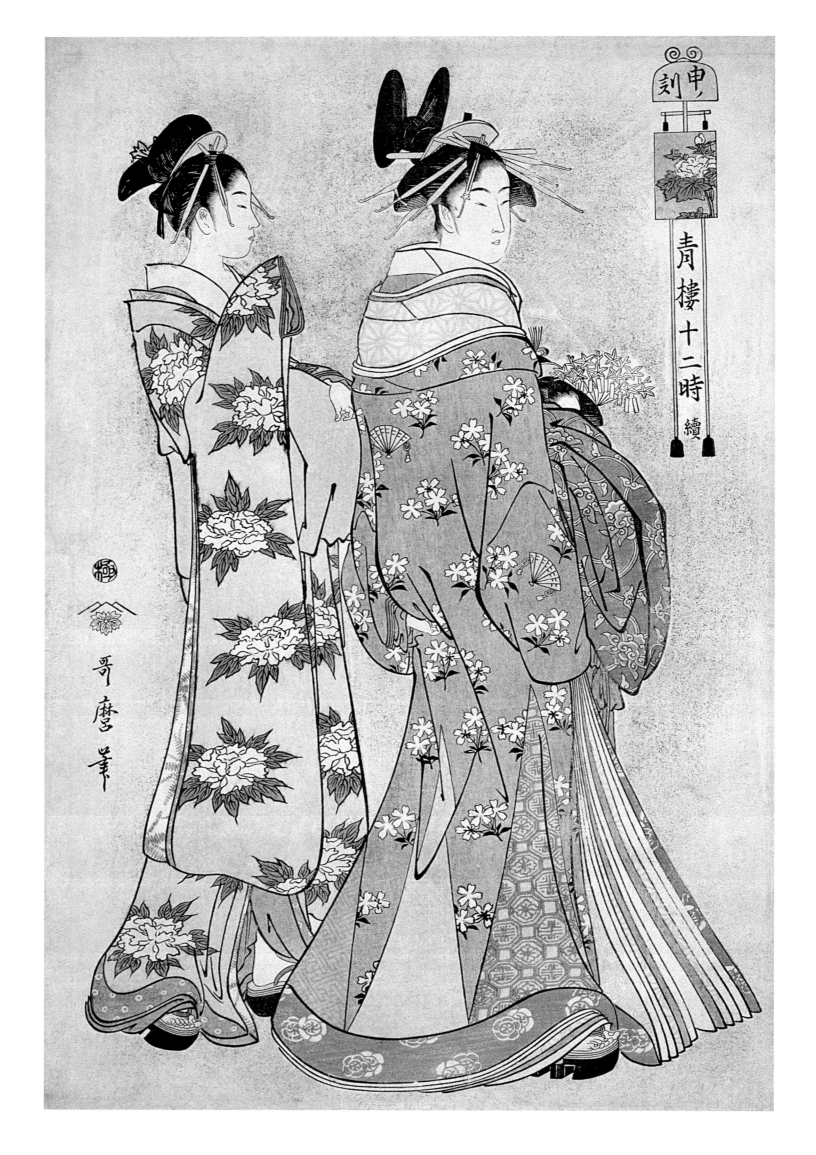

such funny faces?" The book, published in 1786 and signed by Utamaro in collaboration with Rankokusai, is unusual because of the signature, which is almost never present in erotic books.

Hair Styles with a Jade Comb:
A book in black and white, with a much higher print quality than the later erotic books, published in 1789.
The Storehouse of Treasures:
Book in black and white, in three volumes, published without date.
Secret Night Letter:
Book in black and white, in three volumes, published without date.
One Thousand Kinds of Colours:
Book in black and white published in three volumes, without date.
The Secret Mirror:
Book in black and white, in three volumes, published without date.
One Thousand Complaints of Love:
Book in black and white, in three volumes, published without date.
Tsukum's Kettle:

Book in black and white, in three volumes, published without date.
The First Essay on Women:
Frontispieces showing geese, swans, and crows. Book in black and white, in three volumes, published without date.

4. Books in Colour

Among Utamaro's many books in colour we may cite the following:

Yoshiwara Picture Book: Annual Events, or *Annals of the Green Houses* (pp. 195, 196, 197, 199):
At about the time when Utamaro's verve was beginning to flag, there appeared a book in which he gave the public a documentary illustration of the place where he spent his nights and days and which turned the famous painter into a popular one. This book is the *Seirō ehon nenjū gyōji* (1804) (*Sei*: green, *rō*: a house with an upper storey, *e*: picture, *hon*: book, *nen*: year, *jū*: in, *gyō*: what happens, *ji*: thing), the common translation for which is *Yearbook of the Green Houses*, but the word-

for-word translation would be *Illustrated Book of the Things which happen through the Year, in the "Green Houses"*. This book, printed in colour, is composed of two volumes in small octavo format; the text is by Jippensha Ikku (1765-1831); the illustrations by Kitagawa, Murasakiya and Utamaro, with the collaboration of Utamaro's pupils Kikumaro, Hidemaro and Takemaro. The wood carver's name was Fuji Kazumune. The printer, Jakushōdo Tōemon. The publisher was Kazusaya Chūsuke Juō, living in Edo, on the main street of the Japan Bridge (*Nihonbashi*). It is composed of several small books published in 1804. One little book is made up of a gathering of ten pictures of women from the waist up; another is ten head-and-shoulders pictures of women, shown in every detail as they are getting dressed. A third little book bears the imprint of Wakai; shown in it are the daily activities of the life of women in Japan, in full-length views of two women or of one woman with a child.

According to the preface by Senshūro, although this work is called a yearbook, it is

not like those of the court of the emperors of the fourteenth century, where the contents are made up entirely of small poems. On the contrary, this new yearbook is inspired by real life, a "very cheerful real life". The book shows the busy face of the *Yoshiwara** throughout the four seasons from the "elegant brush" of Utamaro, for the illustration, and from the witty pen-brush of Jippensha Ikku, for the text.

The cover of the book, in soft blue paper, is embossed with a squares, representing the lanterns carried on the walks in the *Yoshiwara**, with the armorial bearings of that year's celebrities from the "green houses". The reverse of the cover of the first volume bears the screen of command, as held by the judge of the wrestlers. On this screen, printed in red, is the title of the work in the centre, flanked on the right and left by the names of Utamaro and Jippensha Ikku, as homage to their talent, at the same time that the representation of this screen signifies that the book purports to be the judge of the *Yoshiwara**.

The square of poetry, at the head of the first volume, is decorated with a branch of apple blossom and a stem of red camellia. The verses are by Sandara-hōshi and read: "O bell of daybreak, if you understood the heavy heart of the farewells, you would be glad to lie instead of ringing the six strokes." The square of poetry at the head of the second volume, surrounded by chrysanthemums and *momichi,* encloses a description of the river Sumida as it passes by the *Yoshiwara**.

The frame around the table of contents depicts the gate in the wall around the *Yoshiwara**, the upper lines for the text, the lower lines for the illustrations. At the end of the second volume, a forthcoming edition of a second series of the work is announced, a publication which never appeared because of differences between the author and the artist. Jippensha Ikku attributed the success of the work to his prose, Utamaro to his artwork. Of the *Yoshiwara Picture Book: Annual Events,* or *Annals of the "Green Houses"* (pp. 195, 196, 197, 199), which was printed in colour, there exist several copies in black and white, printed in advance and in a

limited number for Utamaro and his collaborators to use to test, in watercolour, the colours for the printed plates.

A few explanations: Europe has some very incorrect ideas about Japanese prostitution, at least traditional prostitution. The fifty "green houses" of the *Yoshiwara** and the hundreds more outside the wall, owed their sumptuous existence and their splendour not to the wealthy population of Edo, nor to foreigners, but to the ambassadors, the provincial and commercial *chargés d'affaires,* of the three hundred and sixty princes who were accredited to the court of the Shogun, and who lived in his capital without their families. A woman of a "green house" is not the base prostitute in the image of the prostitute in the west, the one who can be taken simply by walking in the door, the woman "who belongs to no class, the woman of the *nagaya,"* as she is called and exists in Japan. The woman of a "green house" is a courtesan.

The origins and the establishment of these in-house courtesans are lost in the mists of time. Their existence is known under the

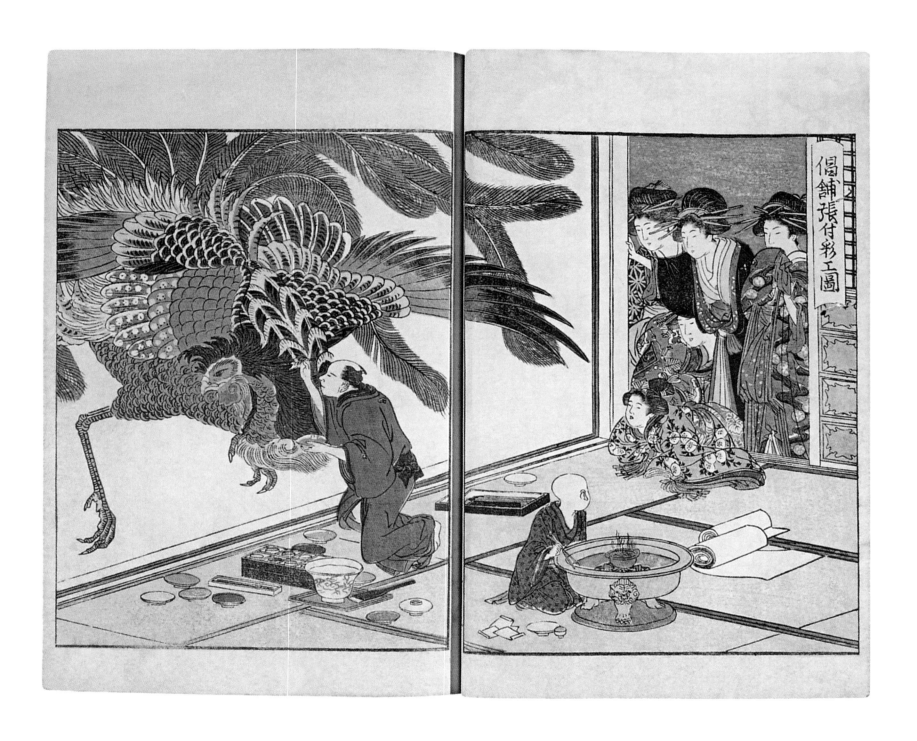

Yoshiwara Picture Book: Annual Events or *Annals of the Green Houses* (Seirō ehon nenjū gyōji),
Summer 1804.
Ehon, nishiki-e, 22.8 x 15.8 cm.
The British Museum, London.

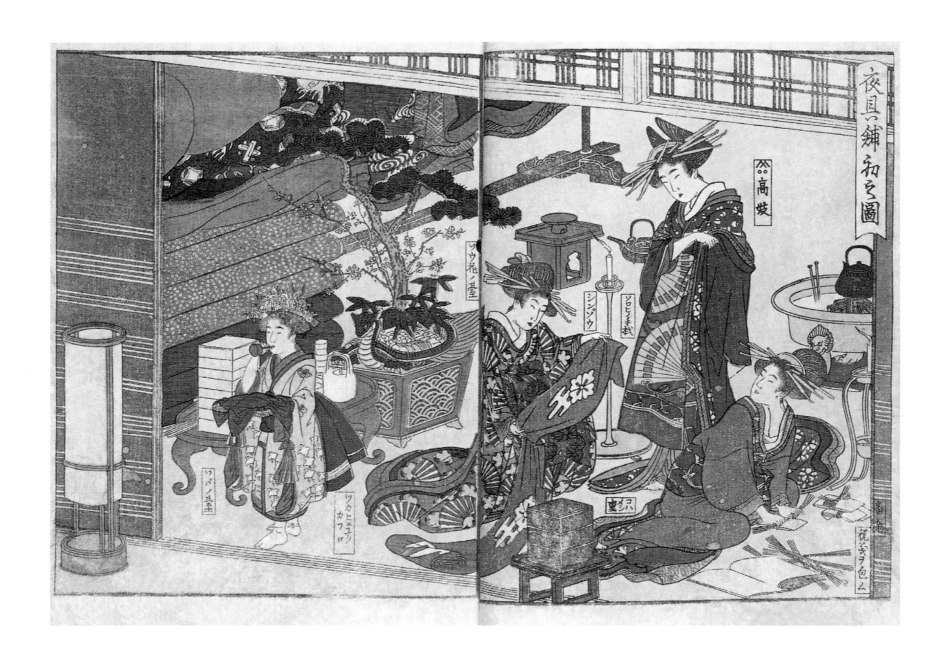

Yoshiwara Picture Book: Annual Events or *Annals of the Green Houses* (Seirō ehon nenjū gyōji),

Spring 1804.

Ehon, nishiki-e, 22.7 x 15.8 cm.

Musée national des Arts asiatiques – Guimet, Paris.

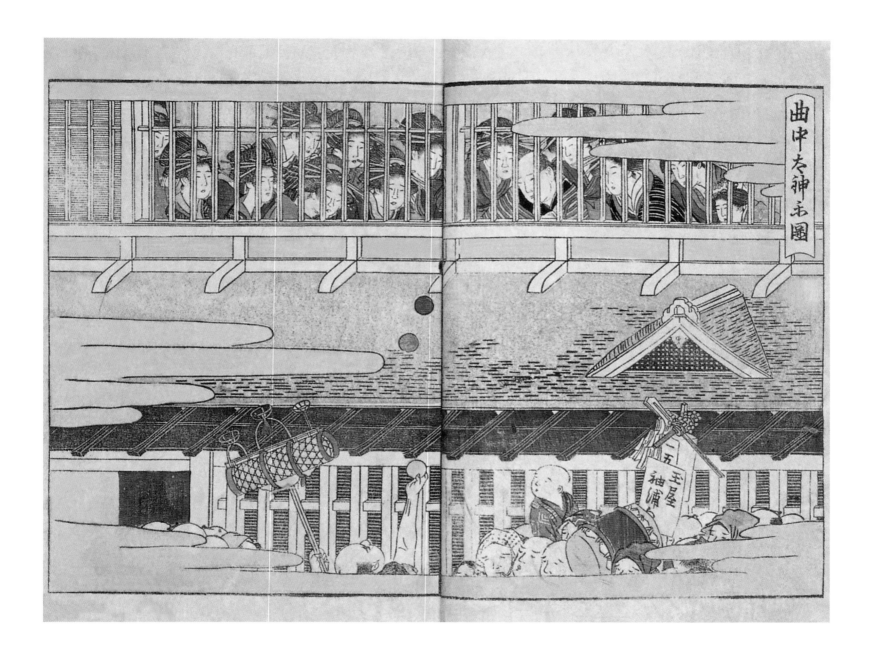

Yoshiwara Picture Book: Annual Events or *Annals of the Green Houses* (Seirō ehon nenjū gyōji),
Spring 1804.
Ehon, nishiki-e, 22.7 x 15.8 cm.
Musée national des Arts asiatiques – Guimet, Paris.

emperor Shomu, as early as the eighth century, and the *Manyoshu,* a collection of ancient poetry, is full of poems celebrating them. It was around 1600 that the *Yoshiwara** of Edo was created, by order of the administrative authority. The location at the time was near the shogun's palace. Later, in 1657, following a great fire, a new location was furnished in the suburb of Asakusa, where, in a sector enclosed by a wall, the *Yoshiwara** was inaugurated. The houses were separated by five streets, the central one being the most important, where there was nothing but tea houses (*tehaya*) facing the street for its entire length. The cleanliness and beauty of these tea houses occupying both sides of the central street made one wonder, according to the expression of Ji-pensha Ikku, "if one is truly on this earth". We find the rules of the *Yoshiwara** in the *Daisen.* The *Saiken* contains, in the greatest detail, all the names of the courtesans and of the musicians of the tea houses.

Here is author of the text of the *Green Houses* on these women so omnipresent in the painting and poetry of Japan: "The girls of the *Yoshiwara** are raised like princesses. From childhood they are given the most thorough education. They are taught reading, writing, the arts, music, tea, and perfume (the ritual of perfumes is similar to the ritual of tea; perfumes are blended and burned, and one must guess the perfume from its scent). They are exactly like princesses, raised in the isolation of palaces... So, why should one think twice about an expense of a thousand *rios*?" These women who came from all the different provinces of the Empire of the Rising Sun with their local dialects, 'forgot' them and spoke an archaic language specific to the *Yoshiwara**, the noble language, the poetic language, the language of court from the seventh to the ninth century, slightly modernised.

Between the *daimyos**, these cultured noblemen and these women who had received the education of grand courtesans, "the contact of the two skins" did not happen immediately, for these resident prostitutes had in their choice some of the liberty of our free-market prostitution. The prints of this series by Utamaro show the formal steps in the relationships, the kind of ritual which governed them and the three visits which were nearly indispensable before reaching intimacy. The first visit, which was no more than a courteous introduction to the woman, the second, which was the "intensification" of the first visit with the granting of certain liberties, and finally the third visit, called the "visit of mature acquaintanceship".

It would perhaps be interesting to describe the layout of the pleasure houses, the largest houses in Edo, accommodating ten to twenty first class courtesans, and fifty to sixty second class courtesans, each with her own little apartment. The houses were set back from the pavement, the small area in front planted with bushes which decked the front of the house

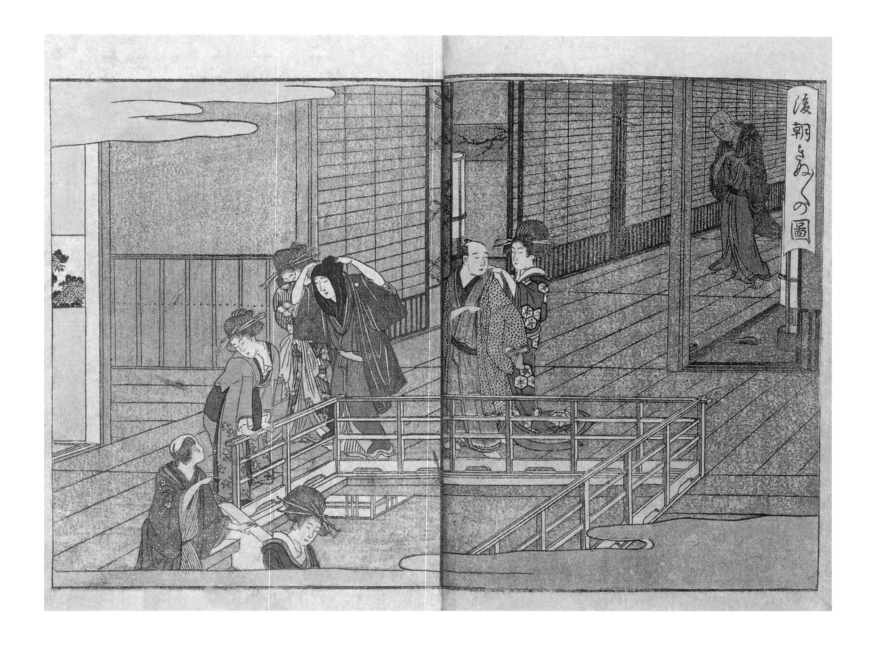

Yoshiwara Picture Book: Annual Events or *Annals of the Green Houses* (Seirō ehon nenjū gyōji), Spring 1804.
Ehon, nishiki-e, 22.7 x 15.8 cm.
Musée national des Arts asiatiques – Guimet, Paris.

Performance by a Trained Monkey, from the album *The Young God Ebisu* (Ehon waka ebisu), 1786.
Ehon, nishiki-e.
The British Library, London.

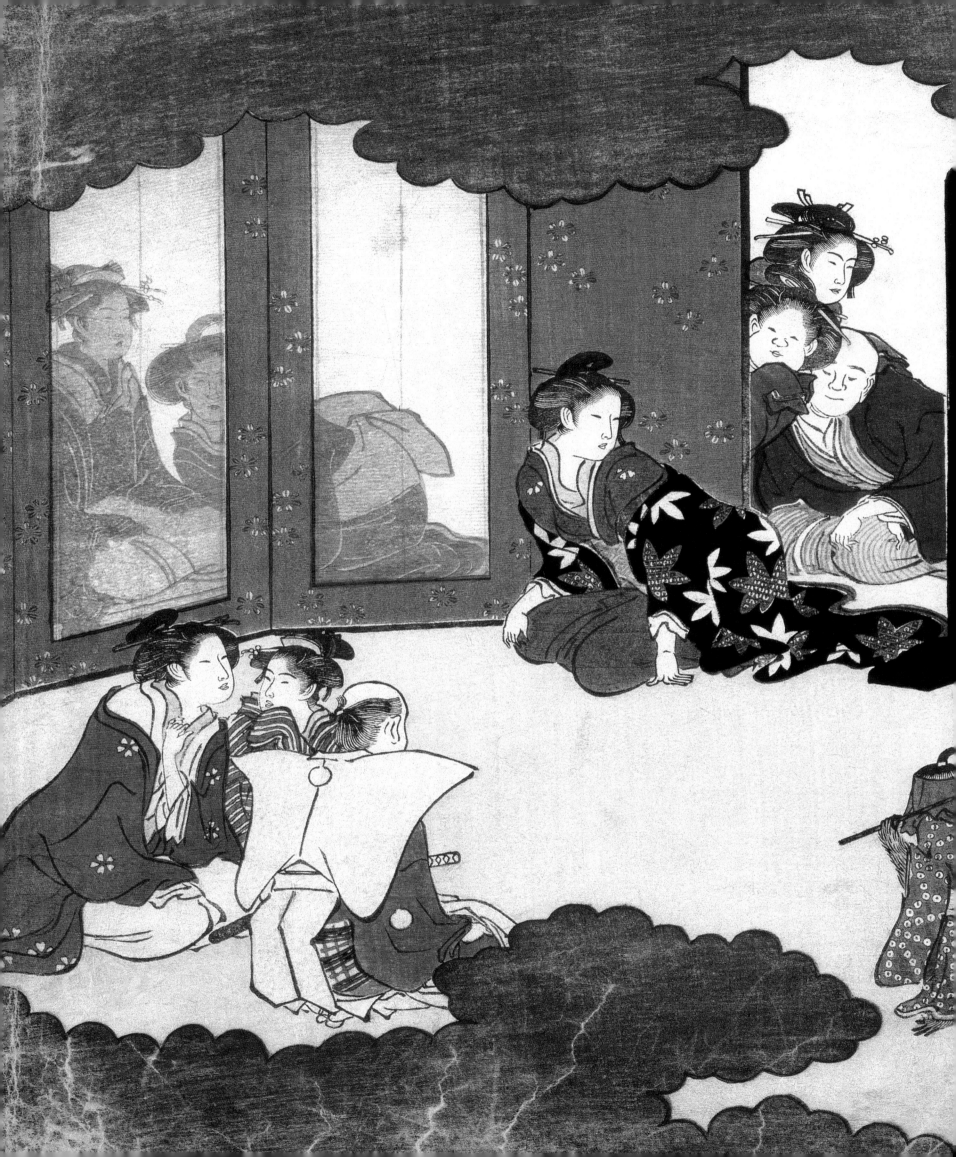

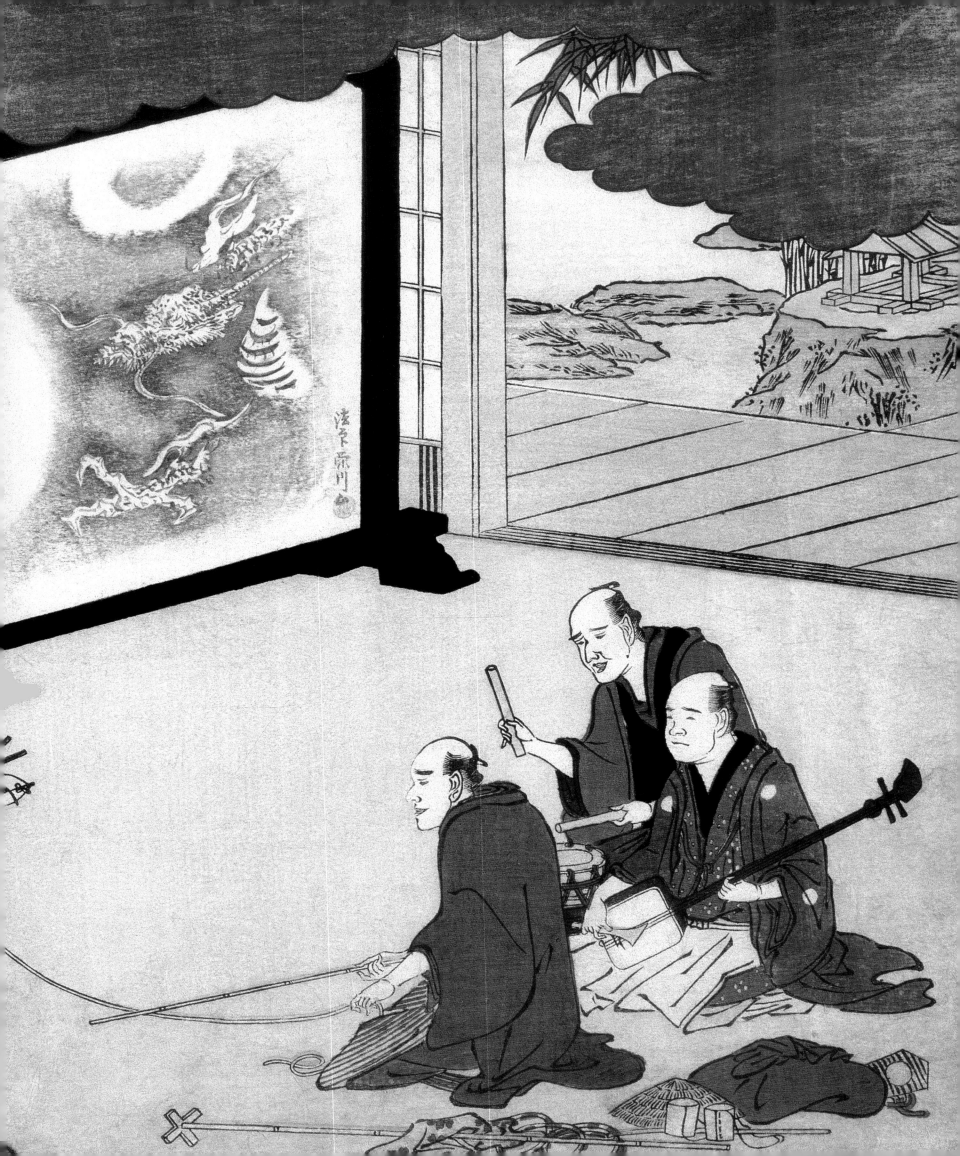

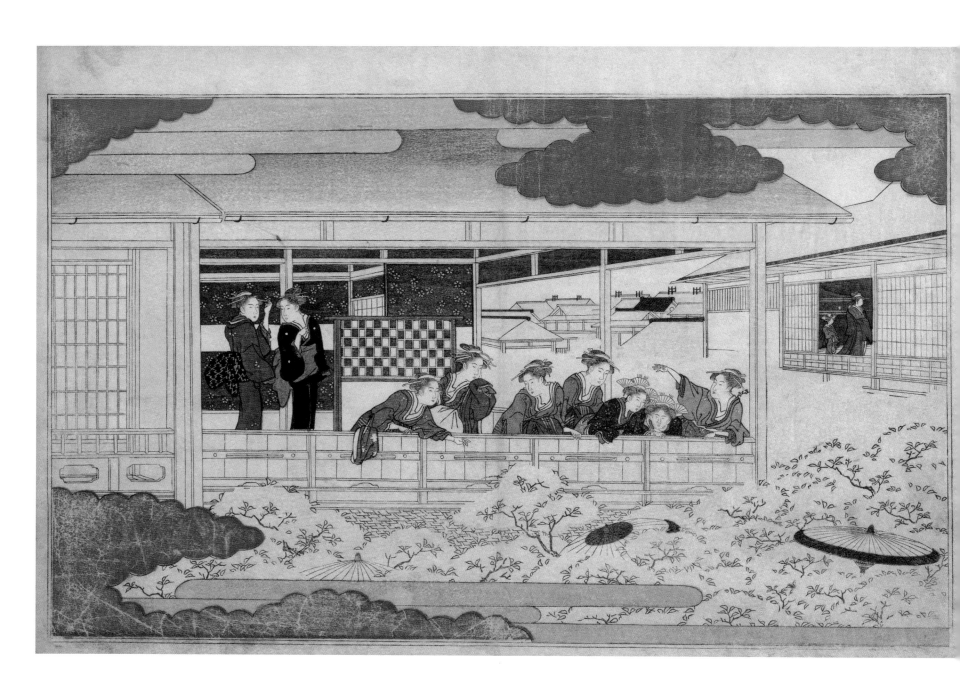

Cherry Blossom,
1790.
Ehon, nishiki-e, 35.6 x 22.5 cm.
The Metropolitan Museum of Art, New York.

with greenery and flowers. The entrance was typically on the right. Behind a sliding door, enclosed by an artistically-worked trellis, was an anteroom with a dirt floor, at the far end of which there was a stone step, where shoes were left, the *gueta* and the *zori*, the *gueta* made of fine straw, the *zori* of wood. From there, one entered the great hall, a large room which, like all the other rooms, had a floor covered with *tatami*, fine white mats, atop tightly-woven rice straw, seven centimetres thick, a very soft surface on which to walk. In the middle rose the staircase, leading to the upper floors and the rooms; this staircase so often represented in the images of the "green houses," with courtesans overhead leaning on the railing, making their tender *adieux* to the clients. The great hall was connected to two or three small sitting rooms, where clients were asked to wait when there was too big a crowd in the great hall. At the left was the office with the cash desk, and at the right, jutting into the garden, a room for the employees, the dining room, the baths, and the kitchen. Except for a few rooms reserved for special patrons who wished to be on the garden level, all the women's apartments were on the first and second floors. Behind the house, spreading beyond the open galleries, were the large gardens represented in the prints, decked out in roses and framing the delicate architecture, bathed in light and sunshine entering through the huge openings and window-walls.

The following are the ten prints making up the illustrations of the first volume:
I. *New Year's Day Wishes on Nakanō-chō (Central Street)*.
II. *Inauguration of the new Blankets*.
III. *Debut of a Shinzō*.
IV. and V. *The Display of the Women, at Night, at the Windows facing the Street*.
VI. *Decking the Central Street with Flowers*.
VII. *The Absence of the Mistress of the "Green House"*.
VIII. *Debut of a Singer-Musician*.
IX. *Festival of the Lanterns*.
X. *Niwaka*.

First print: *New Year's Day Wishes*:
On the arrival of the first day of the New Year there was great activity in the *Yoshiwara**. For five days everyone had been busy with the "pine decoration", setting up in front of the houses large branches held up with bamboo rods, connected by cords. The Japanese were very careful that the pine branches faced the entrance of the houses and turned their backs on the street, the superstition being that "turning one's back" was the negation of love. On the second day, all of the courtesans came out into the middle streets to meet their acquaintances from the other houses and wish them Happy New Year. In an outing known as *Dō-tchū* (voyage), all the cross streets of Kyōto and of Edo were alive with the parade of well-wishers. It was a fashion contest, where each establishment had its own individual style, where each woman could give free rein to her taste, where certain old traditions were kept alive, where, for example, the Shōyōro house still wore the old-fashioned sandals rather than replacing them with the lacquered wooden shoes *(kamagheta)*, invented by Fouyō of Hishiga and generally worn thereafter. All during this day-long procession down the central street, the silk sleeves glistened and the embroidered dresses filled the air with the most delightful perfumes.

Second print: *Inauguration of the New Blankets*:

The new blankets and the new cushions, given by the sweetheart, were displayed in the main room of the house. There, the courtesan was congratulated on the beautiful items that she had received. This was the occasion for a little celebration, and the mistress of the house provided her most excellent fish and her best sake. While the courtesan received these night-time items in her quarters, she gave presents to the women and men employed in the house. The first night when she used her new blanket and cushion, it was customary for her to make the polite gesture of sending everyone in the house and her friends *sara-zin* or rice cakes. For his part, the swain was expected to distribute presents of dyed cotton scarves showing the intertwined coats of arms of the lover and the courtesan. In return, the household employees gave him, much like a "wedding basket", a box planted with a sprig of pine, bamboo, and plum, and to thank them, the lover distributed gratuities ("flower" in Japanese), since gifts of money were referred to as flowers in this refined milieu. In those

times and in those pleasure houses, there was a certain diffidence about the question of money. During the hours or days spent with the courtesan, one never took any money from one's pockets, and none was ever asked for by the woman: the bill was paid only on leaving the house.

In fact, this day of a new blanket was very important to a woman's reputation, particularly when the bedding was expensive, distinguished, or sumptuous. "This is the day," says the author of the *Green Houses*, "when the uncouth man who asks for a second chopstick when they have given him chopsticks that fold in half, who asks to be served something better when he has been served an *arami* (a fish with soft bones) ... when the repulsive or unlikeable man may, by his gift, win the heart of the courtesan...." Jippensha Ikku adds, "In this world, you must pay particular attention to the glamorous appearance of your sweetheart. Be generous with the price, and spare no indulgence. On important occasions, outdo your rivals, and make the employees like you by giving them a 'flower' from time to time. Once you are well

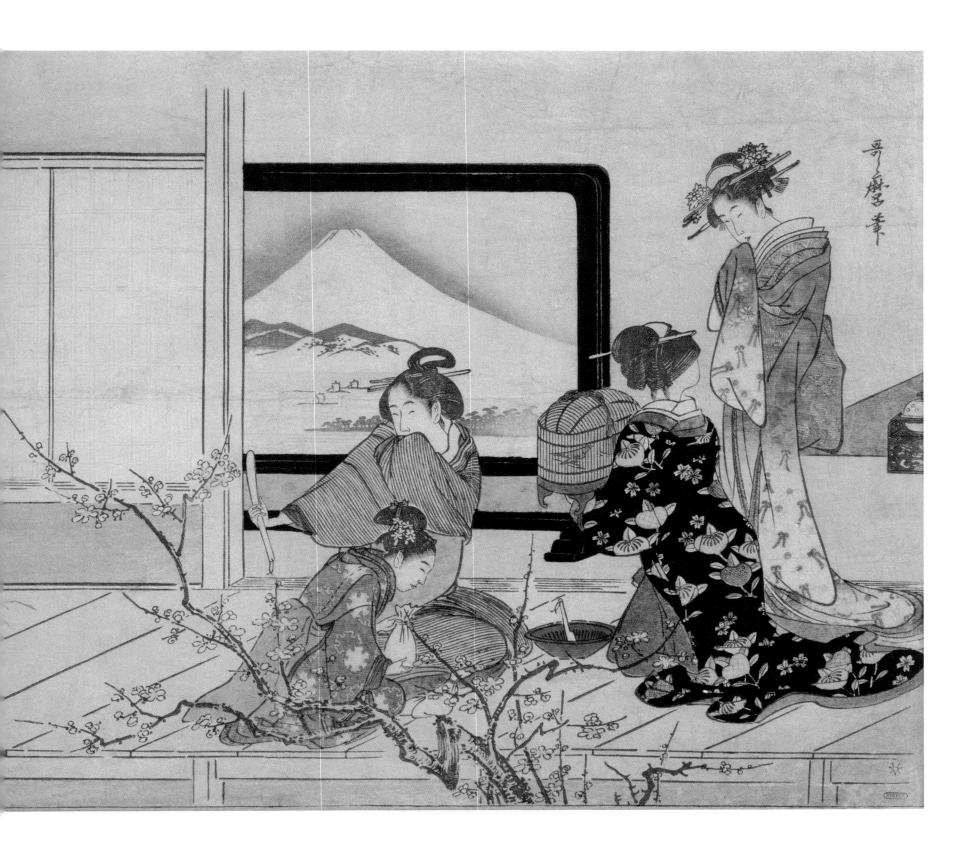

Women Laughing, from the series "*Otoko tōka*".
1798.
Nishiki-e, 18.6 x 24.3 cm.
Musée national des Arts asiatiques – Guimet, Paris.

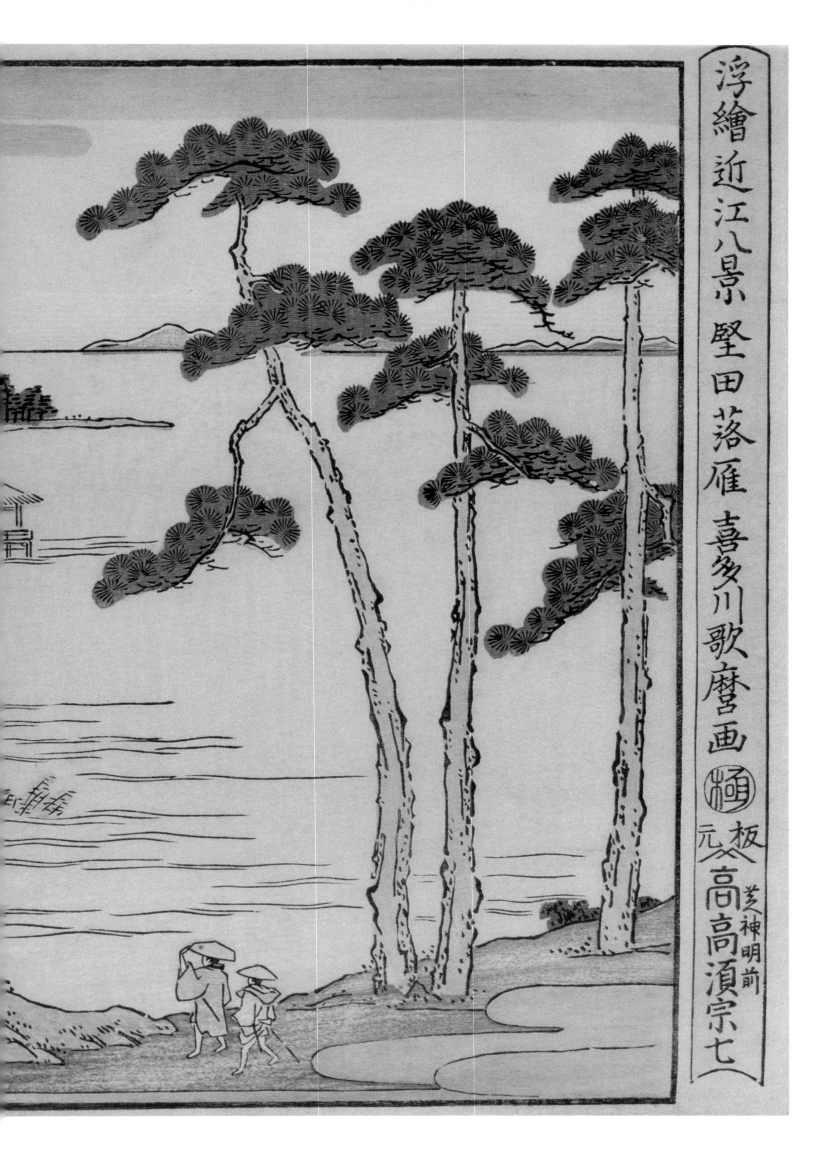

浮繪近江八景 堅田落雁 喜多川歌麿画 〔極〕板 元〆 芝神明前 高高濱宗七

207

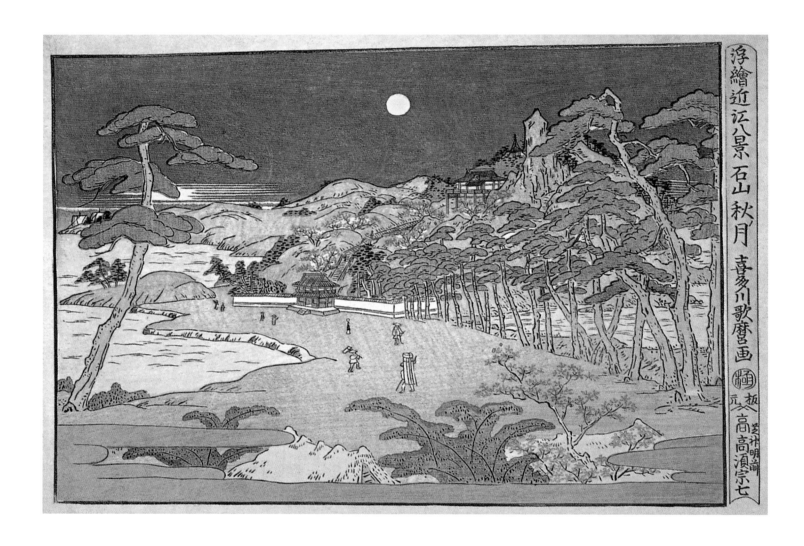

Descending Geese at Katada (Katada no rakugan), from the series *Eight Perspective Views of Ōmi* (Uki-e Ōmi hakkei), c. 1792-1795.
Horizontal aiban, nishiki-e, 22 x 32.8 cm.
Musée national des Arts asiatiques – Guimet, Paris.

Autumn Moon at Ishiyama (Ishiyama no aki no tsuki), from the series *Eight Perspective Views of Ōmi* (Uki-e Ōmi hakkei), c. 1792-1795.
Horizontal aiban, nishiki-e, 22.4 x 33 cm.
Chiba City Museum of Art, Chiba.

known and looked upon favourably in the house, there is nothing you cannot do, and then everything is pleasure for you."

Third print: *Debut of a Shinzō*:

Great courtesans were called *oirans**. Each *oiran** had two young girls, named *kamuros** under her tutelage. When the *kamuros** reached a certain age, they become known as *shinzō**. Later, they made their debut and became *oirans**. On that occasion there was a ritual which had to do with the blackening of the teeth, the distinctive sign of married women. When a Japanese man was in a relationship with a *shinzō** who was becoming an *oiran**, and if he agreed to pay for the procedure, he could ask her to blacken her teeth. In that case it was considered a valid marriage in the *Yoshiwara** and the courtesan could not accept any proposition from a serious suitor, or, at least, not with the knowledge of the man who had paid for the blackening of her teeth. It was expected that she would have no other relationships.

Fourth and fifth prints: *The Display of the Women, at Night, at the Trellised Windows Facing the Street*:

The author of the text, after a passage praising Utamaro and a brief description of these two prints which are small masterpieces, attempts to advise the passer-by in choosing among these women, using psychological observations. "She who is deep in reading a book, paying no attention to the chatter of the others, is the one who will have the most pleasant conversation once you have gained her intimacy. She who, from time to time, whispers with her neighbours, hides her face to stifle a laugh, and looks straight into the whites of a man's eyes, is capable of pulling the wool over your eyes with unsuspected cunning. She who stands motionless with her hands in her dress, chest high, and her chin resting on her neck, is the one who is nursing a broken heart. Ah, she may not be amusing the first few times, but on the day when you have won her heart, she will never again leave you..... She who jabbers, jokes and laughs with the under-mistress then

turns around suddenly to hear a passer-by's comment is a very flighty creature. If she fancies you, you will immediately be her favourite. She who is busy writing letter after letter is the woman who wants to build up her clientele. Becoming her beloved will be difficult, but if you are old, ugly or incapable of being loved by the other women, then with her you will have the irresistible attraction of your money. She who, still very young, spends her time playing and has remained an innocent, you will be able to do with her what you will...."

Sixth print: *The Planting of the Cherry Trees along Nakanō-chō*:

During the third month of the lunar calendar the central street was lined with cherry trees in blossom. This was a day full of activity, and the street was alive with men and women strolling. A large composition by Toyokuni, a strip of five prints, represents this floral embellishment and the parade going through it. This decoration is interesting, since just as their buds are beginning, the cherry trees

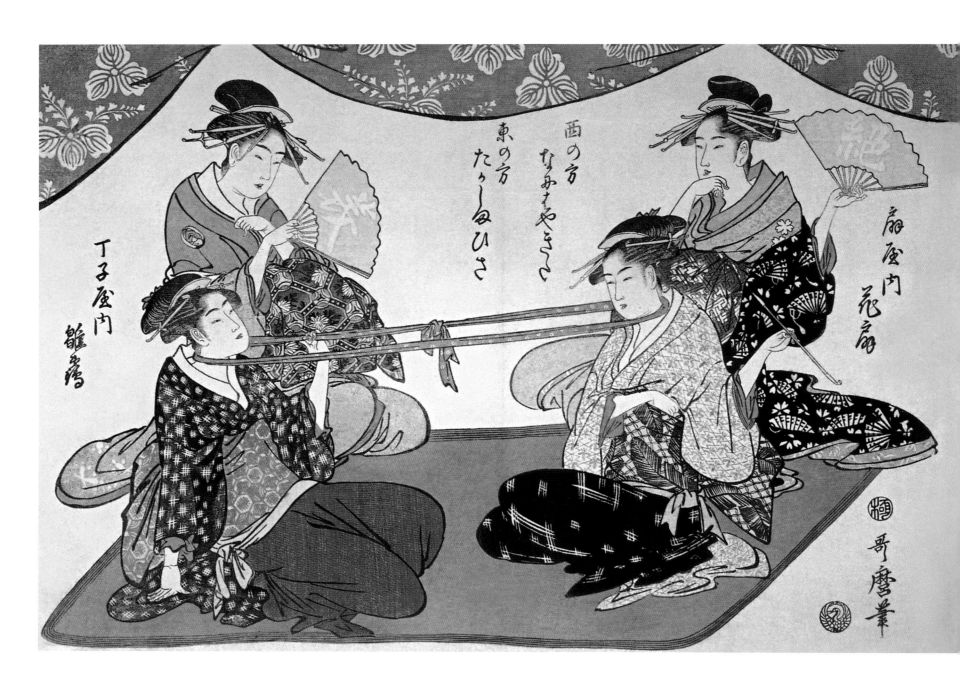

Two Beauties in a Tug-of-War with a Sash Looped Round their Necks (Ni bijin kubi-biki),
c. 1793-1794.
Horizontal ōban, nishiki-e, 26.4 x 38.4 cm.
Hagi Uragami Museum.

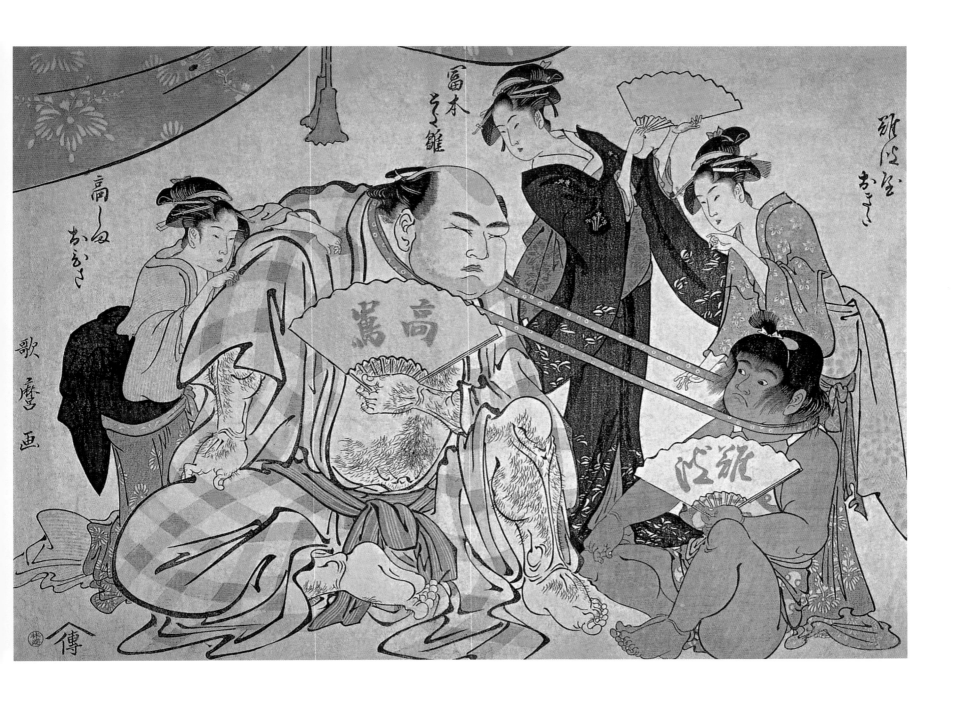

Neck Tug-of-War between Tanikaze and Kintarō (Tanikaze to Kintarō no kubi-hiki),

c. 1793.

Ko-bōsho, nishiki-e, 30.5 x 43.3 cm.

Chiba City Museum of Art, Chiba.

are planted directly in the ground and create what looks more like a pathway in a park than a city street. In this type of improvised forest, there is a constant flow of superb courtesans with little cortèges of their *kamuros** and of their *shinzō**, making their way with difficulty through the crowd of people, young and old, casting glances and gallant compliments their way as they pass. The spectacle is truly charming in the background, where through the snowy flowering of the cherry blossoms, almost covering everything, there is the occasional glimpse of the corners of houses, bits of roof, and tantalizing parts of a woman.

Seventh print: *The Absence of the Mistress of the House*:
A print that Jippensha Ikku does not describe is a scene where the mistress of the house being gone, no doubt for an outing in the country during the cherry blossom or the chrysanthemum season, there is a huge game of hide and seek, in which women, trying to escape the hands reaching for them, fall flat on their faces.

Eighth print: *Debut of a Singer-Musician*:
In the great hall, amidst the general curiosity of the women and of the heads poked out from the doors, a singer is making her debut, preceded by a number of little screens on which her name is written, surrounded by verses praising her person and her talent.

Ninth print: *The Festival of Lanterns*:
This festival, known as *Toro*, takes place in the middle of summer; the scene shows the whole household busy hanging lanterns. In this festival, the lanterns depict highly amusing caricatures on their back-lit sides.

Tenth print: *Niwaka*:
A kind of carnival unique to Japan, where all the women singers are disguised as men, with their hair cut in the fashion of young boys.

The illustration of the second volume contains only nine prints:
I. *The first Day of the Eighth Month*.
II. *Contemplation of the Full Moon*.
III. *First Meeting*.
IV. *Mature Acquaintanceship*.

V. *The Morning after*.
VI. *Taking Leave* (p. 199).
VII. *The Punishment of the Kuruwa (the Wall of the Yoshiwara)*.
VIII. *Making Rice Cakes for the End of the Year*.
IX. *The Painting of a Hōō* in a "Green House"* (p. 195).

First print: *The first Day of the eighth Month*:
In the great heat of late August and early September was the ceremony of the white dress, in which all the women put on white dresses, which they showed, for just one day, in the central street; an exhibition of picture-dresses, which drew the attention of the entire city. For this parade, lasting only a few hours, white dresses were painted by the greatest Japanese painters. In a special book about courtesans, there is a dress, shown after a drawing by Korin, which the painter had decorated for the famous Ousougboumō.

Second print: *Contemplation of the Moon*:
A print which shows courtesans in the

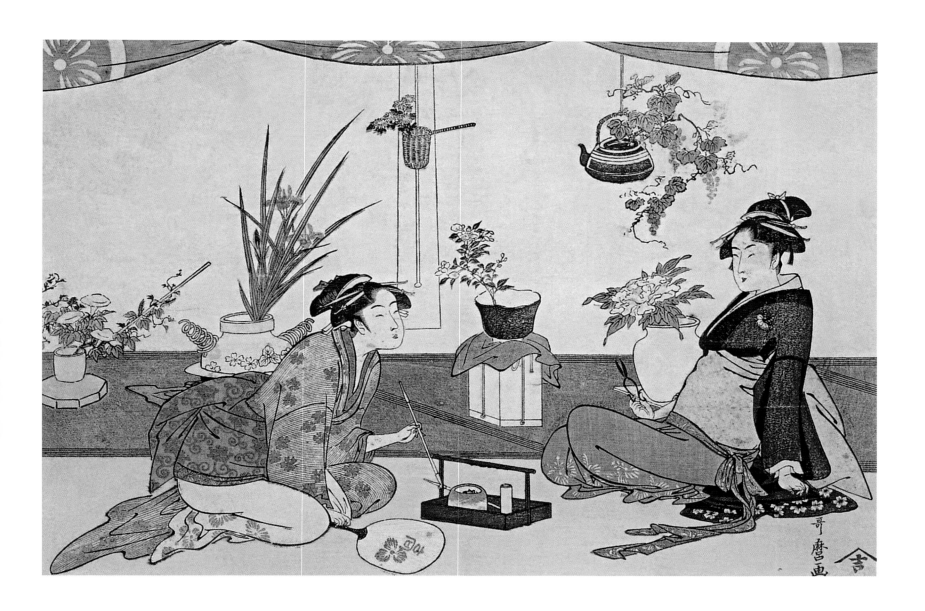

Contest in Flower Arrangement between Takashima Ohisa and Naniwaya Okita,
1793-1794.
Ōban, nishiki-e, 25.2 x 37.6 cm.
Honolulu Academy of Arts, Honolulu.

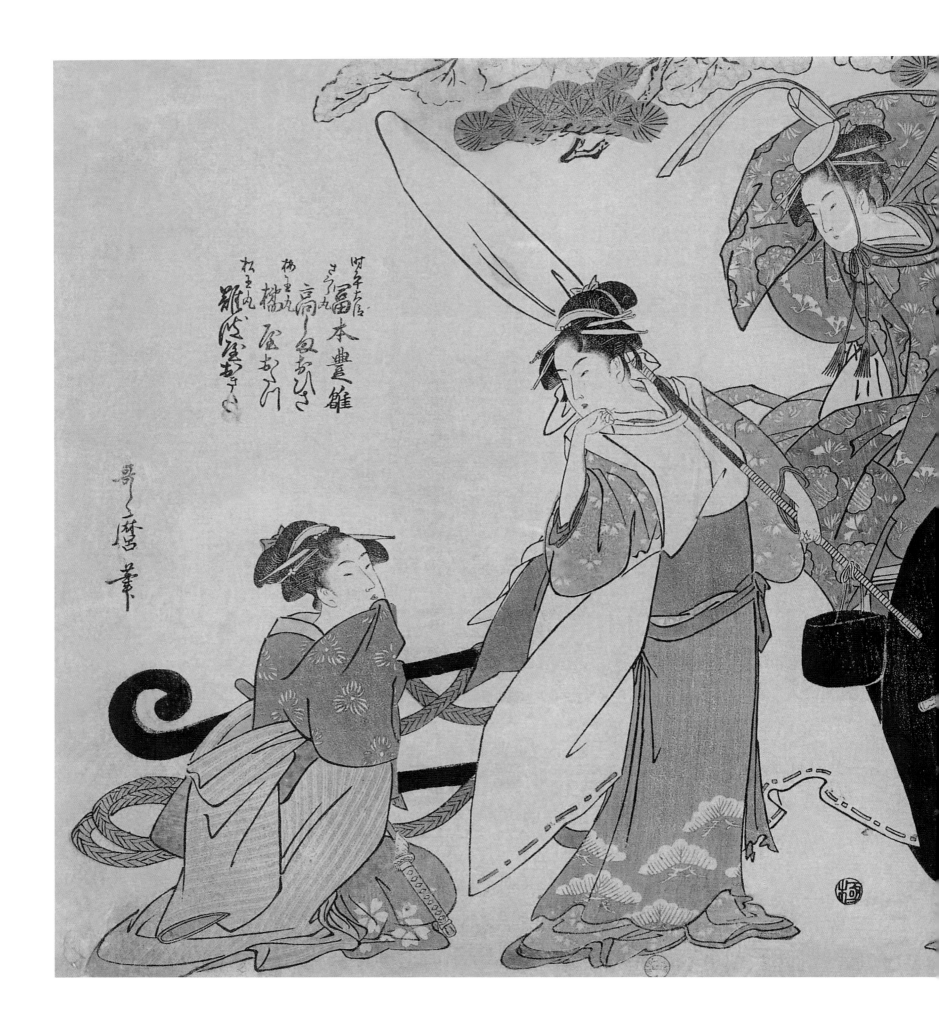

company of their lovers on a terrace, their eyes turned to the sky, in the contemplation of a beautiful summer night. Their education has endowed the women of the *Yoshiwara** with a poetic sensitivity, and the silvery light of the moon, in the melancholy serenity of the beautiful summer nights, inspires in these improvised poetesses reveries of an elegiac lyricism. Here are the verses of the courtesan Kumai: "It is when admiring it as a couple that the moon seems beautiful to me. When I am alone, it inspires in me too many sad feelings!" Or the verses of the courtesan Azuma: "And this evening, who will take the softness of my being, in this transient world, with my floating body?" The verses of the courtesan Kameghiku: "Ah! how brilliantly the moonlight shines on the water of the Sumida (in the image of its existence), but how I long for the autumn, on the other side of the clouds (honourable life)!" The courtesan Miyako: "Although I am only a lowly woman here below, the moon brightens my heart with its consoling beam," and the verses of the courtesan Miyaghino: "How often I take leave of the man, whose shadow I no longer see under the moon of dawn."

Third print: *The First Meeting, the First Acquaintance, the First Night*:

If the customer was not pleasing, the courtesan was free not to spend the first night with him. This is the time to relate this story, which is probably not a legend: the famous Takao, cited in the *Kwaghai Mauroku*, refused Prince Dati of Sendai, because of her passion for her true love. The Prince, having tried in vain every method of winning her over, invited her on a boat ride, then, after killing her, threw her in the Sumida. "If you are not accepted the first time, and if you are patient," says Jippensha Ikku, "you may, on the second visit, fulfil the criteria of the 'second try'." On the third visit, one must reach "mature acquaintanceship". It was well known that he who made a conquest the first time was required to pay a second visit. A very interesting and little-known detail is that the man making a stop in a "green house" changed his clothes and put on, as the expression goes, the uniform of the house: these clothes made each man, while there, the equal of any other man.

Parody of the "Carriage-Breaking" Scene (Mitate kuruma-biki),
c. 1793.
Ko-bosho, nishiki-e, 32 x 43 cm.
Bibliothèque nationale de France, Paris.

Fourth print: *Mature Acquaintanceship*:

Mature Acquaintanceship was preceded by a private meal together, taken using bowls and dishes emblazoned with the woman's coat of arms and where ivory chopsticks were used, a practice which was seen as tantamount to a promise of marriage. This mature acquaintanceship was followed by a "general bouquet", that is, giving money (flowers) to all the employees, men and women of the house, of whom there were sometime as many as fifty in the large establishments. Following this evening and this night, it is said that "Madam has made a genuine friend." If a man who had reached the level of mature acquaintanceship could afford the cost of staying two or three days, or even a week, that, to use the expression in the book, was "The enjoyment of a marital life, which is nothing but a series of dalliances and amusements in delight."

Fifth print: *The Morning After*:

The fifth print represents the morning after the night spent in the "green house". People are cleaning the house and preparing a cup of tea, while in spite of the inner contentment attributed to him by the book, the "genuine friend", sitting on a windowsill, looks sadly out at the snowy landscape while brushing his teeth.

Sixth print: *Taking Leave* (p. 199):

A woman putting a man's robe on his shoulders, another woman pulling up a man's hood, and the tender "good-byes" by a third woman to another man as she leans gracefully over the railing of the stairway; all the coquettish kindnesses of parting.

Seventh print: *The Punishment of the Kuruwa (the Wall of the Yoshiwara)*:

When a Japanese man has given his coat of arms (of his family or an invented one) to a courtesan and has been unfaithful to her, it brings great shame to the woman. She therefore is within her rights to punish him. To this end, she sends her friends out around the women's quarter to spot the traitor and discover the house where he is going. They wait for him to come out and grab him by force, taking him to the courtesan, where they inflict every kind of indignity on him, while not being overly unkind. The seventh print represents the guilty party, dressed up like a little girl, a *kamuro**, on his knees, begging the courtesan's pardon in the midst of the laughter of all the women, including the *oiran** who was victim of his betrayal.

Eighth print: *Making Rice Cakes for the End of the Year*:

This print presents the making of the rice cakes for New Year's Day, with the entire household: women, servants—both men and women—and children, all working to prepare the large and small cakes.

Ninth print: *The Painting of a Hōō* in a "Green House"* (p. 195):

Before the childlike admiration of women, one of whom is on all fours on the floor trying to get a better look, a painter is finishing the painting of a gigantic *Hōō** on a wall of the courtesans' great hall; this painter could be Utamaro.

At the time when the *Book of the "Green Houses"* appeared, the women involved in prostitution in the *Yoshiwara** were divided into four classes: the First, the women of

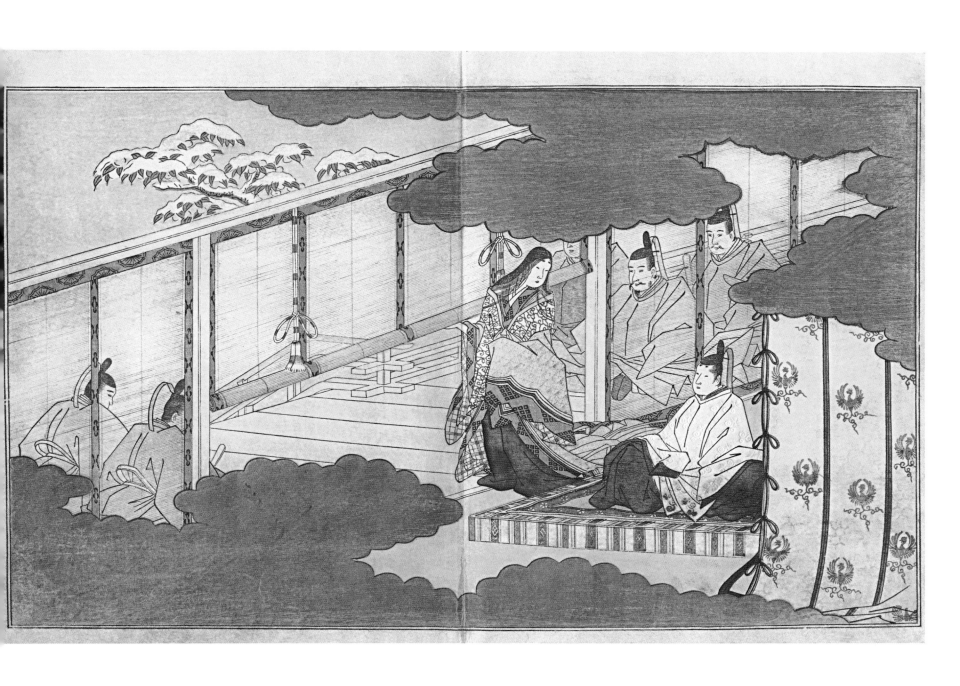

Court Scene in the Snow (Yuki no kyūchū [Sei Shōnagon]), from the album *The Silver World* (Gin sekai),
1790.
Illustrated kyōka, one volume, nishiki-e with brass dust, 25.6 x 18.9 cm.
Institut national d'histoire de l'art, Paris.

Pulling a Boat in the Snow (Yuki no hiki-bune), from the album *The Silver World* (Gin sekai),
1790.
Illustrated kyōka, one volume, nishiki-e with brass dust, 25.6 x 18.9 cm.
Institut national d'histoire de l'art, Paris.

Nakanō-chō (those who did the grand promenade); the Second, the women of Tchōnami (a class enjoying approximately the same esteem as the first); the Third, the women of Koghōshi (the little gate); and the Fourth, the women of Kiri-Misse (retail shops). The number of first-class houses was one-third that of the second class, while the second was only a tenth of the third class and the number in the fourth class was one-quarter greater than the third. There were therefore very few first-class houses and the number of grand courtesans was very limited. In general, it was only the grand courtesans whom the brush of painters like Utamaro depicted. In fact, out of a population of two million inhabitants in Edo at the end of the eighteenth century and in the first years of the nineteenth century, there were only 6,300 women in the Yoshiwara*, and of those 6,300 women, there were only 2,500 prostitutes in all four classes.

Two classes of men and women served in the "green houses", although their duties were somewhat ill-defined and their living conditions still not well known in Europe: the taikomochi* and the geisha. The taikomochi* were amusing male companions, humorous mahouts, elegant cicerones of prostitution, invited, like the geishas, to wedding parties on the initiative of tea-houses and responsible for lending gaiety to the event. These taikomochi* were, according to the Japanese, very intelligent and witty men, informed about everything which was happening in Edo. Men with a temperament with which it was impossible to quarrel, and, in addition, discreet to the point that one could confide any secret to them without the slightest fear! People on whose word one could easily count, their honesty was proverbial. They accepted nothing but the wages paid by the house and the "flower" (the roll of money) which it was customary to give them.

The taikomochi*, for all their low status, were very well bred, and had had good schooling, an education maliciously compared to that of an unsuccessful candidate to the academy of Seïdō (the scientific centre of Edo). Even outside the Yoshiwara*, for anyone with a bit of money, it was a good idea to hire a taikomochi* for a boat ride, for an excursion on the dyke of the Sumida, for there was never a dull moment with this ace of a man, who was as chatty as you wanted and who had a talent for being, with great tact, the companion to match your mood. This fellow was a true resource, when you had drunk too much, for rectifying the errors in the bill and putting your purse and your valuables in his pocket, out of harm's way! If you were resting on the dyke in a tea boat, the better to admire the Sumida through the snowy pink masses of cherry blossom, you would be the first one served. If you were entering a restaurant, you were given the best booth and the menu ordered by your companion was prepared to perfection. In addition, they were known everywhere, and an establishment not approved of by the taikomochi* could never make a go of it. If you were accompanied by a number of geisha, you had to have a taikomochi* to take charge, and everything would go perfectly. He would get the entire troop of geisha into an excellent mood. A science all his own, a science learned in the Yoshiwara*, and which meant that pleasures procured using his services ended up costing less than if you paid for them directly yourself.

The *taikomochi** knew how to dance, sing, and act, but were very careful, when using their talent for ingratiating themselves, never to give umbrage to the geisha, and they never condescended to serve in the second-class "green houses". The accompanying people frequenting that class were called *nodaiko,* which had the contemptuous meaning of country *taiko,* or *taiko* not belonging to the *Yoshiwara**.

The geisha, singers or dancers who were regulars on the main central street, were called *kemban.* They always went two by two, being forbidden to sleep with a man of the town in the *Yoshiwara**. This mutual surveillance saved them from situations when they might weaken. If she did weaken, the singer was banished from the *Yoshiwara**. In general, their conduct was held to be above reproach. That is the explanation of why there were so many marriages by women of this class to very distinguished men.

The geisha and the *taikomochi** were under the direction of the central office of artists, located on Nakanō-chō. In this office small wooden tags on which their names were written were hung on the wall in alphabetical order. When an invitation to the teahouse arrived, in the form of a letter containing the names of the singers requested, the nametags of those hired were taken down, and hung under the labels of the "green houses", which were on another wall: a very ingenious way of keeping books.

The second-class houses had their own singers who lived in the house. The "green houses" were not allowed to invite the geisha or the *taikomochi** directly: it was always through the agency of the bureau of artists that the invitation was made. One could not extend the time beyond the regular hours, except in cases of extreme emergency, and if that happened, the *thayra* had to pay a fine and was not allowed to hire artists for a period of time given in the rules.

If one wished to invite the geisha for an event outside the *Yoshiwara**, the order had to be placed several days in advance, and through the agency of the teahouse. The geisha then went away with you, accompanied always by an employee of the teahouse and by one or two porters to carry the cases of the three-stringed musical instrument called *shamisen**. One interesting fact: the *taikomochi** and the geisha, when they were in the courtesans' quarters, owed them the same respect as any servant to the master, for great courtesans always had to be treated like princesses.

The *Yoshiwara** was depicted by all the Japanese painters. For example, Kitao Masanobu painted the *New Illustration of the Pretty Educated Women of the Yoshiwara;* Shunshō and Shigemasa *The Mirror of the Green Houses,* Hokkei *The Twelve Hours in the Yoshiwara* and Harunobu *The beautiful Women of the Green Houses,* etc. But for nearly all Japanese painters, the images of the *Yoshiwara** are pretexts for slightly idealised groupings of women, lavish theories about the central street, displays of brilliant, embroidered robes, picturesque scenes of women with no indication of the habits, attitudes, or daily lot of the courtesan of the *Yoshiwara**. Utamaro is almost the only one who tells through line and colour the private

Party Scene on a Snowy Night (Yuki no shuen), from the album *The Silver World* (Gin sekai),
1790.
Illustrated kyōka, one volume, nishiki-e with brass dust, 25.6 x 18.9 cm.
Institut national d'histoire de l'art, Paris.

Embankment of the Sumida River in the Snow (Yuki no bokutei), from the album *The Silver World* (Gin sekai),
1790.
Illustrated kyōka, one volume, nishiki-e with brass dust, 25.6 x 18.9 cm.
Institut national d'histoire de l'art, Paris.

life by day and by night of these women, and, oddly enough, Utamaro's rival Toyokuni, the painter whose long, slender figures of Japanese women sometimes leave you unsure about the attribution and forced to find the signature, also published a book on the "green houses". It is interesting to study this book and to compare it with Utamaro's, all the more so since the two books are from the same period: the "green houses" of Utamaro was published in 1804 and the "green houses" of Toyokuni in 1802.

Before describing Utamaro's book, it is important to have a better idea of this type of prostitution, which is so different from the brutally sexual prostitution of the west, and show the almost poetic side of prostitution in the Empire of the Rising Sun, of prostitution where the woman's room contains musical instruments and a library and from a time when foreigners were just beginning to be admitted into the *Yoshiwara**. An informative document is a popular Sino-Japanese song, called the *Study of Flowers in the Yoshiwara*, which goes as follows:

"Do you see these two pretty butterflies on this flower. Why do they flutter about so close together?

— It is, no doubt, because the weather is fine, and they are captivated by the perfume of the flowers.

— Let us also go, like these butterflies, and visit the flowers.

— Have you studied the science of flowers?

— I did, under the direction of an excellent teacher from the *Yoshiwara**.

— Here is the main gate.

— Do you know a professor?

— I know Professor *Komurasaki* (deep crimson).

— Please wait a moment, Professor *Ousougoumo* (light clouds), is coming.

— The professor is making us wait a long time; do you have any idea why?

— The professors of the *Yoshiwara** spent a lot of time making themselves beautiful. First of all they like to use pomade from Simomura and braid from Tsyōzi in arranging their hair. Some adopt the fashion of Katsuyama, others prefer that of Simada. They do not realise that

their tortoiseshell combs and their coral hairpins, on which they spend a thousand pounds, add to their debts. Face powder, neck powder, makeup for their lips, and even for blackening the teeth, everything with them displays prodigality.

A moment later the professor appears.

In truth, she is very pretty, distinguished, amiable. On her eyebrows can be seen the mist of the distant mountains, in her eyes the shimmer of the autumn waves; her profile is regal, her mouth small, the whiteness of her teeth puts the snow of Fujiyama to shame; the charms of her body suggest the willows of the fields in summer. Her outer garment is decorated with flying dragons, embroidered in gold thread on black velvet. She wears a waistband of gold brocade; in a word, her appearance is impeccable.

— I came to talk with you on the subject of taking up the study of flowers.

— But have you given thought to how demanding this study is?

Please come into my room."

Since the description of these rooms is well known, it is unnecessary to speak of it in detail. Over the platform, big enough to hold six mats, there are hung three shades by the painter Hōitsu, representing flowers and birds. The games of *sugoroku* and *go*, the utensils for heating tea, a harp, a guitar, and a violin are stored on it. Beside it, in a bookcase, we find everything from the famous *Tale of the Genji*, of Murasaki Shibiku to the novels of Tamenaga Shunsui.

That is her room and this is the courtesan's dressing-room, every bit as much as the respectable woman's, an elegantly done dressing-room. A small window, of about seventy centimetres, jutting out of the wall and closed by a most artistic bamboo trellis, creates a dressing table on its inside sill. A kind of copper pot serves as a sink for washing. A wooden bucket, bound with bamboo, contains water, which is poured out using a long-handled dipper. The woman's toiletries are in a small black and gold lacquered cabinet. A metal mirror is set on a lacquered easel and covered with a piece of embroidered silk. This small cabinet also holds feminine finery made up of combs in tortoiseshell, in lacquered gold with an endless variety of decorations, and gold or silver hairpins — the only jewellery worn by Japanese women.

When the professor appears for the second time, she is dressed for bed, wearing a shift of red crêpe under a robe of violet satin, decorated with peonies and lions embroidered in gold thread. Loose down her back is her black hair, capable of enslaving the hearts of a thousand men, and partially visible is her body whose whiteness would mortify the snow itself. Her face, with its plum-blossom smile, is like the flowers of a pear tree, dotted with drops of rain.

"— The flower is weak; please water it often." And so saying, the peach blossom blushes, like the setting sun.

Returning to the painter, Toyokuni, to the illustration of his work entitled *The Manners of Today*, the first volume represents reputable women of all classes, but the second is entirely devoted to the *Yoshiwara**.

There is the grand courtesan, leaving for a walk down the central street, between her two *shinzō**, one of whom is making a final adjustment to her dress, and included in her retinue, her two little *kamuros** who are preparing to follow her. There is the *yarite*, the under-mistress, an older woman in charge of running the house, whispering into the ear of the grand courtesan that she is being requested in the drawing room. There is the carnival celebration, very much as it is shown by Utamaro, with large lacquered cases, containing the *shamisen**, being brought and with the geisha dressed as boys.

One interesting print is the office in a house showing details of its specialised furnishing: the racks holding letters in long envelopes, the cash ledger and the ledger of current accounts, the brown-lacquered board on which are written, in white paint, the things to do, orders to give, and events of the day. Below it, the money chest on which there are

Chinese Boys in the Snow (Yuki no kara-ko), from the series *The Silver World* (Gin sekai),
1790.
Illustrated kyōka, one volume, nishiki-e with brass dust, 25.6 x 18.9 cm.
Institut national d'histoire de l'art, Paris.

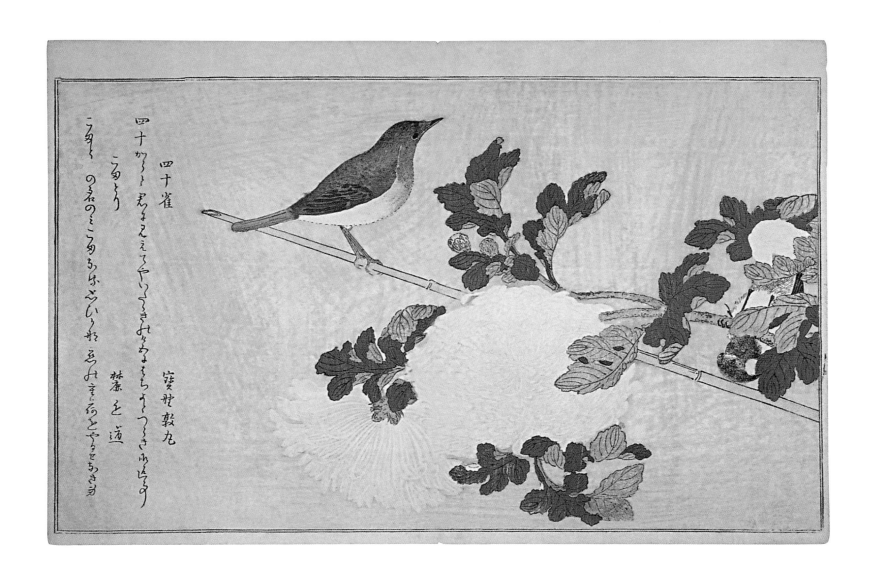

Myriad Birds: A Kyōka Competition (Momo chidori kyōka-awase), c. 1790.
Illustrated kyōka, one volume, nishiki-e, 25.5 x 18.9 cm.
The British Museum, London.

Myriad Birds: A Kyōka Competition (Momo chidori kyōka-awase), c. 1790.
Illustrated kyōka, one volume, nishiki-e, 25.5 x 18.9 cm.
The British Museum, London.

a scroll of letter paper, a writing tray, a rolled kakemono*, a closed fan, and a little teapot (tchiare) in its silk bag.

In one corner, above a cabinet, an altar is arranged, with a little pagoda in the back, surrounded by candles to light it, and a bottle of sake in the front amidst letters containing presents of money (bouquets). Hanging on the wall are strings of paper hens on small red circles, representing, in the embryonic state, little children, which are good-luck charms, and with these charms, a mask of Okame, whose smile in the vestibule of the house is believed by the Japanese to be an invitation to the visitor to be of good cheer. "The smile," said the first king of Japan, Ooanamouti, "is the source of happiness and fortune."

In the middle of the room, the mistress is seated, one hand on her pipe, sitting upright on the floor, while a servant massages her shoulders, and a woman lying flat is examining squares of silk spread out on the mat. These four prints by Toyokuni show the first-class prostitution, but with the fifth print, we take up the prostitution of the second and third classes, as it shows the exhibition room of the women, where through the bars of the enclosure, a fortune teller in the street predicts the women's futures.

Then there is the interior of the house, during their idle hours, where we see the women in relaxed poses, kneeling by the open window, absent-mindedly looking at the scene, or sitting on the windowsill with their backs turned to the street, stretching anxiously or leaning over earthenware vessels, greedily eating little boiled crabs. In the background we see another woman, her body leaning to one side, her neck bent, her mouth open wide, her little nose sticking up in the air and her eyebrows raised in points in her musical ecstasy, holding forth in the most comical fashion, accompanying herself madly on the shamisen*.

Next there is the life of these women in the gardens. One woman is showing another the love tattoo on her arm bearing the name of her sweetheart, sometimes his initial or his coat of arms. There is once again a woman of these houses dressing, combing her hair, putting on makeup, or blackening her teeth.

Then, the artist shows the depths of prostitution, a level to which the artist's brush rarely descends. On the doorstep of a teahouse, courtesans watch, as if with a disgusted curiosity, as, over by the wood piles, hideous old women dressed in rags are giving themselves in the manner of western streetwalkers, in broad daylight, next to dogs mounting each other. In this series, there is one particularly significant print for this nation of water: it is the base prostitution of stream and river, represented in the night of the sky and of the landscape, in the night of still waters, by a long dark woman with bare feet, still and upright, who stands out in the shadows against the whiteness of a boat with a reed roof.

In this book on the Yoshiwara*, Toyokuni, often the equal of Utamaro in his triptych prints, is outdone by his rival. His women do not have the elegance of body, the contorted grace of movement, the physical nobility of the Japanese prostitute. Nowhere in his images is

227

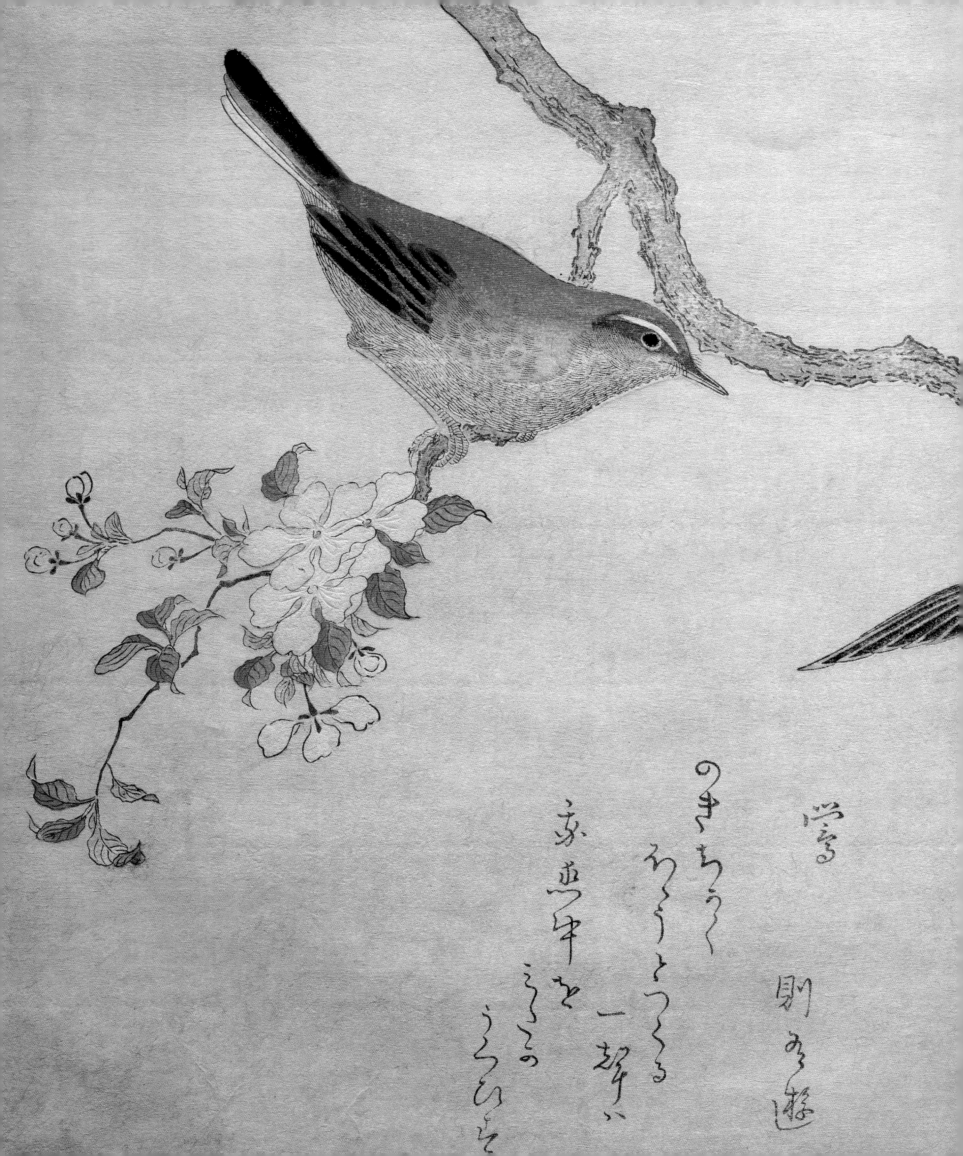

山雀　　紀定丸

君ハ床をあけのらみをれをり
ちゝおらしみ意乃山から

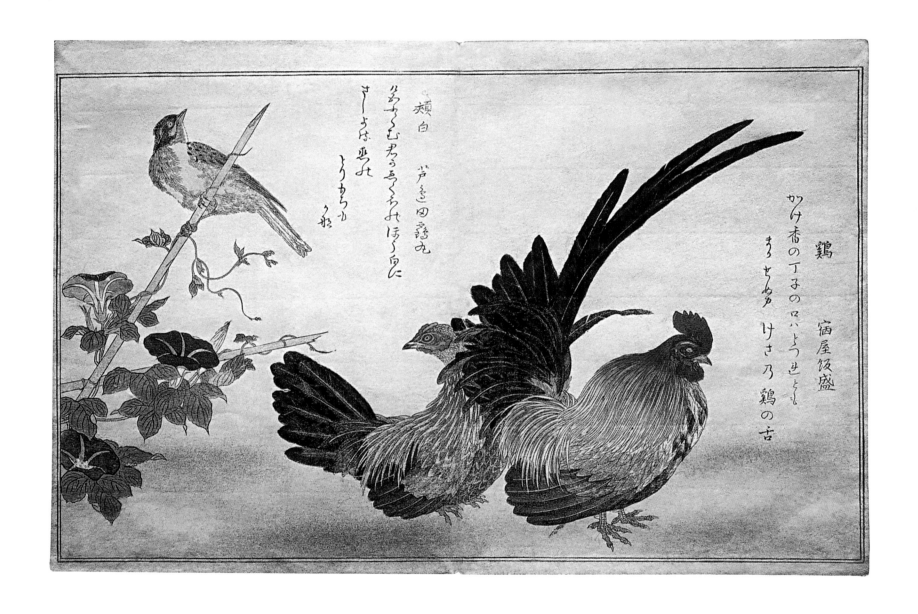

Myriad Birds: A Kyōka Competition (Momo chidori kyōka-awase),

c. 1790.

Illustrated kyōka, one volume, nishiki-e with pigments blown through a pipette, 25.9 x 19.2 cm.

The Fitzwilliam Museum, Cambridge.

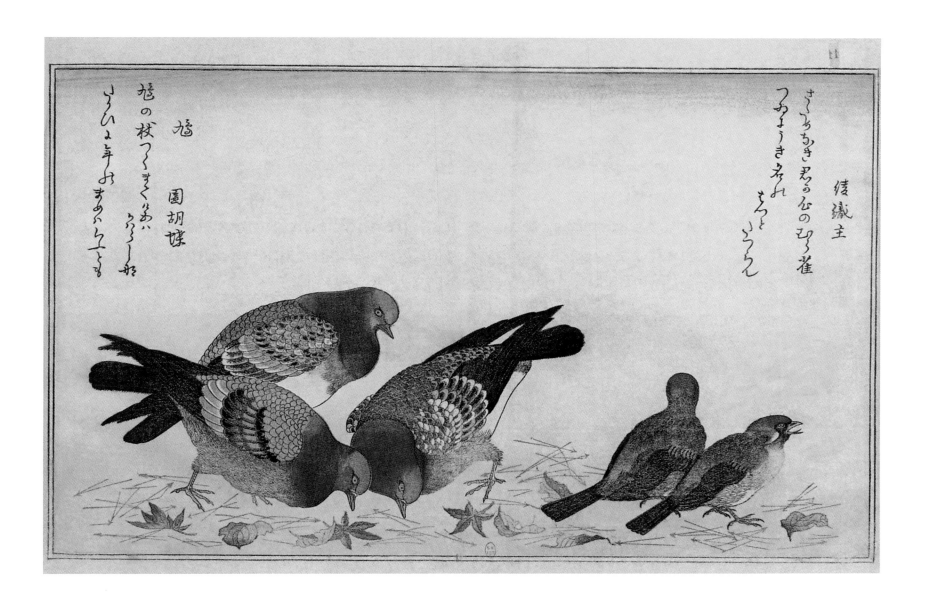

Myriad Birds: A Kyōka Competition (Momo chidori kyōka-awase),
c. 1790.
Illustrated kyōka, one volume. Nishiki-e.
Bibliothèque nationale de France, Paris.

there the intelligence in the design, the life in the composition, the surprise in a hint of voluptuousness in a woman. Then the comical note that Toyokuni seems to prefer in the representation of the scenes of the *Yoshiwara** adds to the triviality and commonness of the work. To appreciate the comparative talent of the two similar painters, one has only to put side by side the women displayed in the window by Utamaro and the same by Toyokuni: the one by the former is nothing less than marvellous, that of the latter is quite ordinary in comparison.

The Japanese woman is small and rather plump. From her, Utamaro has created a slender woman, a woman with refined feelings: a woman who has the reflective thoughts of Watteau's little morning sketches. It may be that before Utamaro, Kiyonaga had, like him, painted her larger than life, but ample and thick. The Japanese woman's face is short and compact, with a bit of the flattening seen in our cheap masks, and has in its features something of the bumpiness of these pieces of cardboard; in short this face, were it not for the inexpressible and gentle vivaciousness of its black eyes, is as it shown to us by Harunobu, Koryūsai and Shunshō.

Of this same face, Utamaro made a long oval! In the formalism of the drawing of the human face in Japan, which dictates that the painter must only represent eyes by two slits with a small point in the middle, the nose with an aquiline stroke of calligraphy and the same for all the noses in the Empire of the Rising Sun, the mouth by two little things which look like curled petals of a flower, Utamaro was perhaps the first to slip into these conventional and scarcely human faces a subversive grace, a naive astonishment, and an intelligent understanding. He was the first painter who, while respecting the consecrated lines and forms and yet bringing them in an almost invisible way closer to human lines and forms, to endow these lines with so much of the life of true portraits, that when looking at these faces one is no longer aware of the hieratic element of this face, this universal face, which has almost miraculously become an individual countenance for each person represented in his pictures.

Utamaro tries and succeeds in beautifying, making elegant, and idealising a woman previously represented by the artists in a graceless way. But, if Utamaro idealises a woman, her look, her body, her style, he is nonetheless a "naturalistic" painter, as illustrated by the capturing of poses and movements, by the imitation of graceful feminine humanity. Since Utamaro's subjects are almost always the women of the "green houses", it is the courtesan whom he idealises to the extent that, according to the expression of one Japanese commentator, he "makes her a goddess".

The strange, implausible, and incredible thing about this artist, this idealiser of the woman, is that when he so wishes he can become the most precise, the most rigorous, the most photographic draughtsman of birds, reptiles, or shells. He is, when he wants to be, the most careful and at the same time the most artistic illustrator of natural history. The depiction of these creatures and things of nature must be seen in three books entitled: *Myriad Birds: A Kyōka Competition* (pp. 226, 228-229, 230, 231, 232); *Picture*

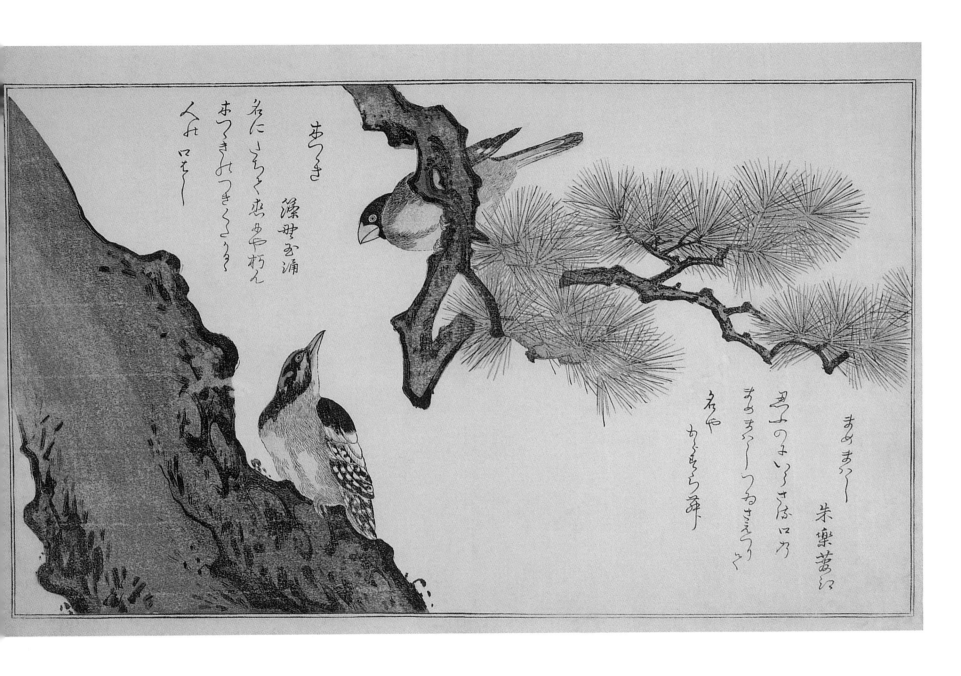

Myriad Birds: A Kyōka Competition (Momo chidori kyōka-awase),
c. 1790.
Illustrated kyōka, one volume, nishiki-e, 25.5 x 18.9 cm.
The British Museum, London.

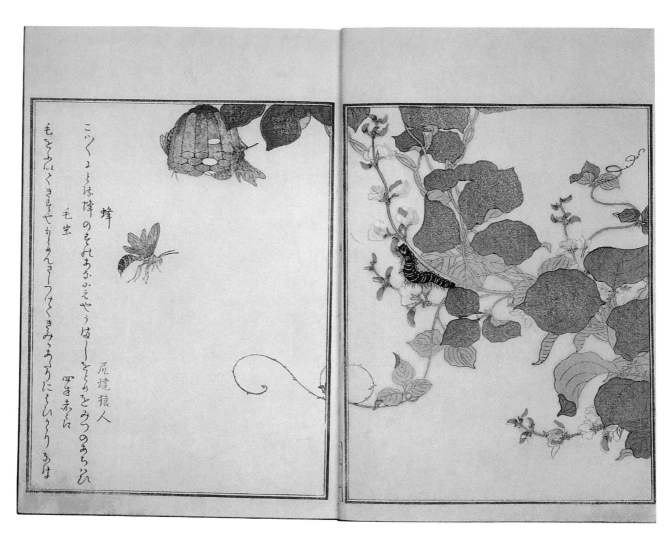

蜂

毛虫

尻焼猿人

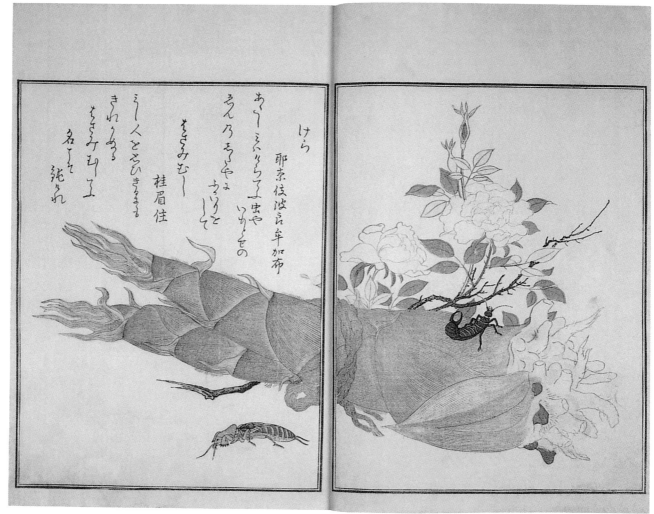

けら

耶宗伎波呂年加布

桂眉住

234

Book: *Selected Insects* (pp. 234, 236, 237); *At Low Tide* (pp. 238-239, 241, 242, 243, 244). These are very different drawings from the vellums of our famous museum of natural history, drawings reproduced in colour prints, such as no country in Europe had then succeeded in printing.

In the series of books in colour with natural history themes there are:

At Low Tide (pp. 238-239, 241, 242, 243, 244):
These are poems on shells by the members of a literary society. A large *in-octavo* book, containing, in addition to the frontispiece representing a stroll by the seaside and the final plate representing the game of *kai-awasse*, six double prints of seashells (book published around 1870).

Myriad Birds: A Kyōka Competition (pp. 226, 228-229, 230, 231, 232):
published by Tsutaya Jūzaburō. The first edition contains eight double-sheet compositions. The second edition, in two volumes, shows fifteen compositions in the following order:

First volume:
1. Owl Sleeping on an old Tree Trunk, near Several Robins, 2. Moorhens and Cranes, 3. Warbler and Sparrow on a Branch with White Chrysanthemums, 4. Pigeons amid *Mo-michi* Leaves and Pine Needles Spread on the Ground, 5. Owl and Jay on a Branch of a Dry Plum Tree, 6. Kingfisher on a Reed, and Mandarin Ducks, 7. Eagle and Kestrel on a Branch of a Flowering Plum Tree.

Second volume:
8. Titmouse on a Branch of a Flowering Peach Tree, 9. Quails and Corncrake in Reeds, 10. Hawfinch and Woodpecker on the Trunk of a Pine Tree, 11. Common Pheasant, Hen Pheasant and Wagtail among Rocks, 12. China Pheasant and Swallow in Full Flight, 13. Greenfinches on Sprigs of Bamboo, 14. Wren on a Branch of Broom in Flower, and Herons in the Reeds, 15. Cock and Hen.

In *Myriad Birds: A Kyōka Competition* (pp. 226, 228-229, 230, 231, 232), what a charming print is the one of the *Pecking Doves* in its appearance of a delicate pen drawing, washed simply in a pale blue. What

an admirable print the one of that duck which, owing to a slight embossing, gives the impression of being painted in watercolour on its own plumage. And yet what a marvel is that other print, representing *Cranes and a Kingfisher Hunting*, cranes which are, with their characteristic silhouette and bodies, little more than white embossing, and that half-submerged kingfisher, half of whose body diving into the stream is a prodigious rendering of the fading of colour and the blurring of form under water.

Sequel to the *Myriad Birds*:
It has been speculated that this might be the second volume, referred to as the second edition, of *Myriad Birds*, and a book to be put alongside the *Myriad Birds: A Kyōka Competition* (pp. 226, 228-229, 230, 231, 232) which has as its title *Copies of Foreign Birds by a Civil Servant from Nagasaki, to be Presented to the Shogun*: 1. Long-tailed Budgerigar, 2. Starling in the Branches of a Cherry Tree in Flower, 3. Warbler in the midst of Peonies, 4. Wagtail among Water Flowers, 5. Silver China Pheasant, Cock and Hen, 6. European Grey Partridge, 7. Oriole Pecking

Picture Book: Selected Insects (Ehon mushi erabi), 1788.
Illustrated kyōka, two volumes, nishiki-e with slight mica, 27.1 x 18.4 cm.
The British Museum, London.

Picture Book: Selected Insects (Ehon mushi erabi), 1788.
Illustrated kyōka, two volumes, nishiki-e with slight mica, 27.1 x 18.4 cm.
The British Museum, London.

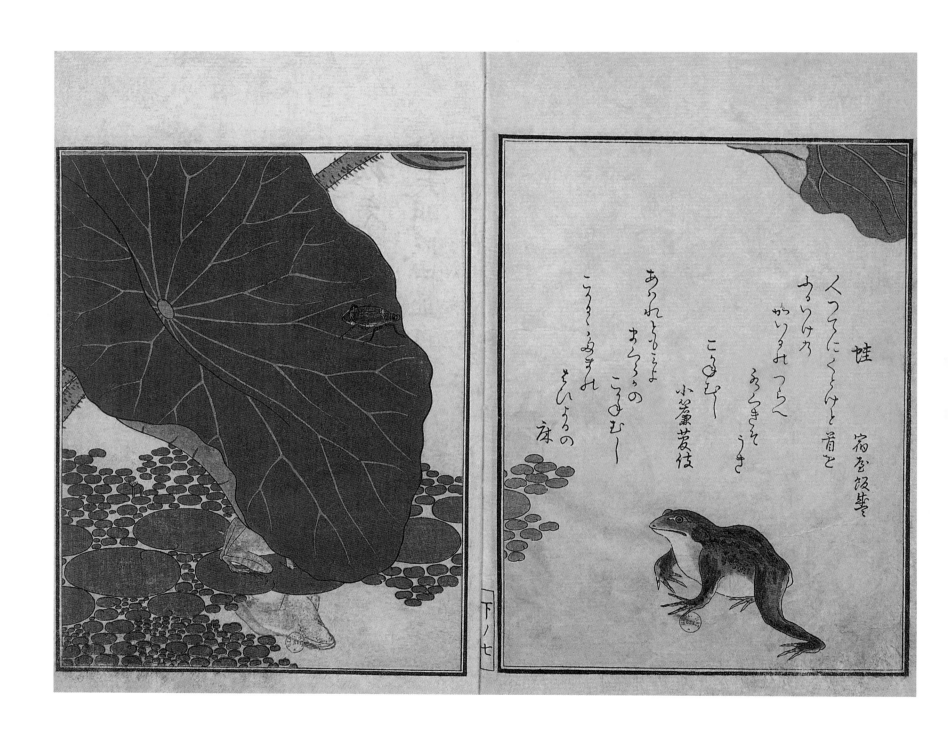

Picture Book: Selected Insects (Ehon mushi erabi),
1788.
Nishiki-e.
Bibliothèque nationale de France, Paris.

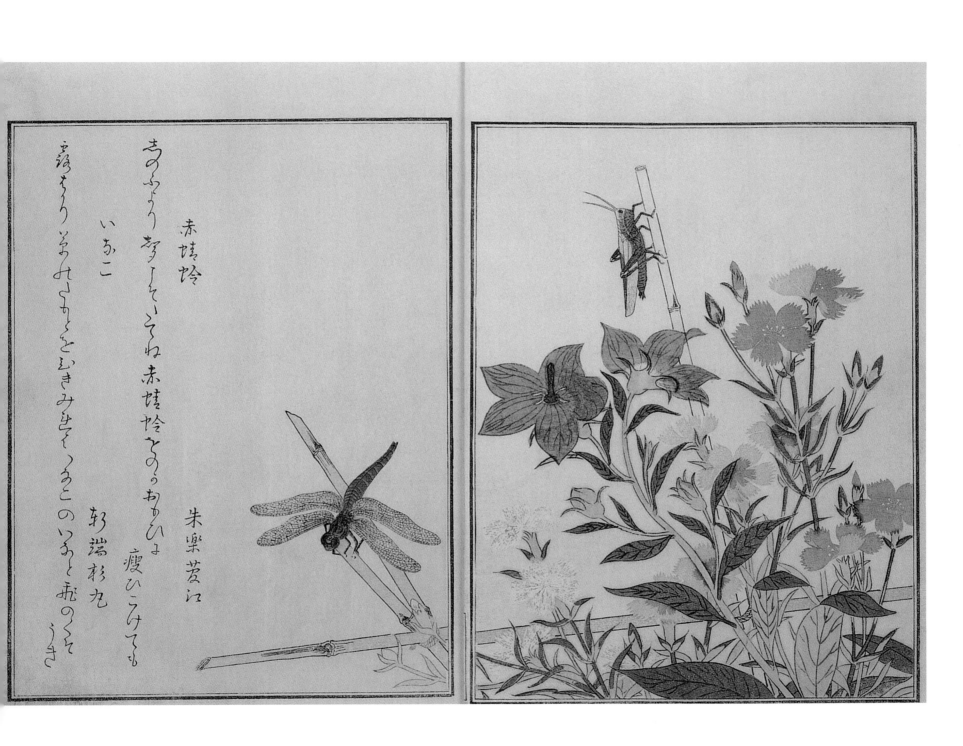

Picture Book: Selected Insects (Ehon mushi erabi),
1788.
Nishiki-e, 27 x 18 cm.
The British Museum, London.

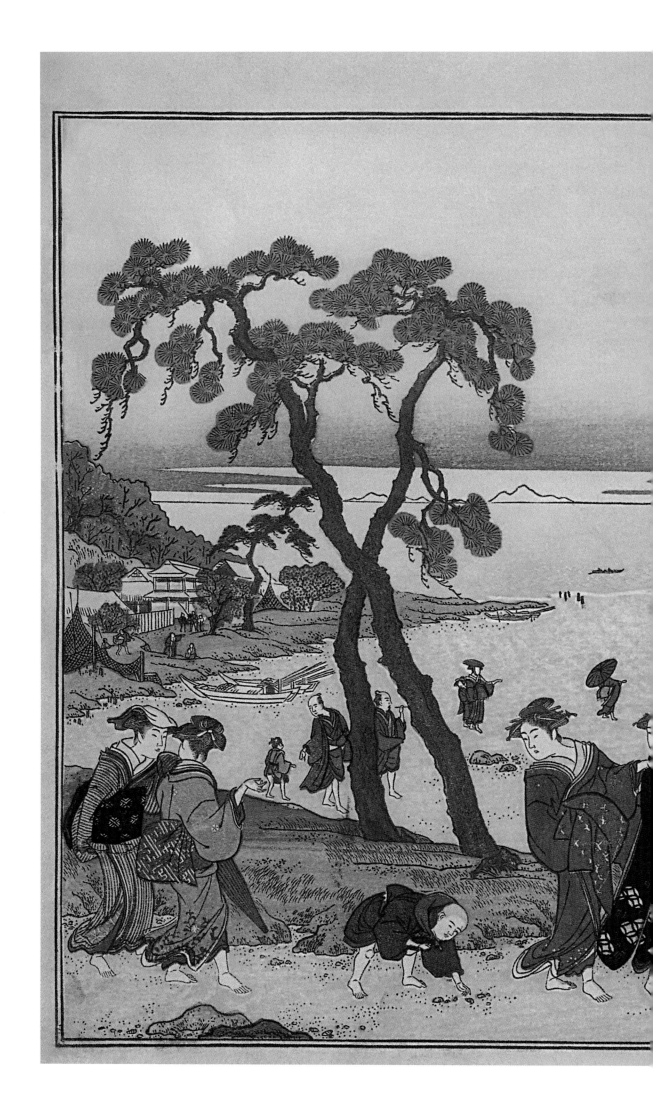

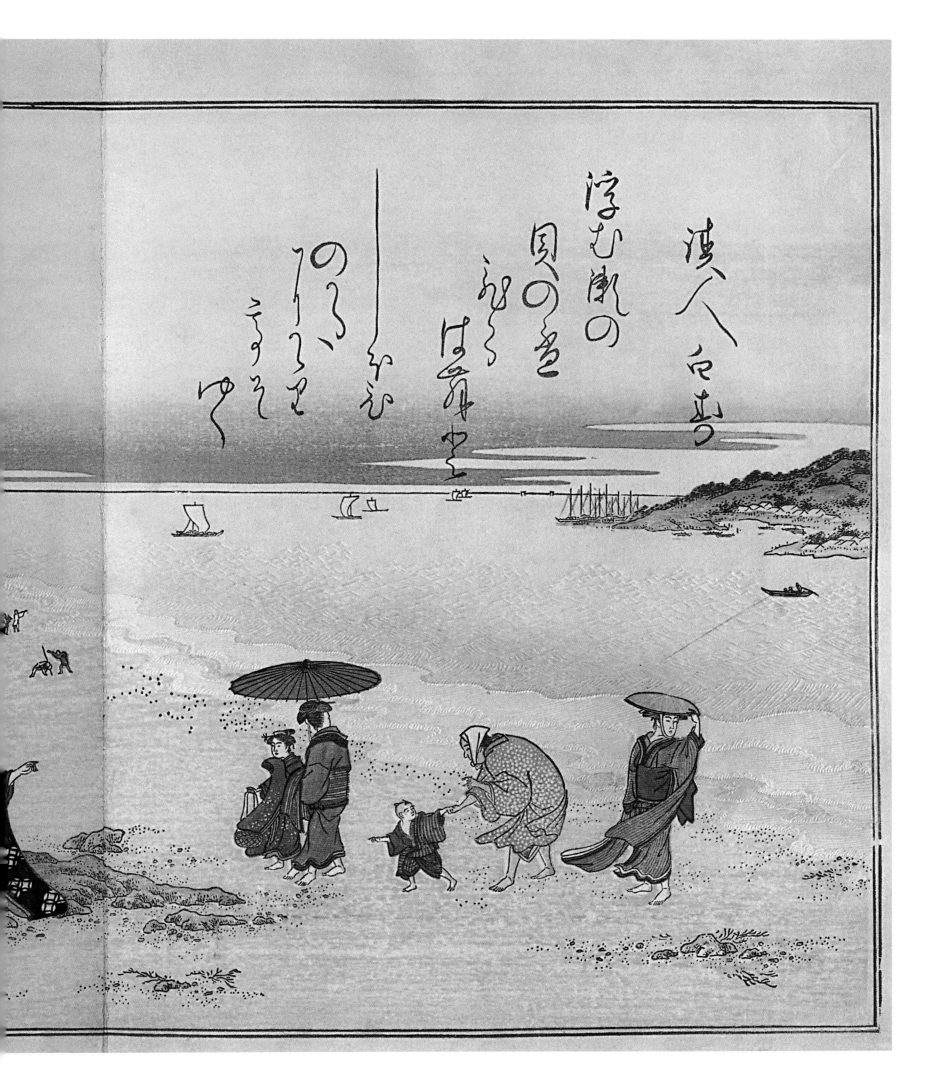

　浜人合毒

浮む瀬の
貝の色
はる日

のうへ
まつる
や

239

Japanese Medlars, 8. Robin on a *Mo-michi* Branch, 9. Jay on a Branch of Camellia in Flower, 10. Grouse.

In addition to these series, there must have existed in a larger format a series of large birds: Gonse has a print representing a falcon on a branch of plum tree in flower and Bing has a large stork standing straight on a branch of an evergreen beside a nest where there are seven offspring, crying in fright at some unknown danger.

Picture Book: Selected Insects (pp. 234, 236, 237):
These are books which ran to several editions, the later of which are greatly inferior to the first. The most complete editions contain fifteen prints (book published in 1788, with a preface by Toriyama Sekien). In the *Picture Book: Selected Insects* (pp. 234, 236, 237) are to be found some truly extraordinary illustrations, such as a frog playing in a water-lily leaf or a snake pursuing a lizard. In all these prints we see the astonishing details of a caterpillar, a grasshopper and a stag beetle as they stand out against the gentle green of the leaves, against the gentleness of the pink of the flowers. Also in these prints we see the *trompe-l'œil* of the bronze-green of the scarabs' corselet, the diamantine and emerald gauze of the dragonfly's wings, and, finally, the inclusion, so sophisticated and so skilful in the colouring of the insects, of shiny surfaces and the metallic reflections which the light causes to appear on them.

Aside from the miraculous perfection of the colour prints in this book, it is of particular interest for it begins with a preface written by Toriyama Sekien, Utamaro's master, praising the "naturalism" (coming from the heart) of his dear pupil, *Outa*.

Here is the preface:
"To reproduce life from the heart, and to draw its structure with a brush, such is the law of painting. The study which my pupil Utamaro has just published here, reproduces the very life of the world of insects. That is the true painting from the heart. And when I remember the past, I recall that, even when he was very small, *Outa* observed things in the most minute detail. In autumn, when he was in the garden, he would chase insects, whether it was a cricket or a grasshopper, and if he caught one, he would keep the creature in his hand and study it to his heart's content. And how often I scolded him, fearing that he would become accustomed to killing living creatures.

Having now gained his great talent with the brush, he has made these studies of insects into the glory of his profession. Yes, he manages to make the shine of the *tamanushi* (an insect) dance in a way that is shaking the old way of painting, and he has used the light weapons of the grasshopper to do battle against it, and he enlists the talent of the earthworm to dig in the soil, under the foundations of the old edifice. And so, he seeks to penetrate the mystery of nature groping in the manner of a larva, his way lit by the firefly, and in the end he disentangles himself by seizing the end of the strand of a spider's web.

He put his faith in the publication of the *kyōka** of the masters; as for the quality of the

At Low Tide. Illustrated kyōka. Institut national d'histoire de l'art, Paris.

At Low Tide. Illustrated kyōka. Institut national d'histoire de l'art, Paris.

At Low Tide. Illustrated kyōka. Institut national d'histoire de l'art, Paris.

At Low Tide. Illustrated kyōka. Institut national d'histoire de l'art, Paris.

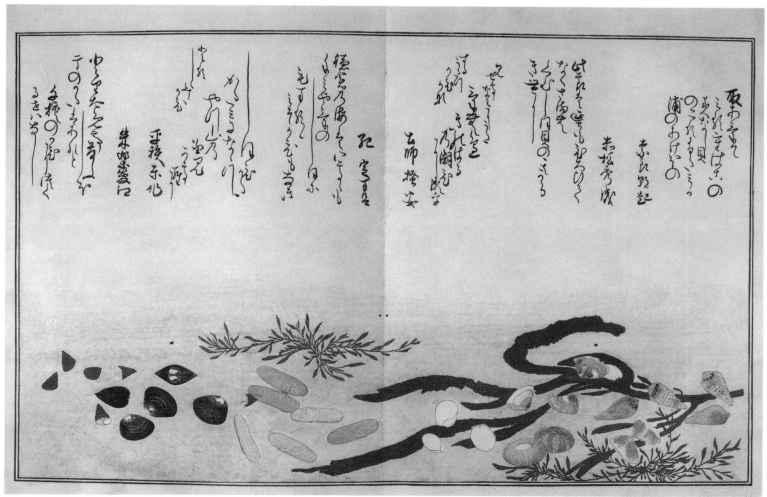

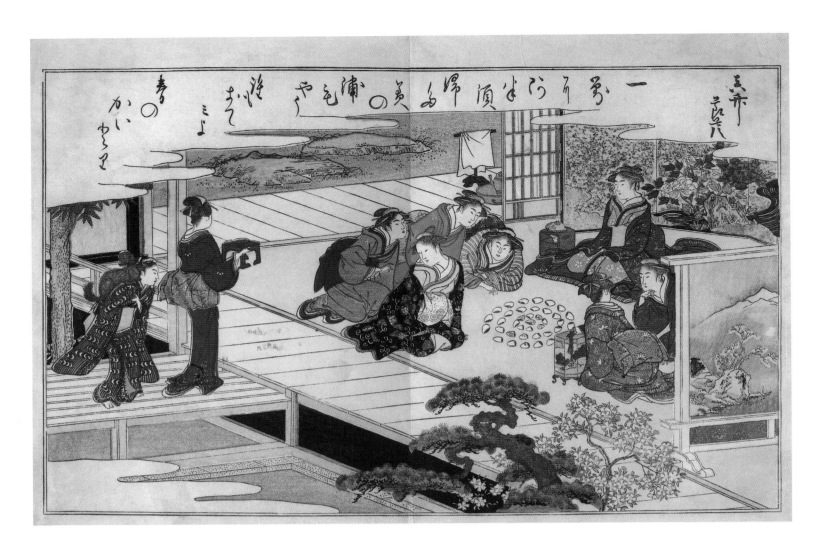

engraving (woodblock carving), it is the product of Fouji Kazumune's chisel.

The winter of the 5th year of Temmei (1787)." Toriyama Sekien.

This preface is a revolutionary manifesto for the non-classical school, for "the popular school" (*Ukiyo-e**) against the old painting of the Buddhist schools of Kanō and Tosa.

Of all these artistic books on natural history, the most exquisite is *At Low Tide* (pp. 238-239, 241, 242, 243, 244):

A first print represents women and children looking for seashells on a beach, from which the sea has receded. Next comes a series of pages in colour, with incredible colouring of shells with scattered touches of precious gems, these mother-of-pearl shells, these "pearly black" shells of burgau, these "streaked ruby-eye" shells revealing right there on the paper the microscopic landscape of these shells with their "flyspecks", these striped, layered, lamellar, tubular, vermicular shells, these shells which are curly like "sea cabbages" or spiked with needles like the back of hedgehogs. The book ends with an illustration representing the game of *kai-awasse*, a special game for young Japanese, whom we see sitting on their heels, in a comfortable room, around a circle of shells.

To these books on shells, insects, and birds, can be added fragments from books also having something to do with botany. Gillot owns the separated illustrations from a book which is probably one of the many done for composing bouquets and arranging them in vases, one of the pleasing talents which in Japan is part of the education of any well-bred girl. These blocks, printed in black and white with a few, sparing, yellow highlights, are seven in number and are all signed by Utamaro.

Among the decorative illustrations taken by Utamaro from natural history, let us also mention some prints in the private collection of Bing, of high style and slightly archaic tones. There are two prints: one, where beside a bit of seaweed two crabs are crawling, the other, where we see a chrysanthemum stem, its root wrapped in rice straw, leaning on a Japanese spade.

Two prints in a series, the second of which is printed on plain and crêpe paper; the first represents two flats of flowers stacked up atop a Japanese well; the second represents a toad holding in his mouth a vase in the shape of a half-rolled lotus leaf, in which there is a branch with yellow and violet blossoms. In two prints of this series we see a turtle carrying a bouquet of chrysanthemums in a vase similar to the toad's, and in the other the god Yebisu holds above his two hands, in a woven vase, a branch of cherry blossom.

Flowers of the Four Seasons:
This work represents women with flowers on the first and last pages of each volume: yellow *Kiria Japanica* flowers for winter, narcissi for springtime, irises for summer, and chrysanthemums for autumn. In one volume, a charming image depicts a room during a storm, where a man is closing the wooden shutters, a child is crying, and a woman in the green shadow of a mosquito net covers her ears out of fright: Utamaro took certain details from it for his large print of *The Storm* (book in two volumes, published in 1801).

At Low Tide. Illustrated kyōka. Institut national d'histoire de l'art, Paris.

At Low Tide. Illustrated kyōka. Institut national d'histoire de l'art, Paris.

At Low Tide. Illustrated kyōka. Institut national d'histoire de l'art, Paris.

At Low Tide. Illustrated kyōka. Institut national d'histoire de l'art, Paris.

The Bay at Akashi (Akashi no ura), from the album *Moon-mad Monk or Crazy Gazing at the Moon* (Kyōgestu-bō), August, 1789.
Illustrated kyōka anthology, (folding album), one volume nishiki-e with brass dust and mica, 25.5 x 19.1 cm.
Institut national d'histoire de l'art, Paris.

Let us also mention:

The Silver World (pp. 217, 218, 221, 222, 225): Snow in Japan, this country of hills and of picturesque trees, is an inspirational topic for poets. The love of snow extends from the educated classes downwards. Hayashi tells of a servant girl who, for fear that she would spoil the beautiful carpet on the ground, cried out one morning: "Oh! Fresh snow! Where will I throw these tea leaves?" This is similar to the bit of verse by the mistress of Yosi-tsūne, known under the title *Footsteps in the Snow*, which reads: "I think lovingly of the remains of the man who went into the mountain of Miyosino, blazing a trail through the snow that he trod with his feet." and this tender poem on the banished lover and the charming words of this other servant: "Oh please, madam, do not send me to the market this morning, a little dog has decorated the courtyard with his paws. I would not want to spoil this delicate painting with my heavy country clogs!" This book was illustrated by Utamaro, with six colour prints on the same theme as that given to the poets, for a poetry contest held at certain times every year: snow.

Figure of Fughen. Fughenzō (in Sanskrit, *Slovera Chadra)*, Buddhist goddess of the Bodhisatawa class. *Fughen* means "universal sage".
This goddess is worshipped in Japan along with Manju, *Manjushiri-satawa*, and in his illustration of this book Utamaro alludes to the virtuous beauty of the woman (book *in-quarto*, illustrated with five double prints, published in 1770).

The Habits of Women according to their Rank:
This small book in the collection of a Mr Duret represents: 1. A Dancer of Old, 2. A *Koto** Mistress, 3. A Poet, 4. A Courtesan, 5. A Wet Nurse, 6. A *Shinzō**, 7. A Messenger for a Princess, 8. A Widow, 9. A Hairdresser, 10. A Doctor, 11. An Archer and Seller of Bows, 12. A Peasant, 13. A Firewood Merchant, 14. A Sacred Dancer, *Niko*, 15. A Merchant, 16. A *Shiokumi* (a person who gathers seawater for salt). This is a charming copy of a small volume from the height of Utamaro powers, with restrained colouring.

Moon-mad Monk or *Crazy Gazing at the Moon* (pp. 246-247, 249, 250-251):
(quarto book, illustrated with five double prints, published in 1789).

Japanese Poem on a Walk in the Springtime:
(book *in-quarto*, illustrated with five double prints, published without date).
The Cloud of Cherry Blossom:
(book *in-quarto*, published without date).

Finally, several isolated colour prints by Utamaro appear in works illustrated by these colleagues.

In *Collection of Light Poetry*, illustrated by several artists, and including a truly beautiful print by Hokusai, Utamaro pictured the interior of a teahouse where, in a room decorated with a screen representing Fujiyama, a meal is being prepared by women, one of whom is carrying a bird in a cage.
In *Colour of Springtime*, a book of *kyōka** illustrated by various artists and published in 1794, Utamaro has an illustration representing a repairer of mirrors.
In *Portraits of the Actors of Edo by Toyokuni and his pupil Koummasa* (1789-1793), Utamaro, as well as the frontispiece (which is made up of accessories of the *Nō* dance), also drew the small print representing a seated actor, smoking, and watching as three women leave the theatre.

Moon-viewing in Yoshiwara (Yoshiwara no tsukimi), from the album *Moon-mad Monk or Crazy Gazing at the Moon* (Kyōgestu-bō), August, 1789.
Illustrated kyōka anthology, (folding album), one volume nishiki-e with brass dust and mica, 25.5 x 19.1 cm.
Institut national d'histoire de l'art, Paris.

Palace in the Moon (Gukkyū-den), from the album *Moon-mad Monk or Crazy Gazing at the Moon* (Kyōgestu-bō), August, 1789.
Illustrated kyōka anthology, (folding album), one volume nishiki-e with brass dust and mica, 25.5 x 19.1 cm.
Institut national d'histoire de l'art, Paris.

Moon over a Mountain and Moor (Sanya no tsuki), from
the album *Moon-mad Monk or Crazy Gazing at the Moon*
(Kyōgestu-bō), August, 1789.
Illustrated kyōka anthology, (folding album), one volume
nishiki-e with brass dust and mica, 25.5 x 19.1 cm.
Institut national d'histoire de l'art, Paris.

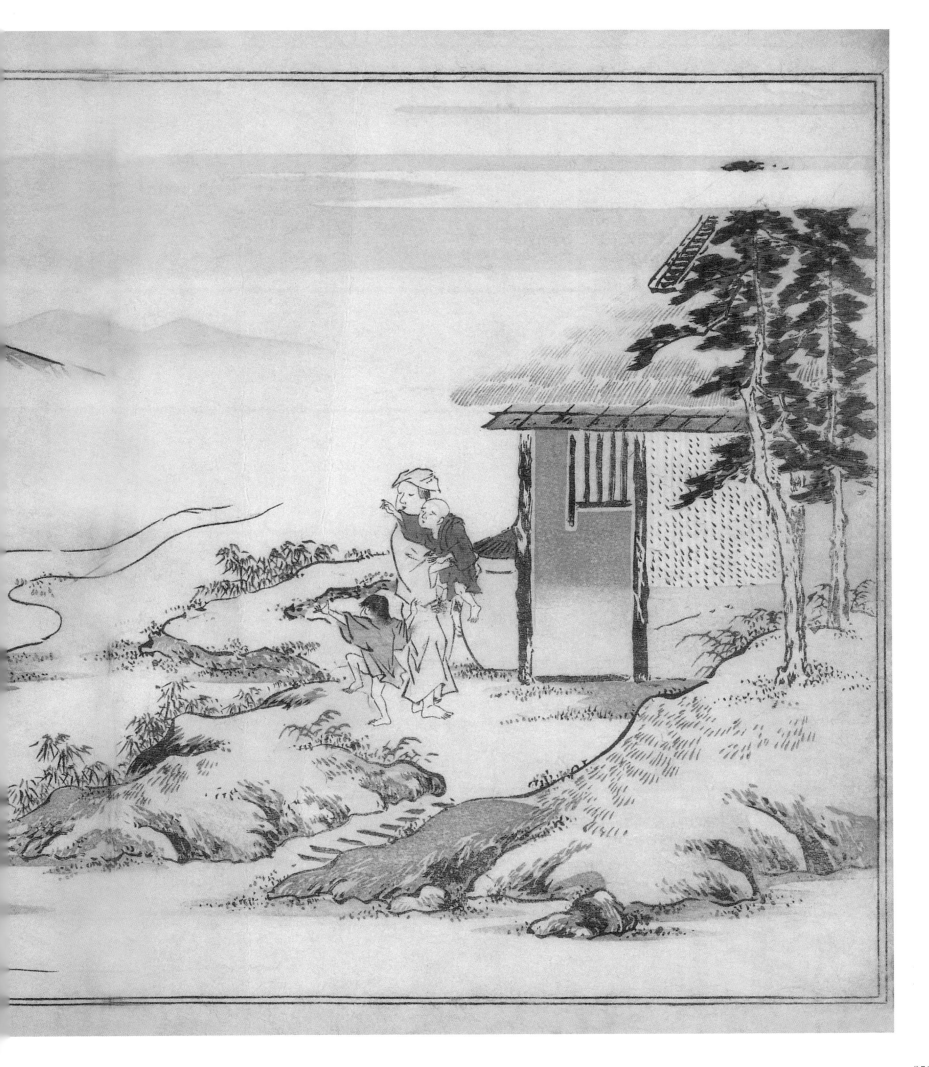

BIBLIOGRAPHY

DORA AMSDEN and WOLDEMAR VON SEIDLITZ
Impressions of Ukiyo-e, New York, 2007.

KITAGAWA UTAMARO
Trois Albums d'estampes, Edo, 1789-1790, reprint Paris, 2006.

JUNKO MIURA
Autour d'Utamaro, catalogue of the exhibition at the Institut national d'histoire de l'art, Paris, 2006.

Images du Monde flottant, catalogue of the exhibition at the Galeries nationales du Grand Palais, Paris, 2004.

GIAN CARLO CALZA
Ukiyo-e, Milan, 2004.

Utamaro, catalogue of the exhibition at the Ueno Royal Museum, Tokyo, 1998.

SHŪGŌASANO and TIMOTHY CLARK
"Kitagawa Utamaro", catalogue of the exhibition at the British Museum, London, 1995.

ICHITARO KONDO (English adaptation by Charles S. Terry)
Kitagawa Utamaro (1753-1806), Rutland, 1956.

EDMOND DE GONCOURT
Outamaro, Hokousaï : l'art japonais au XVIIIe siècle, Paris, 1896.

GLOSSARY

Aiban: print size between *chu-ban* and *oban*, approx. 33 x 23.5 cm.

Biwa: four-string mandolin.

Beni-e: print hand-painted with earthy colours (*beni*: light red colour derived from the carthamus flower).

Chūshingura: *kabuki* play telling of the forty-seven *ronins*.

Chūtanzaku: large print size, approx. 39 x 12 cm.

Chūban: medium print size, approx. 26 x 19 cm.

Daimyo: feudal lord.

E: picture, print.

Eboshi: headdress worn by the noble class, made of black-lacquered silk.

Edo: literally *The Capital of the East*, former name of Tokyo, used until 1868.

Ehon: picture books and illustrated stories.

Hashira-e: literally *pillar print*, print on an upright scroll, approx. 67 x 12 cm.

Hōō: fantastical bird.

Hosho: type of paper darkened with rice powder.

Hosoban: narrow print, approx. 33 x 15 cm.

Kabuki: popular theatre.

Kago: bourgeois *norimon*.

Kakemono: literally *hung object* or *object that one hangs* (from *kake*: hung and *mono*: object), suspended upright scroll, with a weight attached to the bottom.

Kami: Shinto divinity or spirit.

Kamuro: young girl serving a courtesan, destined to also become a courtesan.

Karazuri: literally *dry print*, a technique of printing in relief without ink, creating patterns with white on white embossing.

Kibyōshi: literally *yellow book*, popular novels printed in black, small format, approx. 17 x 12 cm, taking their name from the colour of their covers.

Kimono: literally *what one wears*, traditional raiment.

Ko-bosho: rectangular print, approx. 47 x 33 cm.

Komabue: bamboo flute of Korean origin.

Koto: thirteen-string plucked musical instrument.

Kotsuzumi: Japanese tambourine.

Kyōka: light poetry, humorous and satirical, free-form and rhymeless. *Kyōka* were often associated with a print.

Makimono: decorative horizontal scroll displaying painted images or calligraphy.

E-Makimono: illustrated horizontal scroll.

Manga: literally *whimsical images*, a book of sketches.

Mitiyuki: a pair of lovers.

Musume: a young girl.

Naga-oban: literally *long print*, dimensions varying from 47 x 17 cm to 52 x 25 cm.

Nishiki-e: literally *brocade picture*, print combining more than two colours.

Niwaka: the carnival of *Yoshiwara*.

Norimon: a one-passenger carriage carried by men.

Ōban: *large print*, dimensions varying from 36 x 25 cm to 39 x 27 cm.

Oiran: a high-ranking courtesan.

Shamisen: a three-stringed musical instrument resembling a lute.

Shikishiban: literally *square print*, approx. 20 x 18 cm.

Shinzo: the adolescent apprentice of a courtesan.

Shogun: the Japanese military dictator, governing office of the country from 1198 to 1868.

Shōji: a sliding, paper door on a wooden track, mainstay of Japanese architecture.

Shunga: literally *picture of spring*, an erotic print.

Surimono: a luxurious, made-to-order print.

Taikomochi: a court entertainer, the masculine counterpart of the geisha.

Teppō: a prostitute working in poor neighbourhoods.

Ukiyo-e: literally *pictures of the floating world* (from *Uki*: that which floats above, swims above; *yo*: world, life, contemporary time; and *e*: picture, print).

Yashiki: residence.

Yoshiwara: red-light district of Edo, established around 1600 by order of the shogun.

LIST OF ILLUSTRATIONS

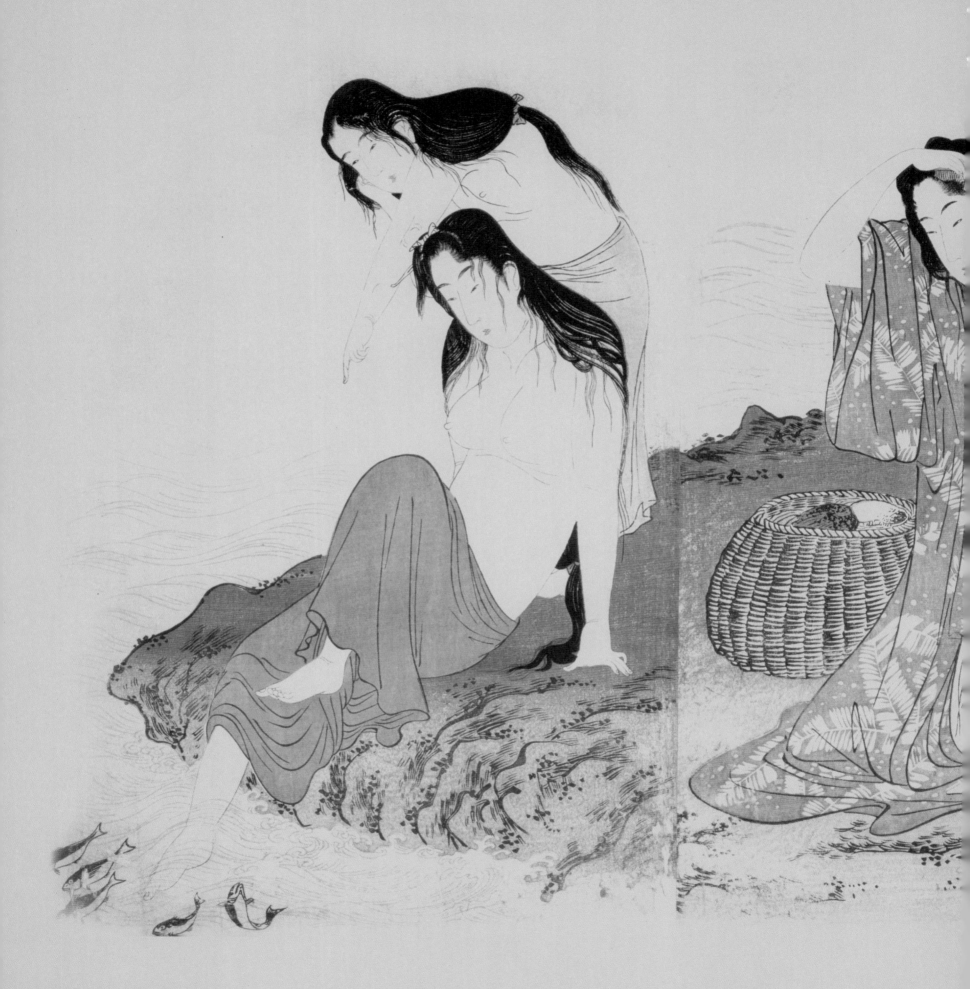